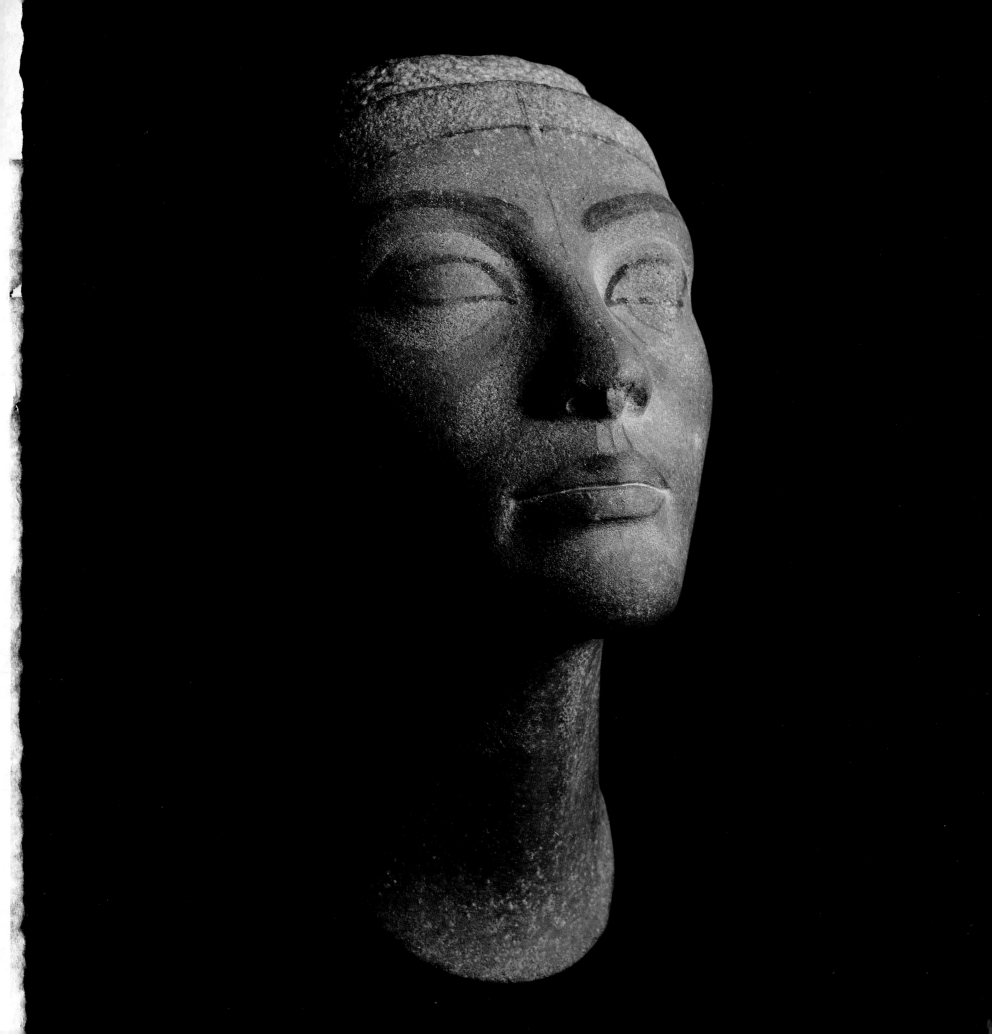

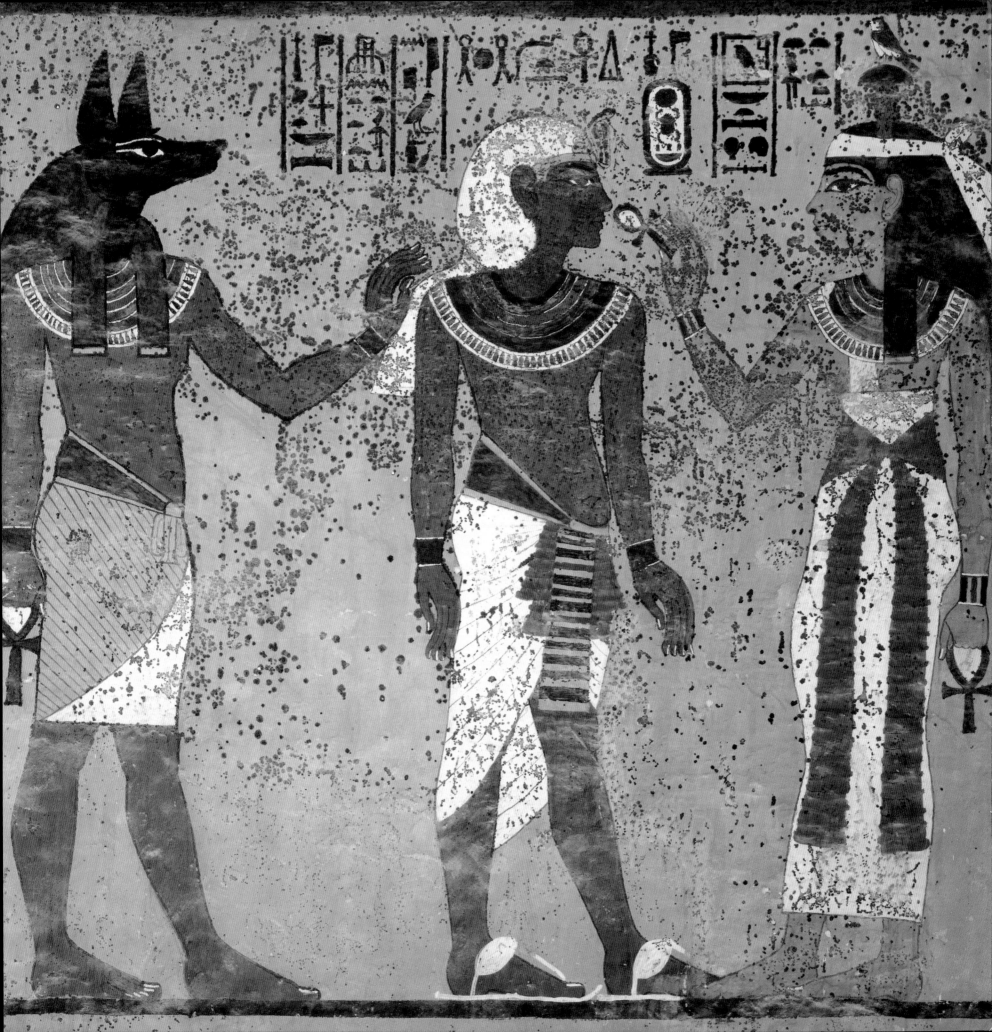

TUTANKHAMUN

THE GOLDEN KING AND THE GREAT PHARAOHS

ZAHI HAWASS

with photography by
SANDRO VANNINI

NATIONAL GEOGRAPHIC

WASHINGTON, D.C.

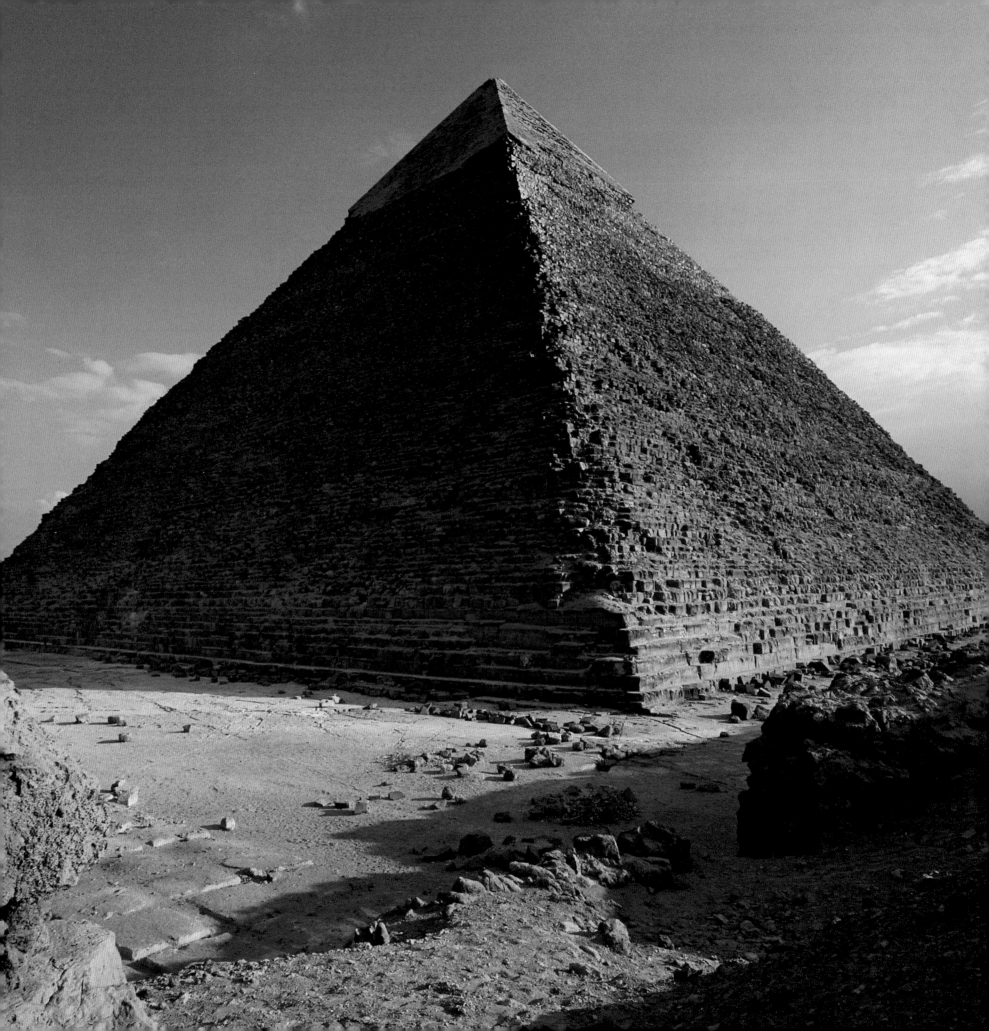

CONTENTS

OPPOSITE: Pyramid of Khafre with remains of limestone casing visible at the top, Giza, Dynasty 4.

PAGE 1: Painted quartzite head of Queen Nefertiti from an unfinished statue, Tell el Amarna, Dynasty 18.

PAGE 2: Tutankhamun flanked by the goddess Hathor and the god Anubis, south wall, tomb of Tutankhamun, Dynasty 18.

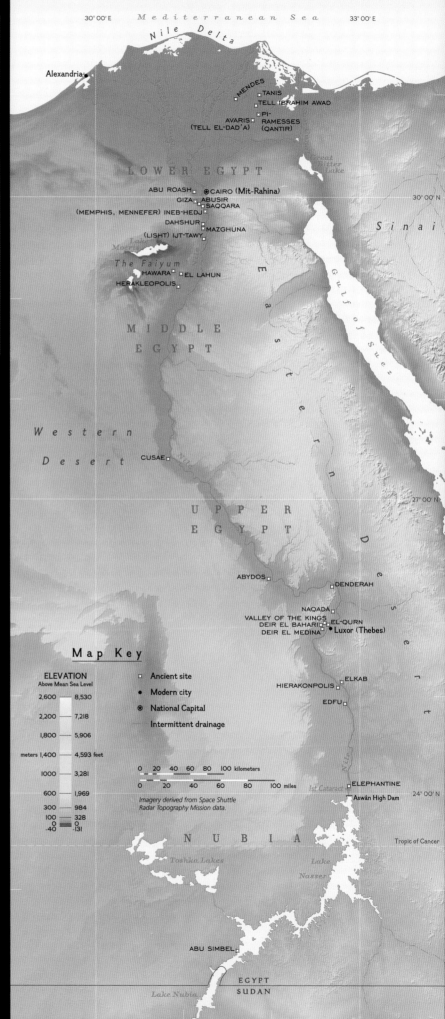

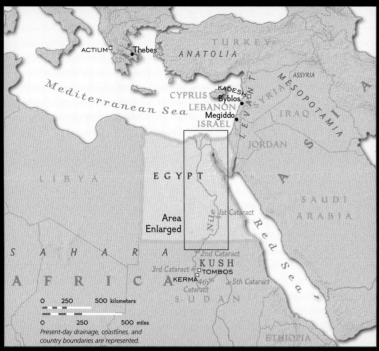

KEY SITES OF ANCIENT EGYPT

Through 3,000 years of pharaonic history, settlements and burials clustered along the Nile River and near oases to the west.

Map Key

ELEVATION
Above Mean Sea Level

meters	feet
2,600	8,530
2,200	7,218
1,800	5,906
meters 1,400	4,593 feet
1000	3,281
600	1,969
300	984
100	328
0	0
-40	-131

□ Ancient site

● Modern city

⊕ National Capital

— Intermittent drainage

0 20 40 60 80 100 kilometers

0 20 40 60 80 100 miles

Imagery derived from Space Shuttle Radar Topography Mission data.

FOREWORD

H. E. Mrs. Suzanne Mubarak

FOR THE LAST THREE YEARS, I HAVE FOLLOWED the success of the exhibition "Tutankhamun and the Golden Age of the Pharaohs" as it has traveled through Europe and the United States. Leaving Egypt for the first time in a quarter of a century, the golden boy is once again acting as our ambassador, providing millions of people around the world with a glimpse into the magical world of ancient Egypt.

I am very glad that we are sending another spectacular exhibition, "Tutankhamun: The Golden King and the Great Pharaohs," to entertain and educate our friends around the globe. King Tutankhamun will now tour cities in Europe and the United States. He is coming both to introduce himself and also to present the greatest of the pharaohs who came before and after him.

In addition to teaching visitors about the lives of Tutankhamun, his fellow kings, and Egypt's ancient elite, this new exhibition offers an important opportunity for us to strengthen our ties with our host countries, and to join with them in using the past to ensure our common future. The company sponsoring the tour, and the museums that will mount the exhibition, are all showing their appreciation—and demonstrating their belief in our shared goals—by donating funds to help redesign and renovate the Suzanne Mubarak Children's Museum. We are also working closely with one of our venues, the Children's Museum of Indianapolis, on this vital project, which is very dear to my heart. Educating our children is both a responsibility and a joy, and I would like to believe that the boy king, who died when he was only 19, would be pleased to know that his treasures were helping our youth reach their potential.

Everyone who comes to see this wonderful new exhibit will be touched by the wonder of ancient Egypt. The pharaohs founded one of the world's oldest, longest-lived, and most magnificent civilizations on the principle of *ma'at,* which Egyptologists translate as "truth and justice." The lessons taught by this rich culture about the heights to which humankind can aspire can help to carry us all into the future. The people of the ancient world looked on Egypt with wonder, and we can do no less today.

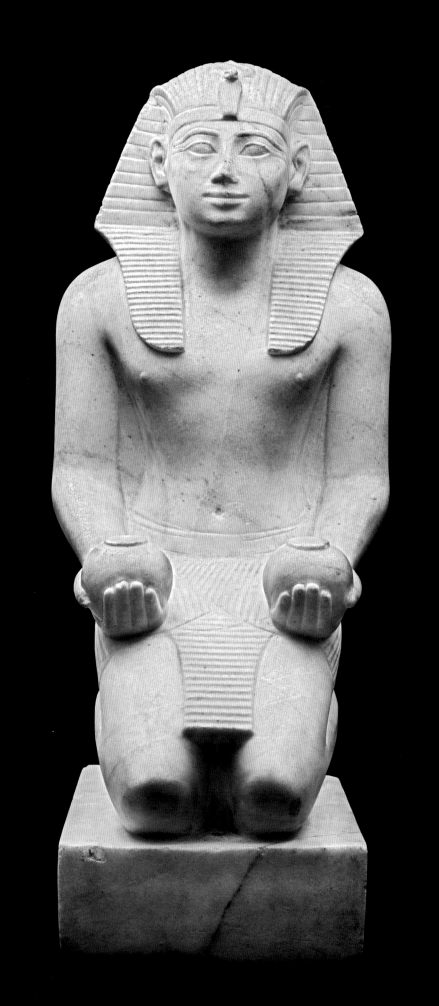

INTRODUCTION

ZAHI HAWASS

STATUE OF THUTMOSE III OFFERING NU-JARS
Calcite
Height 26.5 cm
New Kingdom, Dynasty 18, reign of Thutmose III
Thebes, Deir el Medina
JE 43502a

THIS BOOK TELLS THE STORY OF A GOLDEN BOY who still inspires wonder in us more than 85 years after the discovery of his tomb. I met him face to face when I led a scientific team that used CT imaging to shed light on the questions surrounding his life and death. As the lid of the innermost coffin was raised and I caught my first glimpse of the mummy, I felt my heart tremble.

This book invites all to share that excitement. It introduces not only the pharaohs of Egypt's Golden Age but also kings, queens, courtiers, priests, and everyday people from other periods of Egypt's long history. Many of the objects selected for the exhibition on which this book is based, such as the four statues of Inty-shedu, are traveling abroad for the first time. Inty-shedu was an overseer of the workmen who built the pyramids at Giza. I hope that his statues will help to tell the story of these workmen's achievements.

Four great scholars have joined me in contributing chapters to this book, in which they will share their major discoveries and theories about ancient Egypt. The stories of the great pharaohs will always live in our hearts and will continue to teach us not only about the glory of the past but about the great adventure of archaeology.

This exquisite statue of Thutmose III welcomes everyone to the exhibition. Visitors may be surprised to learn that some scholars believe that it is a fake. So I invite readers who know something about art history, and those who have good powers of observation, to look at the statue for themselves and decide if this statue is real—or if it is just a beautiful forgery.

I would like to dedicate this book to my dear friends Farida and Raouf El-Reedy.

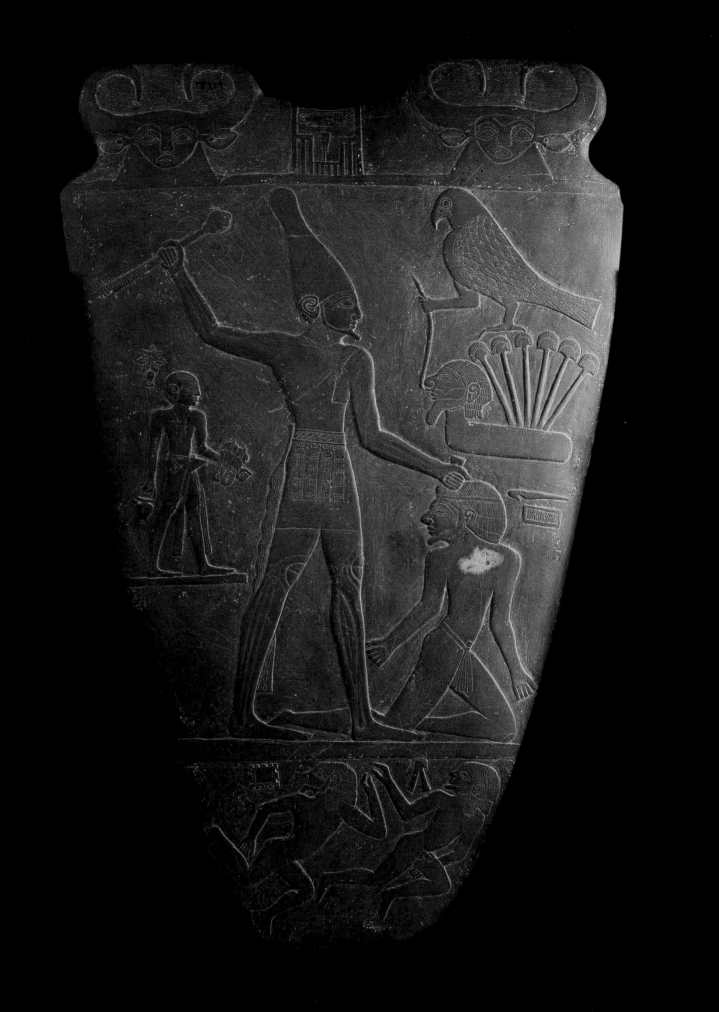

AN OUTLINE *of* EGYPTIAN HISTORY

THE LONG REIGN OF THE PHARAOHS

Zahi Hawass

THE EMERGENCE OF EGYPT as home to one of the world's earliest and most important civilizations was due in large part to the bounty of the Nile. Flowing north through a narrow, cliff-lined valley, and then dividing to irrigate the broad fields of the delta, the river was the country's natural highway and chief source of water. Flooding produced by rainwater from the highlands of Ethiopia caused the river to overflow in the late summer, drowning the fields in water rich with mineral-laden soil. These waters receded, depositing layers of fertile mud and providing nutrients for crops planted on the floodplain. The harvest came in the spring and early summer, producing food enough to feed the population, with a surplus beyond. As Herodotus, the Greek historian who visited Egypt in the fifth century B.C., wrote, "Egypt is the gift of the Nile." The intelligence and determination of the ancient Egyptian people played an important role, too. Egypt is also "the gift of the Egyptians."

Today most scholars believe that the population of ancient Egypt was a mixture of people from Africa and southwestern Asia, and that the culture and achievements of the pharaohs were founded securely in earlier periods of development within Egypt itself. The language of the ancient Egyptians

displays features seen now in languages like Hebrew and Arabic along with those found today in sub-Saharan Africa. Ancient Egyptian mummies show people with a wide range of physical features. In their art, Egyptians represented themselves as physically distinct from both the Nubians of Africa to the south and the Asiatic populations of the Levant and Mesopotamia to the northeast. In sum, the ancient Egyptians, like Egyptians today, seem to have been a unique group of North African people who shared many characteristics with the peoples of southwest Asia.

THROUGH THE PREDYNASTIC PERIOD

There is evidence of hominids—members of the species *Homo erectus*—in Egypt as early as 700,000 to 500,000 B.C., during the Paleolithic period. During the Mesolithic period

NARMER PALETTE, from Hierakonpolis, Dynasty 0, circa 3100-3050 B.C. Wearing the white crown of Upper Egypt, King Narmer smites a northern enemy to symbolize the unification of southern and northern Egypt.

(circa 30,000 to 7000 B.C.), there were periods when areas that are now desert received enough rainfall to support human activities. Groups of nomadic hunter-gatherers moved between these savannas and the Nile Valley, leaving behind stone tools, animal and plant remains, hearths, and even burials.

By about 5300 B.C., the people living in Egypt had established some permanent farming communities. They lived in simple houses built of reeds and mud and buried their dead in shallow graves on the edge of the desert that extended on either side of the fertile river valley. Entombed with the dead were objects such as flint knives, pottery, and jewelry of semiprecious stones or shells.

As Egypt entered the age of metal, artifacts made of gold and copper were included in burials. Over the course of the late Neolithic—which in Egyptian history is considered the Predynastic Period, before the rise of the pharaohs—a social hierarchy was developing, reflected in richer and more elaborate graves for the elite. Egyptian burials dating from the early Predynastic Period included imported goods. Pottery followed a clear sequence of development, with later pieces sporting figurative motifs.

During the early Predynastic Period, distinct material cultures arose in the Nile Delta to the north and in the Nile Valley to the south. Sometime in the late Predynastic Period, between 3500 and 3200 B.C., these two material cultures merged. Southern artifact styles became predominant, although some local differences remained visible.

ANCIENT ROYAL TOMB, Umm el Qa'ab, Abydos, Early Dynastic Period, circa 3100-2687 B.C. Most of the Early Dynastic kings were buried at Abydos, a site later sacred to the god Osiris.

The first evidence for writing, found in an elite tomb at the southern site of Abydos, dates from about 3300 B.C. By this time, leaders that we would probably consider kings were beginning to emerge. We now call this era Dynasty 0, in recognition that the increased power of a ruling class was beginning to show characteristics associated with kingship.

THE EARLY DYNASTIC PERIOD

According to ancient Egyptian legend, the Nile Valley conquered the Nile Delta under King Menes (now identified with King Aha) in about 3050 B.C. Menes/Aha is considered the unifier and the first king of Dynasty 1, therefore, even though he was preceded by a king named Narmer, whose famous slate palette seems to commemorate a triumph of the south over the north. The archaeology of this era suggests, in fact, that the process of unification was more gradual, with southern leaders from the key sites of Hierakonpolis, Abydos, and Naqada first joining together—most likely by a combination of force and intermarriage—and then extending their control north.

The Narmer palette demonstrates that much of the iconography to be seen throughout the pharaonic period was fully formed by this early point in Egyptian history. On one side, the king wears the low, flat crown of Lower Egypt (the north), and on the other he wears the crown of Upper Egypt (the south). The king's kilt, a bull's tail, and a mace, which he uses to smite his foe, are all icons that will figure centrally in Egyptian art for the next 3,000 years. Another detail presages a standard feature of pharaonic art: The scale of the figures reflects their relative importance. The king is the largest figure, next in size is the enemy king, then the Egyptian vizier and the royal sandal-bearer.

According to later Egyptian histories, Menes established a new capital called Inebhedj (White Wall) at the point where the north and south came together. This was later called Mennefer, after the name of the pyramid of Pepi I of Dynasty 6, who ruled from about 2354 to 2310 B.C. The Hellenized version of this name was Memphis, which is the name by which the area is still known today. For many years, it was believed that the Early Dynastic

capital of Inebhedj was located about 24 kilometers south of modern Cairo, near a site known today as Mit Rahina. Recent work here has proved, however, that Inebhedj lay farther north, at the base of the northern escarpment at Saqqara. The successors of Menes ruled Egypt over the course of about 31 dynasties, sometimes flourishing and sometimes simply surviving during periods of disunity and decline.

The kings of Dynasty 1 were buried at Abydos, in tombs far out in the desert marked by stelae, or stone slabs, bearing their names. Associated with each tomb was one or more cult enclosures, established closer to the floodplain. Servants and followers of the king, evidently killed in order to accompany him into the afterlife, were buried around the tombs and enclosures. There are also massive tombs at Saqqara from this era, built most likely for important members of the royal family and court; some of these are also surrounded by subsidiary burials. No evidence of human sacrifice is seen in Egypt after the end of the 1st dynasty.

Most of the kings of Dynasty 2 were buried at Saqqara, in mazes of underground galleries now located underneath the funerary complexes of later pharaohs, those of the Old Kingdom, the term used to designate Dynasties 3 through 6. The superstructures of these early tombs were removed by later kings, so we do not know what form they might have taken. The last two kings of Dynasty 2, Peribsen and Khasekhemwy, were buried, like their forebears, at Abydos.

THE OLD KINGDOM

Recent archaeological discoveries at Abydos confirm that the first king of Dynasty 3 was Djoser, whose name was found on seals excavated from the tomb of Khasekhemwy. King Djoser was buried at Saqqara, in what was both the first pyramid and the first large-scale monument of stone. This "step pyramid" was designed by a high official named Imhotep, an architectural genius who created a pyramid shape out of stone-built "mastabas," rectangular structures with inward-sloping sides. Mastabas of descending size were placed one atop the other, to reach a height of 60 meters. The step pyramid was thought of as a staircase used by the king to

climb up to join the imperishable stars, and also as the primeval mound on which the creator god had stood to bring the world into being. The pyramid sat within a complex of temples and chapels, all surrounded by a high, niched wall. The 3rd-dynasty kings who followed Djoser also began step pyramids, but none seems to have been completed. The tomb of Huny, last king of Dynasty 3, has never been securely identified.

Huny's successor, Sneferu, the first king of Dynasty 4, built four pyramids: one small, with no burial chambers, and three monumental, including the first true, or straight-sided, pyramid. It is now thought that Sneferu ruled for more than 46 years, about double the reign assigned to him by earlier historians. The new type of monument created during Sneferu's reign, scholars believe, added solar symbolism to the pyramid.

Egyptian kingship as we know it best was established during this time. The king was a source of goodness in this life, a link between the human and the divine. He was seen during life as an earthly incarnation of the falcon god, Horus, and when he died, he joined the stars and the sun god, Re. He was required to do certain things during his lifetime, such as building a pyramid for his burial and funerary cult and erecting temples for the worship of the gods.

The king was also responsible for preserving the unity of the Two Lands (north and south, Lower and Upper Egypt), giving offerings to the gods, and smiting the enemies of Egypt. After fulfilling these requirements, the king celebrated a *Sed* festival. Although most scholars have considered the Sed festival a rejuvenation ceremony, I believe that it was a way for the king to demonstrate that, having finished all the tasks required of him by the gods, he was now equal to them.

Khufu, Sneferu's successor, built his pyramid on the Giza plateau. His Great Pyramid has captured the hearts of everyone all over the world. Over the last several years, we have discovered many of the architectural components of his pyramid complex. Among these are the route of the causeway that connected the king's mortuary temple with his valley temple, the valley temple itself, and the satellite pyramid. Recently, we discovered the port where supplies were brought to the complex and an extensive settlement under the modern village of Nazlet el Samman.

In Khufu's complex there are five boat pits, which served various religious functions. Two of these, discovered to the south of the pyramid in 1954, were found to contain full-size dismantled boats. These were most likely symbolic solar boats—boats that the king would use in his afterlife to accompany the sun on its journey through the day and night skies.

To the east of the Great Pyramid at Giza stand four subsidiary pyramids. Three were built for Khufu's queens, perhaps including his mother, while the fourth, smaller and offset to the east, served as a cult pyramid where the king could change costumes during the Sed festival. Large tombs for members of his immediate family also lie to the east of the Great Pyramid. A vast necropolis was laid out west of the pyramid for officials who had served the king and those who maintained his cult after his death.

The 4th dynasty may have been the strongest in Egyptian history. More stone was used to build the pyramids of this dynasty than for all the other pyramids of the Old Kingdom. The size of the tombs at Giza, along with the scenes with which they were decorated, attests to a strong centralized government and a society with a flourishing economy. The titles of the officials buried near the king show a well-developed administration for the country as a whole, and there is evidence of secure trading relationships with foreign lands.

I believe (along with Rainer Stadelmann, a German archaeologist) that Khufu made changes to the cult of the king and appointed himself an incarnation of the sun god in the fifth year of his reign. Changes to his pyramid complex, along with the fact that his burial chamber was aboveground, in the body of the pyramid, might have been meant to associate him closely with this god. His son and successor, Djedefre, was the first to use the title "son of Re."

Djedefre went north of Giza, to Abu Rawash, to build his pyramid. His half-brother, Khafre, returned to Giza to build a pyramid almost as large as Khufu's. Khafre's complex is most remarkable for the temples connected to it, especially the Valley Temple, which still stands at the edge of the floodplain and is visited by thousands of tourists every day. The most famous component of Khafre's complex is the Great Sphinx, which was carved out of the solid rock of the plateau. It has the face of King Khafre and the body of a prostrate lion, making offerings to the

sun god who rose and set in the temple before it. Khafre's son Menkaure was also buried at Giza, in a much smaller pyramid than that of his father or grandfather. He died before the monument had been completed, but the tomb was finished under his son, Shepseskaf.

The kings of Dynasties 5 and 6 built their pyramids at Abusir, North Saqqara, and South Saqqara, and their complexes have yielded good information about this period. The volume of stone used in pyramids decreased after Dynasty 4, but the decoration of pyramid complexes expanded greatly, suggesting that economic decline was not necessarily the reason for the smaller pyramids from the reign of Menkaure forward.

Pyramid Texts—spells inscribed on the burial chamber walls to ensure the king's transition into a powerful and effective spirit and to guide him to his divine afterlife—appear for the first time at the end of Dynasty 5, inside the pyramid of Unas. Various combinations of these spells continued to be inscribed inside the pyramids of kings, and some queens, during Dynasty 6.

Officials and nobles from the earlier part of this period were buried in cemeteries that surrounded the pyramid complexes of the kings they served; the 6th dynasty saw the rise of important provincial tombs at sites such as Abydos and Aswan. The large, richly decorated tombs at Memphis and elsewhere attest to the wealth and power of the elite during the Old Kingdom. The inscriptions they contain provide us with historical information, such as details about trade and military expeditions or stories of palace intrigue. The scenes in these tomb chapels tell a great deal about ancient Egyptian concepts of both the afterlife and life on Earth.

The fifth and last king of Dynasty 6 was Pepi II, who ascended the throne as a child and may have ruled for as many as 90 years. He was succeeded by a queen named Nitocris, and later by apparently inconsequential kings who ruled during the 7th and 8th dynasties. By then the power of the kings had begun to decline, although some, such as Ibi, managed to build pyramids south of Saqqara.

THE FIRST INTERMEDIATE PERIOD

The centralized government of ancient Egypt began to collapse during the late Old Kingdom, perhaps due in part to the long reign of Pepi II, and at the same time regional governors seem to have gained in power. Particularly low or high Nile floods may have affected the land and reduced the crop yield, leading to famine. The resulting decrease in resources brought a halt to most of the great building projects. The tombs of kings may well have fallen prey to robbery by the poor.

By the end of Dynasty 8, the united kingdom had fallen apart. Tomb art and literature from this period and later portray a time of civil war and chaos, with minor kinglets from provincial sites jockeying for territory. The Admonitions of Ipuwer, for example, is a papyrus document that tells a tale of social turmoil and upheaval: The rich become poor and the poor become rich; anarchy reigns; rivers run with blood; farmers must carry shields in order to plow their fields. Foreign trade has stopped, luxury goods are no longer easily available, and there is rebellion against the royal house.

The kings of the 9th and 10th dynasties, who controlled only the northern part of the country, were based at Herakleopolis, near the entrance to the Faiyum, an important oasis south of Cairo and west of the Nile. Texts tell us that one of the kings of Dynasty 9, Merikare, built his pyramid at Saqqara, but it has not yet been located. Some scholars believe that Merikare could be the owner of the so-called headless pyramid, which we are now re-excavating. Our evidence, however, shows that this pyramid actually dates to Dynasty 5 and could have been built for a king named Menkauhor rather than for Merikare.

In the south, a new line of provincial rulers eventually emerged from the Theban region as Dynasty 11. Civil

SNAKE PILLAR, Dynasty 3, circa 2687-2668 B.C. This limestone pillar, discovered reused in the floor of a later pyramid complex, may originally have formed part of a doorway in the Step Pyramid complex of Djoser.

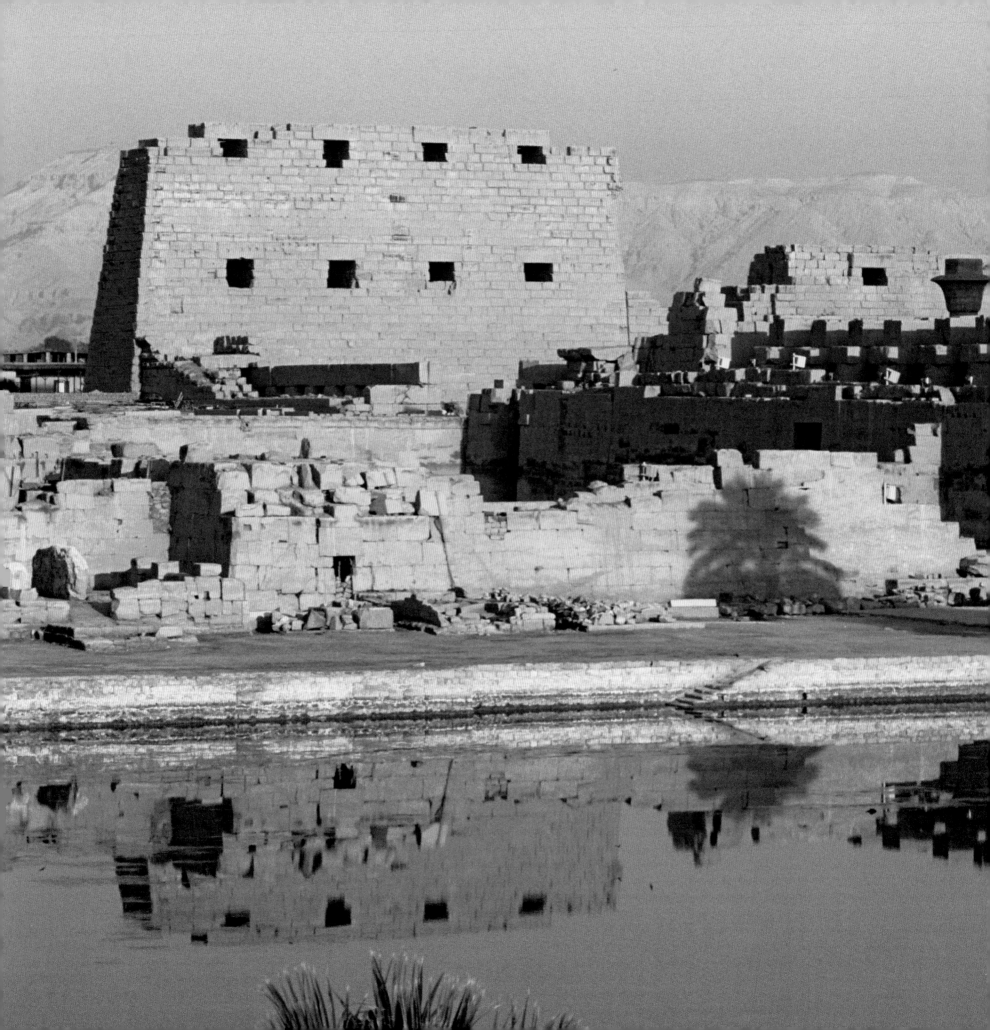

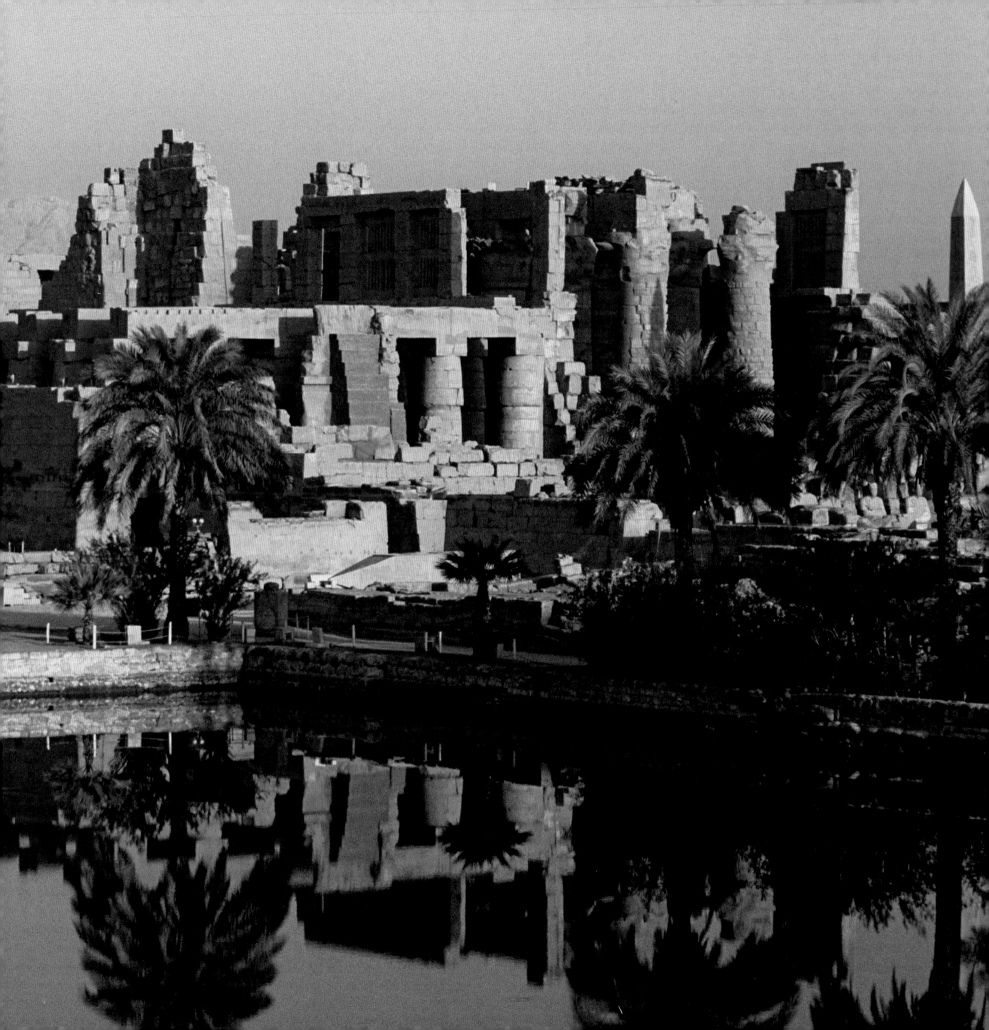

war then ensued between them and the northern Dynasty 10 rulers. Under the banner of Nebhepetre Mentuhotep II, Thebes finally succeeded in defeating Herakleopolis, and the country was reunited.

THE MIDDLE KINGDOM

Nebhepetre Mentuhotep II's reign inaugurated the Middle Kingdom, which represented the next major period of unity and prosperity for ancient Egypt. Under his Dynasty 11, a strong central government was reestablished, with the city of Thebes as its capital. Mentuhotep II led campaigns southward into Nubia, and he constructed a unique tomb at the Theban site of Deir el Bahari.

Dynasty 12 was founded by Amenemhat I, who appears to have been a vizier under the last of the Mentuhoteps. He moved the center of government north again, to Itj-tawy, near the entrance to the Faiyum, most likely because of the agricultural potential of this area, which developed significantly during the next reigns. Amenemhat I paid homage to the greatness of the Old Kingdom by choosing to be buried under a pyramid at Lisht; his successors followed suit with burial complexes at Illahun, Dahshur, Hawara, and Abydos. Their pyramids were not built of solid stone, but they had stone spines filled with mud brick and rubble and stone casings. Substructures became complex again, harking back to the royal burials of the 2nd and early 3rd dynasties.

The pharaohs of this period engaged in military activities in Nubia, where they built a number of fortresses and established Egypt's first empire. The empire reached its height under Senwosret III, the most important king of the Middle Kingdom. The last rulers of the 12th dynasty were Amenemhat IV and Queen Sobekneferu, who appear to have built pyramids at Mazghuna, south of Dahshur.

At the end of the Middle Kingdom, another period of destruction and disturbance began. The governors of Egypt's nomes, or provinces, gained in power, leading to the same type of decentralization that had preceded the downfall of the Old Kingdom. The imperial 12th dynasty was followed by a series of ephemeral kingships during the 13th dynasty.

THE SECOND INTERMEDIATE PERIOD

During the Middle Kingdom, groups of foreigners from the Near East had begun to settle in the eastern Nile Delta. As the central government based at Itj-tawy began to lose power, these settlers (or perhaps a related group of invaders) took control of the delta. They eventually placed one of their kings on the Egyptian throne, pushing the 13th dynasty south.

The Hyksos (a term derived from *Heka hasut,* "rulers of foreign lands") made their principal stronghold at Avaris (modern Tell el Daba), from which they ruled much of Egypt for almost a century as the 15th dynasty. The Egyptians also lost their Nubian empire, and the rising kingdom of Kush was pushing north to Egypt's southern border or even beyond. The native Egyptians, based at this point at Thebes as the 17th dynasty, were caught between these two new powers.

The Egyptian battle for independence began during the reigns of Hyksos King Apophis and Theban Prince Seqenenre Ta'o II: A later story tells of conflict between the two rulers, and Seqenenre's skull still bears the marks of a Near Eastern battle ax, suggesting that he died in battle. Seqenenre's son (or brother), Kamose, began the defeat of the Hyksos by pushing their borders from Cusae back to the Faiyum. He also fought against Kush to the south and reclaimed part of Egypt's Nubian empire. Kamose may himself have died in battle.

Kamose's brother, Ahmose I, finally reclaimed Egypt. He drove out the Hyksos and founded the New Kingdom. Three powerful royal women—Tetisheri, Ahhotep, and Ahmose-Nefertari—also played important roles at the outset of this new dynasty.

THE NEW KINGDOM

This period, also known as the Golden Age of ancient Egypt, began once Ahmose I roundly defeated the Hyksos. After pushing them out of the delta, he pursued them into Palestine, defeated

GREAT TEMPLE COMPLEX OF KARNAK (previous pages), East Bank, Luxor. Founded in the Middle Kingdom, Karnak flourished during the New Kingdom and remained one of Egypt's most important religious centers until the end of dynastic history.

them again at Sharuhen, and laid the groundwork for what would become Egypt's great empire to the northeast. The first king of the 18th dynasty, Ahmose also continued to reclaim the Nubian empire, made internal reforms to strengthen the efficiency of the administration, and inaugurated important building projects. His principal queen, Ahmose-Nefertari, was the first to hold the important ceremonial office of god's wife of Amun. Ahmose was buried at Thebes, in the ancestral necropolis of Dra Abu el Naga. He also had a cult center at the ancient site of Abydos.

Ahmose was succeeded by his son, Amenhotep I. After that, the direct line of the 17th dynasty died out and was replaced by the Thutmosid line, beginning with Thutmose I. During his reign of about a decade, Thutmose I carried out a series of foreign campaigns, marching as far north as the Euphrates River and sending troops to police Lower Nubia. He died at about the age of 50 and was succeeded by his son, Thutmose II. Next his grandson, Thutmose III, took power, but since he was still a child, Thutmose II's queen, Hatshepsut—the daughter of Thutmose I and his chief consort, Ahmose—became regent. After several years, Hatshepsut took the unusual step of promoting herself to full power as a pharaoh, and she ruled as senior king beside her young stepson, Thutmose III, who was the son of Thutmose II and a minor wife.

After about 20 years on the throne, Hatshepsut died, and Thutmose III, now an adult, became sole pharaoh. Known as the Napoleon of ancient Egypt, he began his sole reign with a spectacular victory over a coalition of Near Eastern princes at Megiddo, employing a strategy of surprise and stealth that is still studied at military academies.

Over the next decade and a half, his campaigns in Palestine and Syria consolidated an empire that stretched to the Euphrates. In Nubia, he set the border of the Egyptian empire at the Fourth Cataract of the Nile. To maintain control, Thutmose III had the children of rulers of subject states in Palestine and Syria brought to Egypt and educated in the royal household. He brought not only captives but also all kinds of plants and animals back from his campaigns. Scenes showing these spoils adorn the walls of Thebes's Karnak Temple.

During the early New Kingdom, the political capital again moved to Memphis. Kings used their resources to maintain a strong army and build enduring monuments, especially to the god Amun-Re, the deity they raised to the top of the Egyptian pantheon. The highest officials in the land were the viziers, who reported to the king and kept him informed on matters of national security, government affairs, justice, and taxes.

Thutmose III ruled until perhaps the age of 70. He was succeeded by his son, Amenhotep II. Many scholars have argued that Thutmose III destroyed the monuments of Hatshepsut out of anger after the queen died. It has even been suggested that he had his stepmother murdered. Her recently discovered mummy, however, has shown that she died of cancer and not murder. It is also now generally thought that the destruction of her monuments did not take place until late in Thutmose III's reign or early in that of his son's, perhaps to legitimize Amenhotep II's reign. The Thutmosid line continued through Thuthmose IV, Amenhotep III, and the heretic Akhenaten, and ended with the death of Tutankhamun.

The pharaohs were buried near the religious capital at Thebes, in the Valley of the Kings on the West Bank. Their memorial temples stood nearby, at the edge of the floodplain. The pyramid shape under which the monarchs of the Old and Middle Kingdoms had been entombed remained sacred, and a pyramidal peak now called El Qurn dominates the cliffs that loom over the Valley of the Kings. The royal tombs were decorated with excerpts from a series of funerary texts that had evolved out of the Pyramid Texts of the Old Kingdom through an incarnation called Coffin Texts in the Middle Kingdom. These guided the king through the dangers of the netherworld to union with both the ruler of the dead, Osiris, and the sun god, Re.

Amenhotep IV—the son of Amenhotep III and his queen, Tiye—raised a god called the Aten ("globe of the sun") to the top of the pantheon. He may have done so in a bid to restrict the growing power of the priesthood of Amun-Re. He changed his name to Akhenaten in honor of this deity, and he and his wife, Nefertiti, closed the temples of Amun and moved the religious capital of the country to Tell el Amarna, in Middle Egypt. Eventually they declared the Aten the sole god, and they are considered by many the first monotheists in history. Tutankhamun, who was probably the son of Akhenaten by a minor queen, moved back to

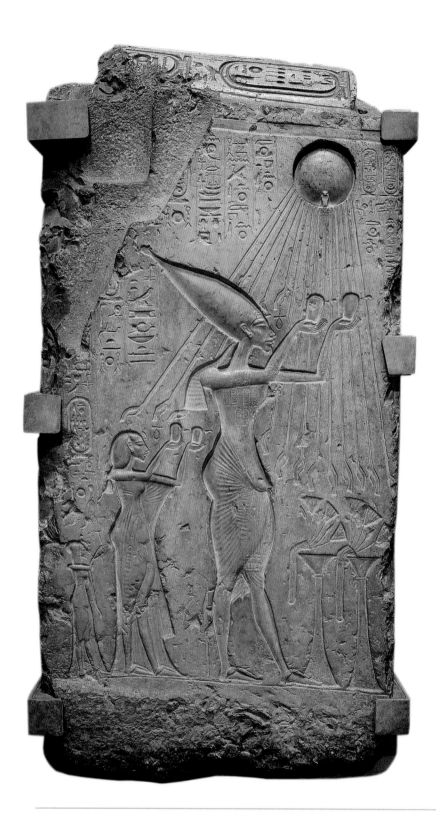

Thebes and restored the cults of Amun and the other gods, but his reign was cut short when he died at about the age of 19.

Diplomatic correspondence has been found at Tell el Amarna between the Egyptian court under Amenhotep III, Akhenaten, and Tutankhamun and the foreign rulers who lived in the Levant and in Mesopotamia. These letters help to explain the politics of the time. The area was in turmoil, with various superpowers jockeying for power. Egypt had begun to lose territory in their Near Eastern empire to the newly powerful Hittites from Anatolia. It was long believed that Akhenaten, preoccupied with his new religion, turned a blind eye to the politics at hand, but recent studies suggest that he may have been a canny diplomat dealing with a difficult situation.

Tutankhamun died without an heir. He was succeeded by Ay, an elderly man who may have been a relative. At Ay's death, the throne was taken by Horemheb, commander in chief of the army under Tutankhamun. This king also died without a living heir and was succeeded by Ramesses I, who founded the 19th dynasty. Ramesses I was in turn was succeeded by his son, Sety I, and then by Ramesses II.

Ramesses II, also known as Ramesses the Great, built extensively all over Egypt, and in Nubia, where his monuments include the great temples of Abu Simbel. Remembered as a great warrior, he tried to hold the line against the Hittites. Early in his reign, he fought the great Battle of Kadesh—a victory of personal valor in which he saved his army from ignominious defeat. It ended in a draw, though, and over the next 16 years, the Egyptians and the Hittites clashed in a series of indecisive battles, until they finally signed the world's first recorded peace treaty.

Ramesses II then was forced to turn his attention to the west, where the Libyans were causing trouble. We know that he had eight principal wives, including a Hittite princess and his own daughters, Bintanath and Meritamun, and that he fathered more than one hundred children. He also built a new capital at Pi-Ramesses (modern-day Qantir) in the eastern delta, near the old Hyksos capital of Avaris.

The 20th dynasty saw a period of slow decline, as Egypt gradually lost its empire to external pressures. The last great warrior of the New Kingdom was Ramesses III, who is remem-

bered for defeating the Libyans and the Sea Peoples—groups of refugees looking for new lands to settle. The target of a conspiracy hatched from within his own harem, Ramesses III survived a first attack. He captured and punished the traitors but is thought to have died of wounds inflicted by them.

THE THIRD INTERMEDIATE PERIOD AND THE LATE PERIOD

Many things indicate that troubles marked the end of the New Kingdom. For example, we have documentation of a series of strikes in the workmen's village at Deir el Medina during the reign of Ramesses III. Papyri from the late 20th dynasty tell of tomb robbers in the Valley of the Kings, a sign of declining royal authority. By the end of the New Kingdom, around 1000 B.C., Egypt had completely lost its foreign empires.

After the death of Ramesses XI, the last king of the 20th dynasty, the throne was taken by Smendes I, perhaps his son-in-law, and the Third Intermediate Period began. During the 21st dynasty the south of the country, still nominally controlled by the northern pharaohs, was in reality controlled by the high priests of Amun. The two ruling houses were closely related by blood and marriage, with the northern kings appointing high priests and, on occasion, the Thebans taking the Tanite throne, named after the northern city of Tanis.

Toward the end of the 21st dynasty, a man of Libyan descent, Osorkon the Elder, took the Egyptian throne. His nephew, Sheshonq I, succeeded him and founded the 22nd dynasty, appointing his own son, Iuput, high priest of Amun. This line continued, with the 22nd dynasty kings consolidating power by marrying into the family of the 21st dynasty and continuing to appoint their sons to the Theban pontificate. Soon the country splintered again.

There is some evidence for foreign relations during this period. Sheshonq I, for example, is generally equated with Shishak, named in the Bible, who mounted a campaign into Palestine. The Third Intermediate Period rulers, both Tanite and Theban, carried out building projects within Egypt, often reusing ear-

lier monuments to do so. In 1939, a French expedition discovered the intact tombs of a number of the kings of this era in the temple complex dedicated to Amun at Tanis in the Nile Delta. While individually not nearly as rich as the burial of Tutankhamun, these tombs did contain fabulous objects of gold, silver, and semiprecious stone.

Far to the south, the Nubian kingdom of Kush had been gaining in strength, and by 732 B.C. it took over Egypt as the 25th dynasty. Egypt was unified once more, and the Nubians, although foreigners, were very Egyptianized, even worshipping the Egyptian god Amun as their principal deity. Soon the 25th dynasty came under pressure from the Assyrian empire to the northeast. The Assyrian king, named Esarhaddon, marched on Egypt. His army sacked Memphis and drove the Kushites back to the south.

Assyria was too far away to hold Egypt comfortably, however, and the local rulers they had appointed and installed soon seized Egypt, establishing the 26th dynasty. The first king of this line, Psamtik I, ruled for 54 years and ushered in a new era of prosperity that lasted almost a century, from 610 to 526 B.C. Contact with the Greeks increased through trade during this period. Greek trading colonies were established within the borders of Egypt, and Greek soldiers began to enter the Egyptian army.

In the sixth century B.C., a new threat arose in the form of the Persians, to the northeast. After the conquest of Egypt by Cambyses in 526 B.C., Egypt fell subject to Persian domination for the next two centuries, with only brief periods of native rule. Defeating the Persians in 332 B.C., Alexander the Great took over Egypt. Ptolemy, who governed Egypt on behalf of Alexander and then his heirs, proclaimed himself pharaoh several decades later. Ptolemy and his descendants ruled from the west delta city of Alexandria, which had been founded by Alexander himself, and followed his precedent of honoring the local gods and, as much as possible, ruling as natives rather than foreigners.

For almost three centuries, the Ptolemies ruled Egypt successfully. Toward the end of their era, the country came more and more under the shadow of Rome. In 30 B.C. the last of the Ptolemies, Cleopatra VII, lost the great sea battle of Actium to Octavius—also known to history as Augustus Caesar—and Egypt became a Roman province.

THE RISE *and the* GLORY

THE PREDYNASTIC THROUGH THE FIRST INTERMEDIATE PERIOD

David O'Connor

EGYPTIAN KINGSHIP and the state it embodied initially developed in late prehistoric and Early Dynastic times, over a period of almost a thousand years (circa 3500-2650 B.C.). Thereafter, the institution of kingship became much more prominent in material terms, and the royal tombs and pyramids from this period are extraordinary monuments that for most moderns typify the glory of the Old Kingdom (Dynasties 3 to 8, circa 2650-2165 B.C.). Yet much about this earliest of nation-states remains mysterious and debatable. The kings and their supporting elite obviously exercised considerable control over a large country with a substantial population, estimated to total almost two million. But how did this administrative system actually work, and did it increasingly conflict with the economic and environmental realities of Nile valley agriculture? Certainly, the almost complete absence of known royal monuments in the following First Intermediate Period (Dynasties 9 to 10, circa 2165-2040 B.C.) indicates that kingship and the rich court culture it supported became diminished, and even impoverished. Many communities throughout Egypt, however, became more rather than less prosperous during this seemingly troubled time.

The origins of Egyptian kingship are becoming increasingly well understood, thanks to recent discoveries. The first kings shown with much traditional pharaonic regalia are Narmer (the "Ferocious Catfish") and his immediate predecessor, called Scorpion, but archaeological indications of centralized rulerships or protokingdoms occur much earlier. Various sites in southern Egypt reveal clusters of especially large and rich elite graves, possibly for royal families of regional kingdoms, from late prehistoric times. At Abydos one such cemetery evolved into one dedicated to the burial of all kings of Dynasty 1 and two kings of Dynasty 2. One earlier tomb here, labeled "U-j" and dating to approximately 3300 B.C., contained the earliest known examples of writing from Egypt. This tomb housed the burial of a ruler thought by some scholars to control an already united Egypt.

Over the course of Dynasties 1 and 2, archaeological records suggest, these kings came to be recognized as having control of all Egypt and a special relationship with the divine world. Two distinct titles, specifying those two royal identities, were to develop a little later. It is also clear that an elite group of high officials and royal relatives occupied an especially privileged posi-

TOMB OF TI, Saqqara, early Dynasty 5, circa 2513-2474 B.C. Elite tombs of the Old Kingdom were decorated with scenes showing activities such as hunting, fishing, and farming, designed in part to ensure an eternal supply of provisions.

tion, while overall a system of national governance was evolving with its capital in the vicinity of Memphis, near modern Cairo.

Here, at Saqqara, some Dynasty 2 kings had been buried, but the status of kingship was much magnified under Djoser at the opening of Dynasty 3. Djoser built the first Egyptian pyramid, stepped rather than smooth in form, and on a much greater scale than earlier royal tombs. His successors initiated, but did not complete, similar projects. In the 4th dynasty, stupendous pyramids were built for several of the kings. One, Sneferu, may have had four pyramids built. Through the 5th and 6th dynasties, impressive pyramids were still built, but they became smaller and more uniform in scale.

It is misleading to read this archaeological history in political terms, interpreting Dynasty 4 rulers as more powerful than those of Dynasties 5 and 6, perhaps forced to share power and resources with the elite classes who provided the kings with the essential agents of governance. Mortuary evidence, royal or other, is often not a reliable guide on such issues. For example, kings probably had the power and resources to build very large monuments prior to Djoser's time, but the idea of doing so had not yet developed. And later, the kings of Dynasties 5 and 6 may have built up a more effective bureaucracy than those of the 4th, even though they built smaller pyramids.

THE GOVERNMENT

Despite scholarly disagreements about its range of power, the Old Kingdom government was a reality. At the center were several agencies with nationwide responsibilities. These agencies were dominated by the *tjaty*—the king's executive official, poorly translated as "vizier"—and his staff. Egypt itself was subdivided into perhaps about 40 provinces. At first, each was administered by a royal official, periodically shifted from one province to another, but in the later Old Kingdom each province had a permanent overseer, often succeeded in the office by a son or another close relative. Mortuary evidence indicates that at all times some—maybe most—provinces had a local elite, but their importance grew once province-specific overseers were installed.

These permanent overseers had staffs that became wealthy or favored enough to have their own handsome tombs erected out of cut rock, stone, or brick.

What did government do for society in Old Kingdom times? On the positive side, it created a sense of ideological unity between the center and the provinces, which reassured at least the elite that their initiatives had national and even cosmological meaning. In addition, government brought order to communities, especially insofar as major local conflicts and disputes about ownership and other issues were concerned. On the other hand, other significant matters such as retaliation for murder may have been left to local systems of feud, revenge, and compensation. The elite also expressed an ethical concern for the welfare of all classes and categories. For example, they encouraged arrangements for famine relief or the support of permanently disadvantaged individuals such as widows and orphans.

On the negative side, the system was largely intended to generate revenue for the kings and government. This revenue was used for several purposes. In part, it supported the kings' major initiatives: large-scale building projects, expeditions out of Egypt to secure raw materials or goods in trade, and expeditions to dominate foreign communities that could provide valuable services. The revenue also secured resources such as land and wealth, deployed as patronage at different levels of elite society. How, in fact, economic resources were actually manipulated is not clear. Land, serfs, and other resources were dedicated to support royal and elite mortuary estates and temples throughout Egypt. Custom was a powerful force in early Egypt, but we should not underestimate the enormous authority of the kings as the principal intermediaries between humans and the divine. They could alter the rules with impunity, as long as they had the administrative strength to make their decisions effective.

Foreign relations were significant in early Egypt, but they focused on the regions that were relatively close by. To the south, little relationship was established with Lower Nubia through much of the Old Kingdom, although several Egyptian-held towns were established there, but the Egyptians did establish close contact with a developing native kingdom in Upper Nubia, centered on Kerma. They also dispatched seaborne expeditions to Punt,

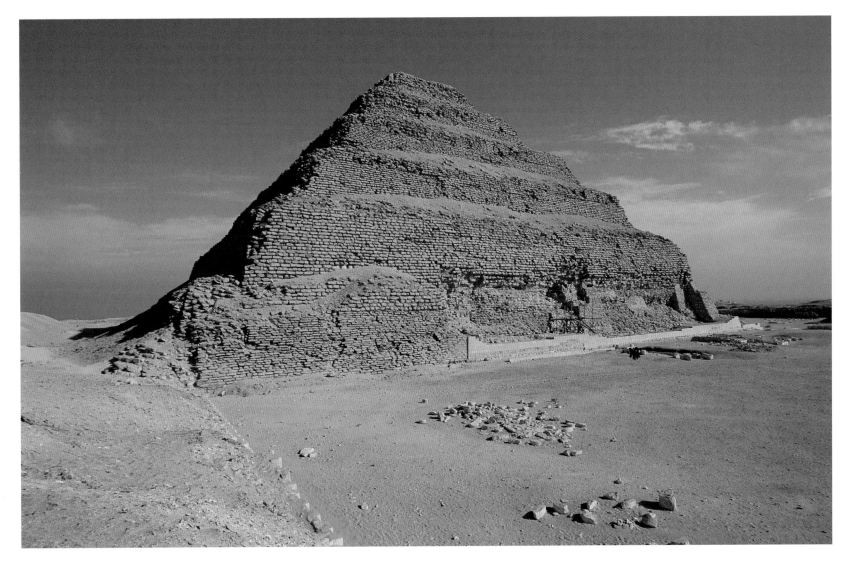

an incense-producing land on the eastern coast of the Red Sea. Relations with the nomadic Libyans to the northwest seem to have been (perhaps misleadingly) of minor importance, but the Egyptians were interested in maintaining a presence in the southern Levant (modern Israel, Palestine, and Jordan), militarily if necessary. The Egyptians also maintained productive diplomatic and trading relationships with Byblos on the Lebanese coast and with local kingdoms in what is today Syria.

None of these foreign regions offered any serious threat to Egypt, and so the decline of kingship after the Old Kingdom must be due to internal causes, although what they might have been is a subject much debated. Did the kings exhaust their resources with their grandiose pyramid-building schemes? This seems unlikely:

Even in Dynasty 4, pyramid building probably involved only a small proportion of the population and of state revenues, while in Dynasties 5 and 6 pyramids were built on a smaller, less economically demanding scale. Was there a disastrous series of seasons during which the Nile floods, on which Egypt's essentially agricultural economy depended, were repeatedly low, creating famine and social collapse? This seems unlikely, since low river levels were a perennial problem, apparently dealt with effectively earlier.

The best theory currently available is that Old Kingdom gov-

THE STEP PYRAMID OF DJOSER, Saqqara, Dynasty 3, circa 2687-2668 B.C., was the world's first pyramid. It is surrounded by courtyards, temples, and shrines for celebrating the deceased king's cult.

ernment became too effective at raising revenue, in the form of grain, goods, and services, from the provinces. Increasingly, a nationwide infrastructure developed, formed by institutions called *hwt,* each administered by a *heka,* or leader, and linked to a great increase in the land and people directly controlled by the king. Paradoxically, the developing hwt created pressures on regional food supplies and societal stability, leading to a collapse of the centralized monarchy and court culture. The provinces, now dominated by local elites, regained economic strength. Kingship survived, but the pharaoh now ruled a divided land, with one dynasty based in the north and a competitive one in the south. It would take a long time before the next return to the glory manifested by Old Kingdom leadership.

ARCHITECTURAL DETAILS

The development of a prosperous nation-state shows forth the glories of early Egyptian kingship, despite the many mysteries still remaining. The other glorious feature of early kingship was the development of one of the most sophisticated systems of art and architecture to appear in the ancient world—and here the record of achievement is much clearer, especially in the royal mortuary monuments and the tombs of high officials that clustered around them.

Initially, royal tombs were only marginally larger and richer than those of the elite, as seen in the tombs of Dynasty 0 kings at Abydos. Even the tomb of Narmer, a pivotal figure in the evolution of kingship, is relatively tiny compared to what came immediately after. For Aha, his immediate successor, a much larger tomb was built, along with a cult enclosure and chapel about a mile to the north. In Aha's reign, for the first time, a large number of apparently sacrificial burials abut the royal tomb (and, in smaller numbers, its distant enclosure). These are retainers, officials, and others ritually slain at the time of the king's funeral and buried nearby to serve him and his cult in the afterlife. Such a fate was likely considered prestigious.

Thereafter, abrupt changes occur from one period to another in the royal monuments. Through Dynasties 1 and 2, royal tombs and associated enclosures largely follow the model set under Aha, albeit with fluctuations in the size of tombs and enclosures and in the number of sacrificial burials, which seem to disappear after the 1st dynasty. Then, immediately after the Early Dynastic Period, beginning with Djoser's Step Pyramid complex, royal mortuary monuments became much larger, built of stone masonry rather than mud-brick, their style dominated by step pyramids. Finally, in Dynasty 4, true pyramids appeared. Over time they increased in scale yet again, and then they scaled down to the smaller ones of Dynasties 5 and 6. These changes in planning, ideological visibility, and building projects are indicated by some simple statistics: Early Dynastic tombs were likely capped by mounds no more than a few meters high; the final form of the Step Pyramid rose to about 60 meters; the Great Pyramid of Khufu in Dynasty 4 rose to almost 147 meters; and most pyramids of Dynasties 5 and 6 averaged about 50 meters in height.

Yet there are also significant links among the royal tombs of these periods. Early Dynastic kings' tombs were probably each capped by a large but relatively low mound, as was the tomb in the first phase of Djoser's Step Pyramid complex. In Dynasties 1 and 2, royal mortuary cults were serviced by chapels, separate

from the tomb. Originally simple in plan, chapels became more elaborate by the end of the 2nd dynasty, anticipating the emergence of a true mortuary temple like that attached to Djoser's Step Pyramid. Such mortuary temples were placed on the north side of the pyramid in Dynasty 3, but on the east side later. From Dynasty 4 on, a causeway led down from the mortuary temple at the pyramid to a so-called valley temple, located at the junction between the floodplain and the elevated desert upon which all pyramids were built.

The mortuary enclosures of Early Dynastic times—separate from the tombs, at least at Abydos—are paralleled by the enclosure intended to surround each step pyramid. Later pyramids did not have such massive enclosures, but a partial revival of the concept occurs in the royal solar temples of Dynasty 5: large enclosed complexes centered on a high obelisk in the vicinity of the kings' pyramids. At least one solar temple was associated with a full-scale, if imitation, ship, and ship burials were also associated with at least one Dynasty 1 enclosure at Abydos.

In the Old Kingdom, the mortuary temples found associated with pyramids and causeways were always fairly elaborate in plan. This was particularly so for the pyramid temples in Dynasties 5 and 6, when pyramid complexes tended to become standardized in plan and decoration, perhaps as a reflection of the more highly organized bureaucracy of the times. The essential components of a mortuary temple were an offering chamber, adjacent to the face of the pyramid under which the king lay buried; a so-called square chamber or its antecedent; and a room focused on five shrines set in a row. Each shrine probably housed a royal statue, representing the king in five different modes or regalia—as the funerary god Osiris, for example. The complex was a self-contained unit, and beyond it lay an open court with a roofed colonnade along each side, preceded by a large antechamber that connected to the causeway. Architecturally, the causeway was roofed and simple in plan, but valley temples included columned chambers and porticoes. Probably the approach to these monuments was guarded by sphinxes—the depiction of the king as a recumbent lion with a human head—but all of these have disappeared except for the spectacular Great Sphinx near the end of the causeway of Khafre's pyramid at Giza. The Great Sphinx, cut entirely from native rock

except for a casing of stone masonry, stood 20 meters high and 22 meters long.

From Dynasty 4 on, the interior faces of temples and causeways were probably entirely covered with painted relief. Ceilings likely bore celestial iconography. Few examples of these reliefs survive. Most were badly destroyed, primarily in much later times, when their stone masonry was reused in other structures. The better preserved examples, however, in the valley temples reveal complex scenes and texts rich in ritual and symbolic meaning: the king hunting animals or defeating foreign foes, for example, both tableaus equivalent to the royal overthrow of supernatural expressions of disorder in the cosmos. The entrance area of the causeway displayed scenes of the king as a sphinx or griffin, trampling foreign foes or smiting them with a mace, or receiving foreign prisoners as they are presented to him by the gods. Many of the reliefs along the causeway related to other royal deeds, and especially to the construction of the pyramid complex. In some cases the pyramidion—the symbolically important pointed peak of the pyramid—was shown being delivered and installed. Causeway reliefs also portray a flow of many kinds of offerings for the king's cult and for the priests, administrators, and others responsible for maintaining the cult.

In the antechamber of the pyramid temple, the king was depicted enthroned and in the presence of his courtiers. The open court featured scenes of royal hunts and victories, while imagery within the more secluded chambers highlighted relationships between the king and the deities, especially with reference to the Sed festival, a major rejuvenating ceremony for kings that was reflected in earlier architecture, in Djoser's Step Pyramid complex. The offering chamber itself showed the enthroned

SCRIBE from Saqqara, Dynasty 5, circa 2513-2374 B.C. This limestone statue of an unidentified scribe was beautifully carved and then painted in colors that remain vibrant millennia after its creation. The artist has rimmed the eyes with copper and then inlaid them in order to enhance their realism.

PROCESSION OF OFFERING BEARERS (following pages). This is part of a wall decoration from the tomb of Akhethotep and Ptahhotep at Saqqara, created in late Dynasty 5, circa 2436-2374 B.C.

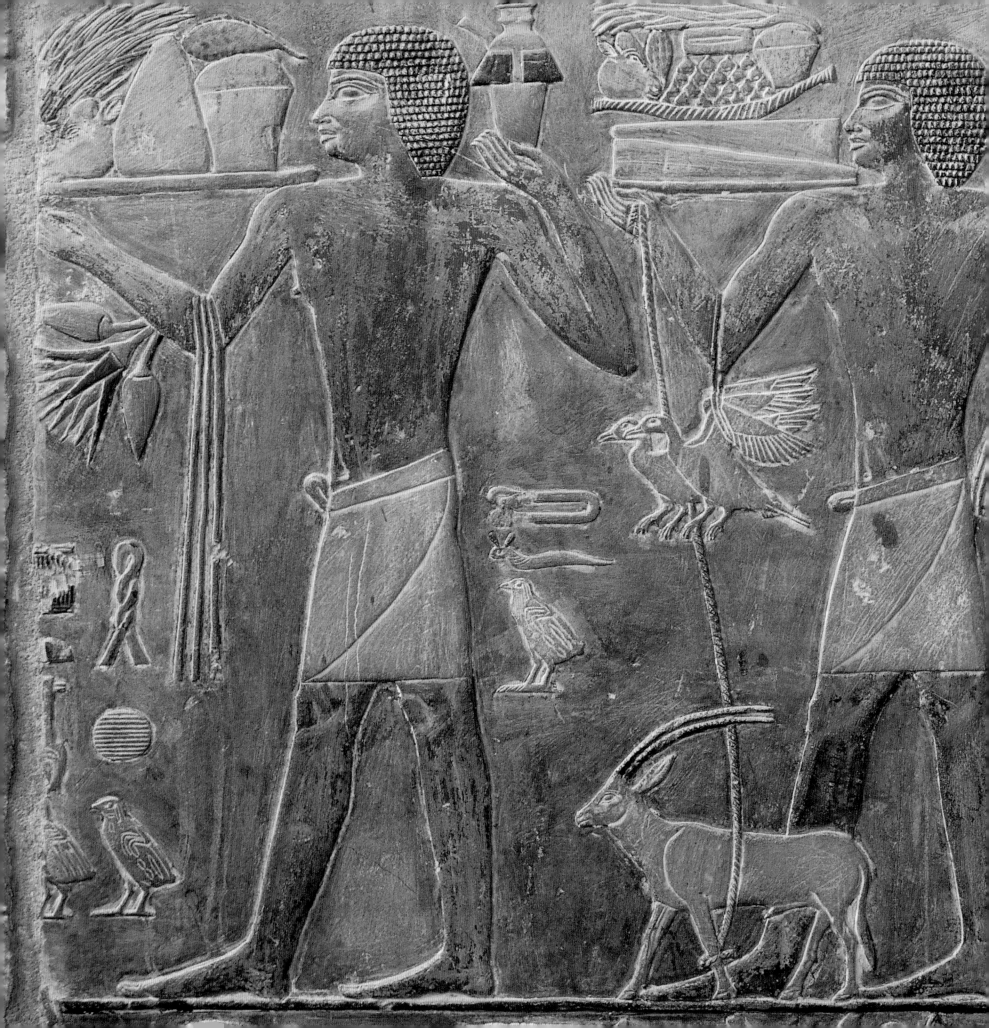

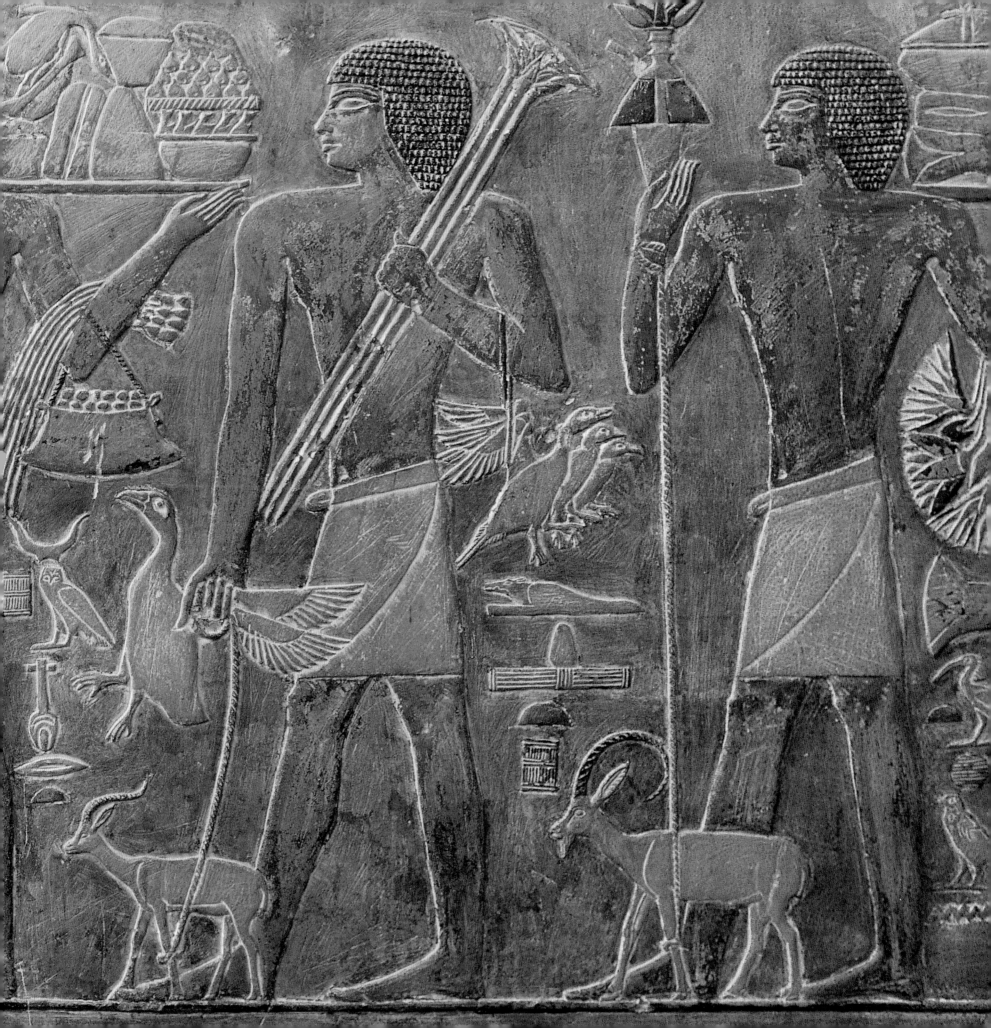

king as he might look when emerging after death from his tomb, receiving a multitude of sustaining rituals and offerings. At the far end of the chamber stood a stela and probably a royal statue, the two of them focal points for the rituals repeatedly performed by priests in the temple.

The painted reliefs in the pyramid complex were of exceptionally high quality and inventiveness. Beautifully carved statues and statuettes of the king were distributed through the courts and chambers. Few survive intact, but some outstanding examples were recovered from the pyramid complexes of Khafre and Menkaure at Giza. In recent decades, Zahi Hawass has discovered the tombs of the artisans and others, including the artisans' higher-status overseers, who were involved in building and decorating the pyramids and monuments at Giza. At the same time, Mark Lehner has been excavating an enormous complex of offices, barracks, and storage facilities related to these same building projects. Such discoveries mean that the processes underlying the production of these monuments and their wonderful art is thus becoming better understood.

The functions of that art, however, are debatable. At one level, the art of the pyramid complex documented the legitimacy of the royal cult and the virtues of the king that made him worthy of such high regard. Depictions of the king overcoming foreigners, animals, and birds—all equivalent to negative supernatural forces—provided protective magic to the complex, especially along its access routes, and helped eliminate any dangers surrounding the king when he was finally invoked to leave the tomb for his temple. The sphinxes, typical guardians of sacred places, served the same purpose. At yet another level, the systematically organized scenes and texts radiating out from the offering chamber through the rest of the complex united into an image of cosmos, which brought the powers of the universe to play in the pyramid and its associated structures.

In contrast, the actual royal burial chambers and any other rooms and passages constructed either below or inside the pyramid (in the cases of Sneferu and Khufu, for instance) were austere and undecorated until the end of Dynasty 5. Thereafter, the walls of the burial chamber, the antechamber, and the passage leading out of the pyramid to the surrounding grounds were covered with Pyramid Texts without pictorial embellishment. These texts provided the entombed king with a multitude of spells and rituals intended to protect and sustain him in the afterlife. They also ensured his identification with Re, the sun god, and Osiris, lord of the netherworld, so the king could share in their endlessly repeated regenerations or rebirths. These texts were organized spatially, to correspond to divisions of the netherworld: The burial chamber parallels the netherworld proper, the antechamber is the liminal zone between the netherworld and the upper worlds, and the ascending passage symbolizes the ascent of the king into the sky, to join the never-setting circumpolar stars, his passage equivalent to the daily rebirth of the sun.

Other impressive examples of Old Kingdom art and architecture can be found in the elite cemeteries. Some tombs consist of rock-cut shafts and chambers topped by mastabas, or rectilinear superstructures, built of mud brick or stone, with chapels attached or inside them. Other tombs were entirely rock-cut, with only minimal features built into them. Some of these elite cemeteries cluster near or around the pyramids, which themselves are distributed along a wide arc west of Memphis, stretching from Abu Rawash to Dahshur and beyond to Maidum. In these cemeteries were buried the chief officials of each king, along with subordinates and relatives as well as the priests and administrators who, generation after generation, serviced the royal mortuary cults. Sometimes these tombs were organized almost like houses along streets, especially in the vicinity of Khufu's pyramids. In other instances they seem more haphazardly arranged, although they seem sometimes to have been clustered according to blood relationships or institutional affiliations among those entombed. Over time, the interstices between larger tombs came to be filled with smaller ones, creating complicated archaeological situations.

During Dynasties 3 and 4, the chapels attached to such tombs were small, and their decoration was sometimes restricted to a single slab-stela, often beautifully carved and painted and set into a niche. Over time, however, chapels grew larger and multichambered, with scenes and texts covering all the walls inside and with a broader array of topics depicted. Offering scenes for tomb owners were of primary importance, but other types of scenes were

depicted as well, showing, for instance, the tomb owner banqueting with his family and others, overseeing agricultural and other activities on his estates, hunting or fishing in the marshlands or on the riverbank, or engaging in intimacy with his wife. Few elite tombs are dedicated solely to women, who tended to be buried in and to receive cult at their husbands' tombs. The execution of art in these tombs is often superb; the colors, when preserved, are bold and vital. Scenes directly relevant to the king and his activities are absent, however. Reference may be made to the kings' activities in the officials' titles and in funerary autobiographies, but no images of him, of any royal ceremonies, or even of the defeat of foreign foes, in which officials were often involved, were depicted in these tombs.

Old Kingdom art reinforced the basic ideological and societal divisions that existed at the time. Just as the king was too august an individual to be depicted in elite tombs, so, in turn, the more elaborate manifestations of art and text found in elite mortuary monuments were denied to lower orders of society. Most of the population were not permitted to maintain art systems of their own or to use writing—however simply—in extended form in their mortuary monuments.

Like pyramid complexes, elite chapels included statues of the tomb owner and others. Sometimes these statues were of high quality; sometimes they were more mediocre in style. Most have disappeared, but a number of examples survive, some superbly carved, in both stone and wood. Some of these statues were placed in serdabs, inaccessible chambers linked to the offering ritual by nothing more than a slot, providing security for the images and symbolically representing the actual entombed mummy in the chamber below. Other statues stood out in the open in the chapels, and even flanked the entrances. In all cases, statues stood ready to embody the deceased as he or she left the tomb and received the benefits of any offerings made.

Beyond the central cemeteries, in Dynasty 5 and especially

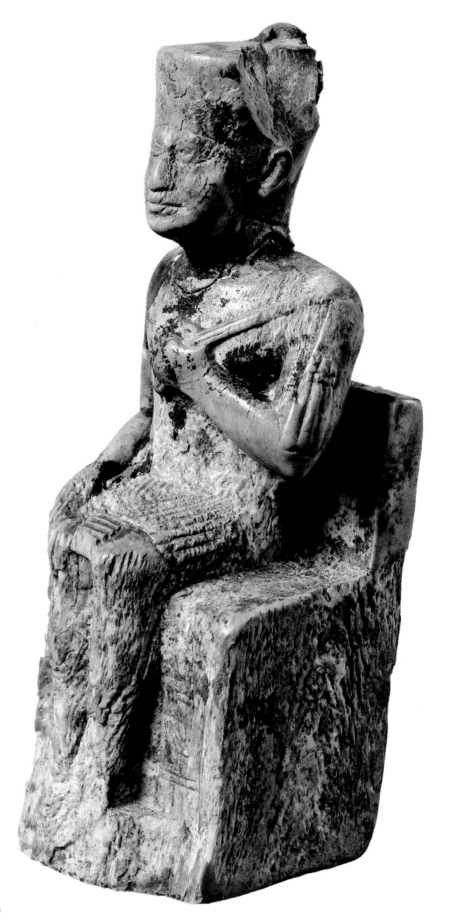

KING KHUFU, from the Temple of Khenti-imentiu, Abydos, date uncertain. This tiny ivory statuette was carved with the Horus name of the 4th-dynasty ruler Khufu, who ruled from about 2609 to 2584 B.C. It is the only known inscribed sculpture of the monarch for whom the Great Pyramid at Giza was built.

Dynasty 6 decorated elite tombs, both built and cut from rock, began to proliferate at many provincial centers. In plan and decoration, these tended to follow the models provided by the center. The texts in them give vital information about the structure of provincial administration. The range of topics is similar to those of the central cemeteries, but the art of the tomb chapels of Elephantine Island, farthest from the capital, became especially original and unusual in its adaptations of the standard model.

Lower-order cemeteries from Dynasties 3 to 5 are not well explored. Grave goods are simple and infrequent, even in higher-order graves, giving a perhaps false impression of widespread impoverishment at this time. Cemeteries dating from Dynasty 6 have been explored more fully. In this later period, representational art was used more frequently. Not only amulets and seals but also vessels and other functional items take the form of humans or animals. Objects such as these might already have been used by the living in earlier times, but from the 6th dynasty on, changes in burial customs meant that they were brought into mortuary contexts.

The influence of royal ideology and control is evident throughout all the forms of art and architecture discussed above. Theoretically, all graves and mortuary cults were provided by the king. In practice, while kings might provide certain features such as stelae or offering tables, tomb owners often used their own resources to build and equip their tombs. Access to the central cemeteries, and maybe to the provincial ones, might well have required royal permission, even if via intermediaries, however, and the kings may have demanded a relative degree of uniformity in the size and programs of elite tombs.

Other areas of royal initiative involving art and architecture are poorly known for the Old Kingdom, unfortunately. Royal resources and administrative effort must have been dedicated to public works, for example, but little evidence of this remains. Such initiatives would have included irrigation systems, the maintenance of local roads, the development of storage facilities and administrative offices for revenue collection, and even the founding of new villages on recently developed or reclaimed agricultural land. There is evidence of a large Old Kingdom dam designed to divert water from cloudbursts over a desert valley into the settled plain—an unsuccessful venture. The architectural and landscaping efforts involved in these initiatives may have been mundane, yet they represent a major area of royal effort alongside the grander pyramid-building projects described above.

A special problem is presented by temples. Textual sources indicate they were numerous at central places such as Memphis, at many provincial centers, and at other sites. Temples were dedicated to major deities such as Re, the sun god, at Heliopolis, near Memphis; Ptah, at Memphis; and the great goddess Hathor, consort and mother of the sun god, at Denderah. A large pantheon of other deities, many specifically attached to provincial centers, was also revered. In later times, kings built and maintained temples for these deities in great numbers, some very large and richly decorated, especially in the capital cities, and others smaller yet still substantial.

Few temples from the Old Kingdom or earlier have been located and excavated. Those that have been, such as on Elephantine and at Tell Ibrahim Awad, are quite small and simply built, typically of mud brick. They provide abundant evidence for cultic activity on the part of the local community, suggesting that most temples of this time were informal, built and maintained largely by local communities led by local elites, with nominal acknowledgment of the king's primacy.

It seems likely that at places like Memphis, however, important deities were honored with stone-built temples equal in size and complexity to those built at pyramids for deceased kings. Even at some provincial centers, like Mendes, indications of once quite large temples have been uncovered. Much remains to be discovered about this area of art and architecture.

RELIGION AND SOCIETY

In Early Dynastic and Old Kingdom Egypt, as later, religion and society were linked inextricably. All Egyptians instinctively correlated their daily lives with their religious beliefs and practices. At all social levels, no matter how modest their means might be, they were concerned about their futures in the afterlife. Egyptians

represented an ethnolinguistically cohesive national community. Although the level of sophistication and elaboration varied, all shared the same fundamental beliefs and practices up and down the social scale; otherwise, such beliefs could not have been sustained for so long at any social level.

Egyptian society consisted of the king and the royal family; a higher elite, relatively small and closely interrelated; the lower elite, more numerous; and the large general population. Most of the general population was involved in agriculture or herding, and a large number were probably serfs attached permanently to royal, state, or temple lands. Art and archaeology show that there were also many communities of artisans throughout Egypt, some producing tools, weapons, and containers needed for everyday use, and others specializing in the construction and decoration of tombs and other monumental structures.

Officials, apparently ubiquitous, must have kept most Egyptians constantly aware of the king and his ideological centrality. Even at provincial temples, royal ka-chapels were built, dedicated to specific rulers. The degree of actual control exercised by officials over the population is debatable, however, although it may have intensified—with negative results—during the last centuries of the Old Kingdom.

Priests—and, less commonly, priestesses—served throughout Egypt in temples and for mortuary cults. Their positions must have required a certain degree of initiation and training, probably involving arcane material, especially when involved with major state cults and royal mortuaries. Priests were also firmly embedded in the larger population. They served in phyles, or work groups, in the temples, pyramids, and tomb chapels, so much of their time was actually dedicated to farming or overseeing the agricultural land which represented part of their sustenance.

Beliefs about the afterlife are best known to us because of inscriptions in royal and elite tombs. The Pyramid Texts, found in later pyramids but incorporating much earlier material, present a richly detailed view of the other world, traversed by the sun god and deceased king during the night. The god Osiris represented the promise of repeated regeneration after death. He was killed by an envious rival, brought back to potency by his consort, and then revived as lord of the dead by his posthumous son, Horus, who overthrew his father's murderer. The whole myth, royalist in structure, provided the paradigm for pharaonic succession: Each deceased king became Osiris and lived again, while his successor (often his son) ascended to "the Horus throne of the living."

The other world had its own geography, reflected in the night sky but also visualized as a parallel subterranean realm, much of it liquid—in effect, an ocean. But it was also fringed by land, and interspersed with islands upon which deceased kings, deities, and probably all dead Egyptians lived when they were not traversing waterways, marshlands, and the oceans. To the east and west were the *akhets,* or horizons—liminal zones in which the sun god and the dead king were prepared, either for rebirth into the upper world on the east or for successful entry into the other world on the west, the place of death and burial. Many dangers threatened gods and the kings in this other world, but through glorification and powerful rituals and spells, they overcame any threat.

In some mortuary texts, the elite also seek the aid of Osiris, but they were not considered to have access to the kind of knowledge written in the Pyramid Texts, used for non-royals sparingly, and not until the end of the Old Kingdom. It has recently been suggested, however, that the spatial arrangement of elements in elite mortuary art represents a pictorial equivalent to the experiences of the king in the other world, suggesting a shared system of beliefs.

Finally, although royal governance in Egypt during these early periods undoubtedly had its negative effects on the larger population, in mortuary inscriptions the elite often referred to a practical set of ethics that valued equitable dealing, societal harmony, and compassion for the disadvantaged.

These principles in turn reflected the values of kingship itself. The Egyptian king was ferociously aggressive toward foreign foes and native Egyptian criminals or rebels, all in the interest of national security and, ultimately, cosmic order. But he also transmitted to obedient subjects at all levels the tremendous love bestowed upon them by the deities via the king, who as lawgiver and provider ensured everyone's prosperity and secured them successful transitions to the afterlife.

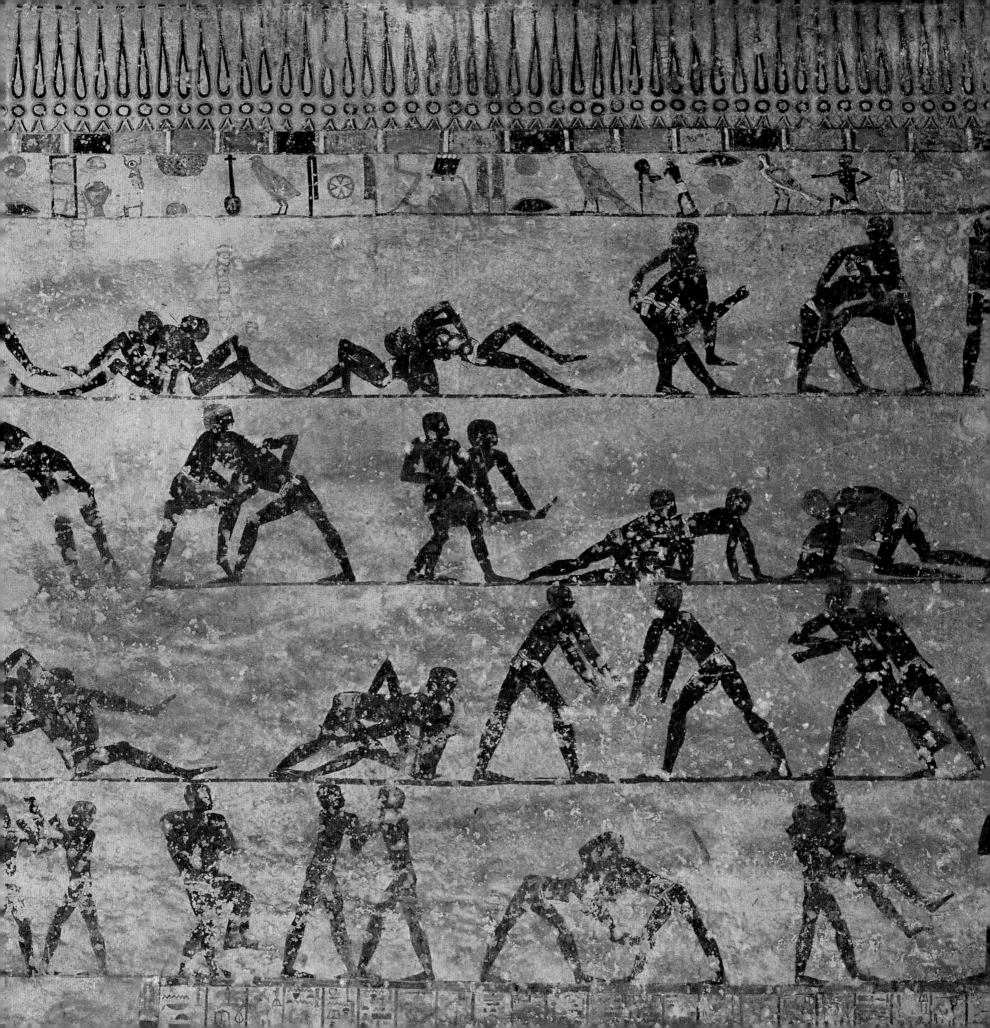

UNITY *and* POWER

The Middle Kingdom and Second Intermediate Period

David P. Silverman

AT THE ADVENT OF the Middle Kingdom, pharaohs faced a land in disorder. Society was divided, and the provinces had gained some independence because of a weakened central government. Nomarchies—the rulership of nomes, or provincial districts—had become inherited governorships, with decreasing loyalty to the pharaoh. Eventually the Herakleopolitan Dynasty, successors to the last of the Memphite rulers, controlled the northern and delta regions. The local rulers of the Thinite nome, based in Thebes, controlled the south.

Earlier analyses hypothesized that the First Intermediate Period may have suffered famine, social upheaval, and economic disaster, but current investigations suggest otherwise. Cemeteries show continuous periods of use, with burials ranging from modest to wealthy. Contemporary inscriptions and later literary compositions portray this period as extremely problematic. Any unrest that may have occurred between the Old and Middle Kingdoms became a dominant theme. Some incidents may have been founded in reality, but the genre of negative scenarios developed to indicate the extreme disorder that the tomb owner had to endure and conquer on the journey to the afterlife. He or she had faced trials, just as a pharaoh had. As the Intermediate

Period came to an end, society had already begun to reexamine its relationship to the king. Individuals realized that they had an important place on Earth and could attain transformation to a higher state in the afterlife. These issues show up in many aspects of the material culture of the Middle Kingdom.

Memphis no longer served as the administrative center, and its substantial cemeteries were things of the distant past. Warfare among the provinces was apparently not uncommon. Around 2134 B.C., the powerful Antef family initiated the 11th dynasty. It lasted until 2061 B.C. and produced three rulers in succession, Antef I, II, and III, each of whom struggled to bring together local factions. Consolidating power in the south, they set the stage for eventual victory over rivals in the northern and central parts of the country. Thebes was the seat of their administration, but they were unable to exert control over the entire country. Strong provincial governors from Middle Egypt had established their own independent power, and they still exerted considerable

WRESTLING SCENES from the tomb of Khety, Beni Hasan, Dynasty 11, circa 2134-2061 B.C. These vignettes decorate the east wall of one of the earliest monumental rock-cut tombs of the Middle Kingdom.

authority. Independent rulers based in Herakleopolis claimed the throne as the 9th and 10th dynasties as well.

About halfway through the 11th dynasty, Antef III's son, Nebhepetre Mentuhotep II, successfully reunited the country, and the Middle Kingdom began. He included *sema tawy*, the symbol of a united Egypt, as part of his name, a phrase referring to his own achievements and promoting his symbolic role as creator god. His long reign, lasting about 50 years, was quite remarkable at the time. According to some texts, his rule saw internal disruptions, and he moved swiftly to extend his rulership through the delta area and prevent incursions from Asiatics. He often made use of the *medjai*, Nubian mercenaries, who became an important component of his forces.

Mentuhotep II also reorganized the royal court, using models from the Memphite Old Kingdom. The many functionaries who held lower-level positions became part of a rising middle class. Burials from the period show that different levels of society were developing at the same time. Of importance in this sector of society were the scribes, and the early Middle Kingdom provides records of their formalized training. Model letters were used for teaching scribal methodology from the 11th and 12th dynasties. The pharaoh relied on the military for maintaining power and developed agriculture in the area of the Faiyum.

After Mentuhotep II's death, two more rulers with the same name followed. The first seems to have continued the major policies of his father. He initiated a few building projects and maintained borders but ruled only about 11 years. Records regarding his successor, Mentuhotep IV, are not particularly elucidating, and his name does not appear on all king lists, suggesting that his short reign may have included disunity and civil disturbances.

Next, a strong individual named Amenemhat took the throne. Apparently not related to his predecessor, he may have been a vizier under Mentuhotep III. As Pharaoh Sehetepibre Amenemhat I, he initiated the 12th dynasty. A Middle Kingdom literary text, the Prophecy of Neferti, known from later Ramesside copies, refers to him as a child of Khen-nekhen (southern Egypt) and as the son of a woman from Ta-seti (northern Nubia). He left few monuments from his 30-year reign, however. Politically astute, he quickly realized that to maintain his control nationwide, he must

establish a presence in the strategic northern Memphite area. He constructed forts in the eastern delta to protect the borders and at some point, probably early in his reign, he broke with recent tradition and moved northward. He established an administrative capital, calling it Itj-tawy, "the seizer of the Two Lands," perhaps in reference to his own actions.

At the new city, he continued to develop a strong centralized administration, with several levels of officials from a variety of areas around the country. Ihy, who was overseer of the royal apartment at Itj-tawy, appears to have had strong ties to Saqqara, for example, and his high position in the funerary cult of the 6th-dynasty pharaoh Teti suggests northern roots. In contrast, Intefoker, Amenemhat I's vizier, seems to have had an Upper Egyptian background like the pharaoh's.

KINGS AND CO-REGENTS

Society's attitudes toward the king may have undergone some change in the early Middle Kingdom, or even before. The Teachings of Amenemhat—a collection of advice on governing, probably composed during the reign of the king's son and successor, Senwosret I—may have served as a justification for a co-regency between the two, an idea alien to the Old Kingdom. Perhaps the unsettled times from the 9th to the early 11th dynasty led society to rethink the nature of their ruler. The text refers to the assassination—actual or attempted—of the king, and thus speaks to the ruler's vulnerability and lack of omniscience: characteristics that were not recognized, or at least referred to, in earlier texts. Several later copies of the Teachings of Amenemhat exist, attesting to its active use during this time and later.

According to other inscriptional evidence, Amenemhat I devoted much time to protecting the borders of the country and led campaigns against Asiatics, Nubians, and Libyans. Internally, he concentrated on reorganizing the administrative structure centered at his new capital of Itj-tawy. He deemphasized the inherited provincial nomarchies and appointed individuals loyal to him as governors in those areas. Each action was calculated to emphasize the unity of the state and the power of the pharaoh.

A co-regency ensured the royal succession and thus brought stability to the land. The ruling structure seems to have remained in place during most of the 12th dynasty, and it served the crown prince Senwosret very well. Upon the death of his father, he stepped into his role as king with a good understanding of what the office entailed. Kheperkare Senwosret I ruled 43 years. His ambitious building program included new temples, chapels, and shrines and the restoration and refurbishment of earlier temples in various parts of the country. Records point out that during his reign, a famine took place, but they report no resulting political disunity or civil strife, further attesting to his leadership. The atmosphere during his reign was conducive to cultural development, and architecture, art, and literature flourished. Not only did the Teachings, mentioned earlier, come from the time of Senwosret I, but also the Tale of Sinuhe and perhaps the Prophecy of Neferti.

Senwosret I reinforced his father's interest in the south. He constructed many fortresses in order to protect Egypt's interests in Nubia and other areas nearby. Several mining expeditions also took place under his reign. In the provinces, he followed Amenemhat I's pattern and placed trusted officials in top positions. From the evidence of the continued building of large-scale funerary monuments in the provinces, primarily in Middle Egypt, it appears that some nomarchs retained their power, however.

Nubkaure Amenemhat II, probably the son of Senwosret I, came to the throne around 1929 B.C. and ruled for 34 years. Little detailed information about his activities appears, but he seems to have continued the programs of his two predecessors. His campaigns against foreigners included expeditions to Asia, Kush, and elsewhere, bringing tribute to Egypt. There is evidence of continuing trade with other nations, including some in the Mediterranean and western Asia.

His probable son, Khakheperre Senwosret II, succeeded him, and the two may have co-ruled for about three years. Senwosret II's reign lasted two decades, shorter than those of his predecessors, and appears to have been quite peaceful. Inscriptions from the provinces indicate continued good relations. A scene from an elite tomb in Middle Egypt dated to his reign contains images of bedouins, probably Semitic, offering products from the eastern desert. Senwosret II seems to have taken an interest in the Faiyum, especially agricultural activities there. Near his burial site of Lahun, he oversaw construction of an administrative city, still well preserved today, with a plan that included roads, sectors dedicated to particular purposes, and open areas. This efficiently organized city was used into the 13th dynasty. Papyri discovered there, including personal letters, legal and economic documents, hymns, and didactic material, reveal much about life in this city.

Khakaure Senwosret III, probably Senwosret II's son, ruled for 35 years. An imposing figure—more than six feet tall according to one account—the new king wasted little time in demonstrating his power. He built and restored fortresses in Nubia and Kush and executed several military campaigns in the southern area. For military and trade purposes, particularly maintaining access to gold and other valuable resources, Senwosret III constructed one canal and cleared out another. His presence must have resonated in the southern territories, for he became an object of veneration there. No such allegiance developed in the north and in western Asia, but he probably did wage campaigns and expeditions in Palestine and possibly Syria.

During the reign of Senwosret III, the middle class continued to rise, and the inherited nomarchies all but disappeared. Construction of the last large provincial monuments coincided with the reign of the next king, Amenemhat III, but the monuments' local owner did not hold the title of nomarch. Senwosret III also began reorganizing the government. He divided it into three geographic units: the north, the south, and the head of the south. Each had its own vizier. Some new designations of officials appeared during his reign, as indicated by the increasing number of scarab seals used to mark these designations from this period. Royal construction centered on the area around the Faiyum in the north and in Thebes and Abydos in the south.

Nimaatre Amenemhat III, probably the son of Senwosret III, served with him as co-regent for about two decades. The remarkable economy continued, and Amenemhat III completed many projects begun under Senwosret III. Beyond restoring and enlarging existing temples, he built a chapel in the Sinai and a temple to Sobek in the Faiyum. He maintained peace through alliances and trade, especially in regard to Palestine. The few

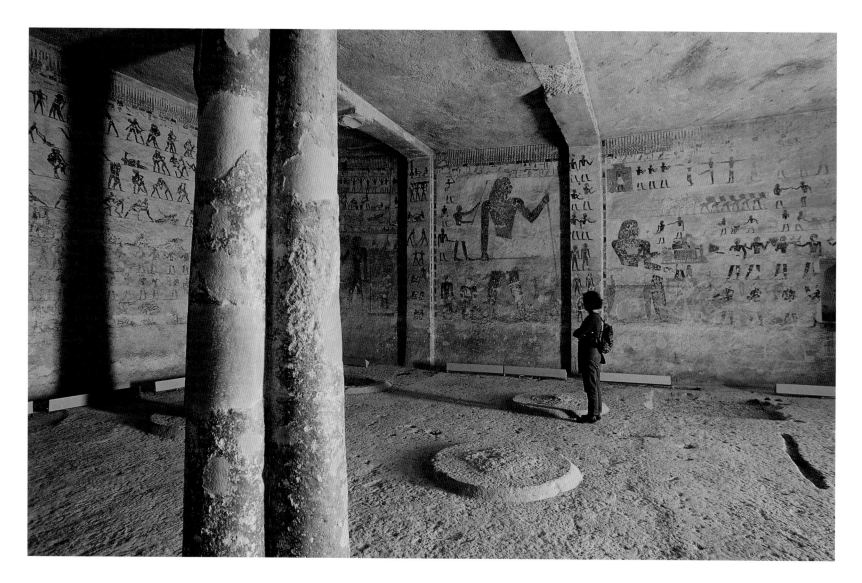

existing military records show that he paid attention to the delta area and stayed vigilant against invasions from west Asia. Several mining expeditions occurred under his rule. His death marked the end of a long line of powerful Middle Kingdom pharaohs whose long reigns had meant prosperity in ancient Egypt.

The last two 12th-dynasty rulers had shorter reigns than those of their predecessors. Maakherure Amenemhat IV, who may have served as co-regent with his father, Amenemhat III, ruled for about eight years. Then Queen Sobekkare Sobekneferu, perhaps his sister, came to the throne, first as queen regent and then as a ruler in her own right, reigning independently for four years. Little contemporary information survives to detail their reigns; both may have continued projects begun by their father.

Lasting almost 150 years, the 13th dynasty had at least 50 pharaohs. The archaeological, artifactual, and textual data is subject to many interpretations. Earlier scholars saw these times as chaotic, but the period may have been fairly stable. Monuments with the names of some of the kings exist in all parts of Egypt, attesting to the continuing national strength of the pharaoh. Toward the end of the 13th dynasty, however, a single head of state with a central administration over the entire country was no longer governing Egypt, and the land was

TOMB OF KHETY at Beni Hasan, Dynasty 11. The size, architectural style, and decoration of provincial tombs such as this one reflect the significant power wielded by local governors such as Khety during this era.

undergoing a period of internal disunity. Records in which the last kings appear derive primarily from the south, implying that the final rulers of the Middle Kingdom were governing only that part of the state, perhaps ruling simultaneously with an independent line of monarchs, Dynasty 14, in the delta area.

The exploits of a few rulers from the 13th dynasty stand out. Sebekhotep II reigned around 1750 B.C., maintaining his residence at Itj-tawy. A papyrus from this period suggests a strong Theban presence, and details the palace and royal activity at Thebes. His successor, Userkare Khendjer, reigned from 1756 to 1751 B.C. and built one of the last pyramids of the dynasty, a small monument in South Saqqara, not far from the burial place of many 6th-dynasty pharaohs. Two stelae, now in the Louvre, document how he directed the restoration of the temple at Abydos.

Khasekhemre Neferhotep I ruled for 11 years, from 1747 to 1736 B.C., and clearly held power over all of Egypt. Records containing his name occur throughout Egypt and elsewhere in the Near East, suggesting that relations with foreigners remained strong. He set up a stela at Abydos regulating cemetery locations at the site. Nubia still remained under Egypt's control, and some fortresses may have been in use well after his reign.

The last major sovereign of the dynasty, Khaneferre Sobekhotep IV, reigned from 1734 to 1725 B.C. Statuary, stelae, blocks, and scarabs with his name indicate that he maintained political unity, although Asiatics settling in the delta began forming their own dynasty. Nonetheless, Sobekhotep IV sent out expeditions to mining regions, ordered the clearing of a canal, and initiated construction projects in Memphis, Karnak, and Abydos. The times were still prosperous, trade continued, and Egypt maintained its borders. The practice of setting up private stelae in family chapels at Abydos generated a successful industry that continued well into the 13th dynasty, and the production of scarabs continued to flourish.

Soon, however, power on a national level dissipated, and Egypt faced political disunity. Rulers in different regions competed, and, for the first time ever, Egypt came under the control of foreign kings. Dynasty 15, lasting from 1664 to 1555 B.C., saw a series of rulers known as the Hyksos. The new rulers governed from Avaris, a delta area into which Asiatics had steadily migrated during the Middle Kingdom.

The Hyksos dominated Egypt and beyond. Engaging in trade, they extended their influence throughout the Near East and the Mediterranean. Imported goods came into Egypt, and artisans adopted the new styles: Frescoes from Avaris show an Aegean influence. As this cosmopolitan and international society flourished in the north, indigenous leaders in the south amassed power. Eventually, a group of strong rulers emerged from Upper Egypt, controlling the area from Abydos to Elephantine, while Kush held power over territories to the south.

From 1600 to 1569 B.C., the Theban kings rose to power, representing the 17th dynasty. They challenged their rivals in the north. The mummy of Seqenenre Ta'o, whose rule began in 1600 B.C., indicates that he received lethal wounds from weapons of warfare; perhaps he died in battle with the Hyksos. Kamose, who came to the throne in 1571 B.C., continued to war against the foreign rulers. By this time, the Hyksos leader Aa-woserre Apophis had allied with Kush, leaving the Egyptians an entity unto themselves. A stela of Kamose's details the conflict and records one successful campaign, but ultimate victory over the Hyksos—together with their expulsion from Egypt and reunification of Egypt under a native pharaoh—did not occur under his leadership. That feat was accomplished by his successor, Ahmose, the first pharaoh of the 18th dynasty, whose reign marks the advent of the New Kingdom.

NEW FORMS IN ART AND ARCHITECTURE

After the reunification during the 11th dynasty, Thebes became quite cosmopolitan, serving as an administrative capital and a religious center. New architectural projects began, requiring statuary and relief sculpture for monuments, and the city became a center for artists, some from the north and some from local areas who had trained in Memphite traditions.

The merging of Theban and Memphite influences is apparent in a large seated figure of Mentuhotep from the period. The powerful lower torso and legs reflect local

Theban traits, while its refined facial details mirror an Old Kingdom Memphite style that survived in the provinces. Soon art and architecture reflected the new unity of the land.

Mentuhotep II maintained his residence in Thebes and began construction of his funerary complex on the west bank, as had his ancestors. Their earlier *saff,* or row, tombs may have inspired his columned portico and other elements, but his final design seems quite innovative. Components like the hypostyle hall, defined by a roof and enclosing columns, became a model for all New Kingdom temples. Royal complexes did not focus on a built pyramid, as they had in the Old Kingdom. The location of the temple and tomb in a bay in the cliffs at Deir el Bahari was probably not accidental, however. A high pointed peak hovers above the cliff, and perhaps it functioned as a natural pyramid. Scholars have offered this explanation for the location of the Valley of the Kings, and recent excavations at Moalla indicate that tombs there may have been situated near a natural pyramidal peak as well.

As in many other aspects of his reign, Amenemhat I used the past for inspiration and changed both the location and the type of his burial. Using a simplified Old Kingdom model, he constructed a pyramid at Lisht, not far from his new capital. In the few years that he spent in Thebes, he may have started a mortuary structure that was more Theban in style, but he apparently abandoned it when he moved north. References to another royal pyramid belonging to Amenemhat I appear in the Saqqara tombs of two officials who served in the royal court at Itj-tawy, but its location has never been found.

The text called the Teachings of Amenemhat tells why this 12th-dynasty pharaoh relocated his court to Lisht. One section of the papyrus refers to the king's assassination. If Amenemhat I survived such an assault, he may have reconsidered where to be buried soon afterward. The perpetrators came from within the royal court, according to the text, which may have moved the king to alter his burial plans and, perhaps, to adopt a new Horus name—Wehem-mesut, "repeater of births"—to commemorate his survival and renaissance.

Whatever actually happened, this pharaoh chose the Memphite model for his burial pyramid rather than the Theban model of his predecessors. The monument at Lisht incorporates elements from royal monuments at Giza and other details of typical royal funerary complexes of the 6th dynasty. Art of his reign also relied on past models, but the final products always had distinguishing innovative elements.

New forms of statuary were developed, such as the figure in a sedan chair, which may have served as the impetus for the development of the block statue, so important in the repertoire of sculpture in the round in the Middle Kingdom and later. The style of this period reflects the inclusive nature of the new administration and represents a transition to the more mature style characteristic of the later 12th and 13th dynasties.

Like his father, Senwosret I used the burial site of Lisht. Following Old Kingdom royal models, he included a pyramid for himself, others for members of his family, a satellite pyramid, a causeway, and mortuary and valley temples. He reused blocks from monuments of Old Kingdom pharaohs and built a complex that closely resembled one built by a 6th-dynasty pharaoh in Saqqara. The art of his reign shows signs of experimentation, however, and few of his royal representations resemble each other.

NEW TYPES OF BURIALS AND PORTRAITS

The next two pharaohs appear to have modeled much of what they did on the programs of their predecessors. Both diverged, however, in regard to burial arrangements. Amenemhat II chose the site of Dahshur, used by the 4th-dynasty pharaoh Sneferu, and created a complex reminiscent of Djoser's 3rd-dynasty burial, including mud brick used for the core of the pyramid.

Senwosret II chose Lahun, near the entrance to the Faiyum, as a burial site. His builders constructed the entrance to his pyramid on the south rather than the traditional north. His short reign may have dictated other design changes. Since it sat on a rock outcropping, the pyramid required less of a core, and it was filled with mud brick. This method saved time and labor, but when the casing was removed, the core turned to rubble.

Senwosret III's reign introduced the more mature style of the Middle Kingdom. His statuary portrays not the generalized state of youth of earlier rulers, often with a neutral expression, but a

distinctive face with heavily lidded eyes, facial furrows, and an expressive mouth. Scholars have variously described the effect as pessimistic, humanized, or middle-aged, and yet the statues retain an air of divinity as well. The combination may reflect the duality inherent in the king: a human being within the divine office of kingship. Contemporary texts refer to such ideas. The concept of divine kingship was a subject of interest reflected in both the art and the literature of the 12th dynasty and the later Middle Kingdom, and it may connect with changes in religious practices and burial customs. The pharaoh still retained his absolute power and maintained the unity of the country, but other aspects of the culture were undergoing change.

Senwosret's mortuary arrangements seem at first to have been traditional, with a pyramid complex at the familiar site of Dahshur and a sarcophagus whose outer surface may have been inspired by Djoser's niched enclosure wall. Dahshur, however, may not have been his actual burial site. He built another complex, which some scholars suggest was a cenotaph, at Abydos, and founded an administrative town nearby that continued to operate well into the 13th dynasty. Recent excavations suggest that Abydos was his likely burial place. A structure situated on the edge of the cultivation just before the desert resembles a lower temple associated with a pyramid, but no royal pyramid was built at the site. Instead, Senwosret concealed his tomb in the nearby cliffs. A pointed peak above may symbolize a pyramid, similar to the arrangement associated with Mentuhotep II.

Amenemhat III, the successor to Senwosret, also chose Dahshur as his burial site, but he never completed his structure. Construction faults may have deterred him. His burial actually took place in the pyramid he built at Hawara. Close to the Faiyum, the Hawara site allowed him to take advantage of its proximity to

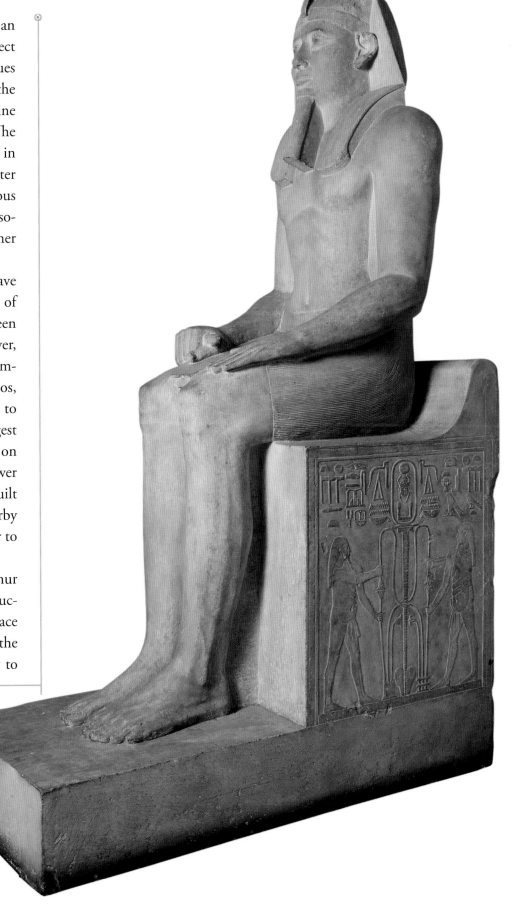

SENWOSRET I, from Lisht, Dynasty 12, circa 1971-1928 B.C. This limestone statue was one of a series in the king's pyramid complex. On its base, two figures tie plants around the lungs and windpipe of an animal—the hieroglyph for "unite."

TEMPLE (following pages), Deir el Bahari, Dynasty 11. Only ruins remain of the mortuary temple of Nebhepetre Mentu-hotep II, who reunified Egypt and founded the Middle Kingdom.

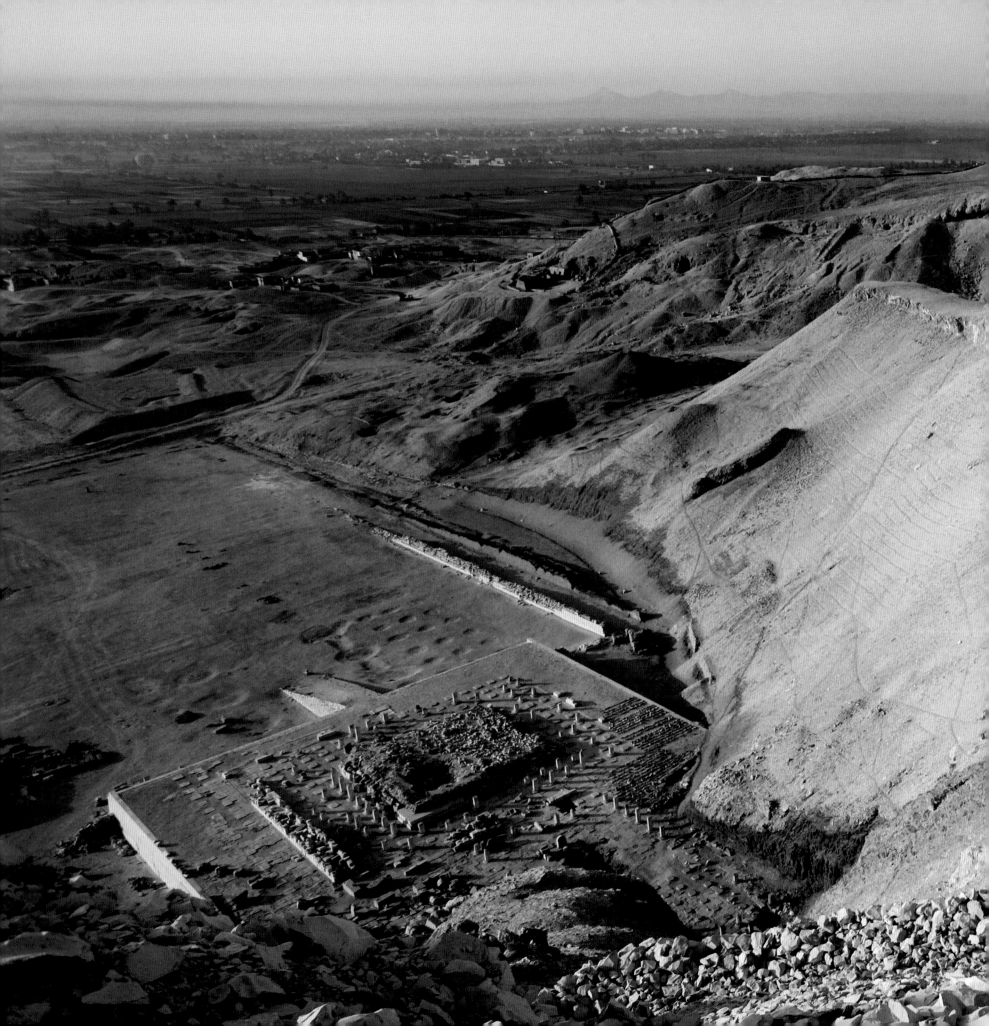

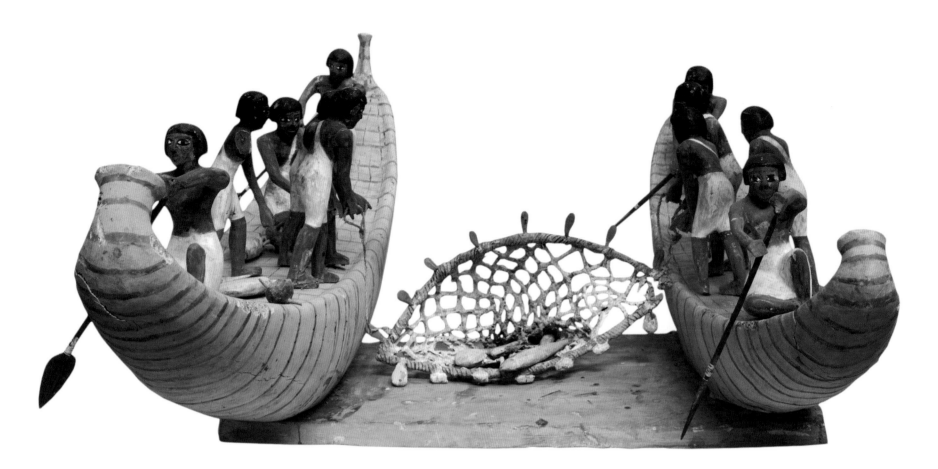

the administrative city, Lahun. The pyramid contained a variety of devices developed to thwart would-be robbers.

Through the rest of the 12th dynasty, the quality of art remained high. Royal faces continued to portray humanistic qualities, with realistic details around the eyes and mouth. Traces of these features also mark the style of the 13th dynasty, but a tendency to generalize the overall look of the face began to predominate. The times were still prosperous, trade continued, and Egypt maintained its borders.

An extremely large number of stelae survive from the private chapels at Abydos. Dated well into the 13th dynasty and produced for owners throughout Egypt, they attest to the continuation of the practice of monumental stelae. Different styles of work indicate many workshops and imply the emergence of a number of provincial schools of art in different parts of the country.

MODEL, Tomb of Meketre, Deir el Bahari, Dynasty 11. By the Middle Kingdom, models appeared in tombs instead of or in addition to two-dimensional wall scenes. This one portrays fishermen dragging a net between papyrus skiffs.

Many burial sites of the rulers of the 13th dynasty remain unidentified, but that of Khendjer is known. A pyramid at a Memphite location, it retained the Middle Kingdom tradition. Internal disunity and foreign rule during the Second Intermediate Period meant that Egypt would have to wait until the advent of the New Kingdom for the emergence of a new national style.

KINGSHIP AND DIVINITY

For ancient Egyptian society, the act of unification reflected events on a cosmic level. The original consolidation of the state symbolized the order that the creator gods had established from out of the overall chaos of primeval times. Pharaohs who came to the throne and participated in the coronation ritual represented the creator god who had established and maintained cosmological as well as earthly order. As the gods created the order of the cosmos, so the pharaoh established order on earth. Creator gods and the king set up and maintained *ma'at,* divine order, in their

spheres of influence, thus insuring that the universe—both the world of humankind on Earth and the perceived world of the gods and the afterlife—would continue to exist.

Contemporary views of the nature of Egyptian rulers often picture a nearly divine pharaoh with absolute power. Kingship in ancient Egypt, however, was more complicated, and it underwent a long process of change. What remained fairly constant was the distinction between the royal office and the individual who inhabited it. The office remained divine, but the human holding the office achieved divinity only after death and burial. Gods received veneration and worship; pharaohs received respect and adoration. Not until the New Kingdom did the concept of the divine birth of the living king and the worship of the pharaoh as a living deity take shape, but the first of these ideas had roots in the Middle Kingdom.

The Middle Kingdom represented a new period of reunification, leading to centuries of political stability. As the land emerged from a time of national stress and disunity, new religious concepts evolved, especially views of the place of society on Earth, in the cosmos, and in relationship to the pharaoh. Two new gods were introduced at a national level, Montu and Amun. Both already had prominent roles in Upper Egypt; Amun would become preeminent in the divine hierarchy.

Burial customs illustrate some of the modifications. Identification with Osiris in funerary contexts had been a royal prerogative, but now it became an association claimed by elite tomb owners as well. Nonroyal epithets indicating positive divine judgment became standard in inscriptions in the tombs of the elite during the Middle Kingdom. Private funerary spells had appeared only sporadically before, but now they came into widespread use. Collected together in the Middle Kingdom, they were called Coffin Texts. Like the royal Pyramid Texts of the Old Kingdom, this set of magical formulas helped ensure an individual successful entrance into the afterlife and transformation into a higher state of being after death.

Some Middle Kingdom tombs were decorated with regalia and insignias earlier associated only with royalty. Tombs in Middle and Upper Egypt used newly developed iconography that displayed the enhanced status of citizens in society. One tomb

includes the depiction of the king; another pictures a huge statue, presumably cultic, of the tomb owner; and a third contains a figure of the owner in a shrine, referred to as a deity. Private individuals began to set up statuary within temples during this period. Literary texts from the same time suggest new levels of religious contemplation. In the text called Dialogue of a Man with His Ba, for example, the individual contemplates the nature of death and suicide.

The concept of the king and the office of kingship seem to have undergone a corresponding change. Literary compositions imply that the Old Kingdom assumption of the exalted state of the pharaoh had been reconsidered. In some of these texts, the king exhibits human qualities, such as fallibility, weakness, and lack of omniscience. Some passages indicate that he needs guidance, advice, and information. The Teachings of Amenemhat details the pharaoh's ignorance of the plan to kill him. A tale dated to the 13th dynasty or later shows similar ambiguities. Set in the 4th-dynasty court of Khufu, it shows the Old Kingdom ruler in quite human terms but refers to the divine birth of the first few rulers at the advent of the 5th dynasty. Concerns about kingship also surface in the mature art of the 12th dynasty, where the careworn visages of Senwosret III and Amenemhat III contrast strongly with the removed and isolated representations of rulers of the Old Kingdom.

Burial customs also reflect the changing beliefs in the Middle Kingdom. Although relying on the pyramid complex for inspiration, some of the pharaohs of the 12th dynasty did not include the Pyramid Texts on the walls of their burial chambers. Instead they used the interior rooms and plan of the pyramid to represent the hours of the underworld, thus anticipating a decorative program that would become the rule in the New Kingdom. In nonroyal burials, *shabti* figures began to appear, spells became longer, and in general, the reliance on magic seems to have increased. Amulets, charms, sculpted figures, inscribed ivory wands, and other magical implements came into greater use, both for daily life and for the afterlife. While the politics of the Middle Kingdom appear to have remained stable, religious beliefs were not static, and the continuing evolution of spiritual beliefs affected the material culture of art and architecture.

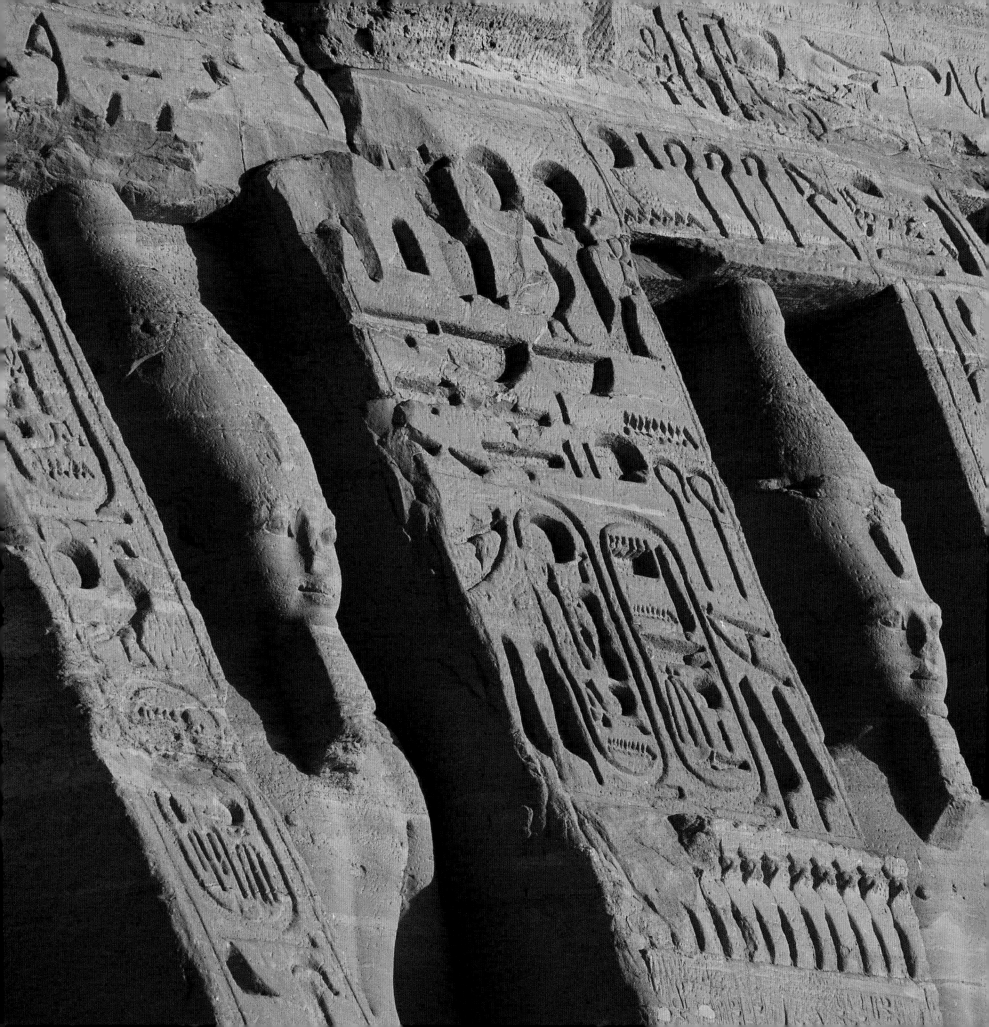

THE GOLDEN AGE

THE NEW KINGDOM

Betsy M. Bryan

THE NEW KINGDOM spanned nearly 500 years, from 1569 to 1081 B.C. Born out of the Theban 17th dynasty, kingship in this period exhibited characteristics of its roots. Kings built a ruling house in southern Egypt through military victory over the Hyksos overlords in Egypt's eastern delta, and a culture of warfare greatly influenced society. The Hyksos kings traded with Syria, Anatolia, and Cyprus, and maintained a relationship with the powerful Kushite kingdom in the Sudan. As a result, kings of the New Kingdom were part of a larger world system, and the society they led reflected this cosmopolitan stage. Women enjoyed increased visibility at all social levels, especially in the royal family. In society at large, the army became professional, an important element in administration. Bureaucratic traditions developed since the Old Kingdom persisted through the Second Intermediate Period, despite a weakened kingship.

ers frequently eclipsed their activities as keepers of domestic or divine order, as the numerous temple wall scenes of pharaohs smiting foreigners can attest. Perhaps not since the dawn of Egypt's monarchy had the militarism of its kings been as celebrated as during the reigns of such great rulers as Ahmose, Thutmose I and III, Sety I, and Ramesses II. The family of Ahmose had galvanized the southern areas of Egypt to combat Nubian incursions threatening the great towns of Edfu, El Kab, and Hierakonpolis, and Seqenenre also took the battle northward against the Hyksos rulers in the delta. The military flavor of the kingship was particularly strong as the efforts to conquer the Kushites in the south and later the Levantine city-states to the northeast proceeded during the 18th dynasty. The fierceness of the fighting resounds in the brutal language used in royal victory inscriptions, such as Thutmose I's at Tombos: "The Nubian warriors fell in a slaughter, placed on the side. Their entrails bathed their valleys, and their arrows were like the downpour of a rainstorm. The carrion birds

KINGSHIP AND MILITARISM

At the top of society, kings of the New Kingdom were called "victorious bull" as part of their titles. Their roles as military lead-

SMALL TEMPLE at Abu Simbel, Dynasty 19, circa 1304-1237 B.C. Osiris-like figures and deeply carved cartouches of Ramesses II adorn the facade of the small temple dedicated to Queen Nefertari and the goddess Hathor.

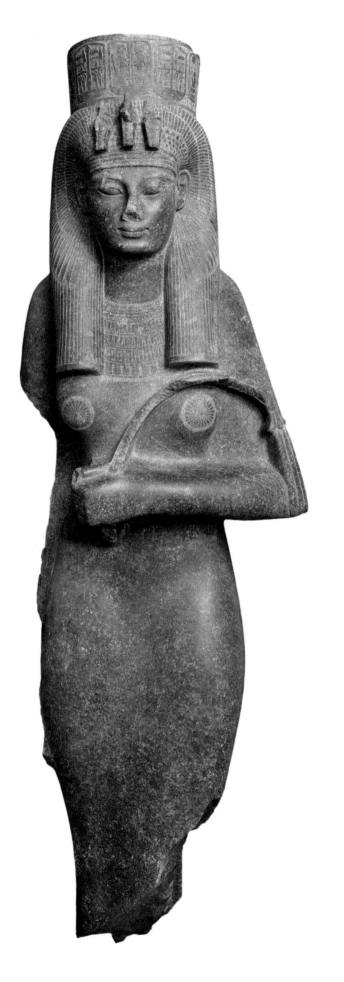

upon it were numerous; birds were snatching and taking over to another place. The crocodile [the king] seated himself upon the fugitive who would have hid himself from Horus, strong-of-arm." Kings also proudly depicted their exploits in works of art. In the Armant and Karnak temples, Thutmose III represented African rhinoceroses and Syrian water plants secured on his campaigns.

Although the expectation that a son would lead his father's army was probably common from the Second Intermediate Period onward, by the reign of Thutmose I an inscription confirms that Prince Amenmose was among his father's military leaders. A similar military role for kings' sons is confirmed at the beginning of the 12th dynasty, when the kings also faced prolonged periods of warfare. The small number of kings' sons who survived their fathers in the first 50 years of the 18th dynasty is likely testimony to the constancy of war. Indeed, following the deaths of several princes of these early kings, the representation of kings' sons nearly disappeared from royal monuments until the reign of Sety I. Amenhotep I left no son, and the kingship moved to Thutmose I, a great soldier, who married a woman of the royal family.

Perhaps to combat this threat to the dynastic family, a characteristically 18th-dynasty institution was fostered to nurture and protect all offspring of the royal courts. Royal nurses, both male and female, cared for princes and princesses; members of the most elite families of Egypt held these offices. Female royal nurses, such as those of Hatshepsut and Tutankhamun, were honored with their own tombs, and male nurses could combine the tutelage of royal children with other functions. Hatshepsut's steward, Senenmut, was also nurse to princess Nefrure, for example. Benermerut—a statue of whom was found in the Amun temple of Karnak—demonstrated service to the king by caring for the princess Merytamun, although in his official governmental role he controlled valuable commodities in the treasure house.

By the reign of Thutmose III, the ranks of princes and princesses were burgeoning, and at the royal residence in Memphis these young royals were raised with the children of nurses and

STATUE OF TIYE, Karnak, Dynasty 18. Recently discovered in the Mut Precinct, this elegant granodiorite statue was originally carved for Tiye, who was the chief queen of Amenhotep III.

other officials. Some of these youths went with the king-to-be on military expeditions and forged lifelong relationships. The swelling ranks of the army included even the sons of old elite families. Soldiers from less lofty classes of society won prestige and, more importantly, land, gold, and new postwar professions by their courageous service on the battlefields.

The pharaohs' professional armies grew in numbers and became more specialized through the 18th, 19th, and 20th dynasties. The allure of the warrior's role is seen in the literary character of Mehi, a chariot-driving prince who appears in a number of love poems. By the late 18th dynasty, a general named Horemheb was power-ful enough to usurp the kingship, and Ramesses II counted a captain of bowmen, Ameniminet, as one of his close associates. Even popular literature featured soldiers as main characters. For example, a famous general of Thutmose III's, Djehuty, was the hero of an Ali Baba–like story about the taking of the Palestinian town of Joppa, while another tale featured a prince who disguised himself as a charioteer when traveling abroad.

The New Kingdom rulers developed their own approach to annexing foreign countries. The king placed a man at the head of the military effort to defeat Kush, designating him a "king's son" and thus implying that his authority derived from the royal family. Thus Nubia was brought under the control of the "king's son and overseer of southern lands" (later called the "king's son of Kush") as Egyptian forces and administrators settled in fortresses, often reused from earlier times, and in administrative towns. Lands to the south, including the Kushite ruler's residence at Kerma, had regional governments that emulated Egypt's own. Local Nubian rulers were left in control, while their children were taken as hostages to Memphis, where they became Egyptianized Nubians. They followed their fathers on their thrones, and their tombs show increasing Egyptianization, indicating the success of this empire-building strategy.

The "gold lands of Amun"—the gold-bearing wadis of Lower Nubia—came under Egyptian control and were the major asset gained by the conquest of Nubia. The bureaucracy organized under the king's son of Kush thus guaranteed not only security but also revenues, including gold and African commodities acquired through trade. These viceroys moved back and forth between Egypt and Nubia to guarantee the deliveries. They also oversaw the construction of temples on behalf of the rulers at a variety of strategic sites in Upper and Lower Nubia, as far south as the Fifth Cataract of the Nile. The line of fortified temples, like that of Ramesses II at Abu Simbel, may have also helped to regulate the local sedentary and seminomadic populations.

THE VISIBILITY OF WOMEN

From the beginning of the 18th dynasty on, female members of the ruling family figured prominently in royal monuments, as can be seen with such powerful queens as Ahhotep, Ahmose-Nefertari, and Hatshepsut. Over time, even queens born of nonroyal parents achieved visibility, as was the case for Tiye, Nefertiti, and Tawosret. In an environment where the weaker kingship moved through several elite families rather than a single ruling dynasty, the presence of daughters of previous rulers as wives or mothers of new ones strengthened both clans' legal claims to rule. Royal females thus provided a form of continuity, perhaps one reason they became more visible on formal monuments.

During the wars in which the Hyksos overlords were expelled from Egypt, one Theban family emerged to found a new dynastic line. Patrilineal royal succession was dominant at all times in Egypt, but near the end of the 17th dynasty the throne may have moved from brother to brother. From the time of Ahmose, however, royal monuments focused on the descendants of that ruler's grandmother, Tetisheri, through the full brother-sister marriage of her children Seqenenre and Ahhotep. It is probable, but not certain, that the remarkable objects from the coffin of Queen Ahhotep (pages 185-87) belonged to Ahmose's mother and not another queen of the same name.

Beginning with Seqenenre and Ahhotep, the dynasty was preserved through intra-family marriages, first between half brothers and sisters whose fathers were the king and whose mothers were various nonroyal queens, and then between fathers and daughters. In the latter case, it remains questionable whether these women were sexual partners to their fathers. Several such examples occurred in the times of Amenhotep III and Akhenaten.

Except for princesses who married kings, the "king's daughters" with dynastic blood did not marry outside the family during the nearly 200 years of the 18th dynasty. This custom prevented rival elite families from claiming the throne.

Although they never became a significant element in the administration of the country, many women held positions of authority as priestesses. As the Ramesside dynasties continued, more women owned their own Books of the Dead, dedicated their own statues, and appeared as central characters in literature. Queens such as Tiye and Nefertiti appeared so frequently on royal monuments that they appear to have shared both temporal and religious authority with their husbands. Frequently their appearance signaled a queen's mythological role as counterpart to the king. In 19th-dynasty Abu Simbel, for example, where Ramesses II was represented as the sun god, Re, Queen Nefertari enacted the role of the goddess Hathor—an example of the profound importance of duality in Egyptian culture. At the end of the 19th dynasty Queen Tawosret, widow of Sety II, was also represented wearing Hathor's regalia. She assumed the kingship for a short time and left her own tomb in the Valley of the Kings.

A RISING ELITE

In the New Kingdom, as earlier, regional elites gained influence from their wealth in real property. Agricultural workers were essential to economic production. Even people of very slim means could work the land as tenants. A centralized bureaucracy managed the collection, distribution, and taxation of agricultural commodities. The bureaucracy was run by northern and southern viziers, the overseer of the seal, and the overseers of granaries, all answerable to the king; it also employed professional bureaucrats. Viziers and their agents did not always have bureaucratic backgrounds, which may have prompted the composition of literary texts on the proper behavior and organization of the vizierate. Written on the walls of several viziers' tombs, these texts emphasized impartiality in economic and judicial governance.

Later in the New Kingdom, the importance of honesty, accuracy, and piety formed the major themes of the long, poetic Instruction of Amenemope. Scribes and temple administrators were responsible for large amounts of produce, presenting opportunities for corruption or bribery. During Akhenaten's reign and immediately after, it appears that the social fabric of the country was wearing thin. King Horemheb moved to stop corrupt practices by regional and royal administrators.

With the restoration of order at the end of the 18th dynasty, a new era of professionalized civil service began, notable for its increased reliance on written records. Writings from the next dynasties record how artisans were organized to build the kings' tombs, chronicle judicial proceedings surrounding a harem conspiracy, and detail tomb robbing in the Valley of the Kings. Reading and writing were taught to more people than ever before. Bodies of literature were created to train various specialists: Such texts included mathematical digests, medical compendia, religious texts containing theologians' wisdom or ritual details, and lists of people, places, and things.

STATUARY AND PORTRAITURE

A statue served as a container for the spirit of the person or god depicted. A portrait statue embodied the *ka,* the spirit that could receive food and drink in order that the person might live. These images represented the statue owner as an eternal and divine hieroglyph, defined by iconography. The kneeling statue of Senenmut holding Nefrure (page 120) is an example of this carefully constructed image. The idealized face of Senenmut, a steward, bears traits of the portrait of Hatshepsut, the queen. Until the Late Period, private persons were rarely represented with their own identifiable features; rather, they commissioned images of themselves with the face of the sovereign they served, thereby expressing loyalty and guaranteeing life in the hereafter.

In the New Kingdom, the royal administration fostered artistic centers, clustered around cemeteries and temples, where sculptors created large- and small-scale statues for kings and private persons and, by a process still unknown to us, composed a royal portrait type for each ruler. There were variations in the portraits, and sometimes more than one type was created, as with Ramesses

II. Through the 18th dynasty and part of the 19th, statues bore identifiable faces of the sovereigns. The waning of the New Kingdom affluence in the later 19th and 20th dynasties resulted in more generic royal portraits, perhaps simply because kings had less direct contact with the sculptors.

As with other aspects of Egyptian art, portraiture did not involve a realistic rendering of a person. Rather, the artists designed a composite hieroglyph that represented a particular ruler, using characteristic facial and body features. Senenmut, for instance, was associated with a triangular facial shape: broad cheekbones, heavy in the midface, tapering to a narrow chin.

The portraits of a king with a long reign might change in configuration over the period of his reign. The statues of Thutmose III, for example, who ruled for 54 years, evolved over time, with less tapering in the face shape in later sculptures. Amenhotep III's portrait, represented by the mud head from Karnak (page 100), is highly individualized, with a rather long and fleshy face, little or no suggestion of bone structure, and narrow, ovoid eyes. In most cases, Amenhotep III's eyes are set at a slight angle, in a manner one might call Asian. The mouth spreads as wide as the base of the nose, and the upper and lower lips are full. The entire mouth is rimmed by a raised lip line, consistently found in this king's statuary. All these features add up to a highly identifiable face.

The portrait of Amenhotep IV in this exhibition (page 144) exaggerates many of the same features: It shows angled, ovoid eyes, so narrow that the king appears to be squinting; the face is extended in length but not width; the chin is noticeably knobby. The head of an Amarna princess (page 113) provides a different version of the same features. Her youthful face shows a chin that is round and knobbed but less extended in length. Her large, almond-shaped eyes, characteristically outlined in black, are hallmarks of the Amarna age. Her mouth, with its full lower lip and slightly down-turning corners, is also a feature of the period. The traits seen so often earlier in the 18th dynasty—aquiline nose, strong cheekbones, and evidence of an overbite—have all disappeared.

Two portrait styles of Ramesses II were common during his 67-year-long reign, and each had variants. The king frequently was shown, like his father Sety I, with a long aquiline nose and a

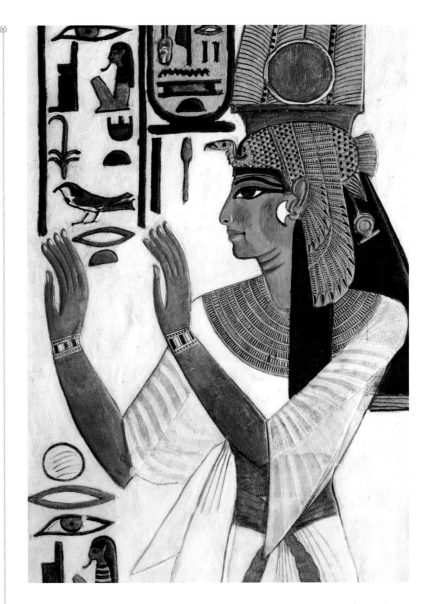

narrow but full mouth. The bust of Paser (page 169) reflects later versions of Ramesses II's portraits. With a fleshy face, a straight but broad nose, and a rimmed mouth, Paser's face alludes to the portrait type of Amenhotep III without copying it. The colossal images of the king from Abu Simbel and most of his temple colossi from Thebes utilized this type of face as well, allowing Ramesses II to share in the past glory of Amenhotep III while also claiming his own.

TOMB OF NEFERTARI, Dynasty 19, circa 1304-1237 B.C. Queen Nefertari, the principal consort of Ramesses II, raises her arms in a gesture of worship in this image from her lushly decorated tomb in the Valley of the Queens.

TEMPLES

As in earlier periods of strong kingship, the court sponsored artisanship through temple- and tomb-building projects. Relief sculpture on walls and stelae had been a major form of royal artwork since the Old Kingdom, and in the particular flavor of New Kingdom decoration, many large pylon temple gateways were covered with scenes. Some commemorated royal conquests and others, in an early development of the New Kingdom, accompanied written narratives. At Deir el Bahari, for example, under the guidance of Hatshepsut's overseers, such as Senenmut, reliefs told the stories of the queen's divine conception and birth; her descendancy from the great national god, Amun-Re of Karnak; her diplomatic mission to Punt in East Africa; and other themes. By the 19th dynasty, Sety I and Ramesses II used narrative art to depict their military expeditions on a grand scale. Sety's campaigns against Palestine appear on the exterior of the hypostyle hall at Karnak, with geographic labels that trace the mission.

No king used temple walls to proclaim his accomplishments more continuously than Ramesses II. At least seven versions of scenes and accompanying texts on the Battle of Kadesh have been found in Egypt and Nubia, and each iteration is different. Artists had to select details to suit the size and position of the wall surfaces to be decorated. Thus at Luxor Temple, the two flanks of the huge pylon gate of Ramesses II depict a complete version of the battle itself, while at Abu Simbel, since the battle appears on an interior wall, the representation was adjusted to enlarge the king and render other aspects of the scene smaller, and some narrative elements were left out.

New Kingdom rulers rebuilt nearly every major god's temple throughout Egypt and added many in Nubia. Earlier temples had been built of mud brick with stone doorways, but New Kingdom builders used sandstone in southern Egypt and limestone in the north. With the enrichment of Amun-Re's cult in Thebes, the city developed a ritualized landscape. Karnak, the earthly abode of Amun-Re, grew during this time to hold nine pylon gateways, with courtyards for festival crowds in between. Thebes's temples were connected by waterways and roads, often sphinx-lined. People would throng the roadways between temples during the great festivals of Opet and the Beau-tiful Feast of the Valley. The Luxor Temple (called the Southern Ipet) and the small temple of Medinet Habu (Holy of Seat) were built to celebrate the fertility aspects of the god Amun.

Wall scenes at the Luxor Temple showed Amenhotep III's statue being carried to the temple for the ritual; scenes inside the birth room showed his creation and introduction to the gods, and in the appearance room Amun-Re was shown conferring the king's crowns. Statues dedicated for this temple were found buried in the large open court in front of the main building. Now in the Luxor Museum, the Amenhotep III dedications were accompanied by those of Tutankhamun and other kings.

The Luxor Temple's association with the divine kingship was so powerful that more than one thousand years after Amenhotep III, Alexander the Great built a new shrine there to house the divine boat of Amun-Re. Although the Ptolemaic kings sponsored the rebuilding of major temples throughout the upper Nile Valley, in Thebes the work of the New Kingdom pharaohs was left largely unaltered except through restorations, probably because of the citywide grandeur that developed between the reigns of Hatshepsut and Ramesses III. Later kings apparently saw no need to replace the monuments of their ancestors but rather made their own additions to this great stage.

TOMBS

The New Kingdom tombs of kings and nobles are best known from two major cemeteries, Thebes and Saqqara. The kings, with the exception of Akhenaten, were buried at Thebes, even though their residences were most frequently in the north, in Memphis and the delta. From the reign of Thutmose I on, kings were laid to rest in the Valley of the Kings, in deeply excavated chambers that represented the caverns of the earth. In the protection of great stone sarcophagi, mummies of the rulers were prepared with gold and jewels and accompanied by their embalmed internal organs and an array of ritual and personal objects.

The 18th-dynasty royal tombs were of winding design and provided an access point to the netherworld. The great funerary books of the time—the Amduat in the 18th dynasty and later the

Book of Caverns, the Book of Gates, and the Books of Night and Day—were carved and painted on the walls and ceiling to assist the king in the afterlife. From the reign of Akhenaten, the twisting design of tombs was abandoned in favor of a straight axis that allowed the sun's rays to penetrate into the king's resting site.

From the 18th dynasty on, artisans who built and decorated the royal tombs settled in the village of Deir el Medina on the west bank of the Nile at Thebes. They were organized into crews headed by chief draftsmen who were line artists, like masters in later European workshops, their particular drawing styles repeated by their crew members. The work of a number of these chief artists can be identified in the Valley of the Kings.

The inhabitants of Deir el Medina, who lived and worked there for 200 years, left a remarkable legacy in their rubbish heaps. There was a high literacy rate among the artisans who carved the funerary texts in the royal tombs, and so the community left behind thousands of documents of every type: letters, literature, receipts, work records, and judicial proceedings in such volume that they nearly overwhelm our documentation of the rest of Egypt.

The artisans of Deir el Medina built their own cemetery, next to the walled town, and they decorated the lower chambers with scenes from funerary books. When they were not working in the royal valley or when they were not building their own funerary monuments, the artisans of Deir el Medina made funerary art for private sale. Records show that business was brisk within the walls of the village and in Thebes at large. Private tomb decoration outside the village also brought income to the artisans, and the style of particular draftsmen can be found in paintings in Ramesside-era Theban tombs.

Few of the tombs of Theban elites can be proven to have been the work of the Deir el Medina community. They were more likely created by the many temple crews that built the royal funerary temples and worked on the east side of the Nile. Through the 18th dynasty the highest officials of the south were buried at Thebes, including viziers, treasurers, mayors, and the numerous priests of Amun. Their northern counterparts often built tombs at Saqqara, only a handful of which are at present known. Recent excavations by French, Egyptian, Dutch, and English archaeologists have recovered some of the great New Kingdom tombs dating as

early as the reign of Hatshepsut. The tomb of Horemheb before he became king was found, along with those of the treasurer and the royal nurse of Tutankhamun. Until the 19th dynasty, tomb chapels combined decorations that honored the life and memory of the deceased with scenes of funerary processions and rituals. The intent was to focus on the life of the deceased and to encourage visitors to make offerings to the family statues in the chapels.

In the post-Amarna era of the New Kingdom, the aims of tomb owners changed, and decorations from this phase of Egyptian history portrayed the deceased in the afterlife. The successful transition to the next existence was the subject of many scenes on Ramesside elite tomb walls, where the deceased and family were shown meeting the god themselves after leaving life on earth. The personal relationships of the tomb owners with great gods such as Osiris, Thoth, and others reflected contemporary notions of individual religion. Scenes showing the tomb owner's earthly existence were no longer frequent, supplanted by banquet depictions that included family members and friends of several generations, which might encourage those who visited the tombs on specific festival days to make offerings to the statues.

RELIGIOUS PRACTICES

Two major themes may be identified in the theology and religious practices of the New Kingdom. First, solar religion continued to grow in dominance, as it had for hundreds of years. The movement to combine the cult of Osiris with that of the Heliopolitan sun gods—Atum, Re, Shu, and others—culminated in the funerary books of the New Kingdom, during which the sun's power was believed to have united with the great god Osiris to enliven all the faithful dead. The creative power of the sun by day and by night was celebrated in the New Kingdom hymns frequently

LUXOR TEMPLE (following pages). Dedicated to a special form of the god Amun, Luxor Temple—located in the modern-day city of Luxor—dates primarily to the New Kingdom. At the entrance, the principal elements of a temple façade are visible: An avenue of sphinxes leads to a pylon adorned by obelisks and colossal royal statues.

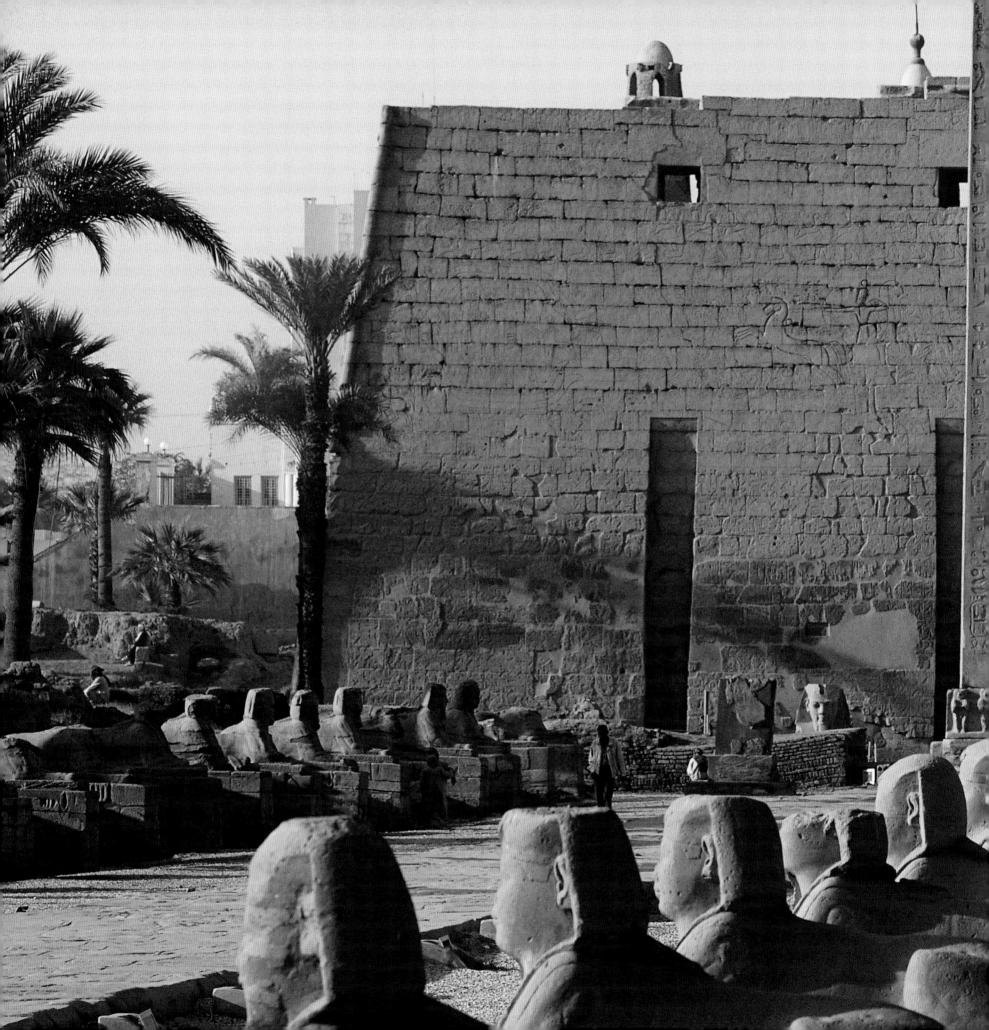

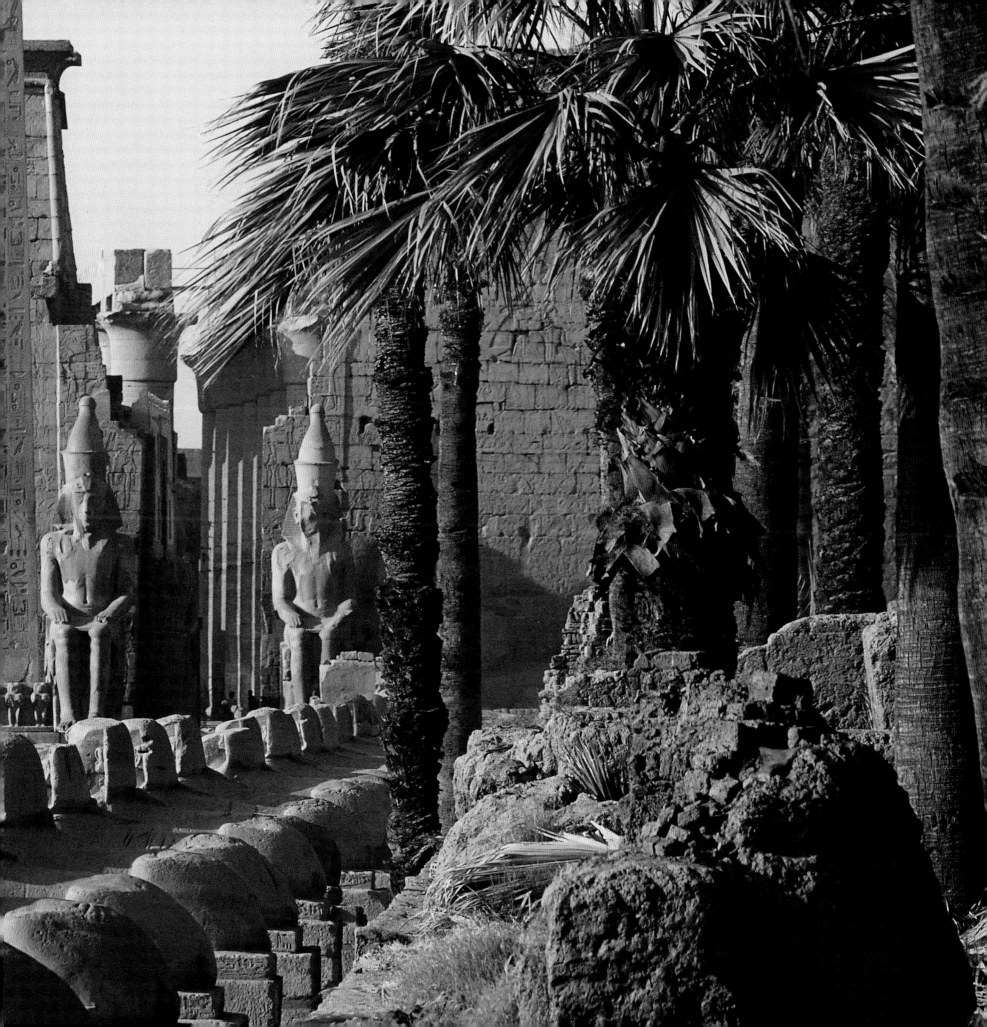

carved on statues and stelae in elite tombs, and the sight of the sun in the sky was reason for exaltation. Tomb entrances were carved with figures coming out to view the sun and also returning inside for the sun's nightly journey through the netherworld.

The Amarna revolution in religion meant a move away from the solar trend of the earlier 18th dynasty. Amenhotep IV and his circle elevated the visible manifestation of the sun, the Aten sun disk, into a single divine force. The sight of this disk and its creative power were reserved for the person of Amenhotep IV/Akhenaten himself, the Aten's son and earthly representative.

equally extreme, and the memory of Akhenaten was obliterated wherever possible.

Yet the individual participation in religion seen in sun hymns and other early prayers to gods became a larger element in New Kingdom religion. Elites and middle-class artisans alike donated monuments to their client gods and addressed them directly. They asked for healing or help with other problems, or sometimes they simply addressed an individual devotion to a god. Personal piety in the New Kingdom existed alongside the large royal temple worship on behalf of all Egypt. One did not replace the other.

Amenhotep IV built temples to celebrate his cult of the Aten, first at Thebes and then at Tell el Amarna. The Aten became the nominal pharaoh of heaven and earth, with its name enclosed in cartouches like a king. Akhenaten was his earthly co-regent son.

The solar religion of Akhenaten rejected traditional mythology about the cosmos. The Aten was a singular force with creative energy that maintained the entire world. The names and images of other deities were removed, suggesting a period of religious extremism. Not surprisingly, the post-Amarna reaction was

The other characteristic of New Kingdom religion was the emphasis on the great national god, Amun-Re of Thebes, whose cult center at Karnak had grown from a small temple in the First

TOMB OF RAMESSES V-VI, Valley of the Kings, Dynasty 20, circa 1156-1149 B.C. New Kingdom royal tombs were decorated with scenes and texts designed to guide and protect the king in his eternal afterlife. The vignettes depicted here evoke scenes from the Book of the Earth, which describes the journey of the sun through the netherworld.

Intermediate Period into a southern home for the Heliopolitan sun deities in the 12th dynasty. The temple exploded in size as Ipet-Sut, the "counting of thrones," referring to the numerous divine manifestations gathered there. Amun-Re's two major aspects, creator/fertility god and sun deity, continued in importance, as priests could show Amun-Re's connections to such gods as Ptah and Osiris on the one hand and Atum and Re on the other.

The temples of all the national gods were staffed with phyles, or groups, of priests. As in the past, priesthoods were hereditary offices, and the sons of elite families counted on monthly income products fed the priests, the administrators, the artisans, and the field workers and represented a major part of the economy.

Participation in temple life depended on social status and religious appointments. Many elites performed monthly cult services, and these men would have been familiar with the interior of the temple front rooms and the rituals performed in them. Priestesses had part-time involvement, particularly as singers in the choruses. The wives and daughters of great men were considered entertainers for the gods. At festivals they held loud, colorful musical processions within and between the temple enclosures.

from their priestly service. The largest temple organization in the New Kingdom was that of Amun-Re of Karnak, which grew from the early 18th dynasty through the 20th and ultimately controlled landed wealth all over the country. The Wilbour Papyrus, which contained land accounts for northern Middle Egypt including the Faiyum Oasis, shows that more than 20 percent of the land in the region was controlled from the Temple of Amun-Re in Thebes, some 200 miles away. The temple organization produced food for divine offerings, but most agricultural

At the top of these temple organizations were a handful of primary priests, often identified as first, second, and third in inscriptions, along with the high priestess, called by the title of god's wife in the case of Amun-Re. Amun also had an adoratress priestess who may have been identical with the god's wife, but other gods such as Re also had adoratresses. These positions frequently were held by women of the royal families, and in the 18th dynasty great women including Ahmose-Nefertari, Hatshepsut, and Nefrure held the title of god's wife of Amun.

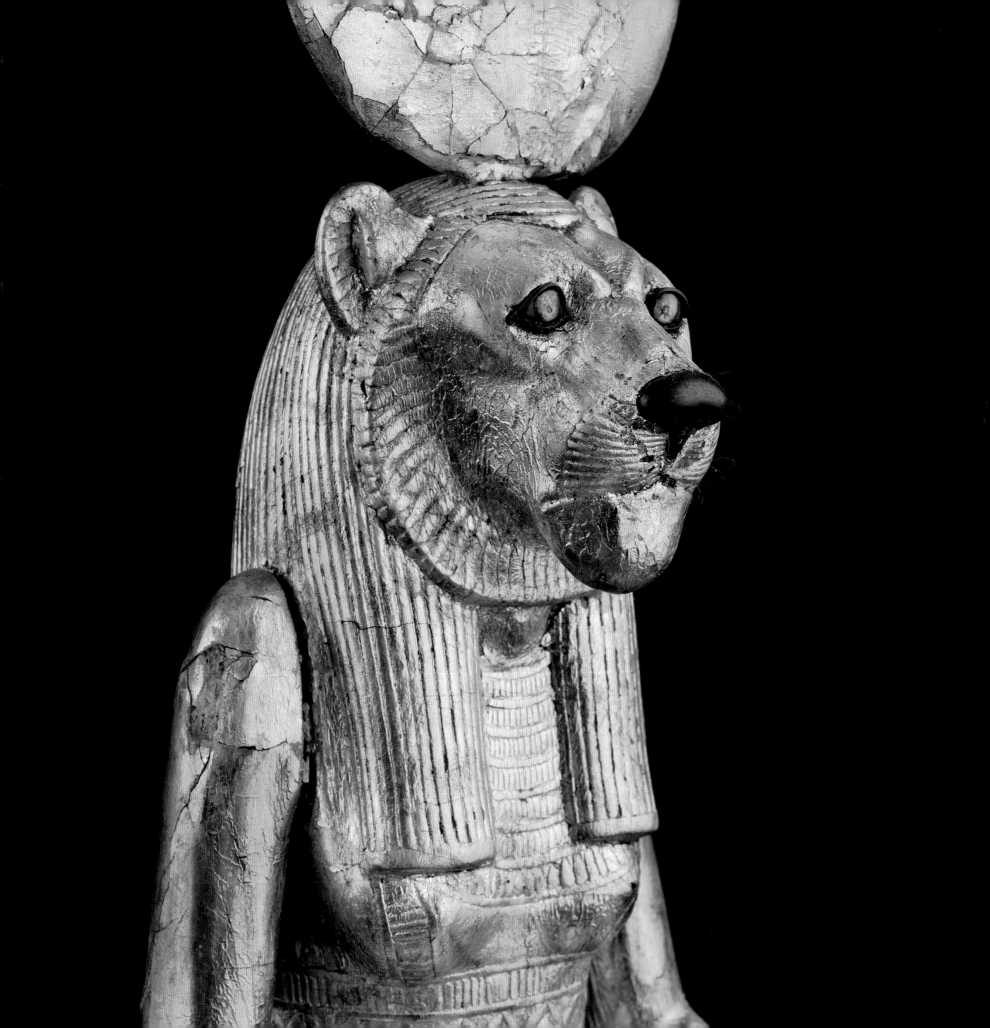

the opportunity, and Carter convinced Carnarvon to apply for the concession. They began working in the valley in 1917, concentrating on the area between the tombs of Ramesses IX and Ramesses VI, using a crew of more than one hundred workmen to clear the sand and stone rubble from the valley floor.

Little of great interest was found between 1917 and early 1922. Lord Carnarvon became discouraged and decided to stop the excavations. Carter traveled to Highclere, Carnarvon's home in England, and pleaded with him to continue for just one more season, even offering to pay for the work himself. Carnarvon relented, and Carter returned to Egypt in the fall of 1922. Legend has it that he brought a canary with him, and when the workmen saw it, they cried out that it would bring them good luck.

Beginning excavations in late October, Carter focused his efforts in an area that had not been cleared before, the space in front of the tomb of Ramesses VI, where a group of Ramesside huts lay. Working quickly, the team dug a long trench through these huts, recording them before they removed them. Carter knew that this was his last chance to find Tutankhamun.

Many stories have been told about the moment of the great discovery, and even Carter never told the same tale twice. But in the version most frequently heard—which is the one most likely to be true—it was Carter's waterboy who found the tomb. Even today, a young man is assigned to bring water to the workmen on an excavation. The water is carried in large pottery jars with rounded or pointed bottoms, which must be set onto stands or partly buried in the sand to keep them upright. The jars are generally brought to the excavation site on the backs of donkeys.

On November 4, 1922, as usual, Carter's waterboy brought his jars to the site in the late morning. The workers were singing as they carried away baskets filled with stone rubble and sand. The boy used his hand to scoop away sand, making a hole into which to set the bases of the jars. But he hit something hard—a slab of limestone. The young boy knew that this was something important, although he did not know exactly what.

The boy ran to Carter's tent and told his *mudir* (the director of the excavations) what he had found. Carter did not answer but followed the boy to the site, noticing how the singing had stopped and the air was filled with anticipation. When Carter

saw the uncovered limestone slab, he recognized that it was the top of a step, perhaps leading to the very tomb he had been seeking for so long. By late afternoon of the next day, they had reached the bottom of the staircase and had found a plastered wall stamped with the ancient seal of the necropolis: nine prisoners surmounted by a jackal. Carter ran back to his tent to send a telegram to Carnarvon: "At last have made wonderful discovery in the Valley; a magnificent tomb with seals intact; recovered same for your arrival; congratulations."

Carter knew at once that the tomb had been opened in antiquity, because his archaeologist's eye noticed an area where the plaster was different. But he knew that something still lay beyond, or the ancient guards would not have bothered to reseal the tomb. He must have impatiently waited for his patron to arrive.

Lord Carnarvon and his daughter, Lady Evelyn Herbert, arrived in the Valley of the Kings in late November, and work began again. The stairs were cleared, and the name of Tutankhamun was found for the first time, on the lower part of the blocking sealing the doorway. The next afternoon, excavations revealed a corridor filled with rubble mixed with potsherds, small jars, and sealings, all suggesting a date in the late 18th dynasty. In the upper lefthand corner of the corridor, the rubble looked different: The tunnel had been burrowed through, then had been refilled by the necropolis police. Although I believe that

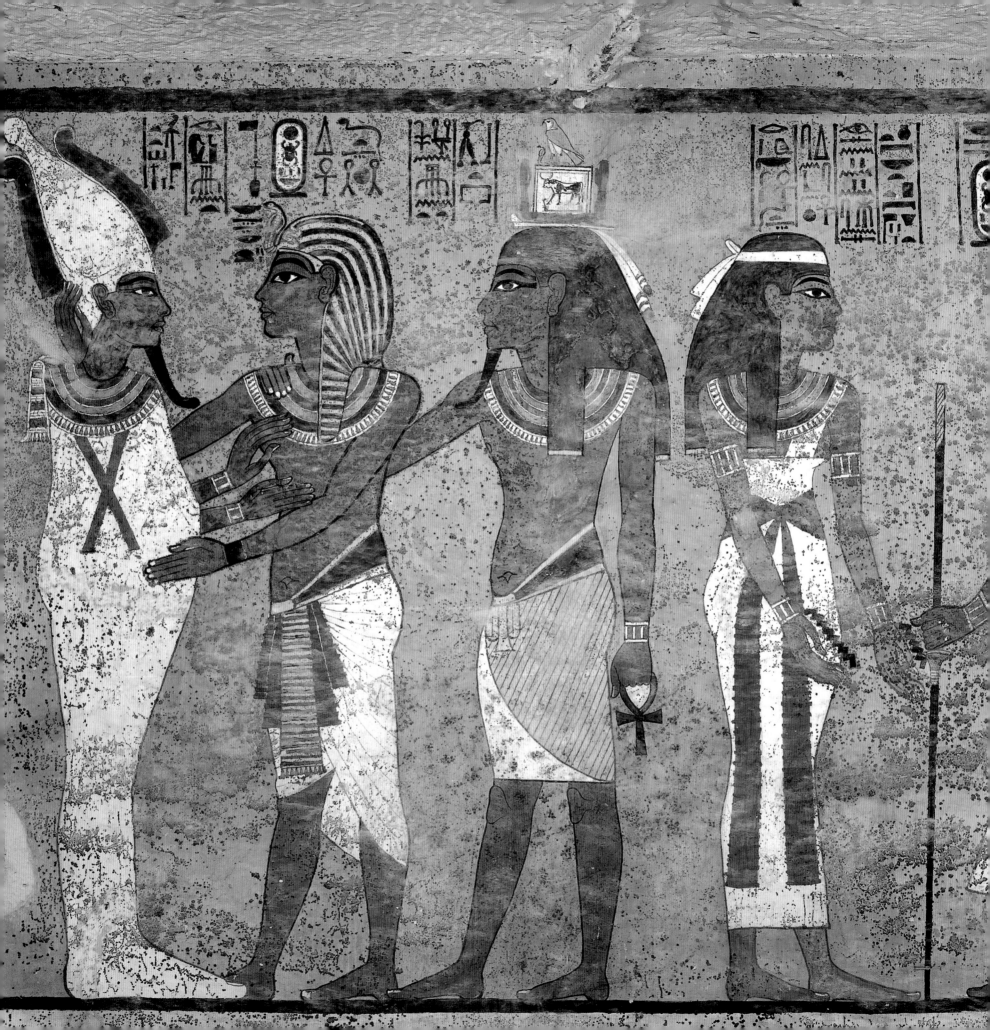

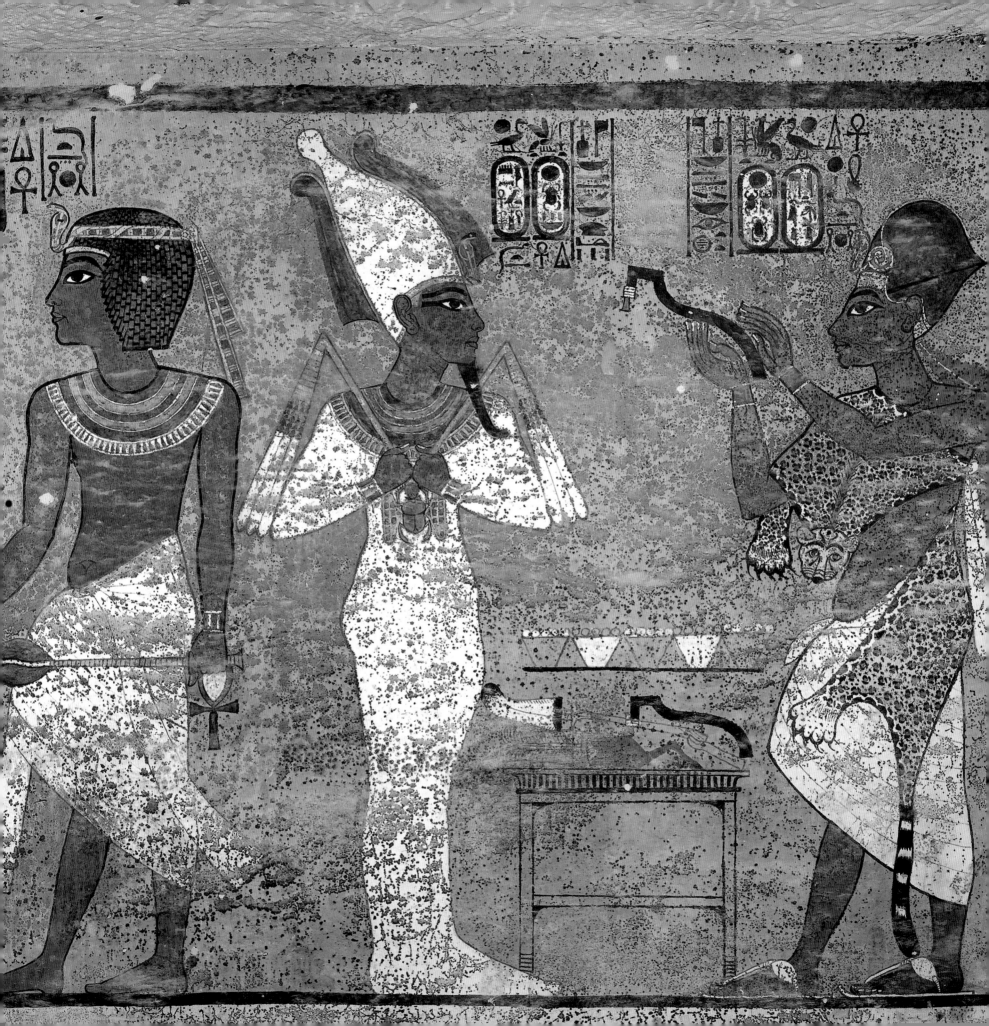

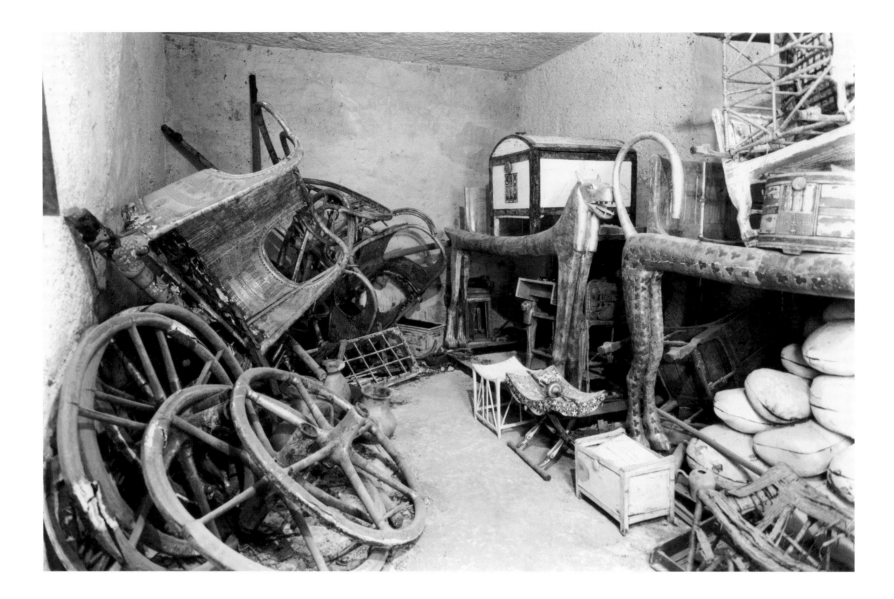

he was certain in his heart that he had found Tutankhamun's tomb, Carter worried that what he had found was a cache of some sort, perhaps with little left inside.

When the team reached the doorway at the end of the rubble-filled corridor, they found that it, too, was blocked by a wall of stones covered with plaster and stamped with the necropolis seals. The great moment had arrived. Carter made a small hole in this wall, and probed it with an iron bar. Beyond was empty space. With Lord Carnarvon standing close beside him, he inserted a candle. When Carnarvon asked what he saw, Carter uttered the famous words: "I see wonderful things!" Later, Carter described that moment of discovery in this way:

"At first I could see nothing, the hot air escaping from the chamber causing the candle flame to flicker, but presently, as my eyes grew accustomed to the light, details of the room within emerged slowly from the mist, strange animals, statues of gold—everywhere the glint of gold."

The tomb was officially opened on November 29, 1922. Architecturally, it consists of a stairway, a descending corridor, and four chambers. The corridor leads to the Antechamber, a

ANTECHAMBER, tomb of Tutankhamun. Dismantled chariots, ritual couches, and pieces of furniture and boxes were piled high and chaotically inside the Antechamber of the tomb before Carter's team cleared it.

rectangular room whose walls were lined with piles of furniture and boxes. At the north end of this room, a sealed doorway, flanked by two life-size statues of the king, blocked the entrance to the Burial Chamber. When this blocking was removed, a huge shrine of gilded wood was revealed, the first of a nest of four such shrines of decreasing size, which protected the sarcophagus and three nested coffins. Most Egyptologists believe that Carter and Carnarvon, with Carnarvon's daughter, Lady Evelyn Herbert, entered this chamber before its official opening.

A doorway in the east wall of the Burial Chamber led to the Treasury, guarded by a larger-than-life-size figure of the jackal god, Anubis, on top of a shrine-shaped box. Inside this chamber were wooden shrines, painted black, containing statues of gods, goddesses, and the king in ritual poses, together with many model boats and boxes, some filled with jewelry. The fourth room, entered through the west wall of the Antechamber, was filled with a jumble of miscellaneous objects.

It took Carter and his team of English and American experts about a decade to clear the tomb, conserving and restoring each object and packing it carefully for transport to the Egyptian Museum, Cairo. They used the nearby tomb of Ramesses IX as a storeroom and that of Sety II as a photo and restoration lab. It was a fascinating job, and Carter did excellent work. His notes and drawings are still of enormous value to scholars today.

THE CURSE

The discovery of Tutankhamun gave rise to many rumors and stories about the "Curse of the Pharaohs." Although these stories are not true, excavators did encounter some serious problems.

The difficulties began with Lord Carnarvon, who had funded the excavations in the hope that he would be awarded "partage," a share in the finds. In general, the rule was that foreign excavators could keep "duplicate" objects, things not considered necessary for the collections of the Egyptian Museum, Cairo. The law also said, however, that intact tomb assemblages should be kept together as the property of the Egyptian government. Thieves may have breached the tomb in ancient times, but it was still considered intact, since the majority of its contents were present and, perhaps more importantly, it was found still sealed, as the ancient police had left it.

Lord Carnarvon tried to argue with the authorities about the nature of the tomb, inventing a story that the tomb was robbed in the reign of Ramesses IX and thus should not be considered intact. He announced that the objects awarded to him would be given to great museums all around the world. Egyptologists such as James Breasted tried to help him, testifying that the tomb had been robbed. The government would not agree, however, so Carnarvon began to look around for other ways to recoup his money. He thought about making a film in Hollywood or a series of books. On January 9, 1923, he signed a contract with the London *Times,* giving them exclusive rights to publish news about the tomb. The agreement gave 75 percent of the income generated to Carnarvon and 25 percent to the *Times.*

The tomb of Tutankhamun was found at a particular time in Egyptian history, when the days of empire and foreign domination were just coming to an end. Carnarvon and Carter were not sensitive to the changing mood of the country. They acted as if they owned the tomb and could do whatever they wanted with it. They treated the Egyptians badly, and they didn't even invite Pierre Lacau, then director of the Antiquities Service, to attend the tomb opening. They ignored the Egyptian press, inviting only Arthur Merton, a British journalist. Carnarvon's contract with the London *Times* made the Egyptians feel as though the tomb were in English territory, and as if they had to hear what was happening in their own country from the foreign press.

The Egyptian press began to attack Carter and Carnarvon, even accusing them of stealing artifacts. On April 5, 1923, Carnarvon died, and Carter, never the greatest of diplomats, was left to deal with the situation on his own. The exclusive deal with the *Times* continued to rankle, and issues also arose about who had control over visitors to the tomb. Morcos Pasha Hanna, Egypt's minister of public works under the newly independent government, was also in charge of antiquities, and he tried to work with Carter. But just after the opening of the sarcophagus, in February 1924, Carter became very angry because the Egyptians refused to allow a group of women, primarily the wives of his team members, to visit the

tomb. The archaeologist closed the tomb in protest, leaving the lid of the sarcophagus hanging precariously above the box. Hanna reacted by taking away the concession and locking the tomb. Carter's dismissal was wildly popular. In fact, Egyptians marched in the streets, crying, "Viva Morcos Pasha Hanna!" Carter was unable to return for a year and was forced to give up any claim to a share in the finds for himself or on behalf of Carnarvon's widow.

When Carnarvon died, in 1923, the newspapers began making up all sorts of stories and attributing anything bad to vengeful spirits from the past. For example, Carter's first assistant, Arthur Mace, died in 1928, and this was attributed to the curse. When an x-ray expert on his way to study the mummy died, his death—and those of others who were planning to or had visited the tomb—was blamed on the curse. The net spread wider, to anyone connected with Egypt or Egyptology: An Egyptian prince who lived in London (and never even visited the tomb of Tutankhamun) murdered his wife; the press blamed the curse. Jean-François Champollion, the man who cracked the hieroglyphic code, had died in 1832, long before the discovery—and his death was blamed on the curse.

In reality, the death toll for those who worked in the tomb was no higher than normal for the time. Carter himself lived until 1939, and Lady Evelyn Herbert, the daughter of Lord Carnarvon and one of the first people inside the tomb, lived until 1980.

But the curse lives on in the mind of the public. A German author wrote a book on it in 1980. He blamed the curse of the pharaohs for the death of Gamal Mehrez, a head of the Antiquities Service, who died the day after an interview in which he claimed not to believe in the curse. In fact, Mehrez was not even an archaeologist, but an Islamicist—and a very sick man.

Anything out of the ordinary that happens to me is also blamed on the curse—but in fact, I believe in the opposite, since I have survived many things that could have killed me. Once, while excavating a tomb in the Bahariya Oasis, I received a bad electric shock. I was nine meters underground, holding an ax in my right hand and a lamp in my left. I uncovered a statue and moved the lamp for a better view. A wire was broken, and the electricity knocked me unconscious for 30 seconds. When I came to, I told my assistant, Mohammed Afifi, that I was glad to

have survived, because if I hadn't, everyone would have blamed the curse! More recently, a big block of stone fell on my head while I was visiting excavations at Taposiris Magna. Other than a headache, I was fine—and, in fact, that stone made me recognize a problem with my eyes.

The curse was born again in 2005 when I CT scanned Tutankhamun's mummy. When I left my hotel to go to the Valley of the Kings, my driver almost hit a child who had run out in front of the car. Then, on the way to the valley, my sister called to tell me that her husband had died. Friends who were with me immediately attributed these two events to the curse of Tutankh-amun. I arrived at the Valley of the Kings and found Japanese television representatives there. They asked me for an interview, and as I was finishing it, a big rainstorm came up suddenly. Rain is so uncommon in Egypt, the Japanese blamed it on the curse.

I entered the tomb and took the glass off the top of the sarcophagus, where it had been left by Carter to protect the wooden coffin inside. When I looked at the mummy, I felt the magic of the golden king, and I thought that this could be one of the best hours of my life.

I put the mummy into the CT scanner, and everything went fine for a while—but then, suddenly, the machine stopped and refused to scan. This time, I was the one who began to believe in the curse! It turned out that the machine had just become overheated, and the problem was solved by a simple plastic fan.

Personally, I believe that all of these things were accidents. There is some danger in opening tombs that have been sealed for thousands of years, from microbes and other dangers that can grow in a closed system. In fact, when I discover a sealed chamber, I make some sort of opening that allows the old air to escape, and I don't let anyone come near it for at least several hours. I never shave before entering such a tomb, either, as shaving creates openings in the skin through which invisible poisons could enter.

I still believe that the magic of King Tutankhamun will never end, and the stories will always continue.

BACK OF GOLDEN THRONE, tomb of Tutankhamun. One of the most splendid objects found in the Antechamber, the golden throne is decorated with this scene showing the king attended to by his queen, Ankhsenamun.

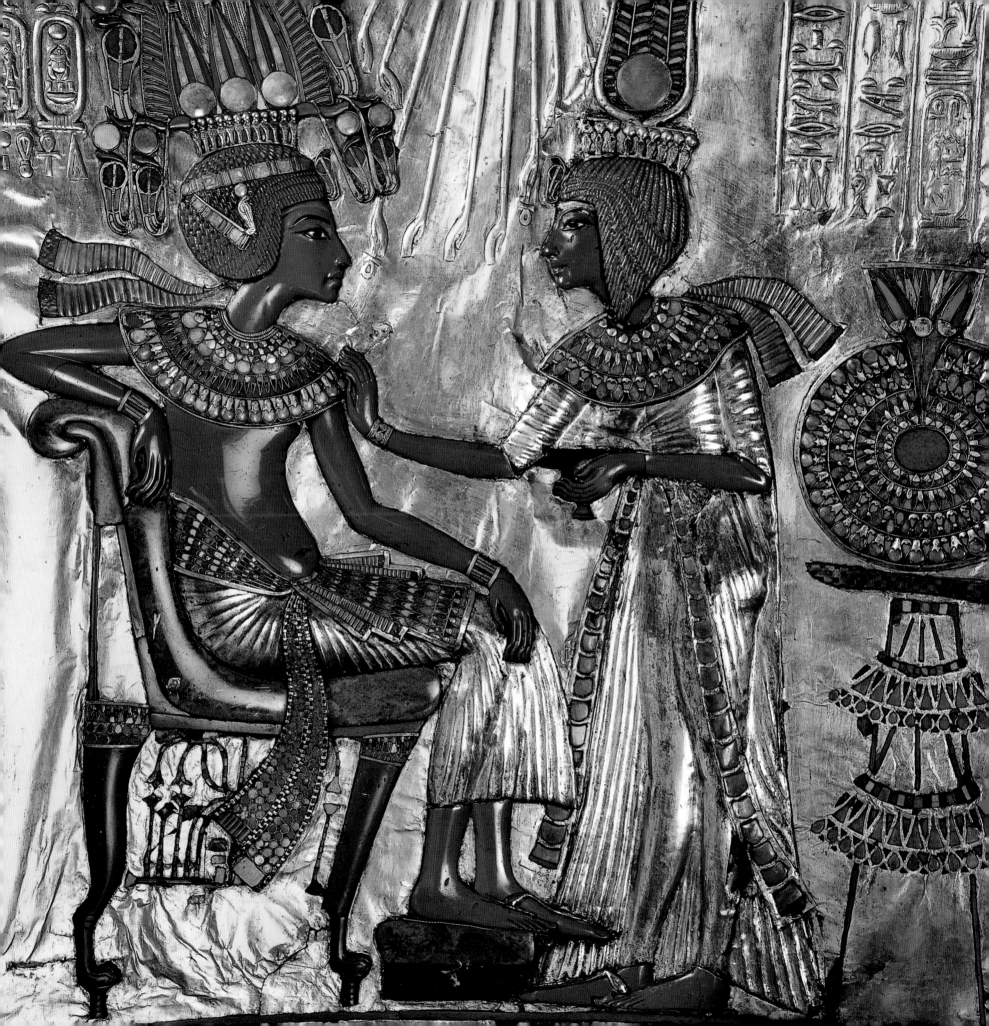

THE FALL *and the* RISE

THE THIRD INTERMEDIATE AND LATE PERIODS

Donald Redford

ONE CAN DETECT, beginning in the 12th century B.C. and continuing into the 11th, a noticeable downsizing in every aspect of Egyptian sociopolitical, cultic, and ethical activity associated with the pharaohs and the monarchy. The causes of this decline, if one can use such a judgmental term, are undoubtedly multifaceted. Fertility was inevitably linked with the divine kingship, and so any drop in agricultural productivity—the inevitable poor harvest, a reduction in food stocks, rationing, and even sporadic famines—were all laid at the doorstep of the pharaoh.

The growing impoverishment of the community and an increasingly weakened central government rendered the kings of the late New Kingdom incapable of maintaining the empire in both the north and the south. Canaan was lost sometime after the reign of Ramesses VI, and Nubia and Kush were lost during the time of Ramesses XI. The all-pervasive image of the warrior pharaoh, triumphant in sport and in battle, began to disappear from monuments and literature.

With the loss of empire came the drying up of revenue from the provinces, and the resultant weakening of the exchequer. In contrast to the period of empire, little or no construction was undertaken after the reign of Ramesses III, and his successors were often constrained simply to add reliefs to blank spaces on the walls of existing structures.

Tanis in the north and Thebes in the south, the latter governed by the high priests of Amun, enjoyed a close, symbiotic relationship, although oriented on different paths and toward different goals. Essentially Tanis was to be a clone of Thebes in its honoring of the Theban triad, Amun, Mut (or Anat), and Khonsu. Priestly titles were borrowed from the city of the south. The high priests of Amun, descendants of one Piankhy, appointed under Ramesses XI, were formally subservient up to the 21st dynasty, and sometimes they intermarried with the royal line. But for all intents and purposes, the vital interests of the two cities diverged and began to follow different courses.

Smendes, founder of the 21st dynasty, and his descendants adopted the guise of merchant princes, mightily concerned with trade with the Levantine coast and Cyprus but militarily powerless to interfere in the politics of western Asia. With

SHABTIS of Djedkhonsu-iuf-ankh, from Sheikh Soby, Dynasty 26, 569-526 B.C. Made at a time when the provinces were gaining in importance, these faience funerary figurines come from the tomb of a governor of the Bahariya Oasis.

a jurisdiction essentially confined to northern Egypt, Smendes lacked the resources to build or even renovate. The Sinai turquoise mines had shut down, and expeditions to the quarries and gold mines were very rare, with the result that the reward system was drastically reduced, dependent as it was on plentiful supplies of medals, collars, and gems. The one surviving link with Thebes, the royal right of burial in the Valley of the Kings, was terminated: Now kings began the practice of burial in modest, gerry-built tombs within the temenos, or designated plot of land, of the town god, often in sarcophagi and coffins purloined from earlier kings. Thebes, for its part, was no longer a center of royal administration. After the death of the last of the Ramessides, the population of Thebes shrank drastically, as people moved away and villas were abandoned. Although the high priests could show the old, grandiose titularies, they could construct no new shrines nor even repair old ones. With no one to prevent them, the common people set up hovels within the great temple courts.

Sources for the period, both textual and graphic, show a marked change in genre and style. There are no more triumph stelae, war reliefs, transcripts of royal speeches, encomia, or the like, partly because this kind of celebratory commemoration was a peculiarly Theban tradition and partly because the new Tanite culture lacked the inclination and wherewithal to talk of itself. Paltry remains give the historian little to go on: annals, or records of induction; private biographical texts; and stelae recording land donations, commemorating the interment of Apis bulls, and marking the level of the Nile.

A CHANGING KINGSHIP

Personalities and demographic shifts also affected the kingship. Through feuding and ineptitude, the successors of Ramesses III discredited themselves in the eyes of the populace, a denigration which would be echoed by Diodorus a thousand years later. New expedients were obviously necessary, as civil war threatened to engulf the state, but the king was incapable of effective action. At the same time, peoples who had earlier been kept at bay by the powerful pharaonic state now found it easy to infiltrate the delta and Upper Egypt, where they settled peacefully. The Mashwesh and Labu tribes from the Libyan deserts, speaking their own languages and largely maintaining their own cultures, settled in Lower Egypt. Because of their warlike prowess, they contributed to the military establishment. The Libyans practised a mobile lifestyle, camping outside Egyptian towns then moving on, much to the chagrin of the native inhabitants. Maintaining their own language and preserving their native costume, Libyan enclaves were easily discernible and were at first disinclined to interact with the Egyptians. From the south a revitalized Kush, deeming itself of pure and orthodox belief, was invited into Egypt, especially by the Thebaid. Both ethnic groups eventually achieved the kingship and were honored by the appropriate titularies, but the phenomenon of a pharaoh of foreign stock, speaking a foreign language, dealt a serious blow to the prestige of the monarchy. The ninth and eighth centuries B.C. witnessed explosions of rebellion against the foreign kings in Thebes and the delta and, although they did not succeed, kingship was irreparably weakened.

The Greeks were another ethnic group that entered the greater Egyptian sphere. Beginning in the seventh century B.C., Greeks from Ionia and the Greek islands began to enter Egyptian service as mercenaries. At the same time, the wealth of the country attracted Greek merchants to settle in the trading post of Naukratis in the Nile Delta. In the main, Egyptian kings benefited from the presence of Greeks, and some even owed their lives and thrones to them. To a large extent their presence among the Egyptians offered few problems at this period, but they were to prove harbingers of major changes in the Egyptian state and body social destined to occur in the third century B.C.

From the first post–New Kingdom regime on, Egypt degenerated into a political backwater and a morass of socioethnic feuding. In spite of an attempt to revive the Egyptian empire in Asia and a shortlived flurry of building activity, the Libyan rulers achieved nothing internationally, while at home, their country continued to wallow in economic weakness. Phoenician ships energetically plied the sea lanes all over the Mediterranean, carrying Egypt's items in trade. While the memory of Egypt's imperial greatness never died, the rising empire of Assyria ran rampant over the Near East, and the pharaoh was powerless to stop it.

Native resentment against the Libyans exploded in the middle of the ninth century B.C. In an attempt to liberate the country, Thebes rebelled, plunging the country into more than a decade of civil war. Eventually the rebellion was quelled, and the Tanite regime restored order, but at great cost.

Within a few generations of that rebellion, the Egyptian monarchy had sunk to the status of little more than a "first among equals." The king was constrained to share power with a number of "Great Chiefs of the Ma(shwesh)," who appear to have been parochial feudatories in the great cities of the delta, parceling out land to their warriors and to the temples. Some local rulers, such as those of Leontopolis, Herakleopolis, and Hermopolis,

managed to proclaim themselves kings with royal accoutrements and titulary. Royal representations, epithets, and texts betray that the kingship was still very much mired in the rut of the tradition of Ramesses the Great. Perceived ineptitude, however, had denigrated the monarchy, which now operated in several tiers, not only following the numenological hermeneutic of traditional theology but also dictated by the crass reality of politics. Texts of the time speak of various aspects of kingship: apart from

PAINTED INSCRIPTION, tomb of Mentuemhat, Dynasties 25-26. One of the largest and most beautiful Late Period tombs in the Assasif, near the temple of Hatshepsut, this was built for Mentuemhat, a powerful governor of Thebes.

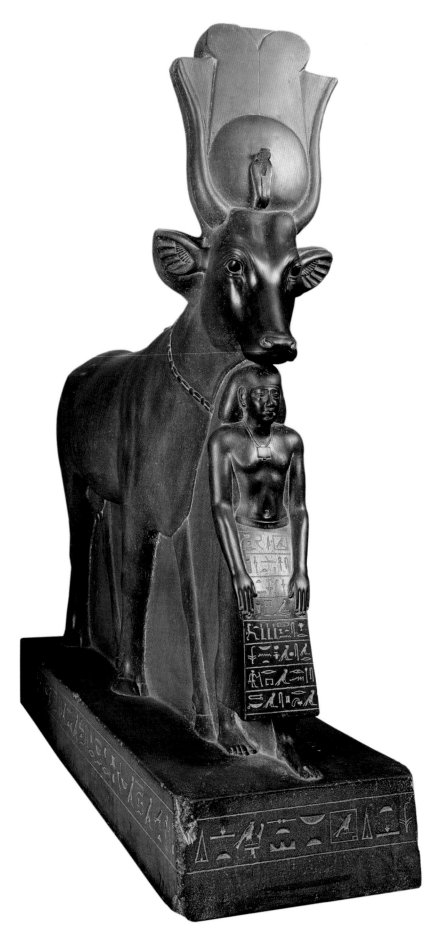

the person of a "true" king—a king proclaimed and crowned by Amun—there was also the "sacerdotal" king created by the gods and the "political" king created by the military junta. In the folklore and literature of the Late Period, the theme of the king as hero and savior (the *Königsnovelle* tradition) recedes into the background, replaced by stories in which the "wise man" and "magician" dominate the plot, while the king is depicted as a weak or even villainous character—if he appears at all. Typical of the new status of the king in literature is a plot something like this: A crisis threatens the state, often occasioned by events over which the king has no control. Though warned in dreams, Pharaoh is utterly powerless to save the situation. At the last minute a wise man, hitherto unknown in the story, steps forward and saves the situation. He is the true hero, and the king pales in significance alongside him.

Along with the image of the weak or powerless monarch, the concept of the tyrant king also developed in the first millennium. Herodotus preserves the folk memory of Khufu and Khafre of the 4th dynasty as ruthless despots who closed the temples and transferred revenues to build their own gigantic tombs. Many of the local dynasts between the eighth and fourth centuries B.C., although celebrated in relief and sculpture as true Horus kings with all the appropriate epithets, were little more than brutal warlords who had only their own personal interests at heart.

THE KING AND THE CULT

During the first millennium B.C. the king remained, as he had always been, the head of the religious cult. Temple reliefs and statuary depicted him in the time-honored role of celebrant and festival leader, offering and libating to the gods and participating in Sed festivals. In fact, the figure of the monarch was increasingly intertwined in a web of courtly and religious ritual, which may have curtailed his power to act and may have placed him

PSAMTEK AND HATHOR, Saqqara, Dynasty 26. Beautifully carved of schist, this statue represents a high-ranking scribe named Psamtek, who enjoys the protection of the goddess Hathor in her bovine form.

at the mercy of a priestly class. But the king had other ways to impose his will. From the ninth century on, the daughters of the king became increasingly important figures in the cult context. It became customary to devote selected princesses to the service of Amun, and by the eighth century the title of "divine adoratress of Amun" had been installed as a means of tying the Amun priesthood to the current royal regime. This exalted princess was installed as head of the "House of Amun" with virtually queenly status, indicated by cartouches and royal epithets. Completely devoted to the god, the divine adoratress remained celibate throughout her life, and future occupants of the office were installed through adoption.

Amun remained the great national god of Egypt, "the one who had made Egypt great, and not by the hand of man," but increasingly the great Theban establishment of Amun ceded primacy of place to gods from the north of Egypt—Re, Ptah, Neith, and Arsaphes, who shared the wealth and prestige of the contemporary regime through the political prominence of their cities. Theologically the king was still considered chosen by the god himself, the "beautiful child of Amun," but now the god revealed himself in ways not exclusively related to the king.

During the first half of the first millennium B.C., the oracle gained prominence as a way to communicate the divine will and legal judgments. A petitioner would present a problem to the god in his barque, who would respond by "nodding" his affirmation. When the petitioner was the king or a high-ranking dignitary, the case often involved appointments to office or confirmation of kingly dignity. Oracles could also be received through the process of "incubation": A devotee, sometimes even a king, would sleep near the divine avatar and experience a night vision or dream in response to some concern. Popular folklore perpetuated belief in the oracle, describing how a god (usually a ram god) had once issued an oracle prophesying disaster for the country, which came to pass in the form of foreign invasion.

Lacking a system that would protect the country and guarantee its prosperity, Egyptian society closed in on itself and devoted its attention to increasingly parochial matters. In the wisdom texts of the Late Period, hometowns and municipal gods loom large in the thinking of the people, suggesting xenophobia and apprehensions about the outside world. Together with a maudlin concern for sin and punishment and an inclination toward self-conscious personal piety, king and commoner alike seem newly concerned about warding off disease, as shown in the small sanitoria often built close to major temples, where the sick would go for healing. These structures often centered upon a statue or magical stela over which water would be poured, evoking the magic of the spells inscribed on them. This "holy water" would then be used for drinking or ceremonial cleansing.

Kingship in Egypt had always been associated with animals. Earthly manifestations of divinity had been represented in the temples by animals, from whom at death the divine essence would pass to another member of the species. At the close of the New Kingdom, the practice began of treating entire species, not simply a single specimen, as divine and worthy of reverent burial upon death. Vast animal cemeteries full of embalmed ibises, cats, dogs, crocodiles, and other animals came to dot the landscapes near the cities and temples where a particular species was worshipped. Kings sanctioned the practices, but it was often noblemen of private means who actually supported the animal necropolises.

Relationships developed between monarchy and animal cults, as can be seen in the Apis cult at Memphis and the cult of the ram at Mendes. The worship of the bull Apis, an earthly incarnation of one aspect of the god Ptah, had roots in the earliest period of Egypt's history. In the Late Period Apis worship became virtually a national cult around which forces of patriotism circled. Only certain kings were accepted by the priests of Ptah and officiated at the obsequies of the bull, when he was embalmed and interred with pomp in the western necropolis at Memphis. Those kings gained a place on the official king-list, no matter how weak or ephemeral their reigns had been. Similarly, the ram at Mendes was considered to be the cosmic progenitor of the king who had impregnated the queen and sired the king by impersonating his

father. This version of the mythological descent descended from the ancient myth of divine birth, in which Re or Amun came to earth in the form of the reigning king to produce an heir, and it was to surface again in the mythology surrounding Alexander's pedigree. Both the Apis cult and the Mendes ram cult received royal attention in the form of lavish donations and construction.

ART, ARCHITECTURE, AND CUSTOM

In some ways the measure of a pharaoh lay in the artistic and architectural productions of his reign. Art, sculpture, and architecture depended on organizational skills, access to wealth, and maintenance of ateliers of artists and architects.

For most of its course, the New Kingdom maintained a consistent and unremitting high standard of production, and one might have thought that with its demise, art and architecture would have declined rapidly. But curiously, the first half of the first millennium B.C., in spite of the weakness of the monarchy, does not reflect a decline in taste or artistic ability. While funds were lacking for major architectural construction, art and sculpture continued to maintain high standards. The ateliers of outline draftsmen, sculptors, and painters continued to receive adequate financing and to produce work comparable to the best of the New Kingdom, even though artists had to work on walls of block recycled from old buildings. The quality was consistent, and the style and contents of the reliefs harked back to masterpieces of the Ramesside past.

But all this was about to change. From the late tenth century B.C., a major power was developing in the northern Sudan. At the site of Napata (modern Gebel Barkal), where a cult center of Amun had existed from the early New Kingdom, a family of Kushite chiefs entrenched themselves and created a Nubian polity. They spoke their own language but their culture had many trappings of "Egyptianness." Through their fanatical devotion to Amun, the Nubian kings shared interests with those in power in Thebes, who welcomed the expansion of Kushite influence into the Egyptian southland. The new Kushite kingdom found temples and reliefs left behind in the south from the Middle and New Kingdoms, which became important models for the artistic creations of the new regime.

While the geopolitical thrust of the Kushites was northward into Egypt, the Assyrian empire in Asia was also rapidly moving southwestward, intent on filling the political vacuum in the Nile Delta. A shortlived attempt in the western delta by the chief of Sais, Tefnakhte, to reunite all of Egypt under native rule was put down by the Kushite king Piya, whose successor Shabaqa occupied all of Egypt in around 712 B.C. During the 40 years that they held Egypt, the 25th-dynasty kings held Assyria at bay, even carrying arms briefly into Asia. In 671 B.C., however, the Assyrian forces overwhelmed the frontier garrisons and invaded the delta, wreaking havoc for eight years. The Assyrians appointed an Egyptian, Psamtik of Sais, as a sort of governor-general. Psamtik slowly and cleverly extended his own control over the whole country. Thus began the 26th dynasty, which lasted 140 years.

Both the Kushites and Psamtik and his successors shared a view of culture that has been dubbed "archaistic," and the past certainly mesmerized kings and artisans of both the 25th and 26th dynasties. Psamtik I set about to reorganize Egypt on traditional lines that harked back to ancient models. The local baronies of Great Chiefs of the Ma(shwesh) were abolished, the Libyans were deprived of power and in some cases expelled, and ancient nomes and nomarchs were reconstituted. In some cases, kings authorized inscriptions using archaic dialects.

At the same time, Psamtik I was a modern monarch. Sensitive to the need for an efficient, functioning chancery, he supported a development in handwriting, approving of the cursive Demotic script, an innovation that maintained its influence for more than a thousand years. Realizing the wealth to be gained through commerce, Psamtik I opened the country to trade with Phoenicia and Greece, and at the end of his reign he allowed a Greek emporium, Naukratis, to be established in the western delta. Catapulted into the international arena of conflicts involving Babylon, Sardis, and the Medes, Psamtik I sensed the need for an up-to-date military, and to that end he invited Greek hoplites, armed infantrymen, to Egypt. These well-paid mercenaries made the armed forces swell.

The art, architecture, cult, script, literature, and everyday life

habits of the Kushite-Saite period all show a characteristic archaizing tendency, which informed the country's artistic expression for centuries to come. The roots of the movement began earlier, but a veritable tidal wave in the resuscitation of antiquity occurred during the seventh and sixth centuries B.C. Sculptural styles and forms from the Old, Middle, and New Kingdoms were revived, and in many cases specific statues, reliefs, and motifs were consciously copied. We are less well informed about architecture, but it would appear that Saite architects were sensitive to ancient models of shrines and temple courts. Certainly the monumentality of antiquity shows through in such works as the gigantic naoi, or shrines, in the temple at Mendes, or the single roof slab at the temple of Edjo in Buto. Ancient texts were ransacked and arcane titles were brought back into use, although their meaning often escapes us. The Pyramid Texts were reproduced and studied, and a new, edited Book of the Dead was issued. Libraries were investigated for documents of antiquity, which were then recopied (in one famous case on stone) for the interest of Saite antiquarians. Old Egyptian was studied afresh, the Old Kingdom chancery format was revived, and attempts were made to adapt the cumbersome dating system of that ancient time for modern use.

The reasons for turning to the past as a paradigm and a model are never stated by the Egyptians, but it is worth noting that other communities around the Mediterranean, such as Phoenicia, Judah, Assyria, Babylon, and Greece, were undergoing a renewed interest in their own antiquity at about the same time.

Saite attempts to interfere in the politics of western Asia showed mixed results. Initially successful in extending control over the Phoenician coast, Egypt suffered a signal defeat when its army was virtually annihilated by the Babylonians in 605 B.C. at the Battle of Carchemish on the Euphrates River. Thereafter it was with difficulty that Necho II and Amasis repulsed Babylonian invasions on the very frontier of the delta. In the aftermath, Egypt could only stand impotently on the sidelines as the massive Medio-Persian empire moved westward from the Iranian plateau into the lands of the Middle East.

The Persian empire defeated Babylon in 539 B.C. and annexed its territories. Greece resisted conquest, but Egypt experienced defeat on her eastern border in 525. At a stroke, the battle was lost, and the last king of the 26th dynasty perished, his country becoming a mere province within the new world empire from the east. At first the Persians, especially under Darius I, treated Egypt with deference. Apart from installing Persian governors and officers and establishing Aramaic as the language for government, they left the natives to themselves and even employed some Egyptian nobles in the administration. This early period of Persian occupation witnessed the production of excellent works of art, often difficult to distinguish from earlier Saite works. By 455 B.C., however, the country began to suffer neglect at the hands of the imperial authorities, and revolts began to break out. The most serious, that of Inaros of Sais, was bloodily suppressed in spite of military aid from Athens, but by 411, insurrections had become virtually irrepressible. In 404, Amyrtaeos of Sais declared independence, representing the start of Dynasty 28, and five years later Nepherites of Mendes followed suit, executing Amyrtaeos and founding his own dynasty, the 29th.

For 65 years Egypt preserved its independence under the guidance of Mendesian warlords and, later, their cousins of neighboring Sebennytos. The country remained so wealthy that the kings of Dynasty 29, and especially those of Dynasty 30, indulged in a major campaign of rebuilding temples. Many survived into Ptolemaic times, when their decoration was completed. It became customary to inscribe a list on the central naos, or sanctuary housing the deity's statue, documenting both graphically and textually all the paraphernalia of the cult in that temple. Art and sculpture began to revive along lines established by the Saite archaizing tradition. The Mendesian regime hired tens of thousands of Greek mercenaries to bolster Egyptian armed forces, and they succeeded in blocking Persian attempts to retake the country. As in the Saite period, Egyptians became accustomed to a Greek presence, and an unmistakable Greek cast to the art soon began appearing, visible especially in the reliefs of Padi-osiris, high priest of Thoth at Hermopolis, who lived around the time of Alexander the Great.

The art and architecture of these last dynasties of the Late Period, while rooted in the archaism of Saite times, launched off in their own direction, leading into the later Ptolemaic period. The processional temple design still dominated, although it was absent in some delta sites, such as Saft el

Hina and Buto. Characteristic architectural forms developed: the intercolumnar screen, varying floral capitals, birth houses, and roof shrines. Sculptors adeptly worked in the hardest stones, such as granite, basalt, diorite, and schist. Their style favored bold, high relief, with figures and details that virtually burst from the surface of the stone.

Human likenesses frequently showed slanting, almond eyes, full cheeks, and a wide grin. Head-smiting scenes and place-name lists continued to appear on prominent external

yet it still nursed the hope of retaking recalcitrant Egypt and bringing the rebels to heel.

Three attempts to do so resulted in abject failure in 350 B.C., and it appeared Egypt was secure. But in 343, Artaxerxes III amassed a force of overwhelming size and descended upon Pelusium, gateway to the eastern delta. The last king of the 30th dynasty, Nektanebo II, panicked and fled to Nubia, leaving his troops, along with numerous Greek mercenaries, to fend for themselves. The Persians swept in, destroying city after city and

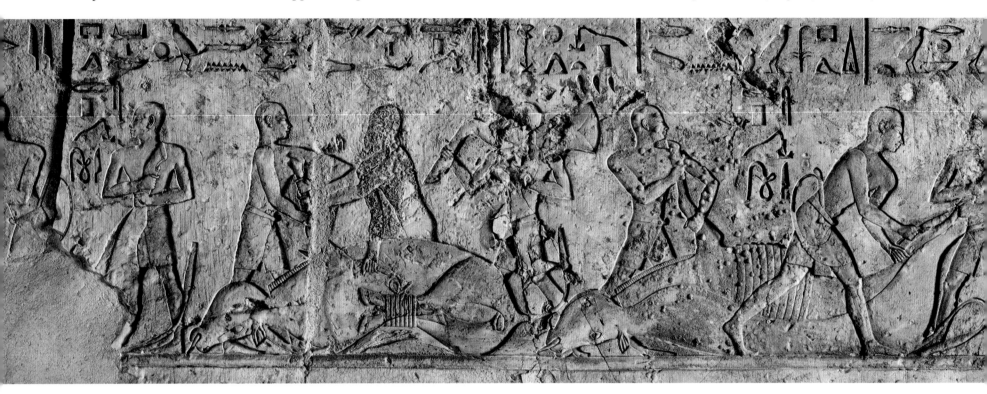

surfaces, and vignettes outlining the various actions of daily service began appearing elsewhere. As one would expect, the king is prominently displayed in all the temple decoration, in reliefs and in statue groups evocative of certain ancient forms. The homogeneity of reliefs and inscriptions drawn from the cultic repertoire bespeaks a centralized state and cultic authority, but soon the design of individual temples in the Ptolemaic period, freed of a strong pharaonic influence, would develop their own parochial styles.

Through the fourth century B.C., the Persian empire suffered decline, many of its territories fragmenting through revolt,

imposing a harsh regime on those they conquered. The utter destruction one sees at Bubastis and Mendes is a bitter reminder of what must have been lost in terms of art and architecture.

As a final impiety, Bagoas, Artaxerxes' eunuch, confiscated the sacred literature and cult paraphernalia from all the temples of Egypt and carried it off to Asia. Temple service was stricken. When the books and implements were finally returned, early in the third century B.C., the priesthood took no chances: Entire cultic books were copied on temple walls—a fitting way to shore up intellectual defenses in case of a repetition of the disaster and to memorialize the history for all time.

THE COMING OF ALEXANDER

In 334 B.C. Alexander, King of Macedon, led his army across the Hellespont and attacked the Persian empire. Two years later he approached Pelusium and the Nile Delta. The Persian governor surrendered, and Egypt passed bloodlessly under Greek domination. With Alexander's untimely death in 323 B.C., Egypt fell to the lot of Ptolemy Lagus who, as governor and then king, founded a Greek dynasty that was to rule the country for more than 290 years. A new city, Alexandria, was founded. Conceived by Alexander himself as

Native Egyptians suffered as second-class citizens in their own country. Greek replaced Egyptian as the language of government. Their land was confiscated, and large grants were given to Alexandrian officials. A few Egyptian officials found positions, but it was not common practice. Some of the early Ptolemies were sensitive to Egyptian needs: Ptolemy II apparently made a practice of visiting Egyptian temples and supported their refurbishment. Ptolemy I inaugurated a new deity: Serapis, derived from the bull god Apis of Memphis, housed in a magnificent temple in

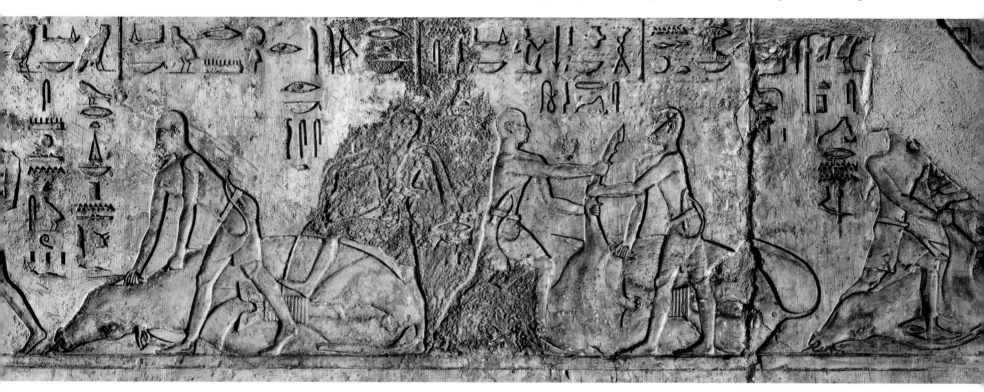

a thoroughly Hellenic settlement, the capital of the new regime sat on the Mediterranean coast at a northwest angle to the delta.

In the third century B.C., an able Ptolemaic administration capitalized on Egypt's wealth and strategic position. Ptolemies I and II adopted the government and tax system of the pharaohs. Greeks established themselves as landowners and townsfolk, living cheek by jowl with the indigenous Egyptians. From 332 to 221 B.C., Greek literature was copied and read, and cutting-edge research was carried on in the Museion and Library in Alexandria. By the end of the reign of Ptolemy III, in 221 B.C., Egypt sat atop an empire stretching from the Cyrenaica to Iran.

Alexandria. The Ptolemies attempted to control the native population through the high priest of Ptah, who functioned as a kind of ethnarch, or regional leader, and appeared for rites and festivities. As the Ptolemies deferred to priests and Egyptian temples, which became bastions for the preservation of ancient Egyptian religious lore, the notion of Egyptian wisdom had its birth.

SLAUGHTERING CATTLE, tomb of Mentuemhat, Dynasties 25-26. Delicately carved in stone, these vignettes illlustrate the steps involved in butchering cattle for the offering meal. As an indication of this era's interest in artistic precursors, they are almost identical to Old Kingdom tomb prototypes.

PHARAOHS *of the* OLD
and MIDDLE KINGDOMS

ROYAL HEAD WITH WHITE CROWN, *see page 88*

THIS GALLERY IS DEDICATED TO KINGS from the Old and Middle Kingdoms, introducing the visitor to some of the basic concepts of kingship in ancient Egypt. From the beginning of Egyptian history, the king was the most important person in the land, heading up a vast hierarchy. In the mythical realm, the first king was Re, the sun god, who ruled earth until he became an old man and people began to make fun of him and disobey him. In anger, he climbed to the sky, sending his daughter Hathor to take revenge on mankind and leaving his son Geb on earth as his heir. Geb was succeeded by his eldest son, Osiris, who ruled with his sister-wife, Isis, by his side. Osiris's jealous brother Seth murdered him, however, and usurped the throne, cutting his body to pieces and scattering them throughout the land. Isis and her sister Nephthys collected the parts of Osiris's body and put them together again, reviving him long enough for Isis to become pregnant with a child, Horus. When Horus reached his majority, he challenged his uncle, and eventually succeeded in defeating the older god and taking his father's throne. The king was thus considered Horus on earth, responsible for establishing *ma'at* (truth, justice, and order), and standing for good against evil.

The kingship and the attitude of the people toward their monarch changed according to the political, economic, and religious situation of each period. In the early Old Kingdom, the king had absolute power: He ruled as an incarnation of Horus on earth. At the end of the 3rd dynasty and the beginning of the 4th, this concept expanded. The first king of the 4th dynasty, Sneferu, seems to have identified himself directly with the sun god, Re, as well, and he was followed in this by his son, Khufu. Khufu's son and successor, Djedefre, was the first to take a "son of Re" name, indicating yet another change in the conception of kingship.

Over the course of the Old Kingdom, the identification of the king as both Horus and the son of Re remained prominent in the symbolic realm. The centralized kingship seems to have lost some of its earthly authority, however, as governors in the provinces became more powerful.

The monarchs of the Old Kingdom were remembered and often revered in later periods. One of the most important was Khufu, whom it is now believed ruled for at least 25 or 30 years. He is portrayed, for example, as a pious and devout ruler in a story known as "Khufu and the Magician," known from a copy dating to the Second Intermediate Period, almost a millennium after his reign. During the archaizing 26th dynasty, kings borrowed from the distant past to legitimize their reigns, and the Old Kingdom rulers such as Khufu, Khafre, and Menkaure were worshipped as gods. At Giza, we have discovered many tombs behind the Sphinx belonging to the priests who maintained their revived cults.

ROYAL NAMES

From early in Egyptian history, kings had more than one name. The first royal names are found inside a rectangular box with a niched lower border called a *serekh,* which represented the royal palace. On top was perched a falcon, symbol of the sky god Horus. Also in the Early Dynastic period, kings were given so-called *nebty* names, associated with the Two Ladies: Wadjet, the cobra goddess associated with Lower Egypt, and Nekhbet, the vulture deity of Upper Egypt. The nebty name indicated that the king controlled the Two Lands under the protection of these two goddesses. The third name that appears in the early periods of Egyptian history was the *nsw-bity* name, written with the sedge plant of the south and the wasp of the north, which referred to the king as the ruler of Upper and Lower Egypt.

Huny, last king of the 3rd dynasty, was the first to write one of his names inside a cartouche: a rope in the shape of a circle, tied at one end and symbolizing the circuit of the sun. Putting the king's name inside this ring, which was expanded into an oval so that hieroglyphs would fit inside,

symbolized his dominion over the entire universe. Huny's cartouches are preceded by the epithet *nsw-bity;* this appears to have been the name he adopted when he took the throne. Later kings have a second name in a cartouche, preceded by the epithet *sa Re* (son of Re). As mentioned before, Djedefre, son and successor of Khufu, was the first to adopt this epithet.

CROWNS

Important symbols of divine kingship in ancient Egypt, crowns of various types were worn by both royalty and gods. All pharaonic crowns were associated with power and the right to rule, but each had its own symbolism and was used for a specific purpose. No actual examples of most of these crowns have ever been found, so Egyptologists can only guess of what materials they were made.

The tall "white" crown of Upper Egypt and the low "red" crown of Lower Egypt are first seen, worn by the king, in the Early Dynastic Period. These crowns continue to appear in the Old Kingdom, with the addition of a uraeus, the protective, fire-spitting cobra set on the king's brow. The god Tata is also seen in the white crown; the red crown is worn by the goddesses Neith, Amunet, and Wadjet. The red and white crowns, while they continued to be worn separately, were also combined into a single crown, the double crown, seen first in examples from Dynasty 1. When the king wore this, he took the role of ruler of a united Egypt. The god seen most often in this headgear is Atum, creator god of Iunu (Heliopolis).

The atef crown—the white crown flanked by ostrich plumes—appears first during the 5th dynasty. Worn by the king on certain occasions, it is also characteristic of Osiris, ruler of the netherworld as well as of Nekhbet, tutelary goddess of the south. A more elaborate variation of this crown is set onto curved ram's horns.

Probably the headdress most frequently worn by the king was the nemes, a striped cloth with the uraeus, or later the uraeus and cobra, affixed to the brow. This appears first during the reign of Djoser, first king of the 3rd dynasty. Paired with the nemes, but seen exclusively in funerary contexts, was the *afnet,* or bag wig. This is also seen in the time of Djoser, although an earlier example may date from the 1st dynasty, to the reign of Den. In addition to the king, the goddesses Isis, Nephthys, Selket, and Neith are shown in this headdress. Together, the nemes and afnet are thought to represent respectively the day and night halves of the solar cycle of life, death, and resurrection.

Another important crown, not seen before the Second Intermediate Period, was the *khepresh,* or blue crown, a round, low crown also known as the war helmet, since kings usually wear this when shown in battle. This may have been made of metal or of leather studded with metal discs.

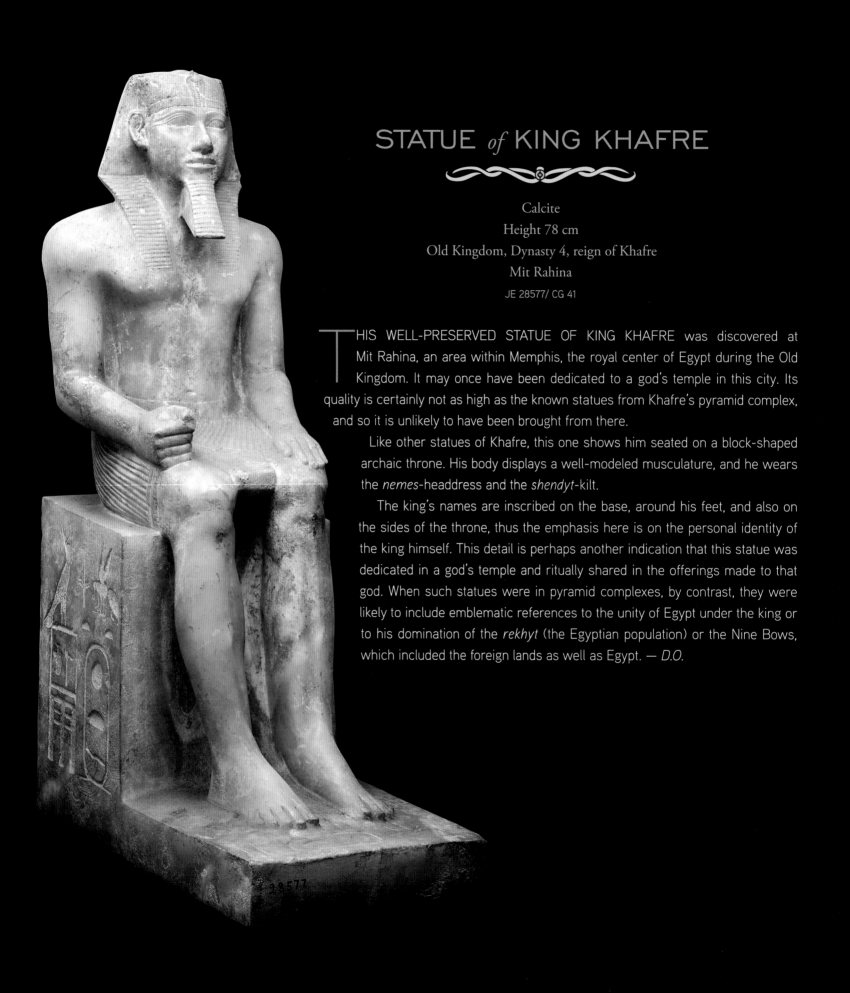

STATUE *of* KING KHAFRE

Calcite
Height 78 cm
Old Kingdom, Dynasty 4, reign of Khafre
Mit Rahina
JE 28577/ CG 41

THIS WELL-PRESERVED STATUE OF KING KHAFRE was discovered at Mit Rahina, an area within Memphis, the royal center of Egypt during the Old Kingdom. It may once have been dedicated to a god's temple in this city. Its quality is certainly not as high as the known statues from Khafre's pyramid complex, and so it is unlikely to have been brought from there.

Like other statues of Khafre, this one shows him seated on a block-shaped archaic throne. His body displays a well-modeled musculature, and he wears the *nemes*-headdress and the *shendyt*-kilt.

The king's names are inscribed on the base, around his feet, and also on the sides of the throne, thus the emphasis here is on the personal identity of the king himself. This detail is perhaps another indication that this statue was dedicated in a god's temple and ritually shared in the offerings made to that god. When such statues were in pyramid complexes, by contrast, they were likely to include emblematic references to the unity of Egypt under the king or to his domination of the *rekhyt* (the Egyptian population) or the Nine Bows, which included the foreign lands as well as Egypt. — *D.O.*

SEATED STATUE *of* MENKAURE

Calcite

Height 160 cm

Old Kingdom, Dynasty 4, reign of Menkaure

Valley Temple of Menkaure, Giza

JE 40704

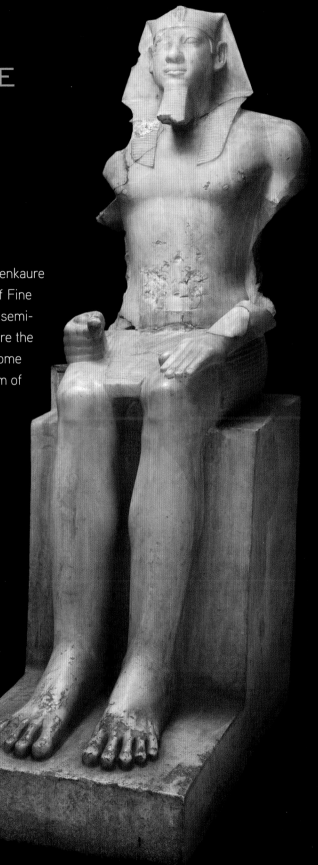

THIS STATUE WAS FOUND by George Reisner in the valley temple of Menkaure during excavations sponsored by Harvard University and the Museum of Fine Arts, Boston. Menkaure's pyramid complex at Giza can be said to have been semi-intact when excavated, with many beautiful objects still in situ. Among them were the famous triads of Menkaure and the goddess Hathor, accompanied by different nome deities, which can be seen today in the Egyptian Museum, Cairo, and the Museum of Fine Arts, Boston. Although they are made of a different material, the triads show the king with the same distinctive facial features as seen in this statue. In particular, the kind expression created by the hint of a smile and the slightly bulging eyes are characteristic of Menkaure's portrait sculpture. This benevolent countenance agrees well with later accounts of his reign, in which he was remembered as a just and compassionate ruler.

Despite the damage the statue has suffered, it retains the air of serene regality common to images of the pharaohs of the Old Kingdom. The king's idealized body is beautifully modeled to show strength and power. He wears the classic royal costume of a pleated kilt and the nemes-headdress with a uraeus serpent at the brow. He is shown seated on a backless throne, his hands resting on his thighs. The success of the artist in depicting Menkaure as the embodiment of the Egyptian ideal of kingship is remarkable. — *Z.H.*

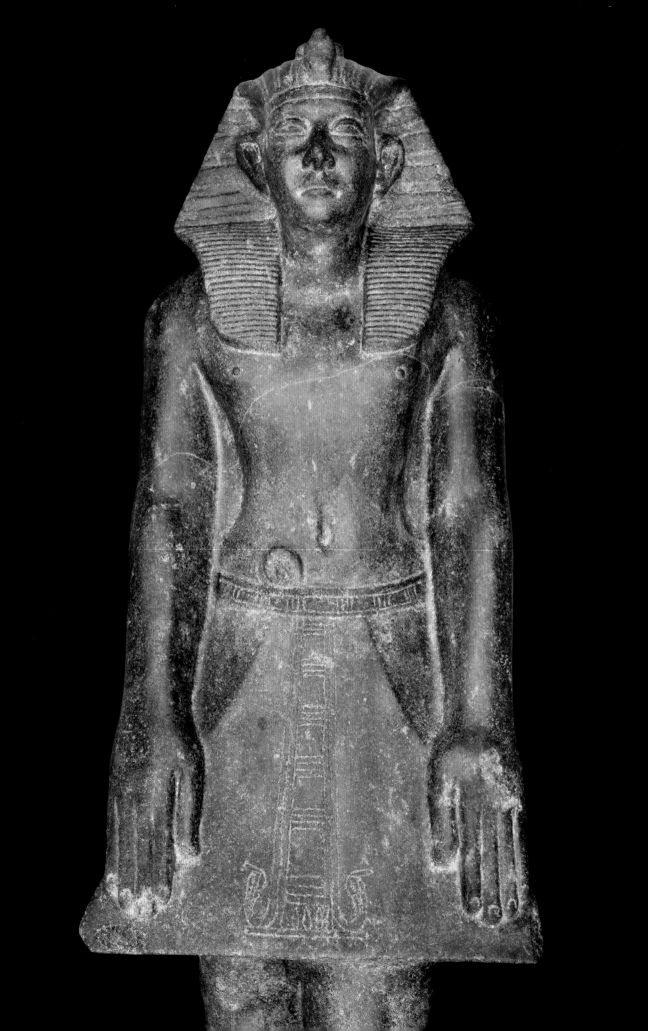

STATUE *of* AMENEMHAT III

Gray granite
Height 87 cm
Middle Kingdom, Dynasty 12, reign of Amenemhat III
Karnak Temple cachette
JE 37391/CG 42020

T HE REIGNS OF SENWOSRET III and his son Amenemhat III represent a long, stable period. The economy flourished, the borders of Egypt remained protected, trade increased, and the central administration was reorganized. It was also a time during which the style of sculpture changed. Instead of portraying the more neutral, almost divine presence of the pharaoh, intermediary between gods and humankind, statuary of the kings took on a more recognizably human appearance. No longer did the faces show a generalized state of youth, as in the statuary of earlier pharaohs, but instead they had heavily lidded eyes, furrows over the nose, and downturned mouths. Some images of Senwosret III make him look visibly tired, as if the burden of his responsibilities weigh heavily upon his shoulders.

Interestingly, the bodies of the king retained a youthful physique, radiating the strength and power of a divine king. Such a dichotomy may reflect some of the changes in religion and concepts of kingship occurring at the time. Evidence of the modifications to the belief system appears in the variations in both royal and private burial customs, the use of funerary texts, and an increasing reliance on magic. Literary texts of the period clearly portray their monarchs as something less than the omniscient, nearly divine kings of the past.

The sculpture of Amenemhat III, however, demonstrates less evolution. During his reign, the figures can be categorized into an earlier period, during which the images seem closer in appearance to those of Senwosret III, and a later one, during which statuary seems more static and portrays the ruler with only a few of the new features.

In this example, the pharaoh exhibits many of the humanizing details introduced in the preceding reign. His face, with some exaggeration around the eyes and mouth, displays a careworn demeanor. The weight of the *nemes*-headdress, with protruding uraeus, burdens this royal individual, who is no longer in the prime of youth. His gaze seems to fix on those over whom he has responsibility, yet his body exudes qualities of the eternally youthful and powerful pharaoh. Amenemhat III places his hands on his skirt, open and palms down, a gesture introduced under the reign of his father. — *D.S.*

ROYAL HEAD *with* WHITE CROWN

Gray granite
Height 35 cm
Middle Kingdom, Dynasty 12-13
Kom el Hisn
JE 42995

THE HEAD OF THIS ROYAL FIGURE was found associated with a tomb of an official, Khesu the Elder, of the 12th dynasty, who located his burial at Kom el Hisn. It is likely, given the probable earlier date of Khesu's structure, that the royal fragment became linked with the tomb well after that individual had died. Kom el Hisn, in the western Nile Delta, has cemeteries with less elaborate burials dating from the First Intermediate Period on, and close by are a few other elite funerary monuments. The area was sacred to the goddess Hathor, whose epithet, "Mistress of Imau," links her to the site, where sacred buildings with her name occur. Much later, Ramesses II focused on this part of the delta as well, building cult structures and erecting stelae.

The kings of the Middle Kingdom had taken an interest in this particular part of Egypt for its strategic location in the north and its agricultural significance. They also were aware of its attractiveness to Asiatics who were migrating into Egypt, especially into the eastern part of the delta, and therefore the rulers wanted to maintain control over the whole area. Amenemhat III also paid attention to this site, and blocks with his name inscribed on them come from a structure dedicated to Hathor. He also set up statuary nearby.

This figure wears the royal white crown of Upper Egypt, and although the surface condition has deteriorated somewhat over the centuries, the details of the face have survived well enough to suggest that it may derive from the end of the 12th dynasty or the beginning of the 13th. The crown comes down low on the forehead of the king, leaving little space between it and the sculpted, not applied, eyebrows. The heavy lids, a feature introduced in the reign of Senwosret III, bear down on fairly widespread eyes, but the creases usually found near the brow are subtly indicated. The lips appear to have originally had sharpened edges, with the lower one slightly protruding. The mouth has a slight downturn, and the philtrum—the indentation in the upper lip—is distinctly indicated. On the whole, the face exhibits flat planes and displays several features that reflect the mature style of the Middle Kingdom that lasted into the 13th dynasty. — *D.S.*

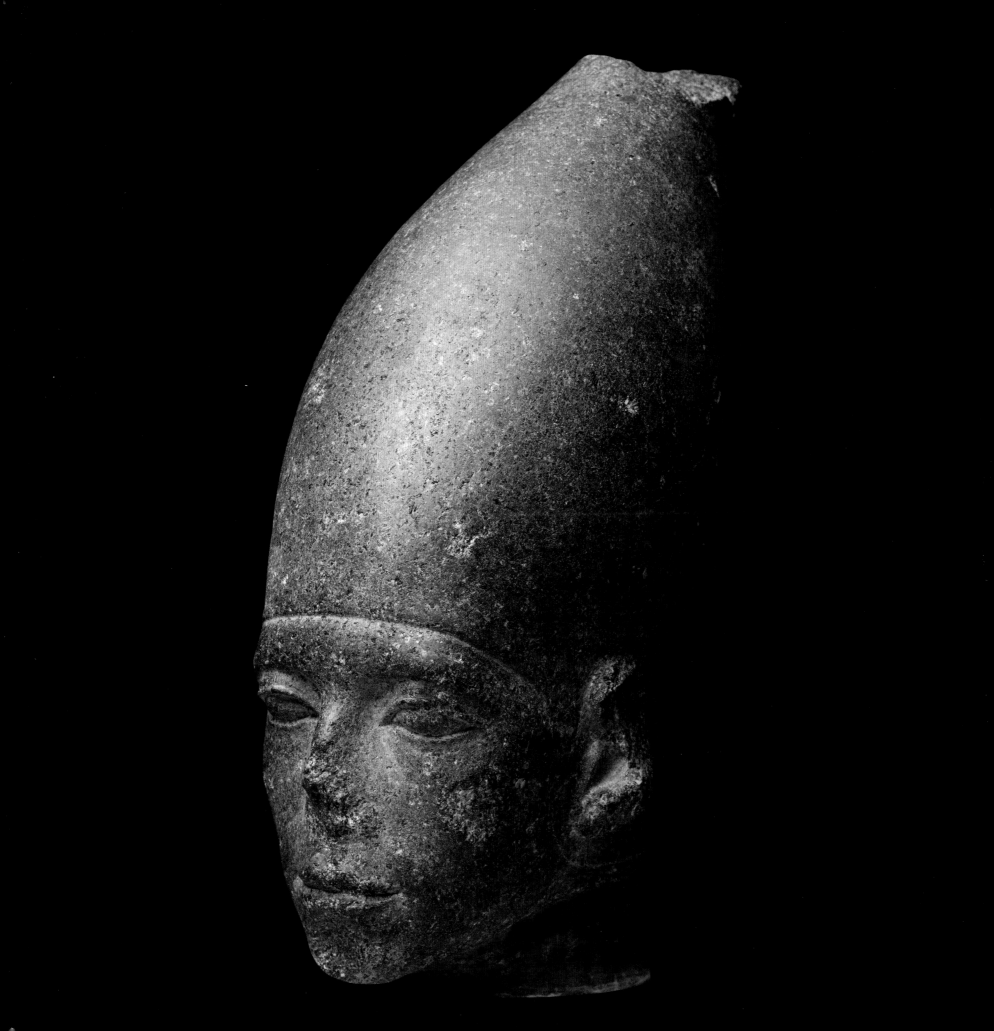

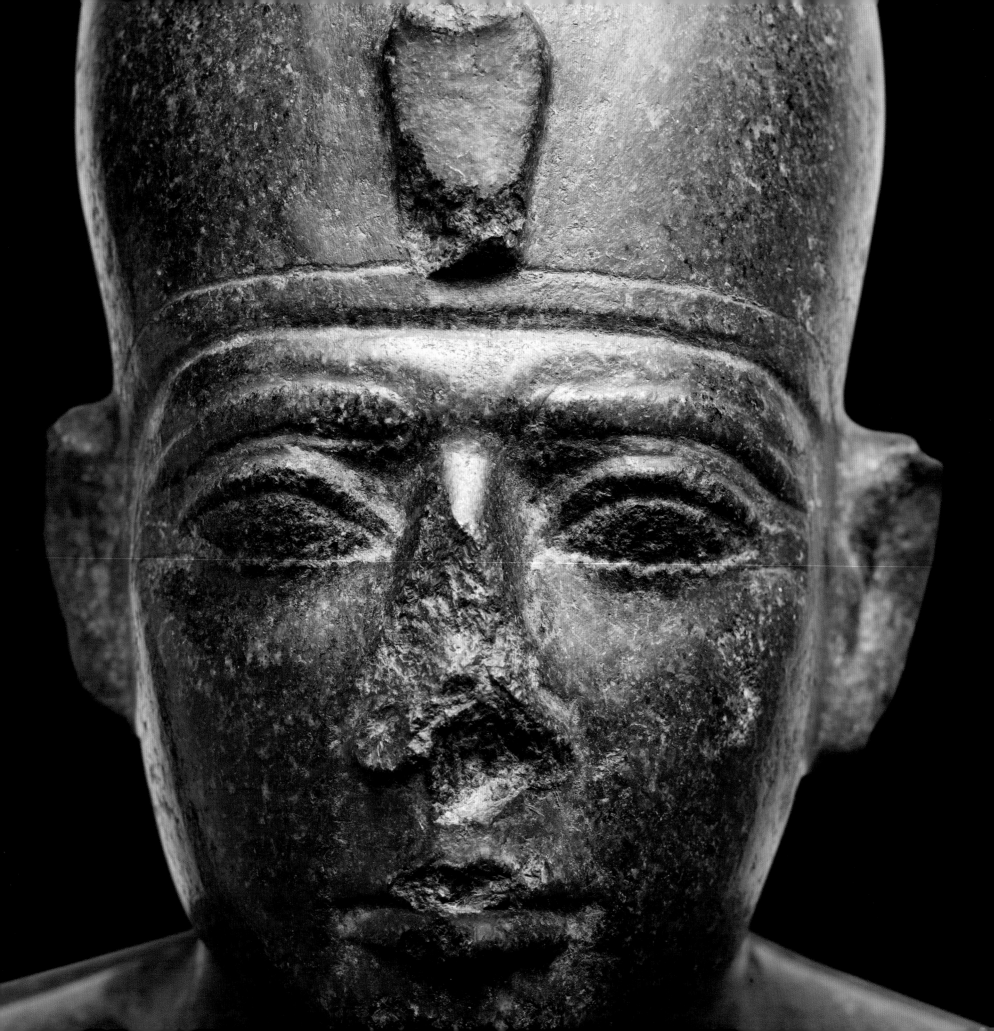

STATUE *of* SOBEKHOTEP

Granodiorite
Height 126 cm
Middle Kingdom, end of Dynasty 13
Karnak, Temple of Amun, Cachette
JE 37421/CG 42027

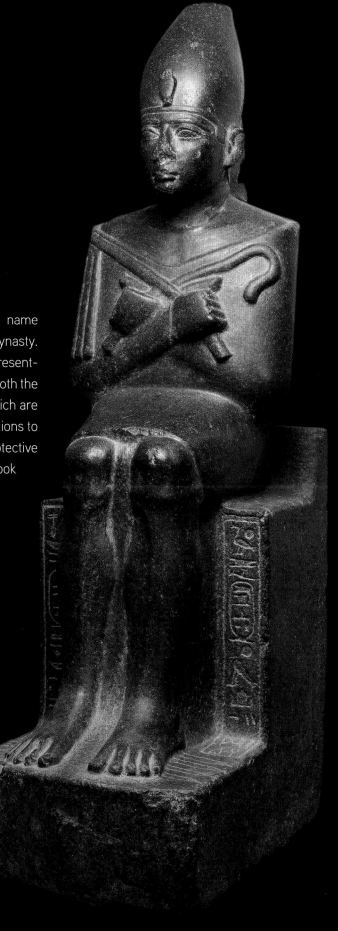

THIS SEATED STATUE portrays the pharaoh Sobekhotep, whose throne name was Meryrehotep—a named possessed by at least six kings of the 13th dynasty. Merkare Sobekhotep VI ruled from 1690 to 1688 B.C., and the Sobekhotep represented in this statue may have ruled slightly later. Next to the figure's legs, ovals encircle both the royal birth and throne names, with epithets introducing these cartouches, among which are "the Good God," "the Lord of the Two Lands," and "the Son of Re." Below are dedications to both Amun-Re and Re-Horakhty. On Sobekhotep's head is a white crown, with a protective cobra attached to the front. He wears the short jubilee costume and carries the crook and flail, all part of the *Sed* festival. These royal insignias were also often grasped by the god of the afterlife, Osiris, and became an important part of royal funerary burial equipment from the Middle Kingdom on.

Dynasty 13 saw continued peace and prosperity, maintaining the power of the central administration for many generations of pharaohs. Artists produced some exceptional works of art, sometimes displaying the sophisticated elements of the mature style of the Middle Kingdom. The situation changed toward the end of the dynasty, as the last kings gradually lost power and the central government weakened. This statue may well reflect the impending disunity of the Second Intermediate Period. A few details around the eyes, nose, and mouth recall the fine features found on royal and nonroyal figures earlier in the dynasty, but they are not well executed or distinguished. The legs are bulky and unrefined, with the bone structure of the knees and the shins displaying sharp edges. This treatment of the lower extremities contrasts sharply with that of the upper body, where the enveloping garment softens all the edges of the limbs. Pharaonic power is surely at a minimum in this sculpture. — *D.S.*

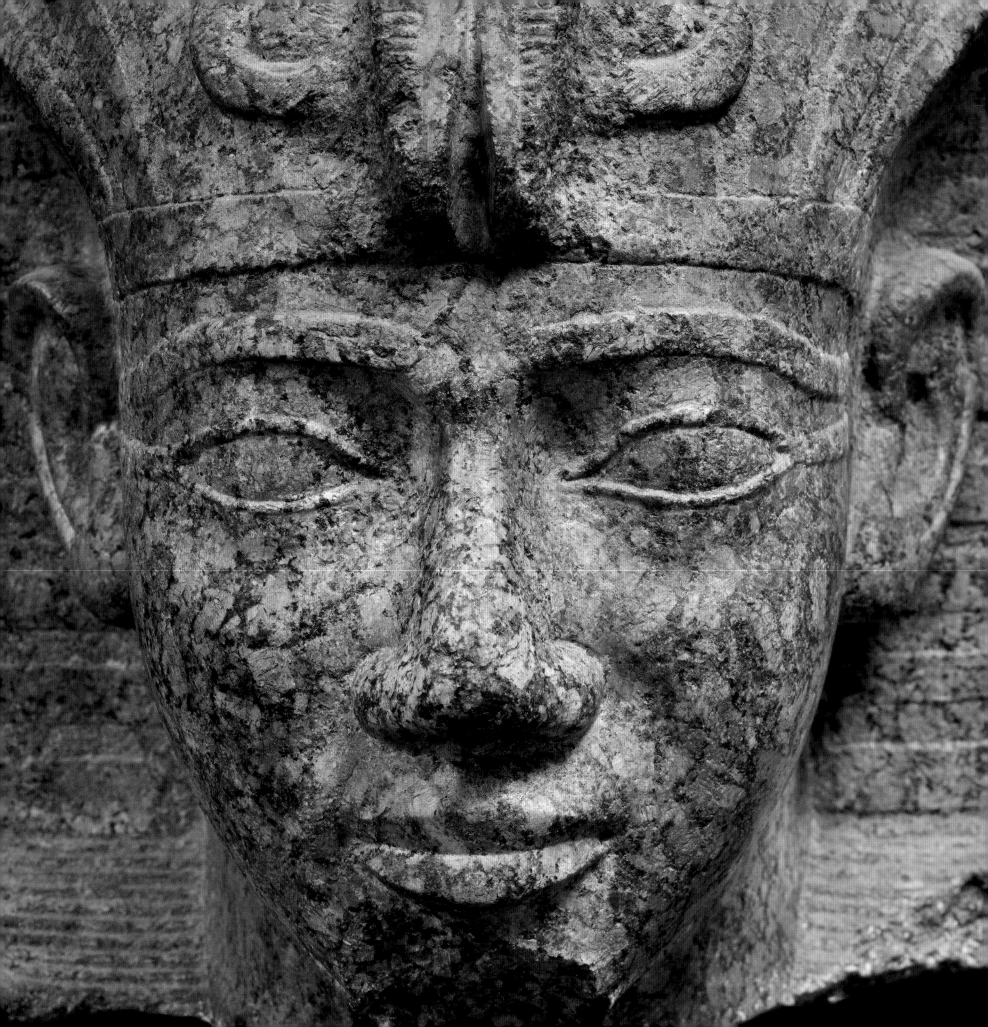

PHARAOHS *of the* NEW KINGDOM *and* LATER

COLOSSAL HEAD OF SHABAQA, *see page 106*

T HE WORD "PHARAOH" APPEARED for the first time during the New Kingdom. It was derived from the term *per aa,* which meant great house, or palace. As in earlier periods, the Egyptians of the New Kingdom believed in the divinity of the king, who was seen as the mediator between humans and the gods. After his death, he became a god, equal to the other deities, and was worshipped in his Temple of Millions of Years, his mortuary temple on the west bank of the Nile at Thebes. Conceptions of kingship did change during this period, however, in part due to the politics of the empire. The invasion of the Hyksos, who were foreign rulers, had left a scar on the Egyptian psyche. The pharaohs of the 18th dynasty reacted by building an empire with new ways to protect their own borders. The king as Horus on earth was no longer the most important divine identification to the military fighters of the New Kingdom. The focus was instead on the king as the son of Amun-Re. Several monarchs, in particular Hatshepsut and Amenhotep IV, even had themselves depicted as the products of unions between Amun-Re and the chief queen, Hatshepsut in her mortuary temple, and Amenhotep III in Luxor Temple.

NEW CONCEPTS OF KINGSHIP

As a woman ruling as a man, Hatshepsut was unusual among pharaohs, since the role of the king was by definition male. The female principle was essential as well, however; queens took the roles of Isis and Hathor, mother and wife of the pharaoh. The king's chief queen was usually of royal blood, and thus she could help legitimize his claim to the throne.

During the 19th dynasty there were additional changes in the concept of kingship. Ramesses II, for example, called himself "the soul of the great god, Re-Horakhty."

The kings had their own private lives as well, of course. Although they were considered divine, they were in reality human. For example, Egyptians in a later period wrote down stories about Pepy II and the sexual relationship he had with the commander of his army. I believe that the Egyptians of the Old Kingdom did not mention this because it did not fit into the proper conception of their universe.

THE HOMES OF KINGS

The kings and their families lived in great palaces. The essential parts of a palace were the private quarters and the throne room, the latter for public reception and ritual display. The administration of the country was also centered around the palace.

One of the largest Egyptian palace complexes known was built for Amenhotep III at Malkata, on the west bank of the Nile at Thebes. This vast compound was constructed of mud brick and decorated with naturalistic scenes painted on plaster. The complex included both state and residential palaces, as well as temples for the royal Sed festival.

In front of the complex at Malkata was dug an enormous artificial lake, now known as the Birket Habu. The king and his queen are said to have gone boating on this lake, perhaps for pleasure but also as part of the royal pageantry that the ancient Egyptians believed to be essential to the proper functioning of the cosmos. A second Theban pharaonic residence may have been built either next to the Temple of Amun at Karnak or perhaps somewhere between the temples at Luxor and Karnak.

Akhenaten built a number of palaces in his new city of Akhetaten (today's El Amarna). At the north end of the city was the North Riverside Palace, evidently the royal family's principal home. In addition to the living quarters, there were storehouses and quarters for the royal bodyguard. Nearby were houses for important nobles as well. The North Palace lay farther south along the Royal Road. Here there were private apartments, gardens, and reception halls. The painted

decoration found in association with this palace consists of naturalistic scenes painted on plaster. More palaces, namely the Great Palace and the King's House, were in the Central City, and these appear to have been more ceremonial than residential. Smaller complexes with palaces and temples associated with Akhenaten's queens were built on the outskirts of the city.

Under Ramesses II, the principal royal residence moved to Qantir, in the Nile Delta, where the remains of his palace complex are now being explored by Edgar Pusch. Traces of the palace that have been discovered include pillared halls, stables, and workshops. A chariot garrison was built above the earlier palace level; the stables that formed part of this garrison covered more than 15,000 square meters and could have housed more than 460 horses.

The Theban palace of Ramesses III was built at Medinet Habu, inside the High Gates that lay before his mortuary temple. The king himself used the East High Gate for his residence, while his queens and princesses lived in the West High Gate. The royal family occupied the second and third floors of these fortresses; nearby were administrative buildings, stables, and training grounds and quarters for the royal staff.

TRACES OF THE PTOLEMAIC PERIOD

The palaces of the Ptolemies lay in Alexandria, the capital city founded by Alexander the Great northwest of Cairo on the Mediterranean coast. Most of our knowledge of this city comes from descriptions written by travelers and historians during the classical era, although modern-day archaeologists are beginning to recover more actual traces, especially in the area that now lies under the sea.

Two French expeditions, with the cooperation of the Supreme Council of Antiquities, have been excavating underwater off the Mediterranean coast at Alexandria, looking for the lost royal city of the Macedonian and Ptolemaic dynasties, which ruled Egypt between 332 and 31 B.C. These investigations have resulted in the discovery of remains of parts of the submerged Royal Quarter, including shafts of red granite columns. Statues of gods, goddesses, kings, queens, and sphinxes have been found, along with pieces of pavement and ceramics.

These archaeological missions have also discovered the island of Antirhodos, the site of one of Cleopatra's palaces; the peninsula where the Timonium, Mark Antony's palace, was located; the Poseidon sanctuary; the Royal Harbor of Cape Lochias; and the remains of the ancient cities of East Canopus and Herakleion in the harbor of Abu Qir.

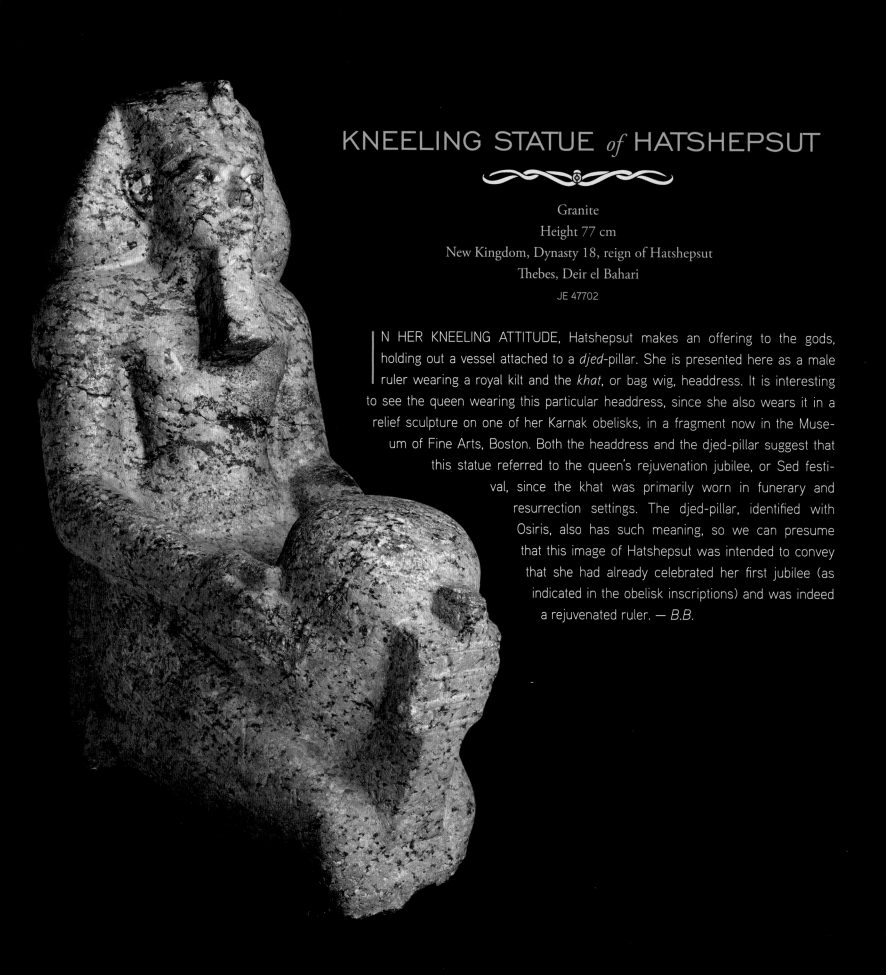

KNEELING STATUE *of* HATSHEPSUT

Granite
Height 77 cm
New Kingdom, Dynasty 18, reign of Hatshepsut
Thebes, Deir el Bahari
JE 47702

IN HER KNEELING ATTITUDE, Hatshepsut makes an offering to the gods, holding out a vessel attached to a *djed*-pillar. She is presented here as a male ruler wearing a royal kilt and the *khat*, or bag wig, headdress. It is interesting to see the queen wearing this particular headdress, since she also wears it in a relief sculpture on one of her Karnak obelisks, in a fragment now in the Museum of Fine Arts, Boston. Both the headdress and the djed-pillar suggest that this statue referred to the queen's rejuvenation jubilee, or Sed festival, since the khat was primarily worn in funerary and resurrection settings. The djed-pillar, identified with Osiris, also has such meaning, so we can presume that this image of Hatshepsut was intended to convey that she had already celebrated her first jubilee (as indicated in the obelisk inscriptions) and was indeed a rejuvenated ruler. — *B.B.*

BAS RELIEF *of* HOREMHEB

Quartzite
Height 187 cm
New Kingdom, Dynasty 18, reign of Horemheb
Cairo
TR 6.11.26.11

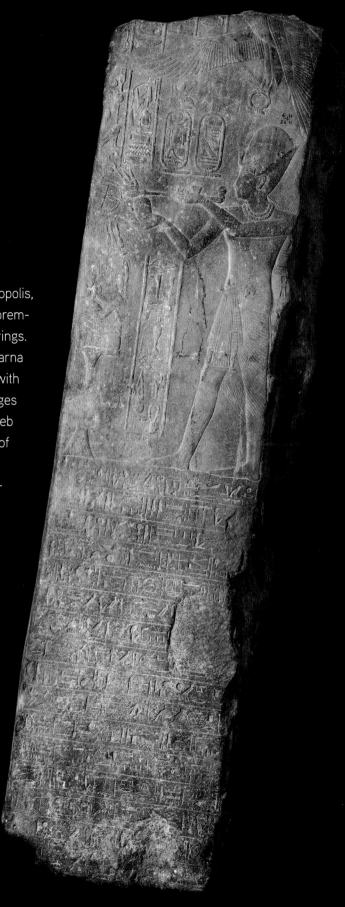

FOUND IN CAIRO, this half of a stela of Horemheb probably originated in Heliopolis, near the quartzite quarries at Gebel Ahmar. The monument once showed Horemheb before the solar deity Khepri, to whom he made incense and water offerings. The king's representation was fashioned to show him with elements of the post-Amarna art style still in evidence. For example, above the king's kilt, his belly swells a bit, with a thickened midriff and a somewhat short torso. These features compare with images of King Ay in his Valley of the Kings tomb and in the tomb of Tutankhamun. Horemheb often was rendered with a slimmer profile than here, particularly in his own Valley of the Kings tomb.

The scene represented here, although only half preserved, shows the king wearing the blue crown, or khepresh. That crown was associated with coronation for Horemheb, and this scene alludes to that royal elevation through the Horus falcon that hovers above. In return for the king's offerings, Khepri grants him "the lifetime of Re and the kingship of Horus in joy." — *B.B.*

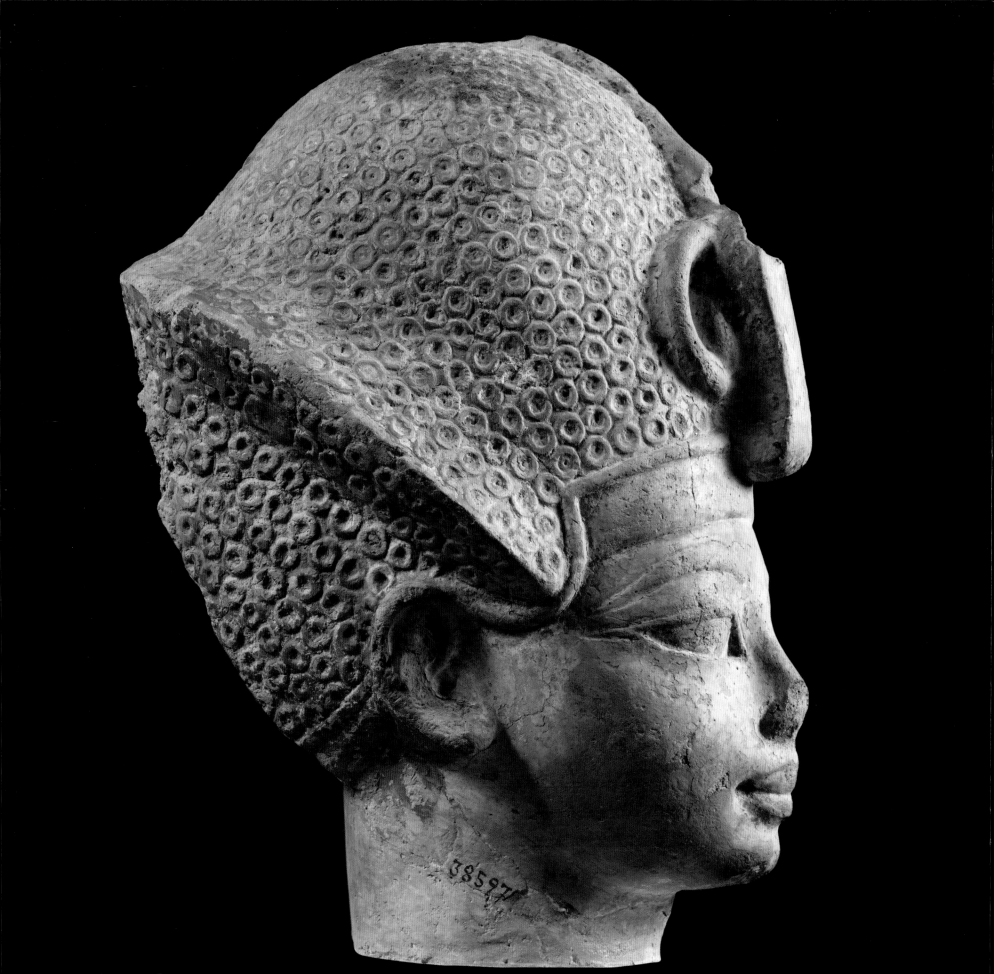

HEAD *of* AMENHOTEP III
in the BLUE CROWN

Plastered and painted unbaked clay
Height 38 cm
New Kingdom, Dynasty 18, reign of Amenhotep III
Karnak Temple Cachette
JE 38597/TR 12.11.26.9

THE CACHETTE AT KARNAK contained a large number of statues in many different states, and this is one of the more unusual. Rather than being a broken fragment of a statue, this head appears to be a complete element in itself. It was modeled in unbaked clay with the features of King Amenhotep III, in particular those seen near the end of his reign, when he was depicted as a new young ruler rejuvenated by means of the jubilee, or Sed festival. The extremely large and elongate eyes and fleshy lips of the king here combine with a round face that resembles nothing more than an idealized and cosmetically altered royal image.

We might imagine that such a clay head could have replaced ones representing the king at an earlier time, and that a ceremony at Karnak could have been the occasion for this. For example, a kneeling statue of Amenhotep III found at North Karnak was missing its head—which, thanks to the detective work of Dr. Hourig Sourouzian, was located in the Greco-Roman Museum in Alexandria. The reason for its removal and dispatch to a site hundreds of miles away is unknown, but one could wonder whether a head such as this one might have been made to substitute for the earlier and less juvenile image.

Yet none of this will explain the red paint that covers the clay head. Egyptian statues were indeed painted, but red paint would normally have been found on the face but not covering the headdress. Indeed, a second clay head of this king wearing a different headdress was also painted red all over. The use of red paint on clay suggests magical intentions as part of temple rituals. The enigmatic nature of this head certainly demands our further inquiry into this beautiful but mysterious object. — *B.B.*

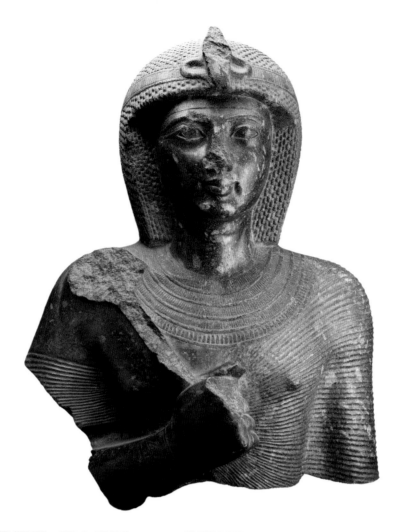

UPPER PART *of a* STATUE *of* RAMESSES II

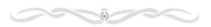

Granodiorite

Height 80 cm

New Kingdom, Dynasty 19, reign of Ramesses II

Tanis

CG 616/Luxor J. 901

THIS BEAUTIFULLY CARVED SCULPTURE of Ramesses II is one of the finest works of its era. Slightly larger than life, the king wears a pleated garment considered royal garb by the late 18th dynasty. The royal headgear is a round wig with fillet; uraei with sun disks hang from the back. With far less stylization than in other monumental images, Ramesses here has slightly bulging eyes accentuated by cutting above and below the eyelids. His mouth is thick but not broad, his chin and cheeks round without clear structure. All these traits combine into a serene, if serious, visage. The famous seated statue of the king in Turin is similar in regalia, and this statue may have been its northern twin, perhaps from the king's great city of Pi-Ramesses near modern San el Hagar, or Tanis. — *B.B.*

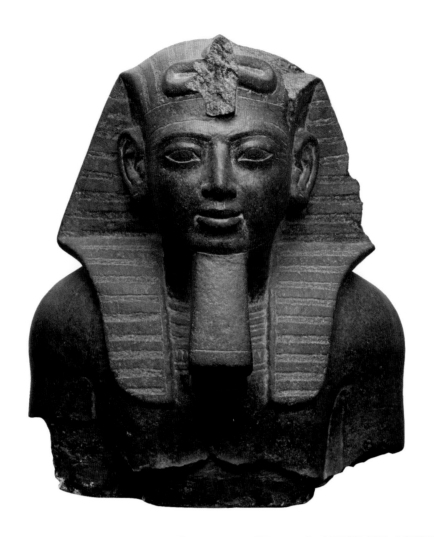

UPPER PART *of a* STATUE *of* MERENPTAH

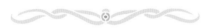

Granodiorite

Height 52 cm

New Kingdom, Dynasty 19, reign of Merenptah

Thebes, Medinet Habu

CG 601

I N THE RAMESSIDE ERA royal sculptors often used images of earlier rulers to make the face and form of the current ruler. Merenptah, son of Ramesses II, used elements of the funerary temple of Amenhotep III to build his own, as did Ramesses III, when he built his temple at Medinet Habu. This statue may first have portrayed Amenhotep III before its conversion to the somewhat generic features of a pharaoh of the late Dynasty 19 or 20. Nearly every element of the face has been modified, as has the nemes-headdress. A generic portrait type persisted through much of the New Kingdom. The king's face was recognizable as pharaoh, and that was enough. As the economic and military woes of Egypt increased from the reign of Merenptah onward, this may have been a reassuring image. — B.B.

SPHINX *of a* KING

White quartz

Height 33 cm; length 53 cm

Date uncertain

Karnak Temple Cachette

CG 42090/JE 37845

HIS SPHINX, RETRIEVED FROM THE KARNAK CACHETTE, shows a king's head on the body of a recumbent lion. The classic sphinx form depicts a guardian figure frequently used to indicate the boundaries of processional paths and entryways in temple precincts. In smaller versions, as here, such sphinxes may have rested atop gateways or flanked the doors of small shrines. This sphinx is somewhat enigmatic, since its base is rather crudely carved and does not extend from the front or rear of the lion's body. The entire figure may once have been set within a separate base, or alternatively the figure or its base, or both, may have been cut down at some point. The idiosyncrasies of this piece do not stop here, since a date for the piece is difficult to suggest through its style. The sphinx has been attributed to the reign of Amenhotep IV/Akhenaten, but this is by no means certain. The style of the *nemes*-headdress is not common for the 18th dynasty, and the shape of the king's mouth is different from that of Amenhotep IV. The hollowed cheekbones and large lips could have been found in the late 12th or even the 26th dynasties, but other features and elements on the head appear to have been recut. Without further study, the king represented here must remain unidentified. Even cut down and perhaps recarved, the statue's signficance to the priests of the temple was sufficient, however, to gain it a space in the depository where so many other rulers' images were stored, even after their use in the temple cult was at an end. — *B.B.*

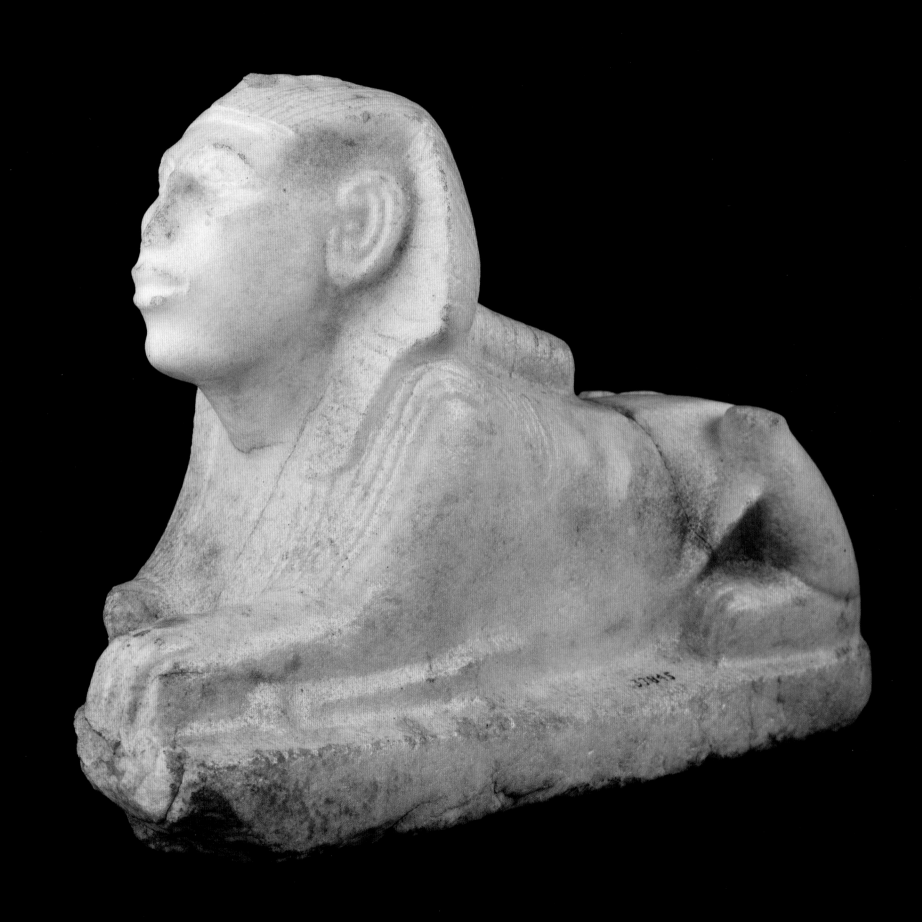

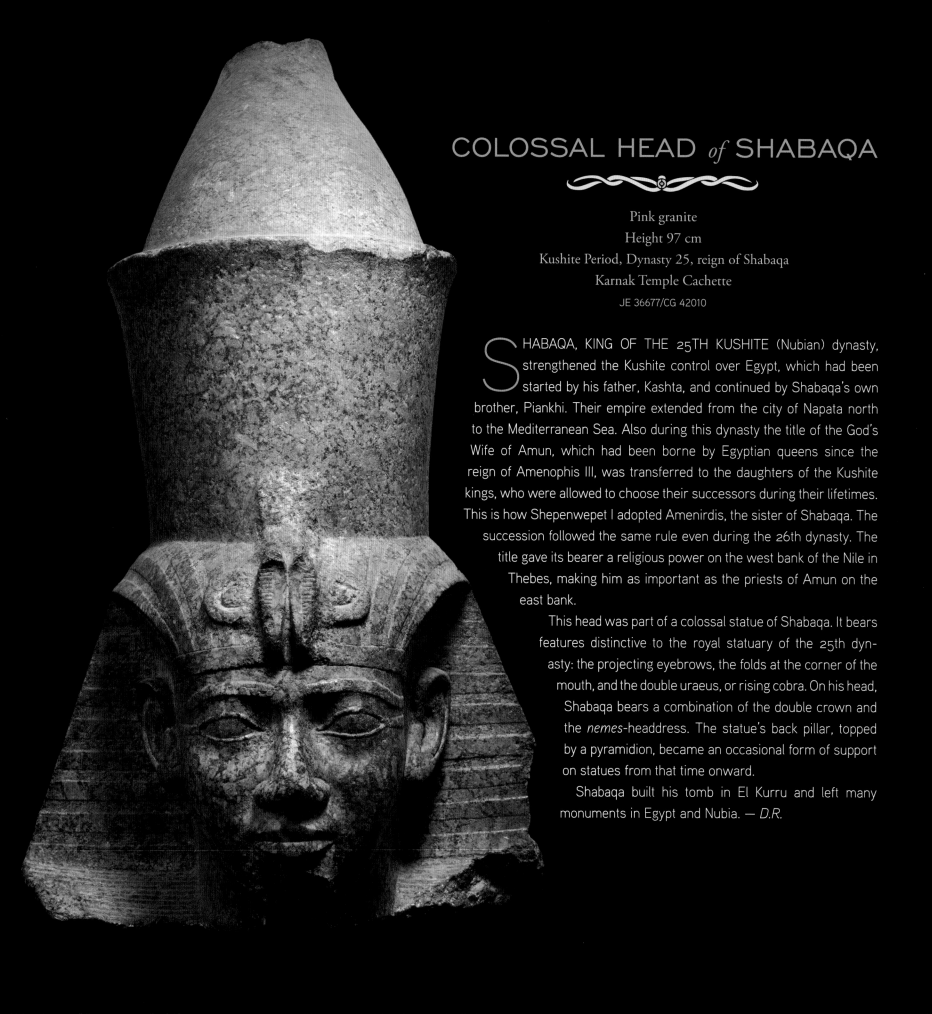

COLOSSAL HEAD *of* SHABAQA

Pink granite
Height 97 cm
Kushite Period, Dynasty 25, reign of Shabaqa
Karnak Temple Cachette
JE 36677/CG 42010

SHABAQA, KING OF THE 25TH KUSHITE (Nubian) dynasty, strengthened the Kushite control over Egypt, which had been started by his father, Kashta, and continued by Shabaqa's own brother, Piankhi. Their empire extended from the city of Napata north to the Mediterranean Sea. Also during this dynasty the title of the God's Wife of Amun, which had been borne by Egyptian queens since the reign of Amenophis III, was transferred to the daughters of the Kushite kings, who were allowed to choose their successors during their lifetimes. This is how Shepenwepet I adopted Amenirdis, the sister of Shabaqa. The succession followed the same rule even during the 26th dynasty. The title gave its bearer a religious power on the west bank of the Nile in Thebes, making him as important as the priests of Amun on the east bank.

This head was part of a colossal statue of Shabaqa. It bears features distinctive to the royal statuary of the 25th dynasty: the projecting eyebrows, the folds at the corner of the mouth, and the double uraeus, or rising cobra. On his head, Shabaqa bears a combination of the double crown and the *nemes*-headdress. The statue's back pillar, topped by a pyramidion, became an occasional form of support on statues from that time onward.

Shabaqa built his tomb in El Kurru and left many monuments in Egypt and Nubia. — *D.R.*

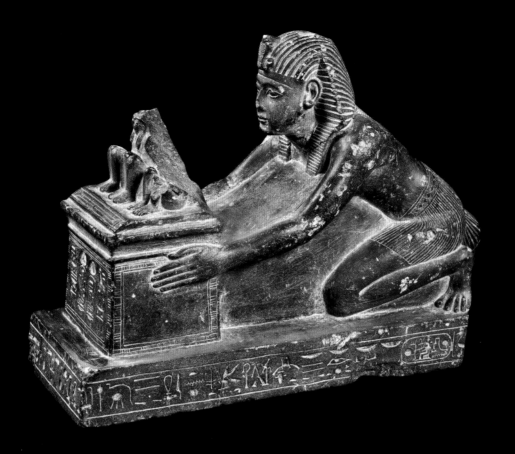

STATUE *of* RAMESSES II KNEELING *with* NAOS

Greywacke (schist)
Height 27.5 cm
New Kingdom, Dynasty 19, reign of Ramesses II
Karnak Temple Cachette

CG 42144/JE 37423

THIS STATUE OF RAMESSES II is on a more intimate scale than many of this king's other gifts to the gods. Here the king is portrayed in a kneeling pose, presenting a box holding statues of three gods—with surprises. Although Ramesses is shown in a pious and humble attitude, as a dedicant to the deities, the inscriptions tell a somewhat different story. For example, the identity of the three gods inside the box is written on the box's front wall: On the left is Amun-Re of Karnak, on the right is Re-Horakhty, and in the center, proudly named, is Ramesses II himself. Likewise the inscription around the base of the statue begins at the center of the box and identifies Ramesses II with Re on the right side and Amun on the left, thus nearly eliminating the need for these majestic deities of Heliopolis and Thebes. As in so many of the monuments devised for this ruler, we find him offering cult statues and offerings to the major gods of Egypt, among whom he counts himself. — *B.B.*

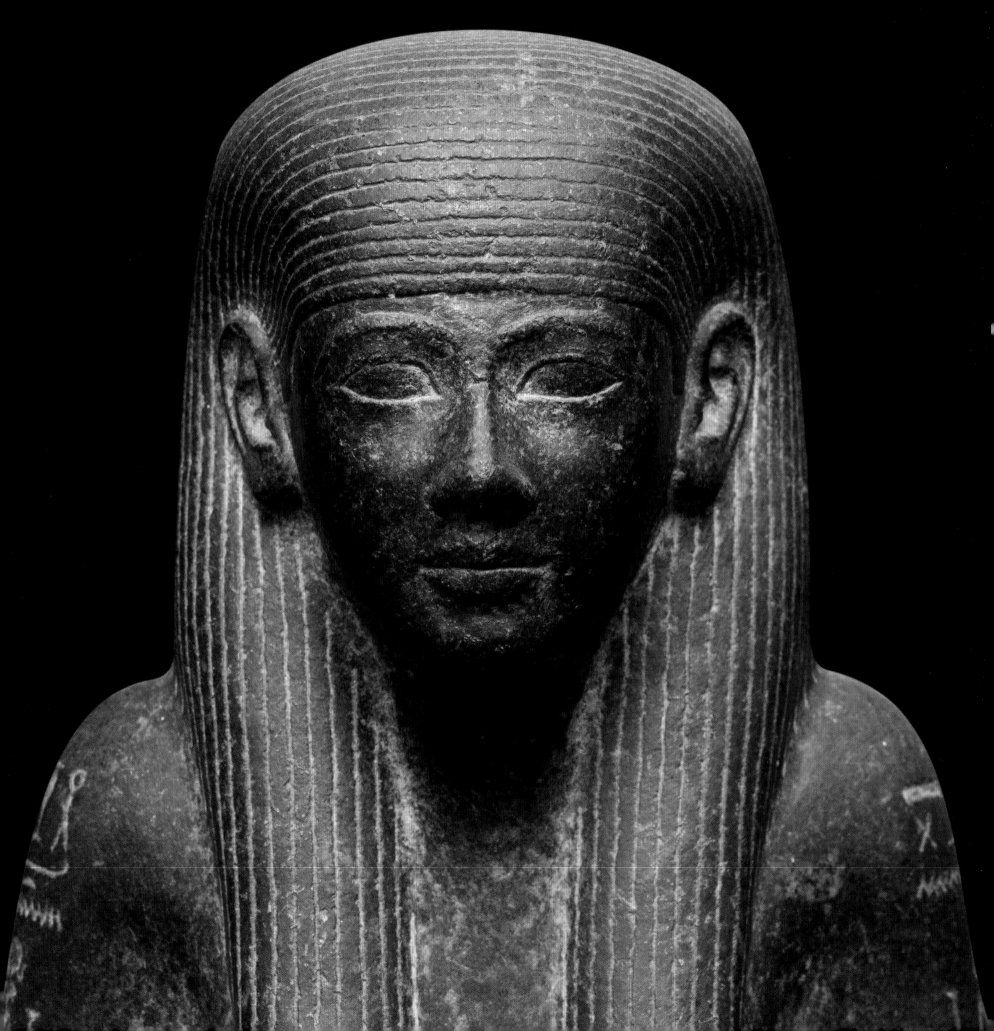

PHARAOH'S FAMILY

and PRIVATE LIFE

SEATED STATUE OF SHEPENSOPDET, *see page 132*

THE FAMILY OF THE PHARAOHS lived in palaces in Egypt's major cities and moved from one residence to another for a variety of reasons. In the Predynastic Period, the southern town of Nekhen, center of worship for the royal god Horus, was one of the key capitals. During this era, other important towns were Buto in the Nile Delta and Abydos and Naqada, also in Upper Egypt. 🏵 In Dynasty 1, a new capital was founded at Inebhedj (White Wall). This was at the junction of the delta and the Nile Valley, a strategic location that allowed these early kings to control trade routes in all directions. The administrative capital of the country remained in this region throughout the Old Kingdom, shifting gradually with the sites of the royal pyramids until it was centered at Mennefer (Memphis in Greek, named after the pyramid of Pepy I). 🏵 The Middle Kingdom began with its capital at Thebes, the hometown of the kings who reunified the country. When Dynasty 12 began, the administrative center moved north, this time to a site called Itj-tawy, near the entrance to the Faiyum Oasis, or possibly at Lisht. In the 18th dynasty, Thebes—again the place of origin for the dynasty that reunited the county—again became Egypt's ceremonial center, and the administrative

center shifted north to Memphis. Under Akhenaten, the religious capital moved temporarily to Tell el Amarna, but it returned to Thebes early in the reign of Tutankhamun.

A new principal royal residence was built during the reign of Ramesses II, this time at the site of Pi-Ramesses (modern-day Qantir) in the Nile Delta, where it remained until the Third Intermediate Period. In the 21st dynasty, Tanis became the capital, and the following dynasties were based at various delta towns.

THE ROYAL FAMILY

Next to the king himself, the most important member of the royal family was the queen. Each king had a principal consort who sometimes took the title "daughter of the god." Although our evidence is scanty, it seems that succession was ensured, whenever possible, through the direct line established by the eldest son of the king and his chief queen. If the principal consort of the king bore only female children, it appears that one of these daughters would marry the son of a minor wife (and thus his half sister), and this prince would become the next king.

It was also possible, as we see in the case of Thutmose III, for oracles to legitimize a successor. There are also examples of co-regencies—cases in which the king would select and crown his heir during his own lifetime, and in those circumstances the two kings would reign together, side by side, for a number of years. This arrangement guaranteed a smooth transition of power at the senior king's death.

Not surprisingly, we know of a number of instances when the transfer of the throne was contested. Some royal wives conspired to make their own sons king, and there were power struggles between various princes. Egyptian history is dotted with mentions of palace rebellions as well: For example, it is said that Teti, the first king of the 6th dynasty, was murdered by his palace guard. Another example of such a conspiracy survives in the detailed record of a trial from the New Kingdom, when a minor queen of Ramesses III plotted to put her son on the throne.

During the early 4th dynasty, royal sons tended to hold many of the high political and administrative positions in the centralized government. The most prestigious titles were *tjaty* (often translated "vizier") and "overseer of all the king's works." For exmple, Sneferu's eldest son Kanefer was his master architect. His grandson, Hemiunu, was vizier and overseer of works for Khufu. In contrast, during the 5th and the 6th dynasties, the key offices and high administrative posts were held by officials from outside the immediate royal family.

In the New Kingdom, and especially during the Ramesside era, royal princes reestablished their power and importance. They are represented as holding important positions in their fathers' governments in scenes at various temples, including those at Luxor and Karnak temples, the Abydos temples of Sety I and Ramesses II, the Ramesseum, and Medinet Habu. Military expertise became essential for the king's sons, who were sent to Memphis for training. During the Third Intermediate Period, the principal titles of royal sons were religious, although these probably also carried administrative and political responsibilities. Very little is known about the role of royal sons in the Late Period.

Royal children were raised in special quarters within the palaces, and they had special nurses and tutors assigned to them. Examples of such nursery staff are Senenmut, tutor of Hatshepsut's daughter Nefrure, and Maya, wet nurse of Tutankhamun.

We have evidence for many powerful queens in Egyptian history. One of the first of these was Meryt-Neith, who may even have ruled during the 1st dynasty. From the 4th dynasty we know of Hetepheres, wife of Sneferu (founder of Dynasty 4) and mother of Khufu (builder of the Great Pyramid), whose burial was found almost intact at Giza. Another important royal woman was a queen of Pepy I, Weret-Imtes, who led a conspiracy against the king. Although we know that the case was investigated by an official named Weni, we do not know the exact details of the plot. At the end of the 6th dynasty came Queen Nitocris, who appears to have ruled as king in the absence of a living male heir to Pepy II.

The 17th dynasty produced a number of remarkable women, including Tetisheri, Ahhotep, and Ahmose-Nefertari. In the early New Kingdom, we have evidence for a key ritual and political role with the title "god's wife of Amun." The first to take this title was Ahmose-Nefertari, wife of Ahmose and mother of Amenhotep I. The title was passed down to one royal woman at a time.

The tradition of powerful queens continued through the New Kingdom. The most famous of these is Hatshepsut, a royal daughter and wife who took on the role of pharaoh. Other key 18th- and 19th-dynasty queens were Tiye, chief consort of Amenhotep III; Nefertiti, who may have been co-regent for a time beside her husband; Nefertari, chief consort of Ramesses II; and Tausert, who ruled as a female pharaoh at the end of the New Kingdom.

The principal queen, the queen mother, and the royal children shared in the divinity of the king and played important ritual roles. The symbol of the queen was the vulture, tutelary goddess of the south. From the Old Kingdom on, queens wore the vulture crown, a headdress in the form of this bird. Queens were also identified with Hathor, daughter of Re. Each main wife had her own palace, with her own officials and servants to support her.

HEAD *of an* AMARNA PRINCESS

Quartzite
Height 21 cm
New Kingdom, Dynasty 18, reign of Akhenaten
Tell el Amarna, workshop of the sculptor Thutmose
JE 44869

THE IDENTITY OF THIS ROYAL WOMAN of Tell el Amarna is uncertain. She is normally considered to be one of the king's daughters, since the bald head could suggest youth, yet the fact is that this head is of an adult woman and has much in common with representations of Nefertiti herself. Indeed the famous bust of Nefertiti also derived from the workshop of Thutmose, and one can certainly see the resemblance between that face and this one. Possibly this statue would have had a headdress of separate material that adorned it during presentation.

The neck of this woman extends into a long cylindrical dowel, indicating that the head formed part of a composite statue of which this head was one component, and probably its material, brown quartzite, was one of several. Composite sculpture, not that common in Egypt before this time, was a characteristic of art from the Amarna period. As a method of working, it would have allowed the artisans to use smaller amounts of favored stones, such as quartzite, and it also allowed the statues to be fashioned without the framework of large stone back pillars and without needing to engineer negative space, such as that between arms and bodies, out of a single block of material. The Amarna artists thus were encouraged to work to make images in stone as animated as those in wood, and the lighter weight of composite sculpture supported those efforts. — *B.B.*

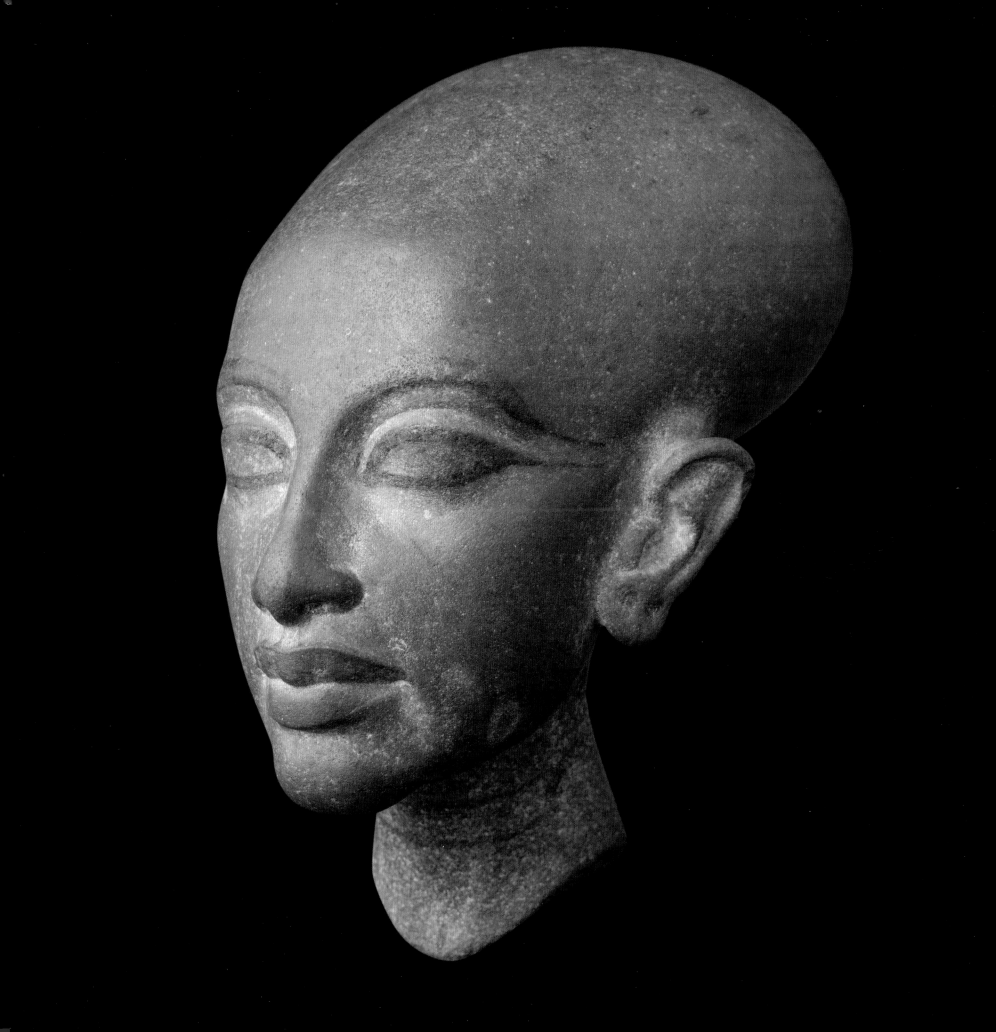

INNER COFFIN *of* QUEEN MERITAMUN

Cedar wood
Length 185 cm
New Kingdom, Dynasty 18, reign of Amenhotep I
Thebes, Deir el Bahari, Theban Tomb 358
JE 53141

THIS COFFIN OF MERITAMUN displays one of the finest of all portraits existing from ancient Egypt. Carved in cedar wood that has hardly been touched by the elements of time or erosion, it shows a face with the distinctive features of Amenhotep I, the second king of the 18th dynasty. There is no doubt that this coffin was made in this king's reign, because he had an unusually shaped nose with a slight acquiline profile and a thickened lower nostril area, replicated in the features of this coffin. Amenhotep I himself is shown over and over with this particular nose shape on his relief sculpture from the Karnak temple, and no other ruler of the 18th dynasty had these facial features. Thus the queen for whom this coffin was made was associated with Amenhotep I, since the features of the ruling king are those used for all human forms, including those of gods. Just as Nefertiti had the same facial features as Akhenaten, so Meritamun had those of Amenhotep I.

The coffin was carefully painted to indicate a wig type known to have been used only in the late 17th and early 18th dynasties. The hairlocks have been filled in with paint paste of blue, while the queen is clothed in a feathered garment also so painted. With the eyes inlaid in glass, the overall impression is so lifelike as to be uncanny. — *B.B.*

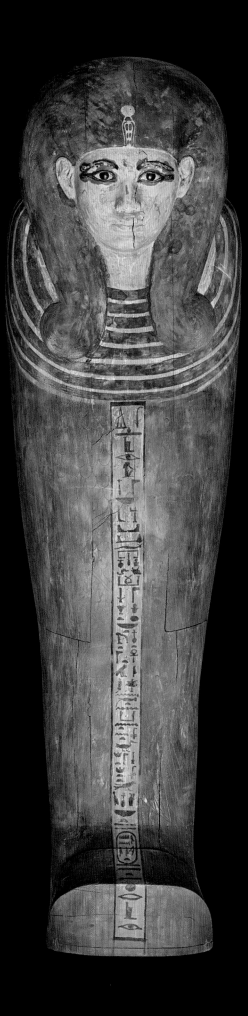

SEATED STATUE *of* QUEEN NOFRET

Granodiorite
Height 165 cm
Middle Kingdom, Dynasty 12, reign of Senwosret II
Tanis
JE 37487/CG 381

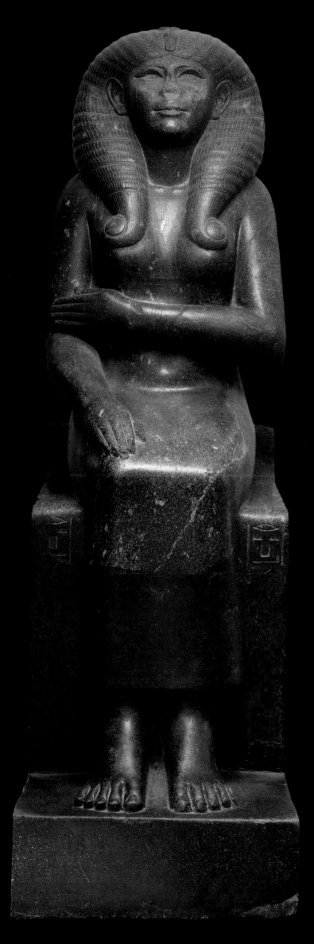

ONE OF TWO ALMOST IDENTICAL FIGURES, this statue of Nofret, the consort of Senwosret II, was found near Tanis in the Nile Delta, but it probably originated from another location. Parts of an inscription appear in a vertical column beside each leg, and the more complete sculpture in the Egyptian Museum, Cairo, shows that the text records the titles of the queen. Nofret bends her left arm at the elbow, reaches across, and touches her right arm just below the bicep. The gesture forms a right angle and parallels the geometrical shape created by her seated body. This angularity contrasts sharply with the obvious curve and recurve of her heavy wig. Formed in three parts, the wig had one section hanging down in the back and two others falling forward over the shoulders. Its considerable bulk forced the ears forward, causing them to look enlarged, a detail characteristic of this period. Nofret's own hair is visible in front of her ears.

Narrow bands, one above the other, appear in rows across each of the lappets of her wig. These bands, meant to hold the tresses in place, form a horizontal focus. This style of hairpiece became quite popular in the 12th dynasty, and it is often found later on statues of the goddess Hathor. As the hair falls down onto Nofret's breasts, each section curves in the opposite direction, encircling a disk.

The figure represents a bold style of carving, emphasizing the features of the face, the obvious gestures of the arms, and the considerable mass of the wig. The details of her clothing and the pectoral suspended from her neck are rendered quite subtly. Archaeologists have discovered actual examples of openwork plaques similar to this one. At her forehead, in the center of the wig, Nofret wears the royal insignia, a rearing cobra.

When complete, with the inlays in the eyes still intact, the statue would have appeared quite vibrant. Its strong statement contrasts with the subtler one of royal images produced during the reigns of earlier 12th-dynasty rulers. Sculptors during this transitional stage seem to have relied more on models from the Memphite Old Kingdom than on the Theban styles of their past, but in this figure there seems to a melding of the two influences. —*D.S.*

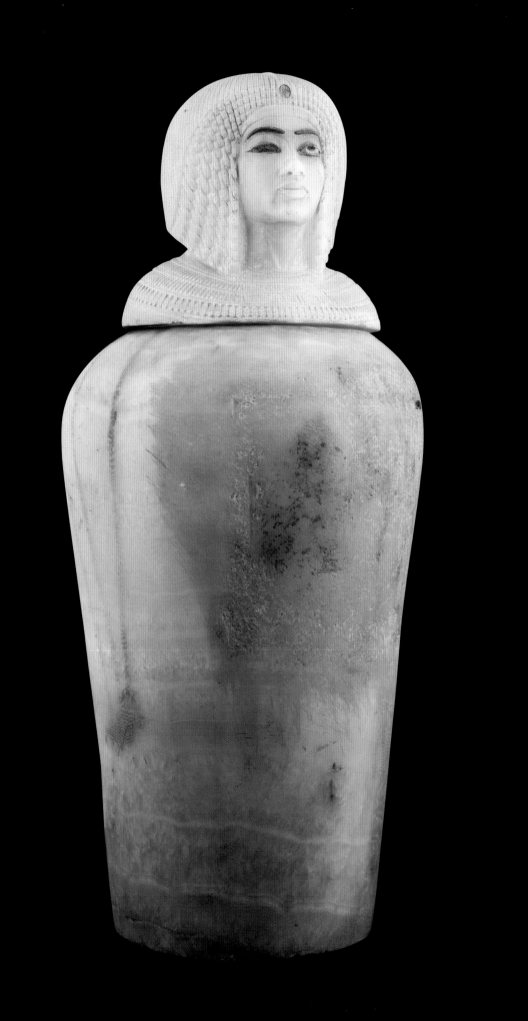

CANOPIC JAR *of a* ROYAL AMARNA WOMAN

Calcite

Height 52.9 cm

New Kingdom, Dynasty 18, reign of Akhenaten

Thebes, Valley of the Kings, KV 55

JE 39637

T HE SMALL, UNDECORATED TOMB now known unceremoniously as KV 55 was carved into the Valley of the Kings just across from the slightly larger tomb of Tutankhamun. KV 55 received the burial objects of royal family members from Tell el Amarna, apparently transferred from that city's royal tomb. A body found in the tomb remains unidentified. Scholars have argued whether it is female or male, but its masculine character is now presumed secure. Many believe that this is the body of Akhenaten himself; others suggest that it is Smenkhkare, who may have ruled briefly at the death of Akhenaten. Objects naming a number of the Amarna royal family members were found in the tomb, however, including the queen mother, Tiye, and Akhenaten. Others, like this canopic jar (and three others in the set), now name no one, because the inscriptions have been deliberately erased. The coffin was likewise altered to remove any name, for reasons not entirely understood.

The calcite jars were apparently inscribed with traditional funerary spells that named the four sons of Horus as the protectors of the embalmed viscera placed within. Such texts would not have been necessary to the solar Atenist religion practiced by Akhenaten and his court, suggesting that the jars may have been made prior to the move to Amarna. The stoppers, on the other hand, are small sculptural masterpieces of the Amarna style, and they must have been made in that royal city. The ovoid, outlined eyes compare well with those of the colossal statue of Tutankhamun in this exhibition (page 247), but the long and knobby chin, a characteristic of Amenhotep IV/Akhenaten himself, suggests an earlier date.

For whom these stoppers were fashioned cannot be said with certainty. Even the gender of the person represented is not clear, since in the Amarna period this echeloned wig was worn by male and female alike. The small, delicate features do suggest a woman, and recent scholars frequently identify the face as that of Princess and Queen Meritaten. As a daughter of Akhenaten, she was also his last major wife. His secondary queen, Kiya, who may have been dishonored in the monuments, has also been identified with these jars. — *B.B.*

BLOCK DECORATED *with* PAPYRUS POOL

Glazed limestone
Length 11 cm
New Kingdom, Dynasty 18, reign of Akhenaten
Tell el Amarna, North City
JE 55524

THE FUNCTION OF THIS OBJECT is difficult to identify with certainty. It is decorated with papyrus clumps and marshes, so it might have held a papyrus flat for writing: an ancient paperweight. The limestone has been glazed with two colors of blue, the deep cobalt blue to suggest water and the turquoise to suggest greenery. Artisans applied these colors into an incised pattern on the stone by carefully painting with mineral and alkaline compounds, and then the stone was fired to create a glassy surface. — *B.B.*

KOHL POT *of* QUEEN TIYE

Faience
Height 13.7 cm
New Kingdom, Dynasty 18, reign of Amenhotep III
Saqqara
JE 55604

SMALL KOHL POTS SHAPED LIKE FLUTES were made during the reign of Amenhotep III, often inscribed with his name and that of his wife Queen Tiye. Most are also marked with wedge-shaped incised patterns like the air holes on a reed flute. Although these eye-paint jars were made in more than one color scheme, this one—dark blue with turquoise infill—is most common. These standardized kohl pots are linked to the workshops of Amenhotep III's palace at Malkata in western Thebes, where the king resided for his three Sed jubilees. It is quite likely that eye-paint pots and other faience objects were made as gifts to be distributed during festivities. Amenhotep III's portrait is known for its long, almond-shaped eyes with heavy cosmetic banding. Such an eye-paint pot recalls luxurious banqueting and the amuletic power of kohl, which protected the eyes of all who wore it. — *B.B.*

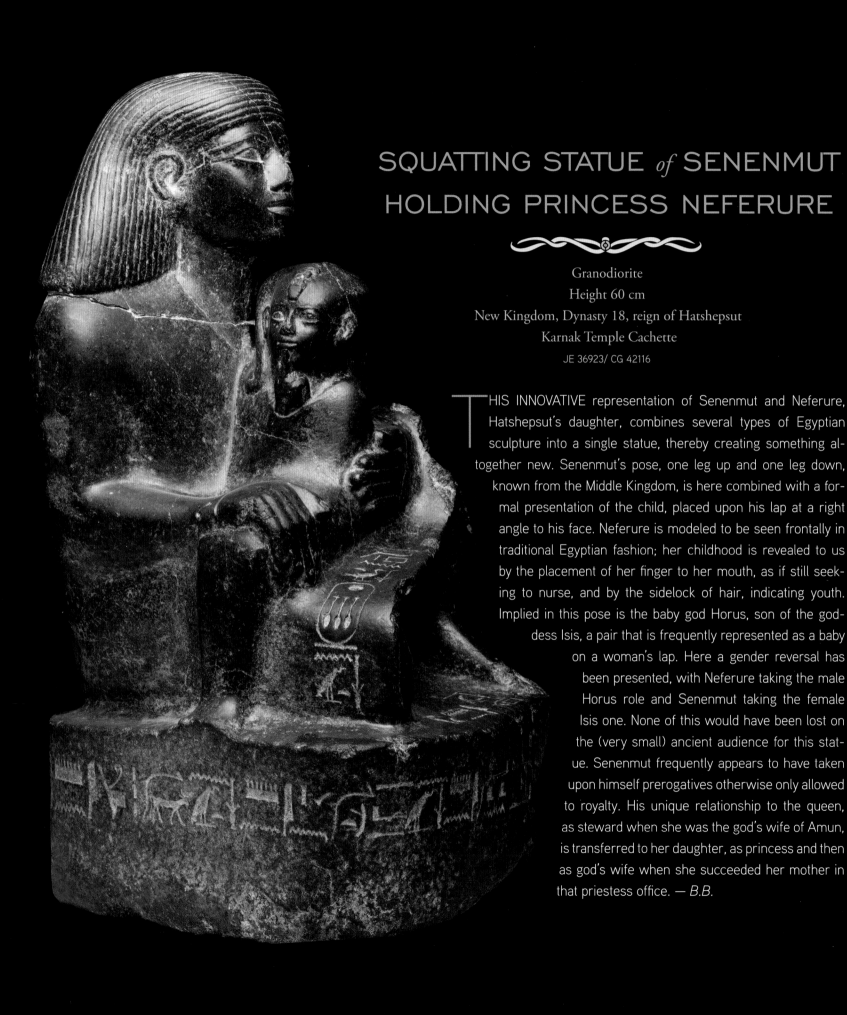

SQUATTING STATUE *of* SENENMUT HOLDING PRINCESS NEFERURE

Granodiorite
Height 60 cm
New Kingdom, Dynasty 18, reign of Hatshepsut
Karnak Temple Cachette
JE 36923/ CG 42116

THIS INNOVATIVE representation of Senenmut and Neferure, Hatshepsut's daughter, combines several types of Egyptian sculpture into a single statue, thereby creating something altogether new. Senenmut's pose, one leg up and one leg down, known from the Middle Kingdom, is here combined with a formal presentation of the child, placed upon his lap at a right angle to his face. Neferure is modeled to be seen frontally in traditional Egyptian fashion; her childhood is revealed to us by the placement of her finger to her mouth, as if still seeking to nurse, and by the sidelock of hair, indicating youth. Implied in this pose is the baby god Horus, son of the goddess Isis, a pair that is frequently represented as a baby on a woman's lap. Here a gender reversal has been presented, with Neferure taking the male Horus role and Senenmut taking the female Isis one. None of this would have been lost on the (very small) ancient audience for this statue. Senenmut frequently appears to have taken upon himself prerogatives otherwise only allowed to royalty. His unique relationship to the queen, as steward when she was the god's wife of Amun, is transferred to her daughter, as princess and then as god's wife when she succeeded her mother in that priestess office. — *B.B.*

STATUE *of* BENERMERUT *and the* PRINCESS MERITAMUN

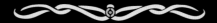

Granodiorite
Height 70 cm
New Kingdom, Dynasty 18, reign of Thutmose III
Karnak Temple Cachette
JE 36922/ CG 42171

D URING THE REIGN OF THUTMOSE III, Benermerut was a chief of the silver and gold houses for Upper and Lower Egypt. He was also an overseer for all royal building projects. He was certainly among those greatly trusted by the king, and for this reason we see him enacting a role characteristic of the mid-18th-dynasty elites: caring for the offspring of the king.

This daughter of Thutmose III, Meritamun, is known from several other monuments, including the Hathor shrine of the king in Deir el Bahari. Benermerut is shown in a squatting pose, as if enshrouded by his garments. As if she were held safely within his robes as well, Meritamun's head appears before Benermerut's, and her finger is placed up to her mouth to suggest her early childhood.

Despite the statue's provenance from the Temple of Amun at Karnak, its dedication is to Khnum, the god of the First Cataract of the Nile. Benermerut functioned late into the reign of Thutmose III, since he is named as the royal agent on a donation stela dated in year 45. Another stela of Benermerut is part of the collection of the Louvre Museum in Paris. — *B.B.*

SARCOPHAGUS *of* PRINCE
THUTMOSE'S CAT

Limestone
Height 64 cm
New Kingdom, Dynasty 18, reign of Amenhotep III
Mit Rahina
JE 30172/CG 5003

THE SON OF AMENHOTEP III, THUTMOSE, WAS THE HIGH PRIEST of Ptah of Memphis during his father's reign. This sarcophagus was used to bury his pet cat in the cemetery of Memphis. The stone box is a smaller version of the type used to bury people, and it is decorated with the funerary deities, such as Isis, Nephthys, and the four sons of Horus, who regularly are invoked to protect the mummies of all people. The cat itself is referred to as an Osiris, an indication that it would be able to reach the netherworld and be judged in the Hall of Truth there.

Pets were not infrequently represented on both royal and private monuments; dogs and cats were the most commonly depicted. Both species were shown accompanying their masters on hunting expeditions, and also sitting calmly beneath their masters' chairs in tomb offering scenes. Like their owners, pets might expect to partake of food offerings through their loyalty, and Prince Thutmose's cat, Ta-Mit (literally, "female cat"), must have been greatly valued by her owner.

It is interesting to note that the mythological significance of cats connected them with the sun god as protectors. The potential of the feline deities to become violent, but also to be family pets, was expressed particularly in such goddesses as Bastet, Sakhmet, Mut, and Tefnut. Both of these behaviors might be protective to the sun god—and to a pet owner, so that a family cat hunting in the marshes performed a role similar to that of Sakhmet killing the enemies of the gods. — *B.B.*

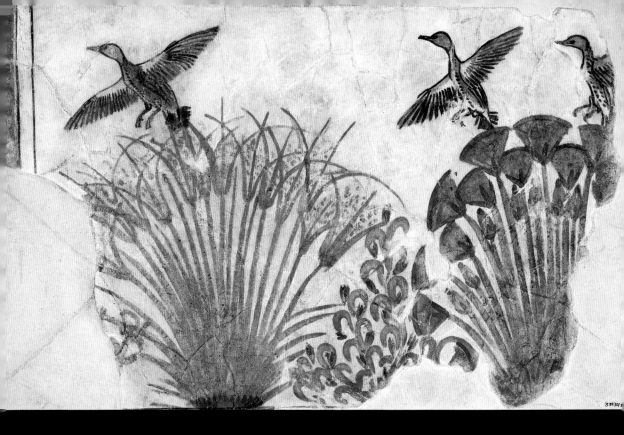

PART *of a* PAVEMENT
from an AMARNA PALACE

Painted plaster
Height 120 cm
New Kingdom, Dynasty 18, reign of Akhenaten
Tell el Amarna, Maru-Aten

JE 33030.1

DECORATED WALLS, FLOORS, AND CEILINGS were typical of Egyptian domestic architecture, and royal houses preserved the best artists' efforts in this arena. The coolness of the marshes is invoked by these painted pavement pieces. Rows of marshy foliage with geese flying up from them could form borders for enormous floor pavements and create a virtual lake within the palace. Nearby might well have stood an actual pool, surrounded by columns and a real arbor, where the householders could spend a cool afternoon. This section of pavement comes from the southern palace that housed King Akhenaten's daughter, later his consort, Meritaten. *B.B.*

LATRINE SEAT

Limestone
Width 53 cm
New Kingdom, Dynasty 18, reign of Akhenaten
Tell el Amarna
JE 55520

N AN ELITE HOUSEHOLD, EVEN THE SANITATION and privy needs of the family were cared for by workers. This toilet seat, placed upon a built latrine box, came from an Amarna palace. Certainly there must have been individual chamber pots as well, but this discovery is of true general interest. — *B.B.*

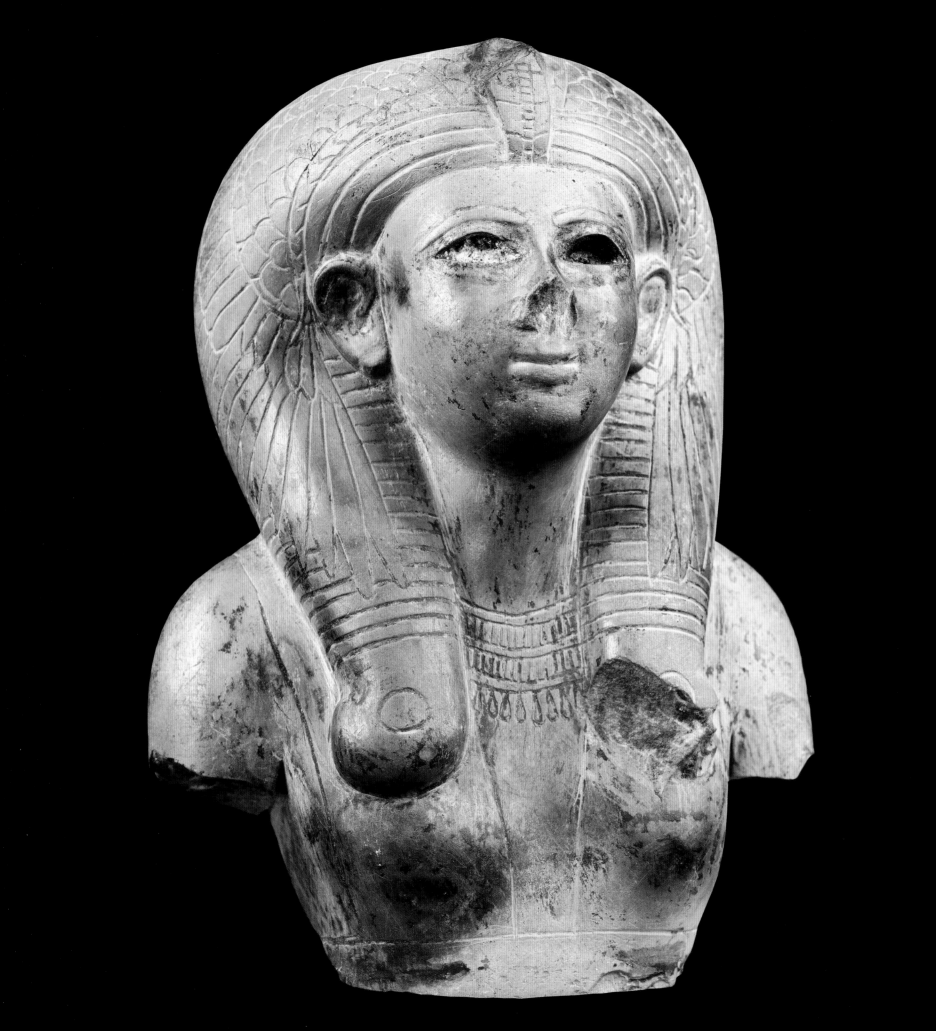

UPPER PART *of a* STATUE
of a ROYAL WOMAN

Limestone

Height 16 cm

New Kingdom, Dynasty 18

Karnak Temple Cachette

JE 37217/CG 42009

THE FEATURES OF THIS TINY FRAGMENT OF A STATUE indicate that its subject was a royal female. She wears a close-fitting sheath dress with a high waist and fairly wide straps. Around her neck is a collar of tubular and droplet-shaped beads, a type found on representations of women of several periods as well as in among actual burial equipment. The artist used shallow, incised lines to render the details of her clothing, beads, and wig. The hairstyle appeared first in the Middle Kingdom; somewhat later, it became associated with the goddess Hathor. The wig has three parts: the two lappets that fall on either shoulder and a third section in the back. Horizontal lines represent bands that held the hair in place. No trace of her actual hair appears below the wig, nor is there any indication of the strands of hair that comprised the wig. At each end, the hair that rests on the upper part of the breasts curls in the opposite direction around a disk. While this hairpiece may not appear as cumbersome as others, it, too, pushes the ears forward, bringing prominence to them—a characteristic detail of portraits of this period, evident also on male figures wearing wigs or headdresses.

This type of wig sometimes shows a center part, but the uraeus—the rearing cobra, a royal insignia—extends fully on this statue and obscures this detail from view in the front. The feathered headdress, further signifying her high position, covers the top and much of the front of the wig.

This bust's empty eye sockets once held inlays, probably of quartz and obsidian, edged in bronze; no cosmetic line was sculpted. The applied eyebrows, full cheeks, and slightly protruding lips, with a fairly straight mouth that turns up slightly, all suggest that the bust comes from the reign of Thutmose III. Representations of two queens of that time appear quite similar. The remaining parts of the face, as with the rest of this fragment, show little modeling. Earlier scholars suggested a date in the Middle Kingdom for the piece, but later analyses suggest a New Kingdom date instead. — *D.S.*

JEWELRY BOX *of* AMENHOTEP III

Gilded wood, faience tile, and copper
Height 51 cm
New Kingdom, Dynasty 18, reign of Amenhotep III
Thebes, Valley of the Kings, Tomb of Yuya and Tiya
CG 51117

THE TOMB OF AMENHOTEP III'S PARENTS-IN-LAW, Yuya and Tuya, was a small undecorated chamber in the Valley of the Kings. Yet when first discovered, in 1907, it was the greatest treasure that Thebes had yet offered. After the discovery of the tomb of Tutankhamun, however, the objects found in KV 46 become nearly unknown again. They are beautiful, nevertheless, and exquisitely worked examples of the royal workshops of Amenhotep III.

This jewel casket does not name either Tuya or her husband but rather Amenhotep III. It is likely, therefore, like the tomb itself, to have been a gift from the king. No jewels were found inside the box, and it is probable that thieves took away most nonritual items made of precious materials.

The box, however, is a treasure in itself. It is made of wood that has been veneered on the lid and sides with panels of glazed composition, or faience. The side panels have been fitted with gilded wood relief, creating a running frieze that repeats the words, "Life, Stability, and Dominion," as a continual wish for the ruler. Cavetto cornices run around the top of the box, whose two folding lids lie flat when closed. The box therefore takes the form of a flat-topped shrine or altar.

On the lid, the cartouche names of Amenhotep III form the headdresses of two kneeling figures holding palm fronds. The viewer looking down upon the lid sees the reference to "millions of years of Amenhotep III." — *B.B.*

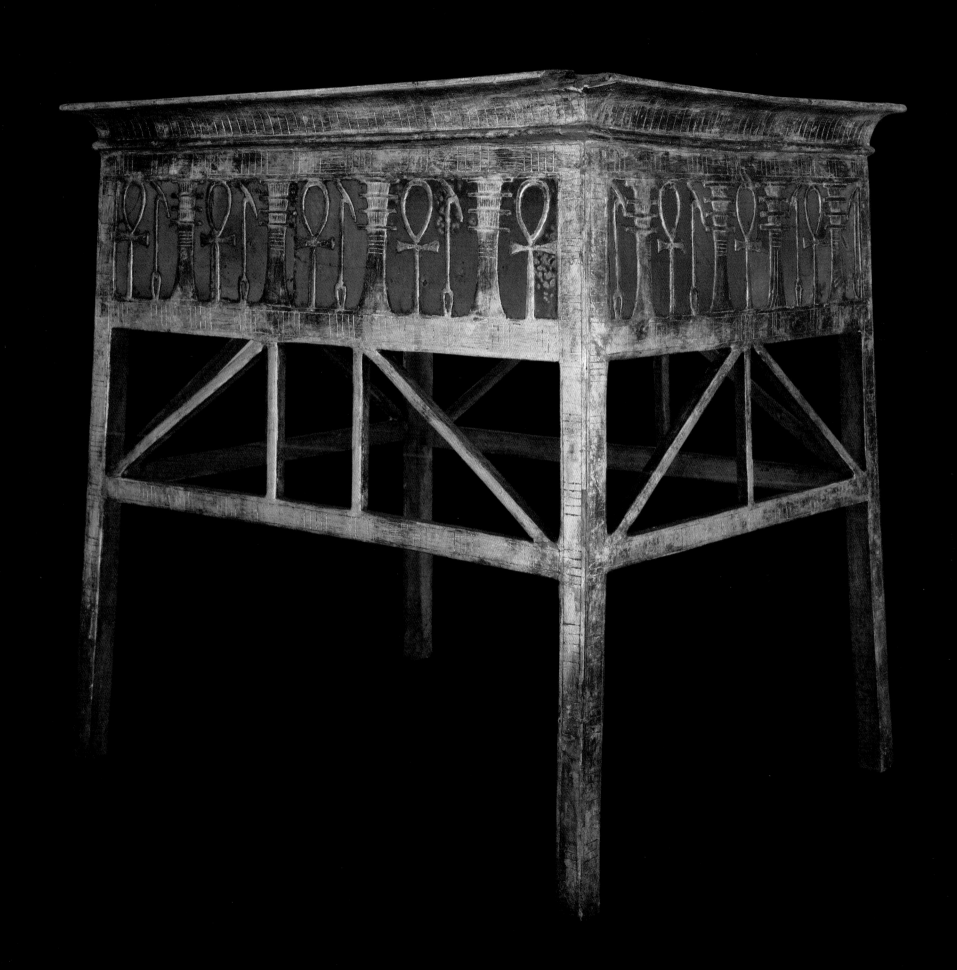

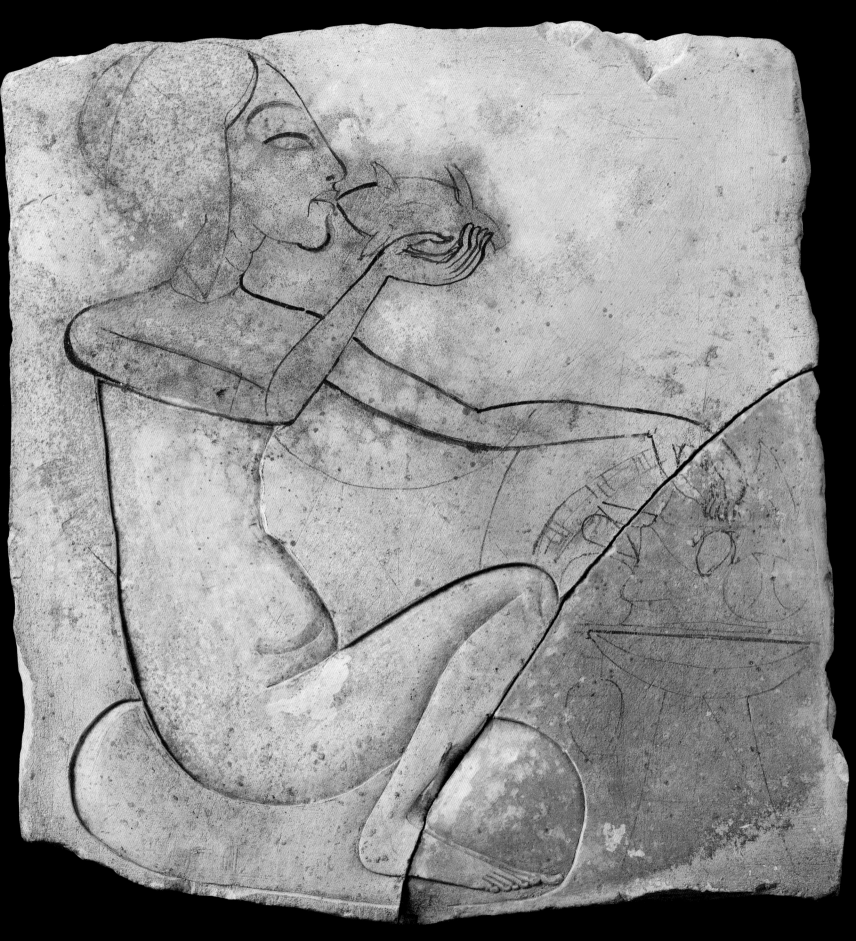

ARTIST'S SKETCH *of a* PRINCESS EATING DUCK

Limestone
Height 23.5 cm
New Kingdom, Dynasty 18, reign of Akhenaten
Tell el Amarna, North Palace
JE 48035

THIS ICONIC AMARNA-STYLE SKETCH of a princess nibbling at a cooked duck has been published in many books—and yet one hardly tires of seeing it. To begin with, it is not only a sketch, but it has been partially carved, as if by making this piece the artist were testing his skill.

Despite the princess's graceful approach to the food, the whole subject of eating was unfamiliar to audiences of Egyptian art. Rules of proper representation had dictated that food could be seen on a table before a figure, but no one would have been shown actually eating or drinking. Even Egyptian rules of behavior imposed restrictions at the dining table. Gluttony was greatly disdained, and people of good manners were warned to deny themselves until everyone else had eaten.

Here, however, not only does the little princess suck upon the bird, but her far hand reaches into the bowl for another delicacy, perhaps a piece of fruit. It is the skill of the artist that has made this scene so charming, because with her lips closed, the demure princess does not become in any way gluttonous—just charmingly youthful. — *B.B.*

SEATED STATUE *of* SHEPENSOPDET

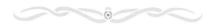

Schist

Height 83 cm

Third Intermediate Period, Dynasty 22, reign of Osorkon II

Karnak Temple Cachette

JE 37383/CG 42228

MADE OF BLUE SCHIST, THIS IS A SEATED STATUE of Shepensopdet, daughter of Namlot, the high priest of Amun at Karnak and military commander of Herakleopolis and, through him, the granddaughter of King Osorkon II, fourth king of the 22nd dynasty (circa 850 B.C.). The statue's inscription also identifies its subject as the "wife of the hereditary prince and count, seal-bearer of the king of Lower Egypt, sole friend [courtier], prophet of Amun in Karnak, prophet of Montu lord of Thebes, correspondence scribe of Pharaoh, Hory." In honor of her father's association with Herakleopolis—from 1200 B.C. on an important government center just south of the Faiyum—this lady has had the image of Arsaphes, the buck of Herakleopolis, incised on her stomach, and the image of Osiris of Naaref incised on the front of her skirt. She is shown wearing a wig and a short-sleeved linen gown, but no jewelry.

The inscription on the statue clearly refers to the importance of Herakleopolis in the cult and politics of the time, but this figure did not stand there but rather at Thebes. Behind the figure of Osiris on the skirt, there is incised a figure of "Isis the great, the god's-mother, of the 'Great Mound of Waset [Thebes].'" The Great Mound of Waset was a cult temenos, or sacred space, at Karnak on the northeastern side of the Amun temple, founded in the early ninth century B.C. and dedicated to the Osirian triad. The earliest of an eventual six shrines in the temenos was the House of Isis, founded by Namlot, and adorned by Hory and Shepensopdet. It was as part of this adornment that this lady's statue was introduced into the small forecourt of the shrine. — *D.R.*

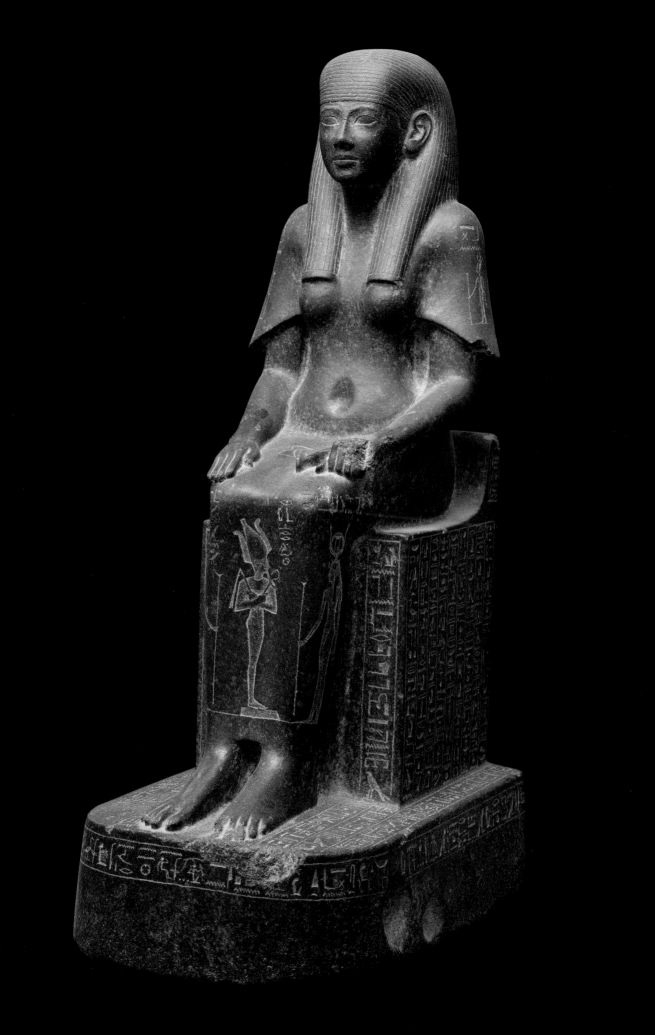

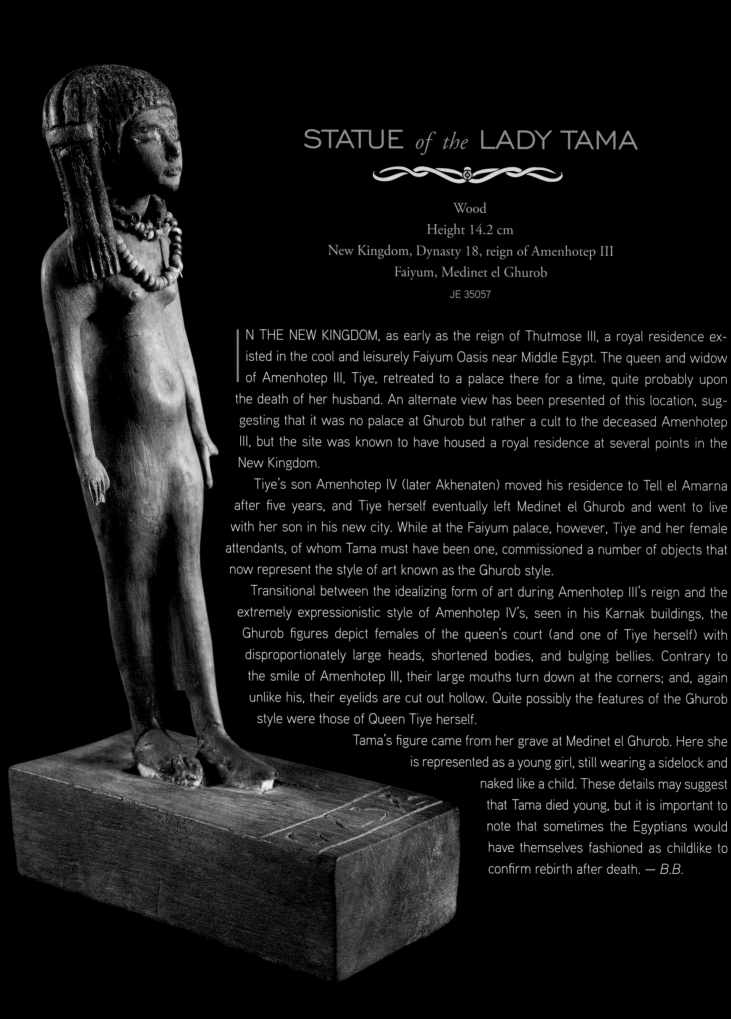

STATUE *of the* LADY TAMA

Wood
Height 14.2 cm
New Kingdom, Dynasty 18, reign of Amenhotep III
Faiyum, Medinet el Ghurob
JE 35057

I N THE NEW KINGDOM, as early as the reign of Thutmose III, a royal residence existed in the cool and leisurely Faiyum Oasis near Middle Egypt. The queen and widow of Amenhotep III, Tiye, retreated to a palace there for a time, quite probably upon the death of her husband. An alternate view has been presented of this location, suggesting that it was no palace at Ghurob but rather a cult to the deceased Amenhotep III, but the site was known to have housed a royal residence at several points in the New Kingdom.

Tiye's son Amenhotep IV (later Akhenaten) moved his residence to Tell el Amarna after five years, and Tiye herself eventually left Medinet el Ghurob and went to live with her son in his new city. While at the Faiyum palace, however, Tiye and her female attendants, of whom Tama must have been one, commissioned a number of objects that now represent the style of art known as the Ghurob style.

Transitional between the idealizing form of art during Amenhotep III's reign and the extremely expressionistic style of Amenhotep IV's, seen in his Karnak buildings, the Ghurob figures depict females of the queen's court (and one of Tiye herself) with disproportionately large heads, shortened bodies, and bulging bellies. Contrary to the smile of Amenhotep III, their large mouths turn down at the corners; and, again unlike his, their eyelids are cut out hollow. Quite possibly the features of the Ghurob style were those of Queen Tiye herself.

Tama's figure came from her grave at Medinet el Ghurob. Here she is represented as a young girl, still wearing a sidelock and naked like a child. These details may suggest that Tama died young, but it is important to note that sometimes the Egyptians would have themselves fashioned as childlike to confirm rebirth after death. — *B.B.*

STATUE *of* SHEPENWEPET II

Granite
Height 130 cm
Third Intermediate Period, Dynasty 25, reign of Shabitqo
Karnak Temple Cachette
JE 36694/CG 42200

THE STATUE DEPICTS SHEPENWEPET II, the daughter of Piya, pharaoh of the 25th dynasty (early seventh century B.C.). She is shown in her role as divine adoratress and god's wife of Amun.

Throughout the early first millennium B.C., the status of royal princesses, dedicated to the service of the great Theban god, rose to the point where one of their number was always selected to function as a kind of high priestess, appointed by the king, her father, to oversee the Thebaid. With her name in a cartouche accompanied by royal titles, the divine adoratress presided over the House of Amun as a titular head.

Celibate like all occupants of the office, Shepenwepet II had been adopted by her aunt, Amenirdis I, the incumbent divine adoratress, and the two frequently appear together in the many chapels built in and around Karnak to honor them both. — *D.R.*

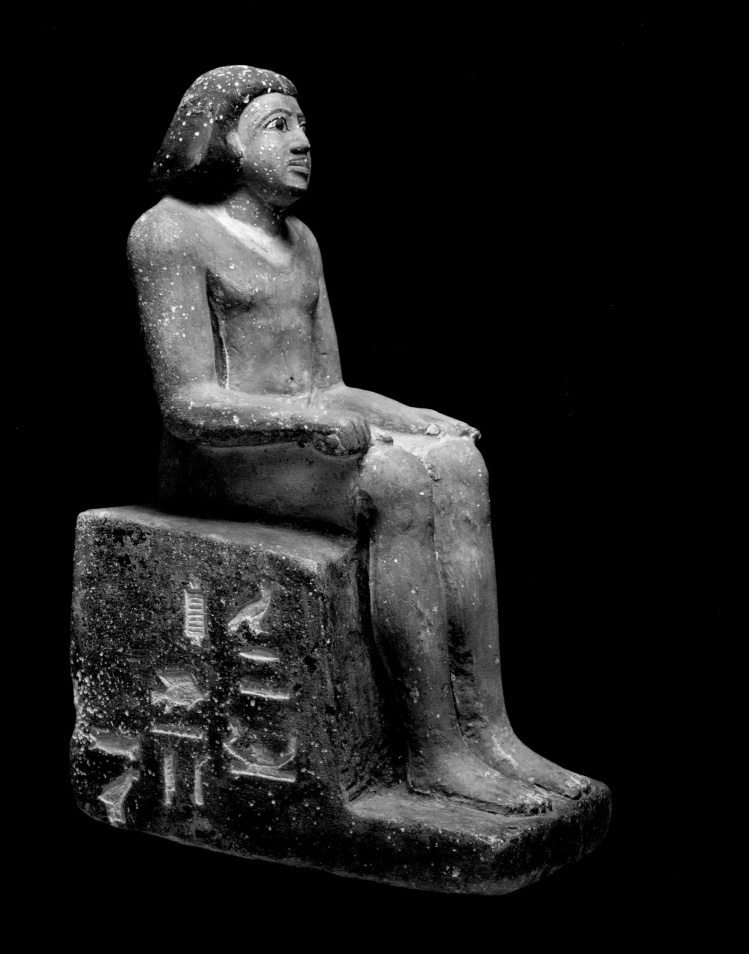

PHARAOH'S COURT

SMALL SEATED STATUE OF INTY-SHEDU, *see page 150*

IN THE EGYPTIAN HIERARCHY, the king took the role of the god on earth and delegated power to his officials. The most important people in the court of the pharaoh were his viziers; by the New Kingdom, there was one vizier for the north of Egypt, residing in Memphis, and one for the south, living in Thebes. The instruction of Thutmose III to his vizier Rekhmire, inscribed on the walls of the latter's tomb, outlines the duties of this high official, who stood second only to the king. From another Theban tomb, belonging to Hepu, comes a scene of his installation as vizier under Thutmose IV. He stands before the king, who holds in his hand a papyrus on which Hepu's principal duties are outlined. ❦ Another important official was the overseer of all the king's work, responsible for all the construction and decoration associated with the royal tombs. Although he is not known to have held this title, perhaps the most important royal architect in Egyptian history was Imhotep, credited with designing the Step Pyramid of Djoser at Saqqara. From the Old Kingdom, famous holders of this title include Hemiunu, who served under Khufu, and Ankhhaf, who was Khafre's architect; from the New Kingdom, Senenmut, architect to Hatshepsut, and Amenhotep, son of Hapu, who served under Amenhotep III, stand out in the historical record.

GIFTS FROM THE KING

In art dating from the New Kingdom, we see many scenes of kings honoring army leaders and important people in the court by giving them the "gold of valor": special necklaces of solid gold that were a mark of great distinction. Successful officials and generals were also awarded land and other gifts.

The king could also choose to award his officials by granting them their own statues or tombs. An example of this is Debehen, director of the king's toilette, who lived during the 4th dynasty. One day Debehen met King Menkaure and asked for a tomb, which was granted to him. It was an important event, so important that Debehen described it in his tomb autobiography. In the New Kingdom tomb of Kenamun at Thebes, we also have an example of a statue given by the king to one of his subjects.

The tomb of Nebamun at Thebes includes an autobiographical inscription indicating that the tomb owner was the chief of police on the west bank of Thebes under Thutmose IV. He lived into old age, and he kept this job until he was promoted to a higher position. Another tomb at Thebes, that of Amenhotep Sise, belonged to a second priest of Amun. Scenes in the chapel show Amenhotep Sise being rewarded by the king, with three registers behind him displaying the royal gifts given to the Temple of Amun. Amenhotep Sise is met by women from his family, who hold the title of chantress of Amun.

AMBASSADORS AND WORKMEN

The pharaoh both received foreign delegations in his court and sent ambassadors abroad. The tomb of one such official, Netjerwemes, from the reign of Ramesses II, was recently found at Saqqara. The archaeologist who discovered this tomb, Alain Zivie, believes that this is the same man who was part of the diplomatic mission that is believed to have been responsible for signing the first peace treaty in history—an agreement made between Egypt and their former enemies, the Hittites.

Supporting the elite and the royal administration were the lower levels of the bureaucracy, including priests and scribes of various sorts, and the artisans responsible for the vast building projects of the pharaohs. The necropolis and workmen's installation of the pyramid builders at Giza, the Middle Kingdom pyramid town of El Lahun, and the village

of the royal tomb builders at Deir el Medina all provide us with a great deal of interesting information about these levels of society, a group that ranged from master artisans and overseers to the men who dragged the stones for the pyramids and tunneled the tombs in the Valley of the Kings.

The houses of nobles and officials were pleasant and well furnished, even by today's standards, with chairs and chests. They were surrounded by gardens and pools. Beer and bread formed the principal diet for most Egyptians, although they also ate various types of meat and vegetables, among many other things. They played games, such as *senet,* and loved festivals and feasts. Dance and music were also important, particularly in the religious sphere.

AN OFFICIAL BURIAL

An interesting example of a member of a pharaoh's court who built an extensive tomb was Hetep, an official who probably served in the court of Amenemhat I at the new capital that the king built at Itj-tawy.

Hetep held a high position in the mortuary cult of the Old Kingdom pharaoh Teti, the first king of the 6th dynasty, as well as one in the cult of the reigning monarch, Amenemhat I. He chose burial in the cemetery of Teti. It is possible that Hetep had roots in this area and may have been an appointment that the new king, who had Upper Egyptian origins, made as part of his program to unify the country and truly nationalize his government. Clearly, the move north to the new capital was a step in that direction.

Amenemhat I was the first king of a new dynasty, and his reign represented a period of transition. During his reign, elements of the customs from his native Upper Egypt became mixed with and in some cases overshadowed by the Memphite traditions of the north.

Evidence of Memphite influence is clear in the tomb of Hetep, where a royal mortuary complex of the Old Kingdom appears to have served as the model for this construction of the Middle Kingdom. In his funerary monument, Hetep adopted and reinterpreted numerous components of earlier royal burials. He included an aboveground structure for mortuary rituals, a courtyard, statue niches, and a descending corridor to a burial chamber inscribed with funerary texts. He even aspired to burial in royal sacred space, and he secured it by placing his coffin in a chamber underneath Teti's enclosure wall.

BLOCK STATUE *of* HETEP

Granodiorite

Height 73 cm

Middle Kingdom, Dynasty 12, reign of Amenemat I

Saqqara, Teti Pyramid Cemetery, Tomb of Hetep

JE 48858/TR 12.5.21.24

HETEP PROBABLY SERVED in the court of Amenemhat I at the king's new capital at Itj-tawy. He had two statues fashioned for the aboveground chapel, one of white limestone and one of granodiorite. These two figures take an unusual shape. Some scholars have suggested that the rounded back may refer to sacred mounds associated with Osiris, and others have noted that their composition resembles that of an individual seated in a sedan chair. In fact, the adjacent Old Kingdom tombs contain representations in two dimensions of scenes depicting the tomb owner in such a carrying chair. Perhaps the palanquin had fallen out of fashion, and the statuary of Hetep represents an attempt by the artist to interpret a two-dimensional image as a three-dimensional one. Whatever the reason, the form allowed significantly more surface for extended inscriptional material, and, while this particular type did not continue to any great extent, it did serve as the inspiration for the block form that would become a staple of statuary of the Middle Kingdom and later. The facial features of Hetep seem to take their inspiration from an artistic style that survived in the provinces at the end of the Old Kingdom. — *D.S.*

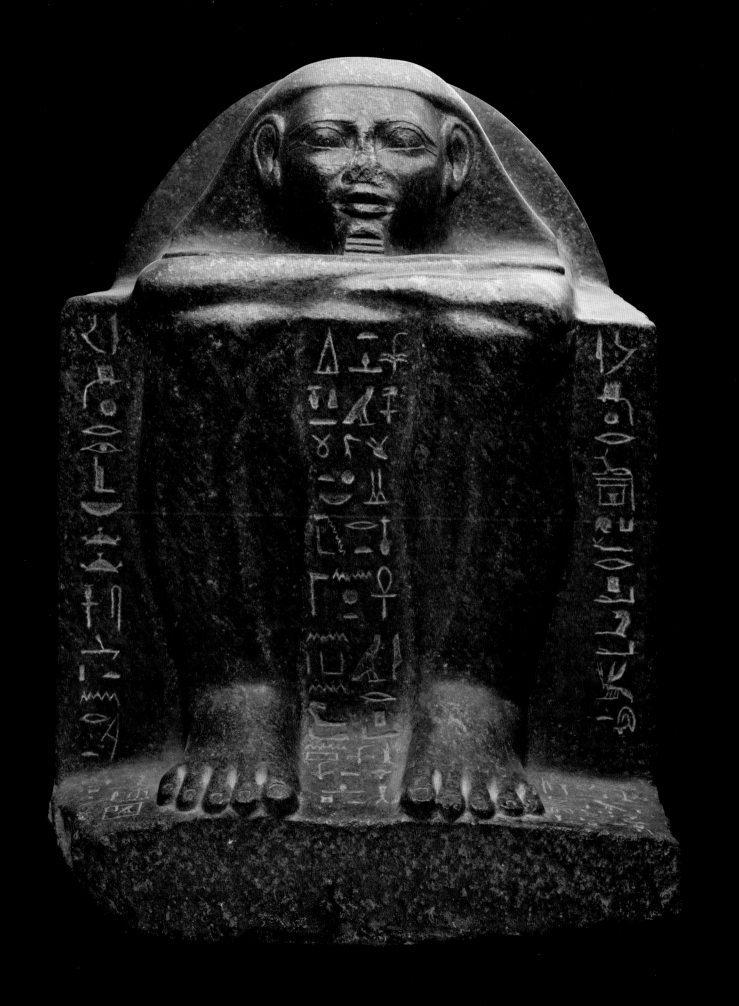

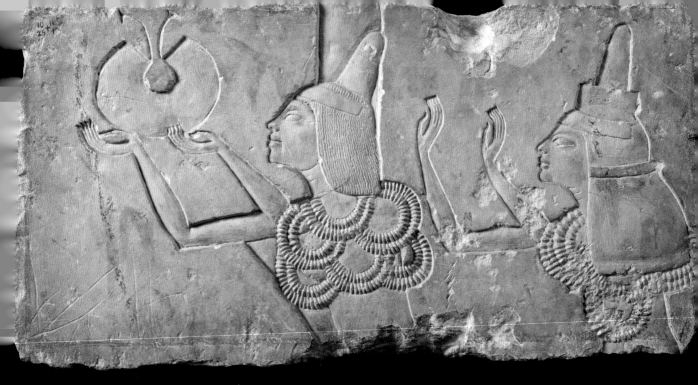

AY RECEIVING *the* GOLD *of* HONOR

Limestone
Height 27.5 cm ; width 54 cm
New Kingdom, Dynasty 18, reign of Akhenaten
Tell el Amarna, Tomb of Ay

TR 10.11.26.1

THIS RELIEF, REMOVED FROM THE TOMB OF THE COURTIER AY, was part of a wall scene where large figures of Akhenaten and Nefertiti dispensed rewards to their favored nobleman and his wife. The relief figures of Ay and Teye are carved in Amarna style. The collars worn by Ay suggest the gold rings called in Egyptian *shebiu* collars, given for bravery and loyal behavior on behalf of the sovereign. Teye appears to wear several sets of garlands that are not depicted as gold, and the collar that Ay catches in the scene also appears to be a floral type named the *wah*, meaning "endure." It is interesting to note that the arms of Ay form the position normally associated with offering, as if he receives and gives at the same time. Teye's arms, on the other hand, are in the classic hieroglyphic mode of

STATUE *of a* STANDARD-BEARER

Green breccia
Height 49 cm
New Kingdom, Dynasty 18, usurped during Third Intermediate Period
Karnak Temple Cachette
JE 36988/CG 42194

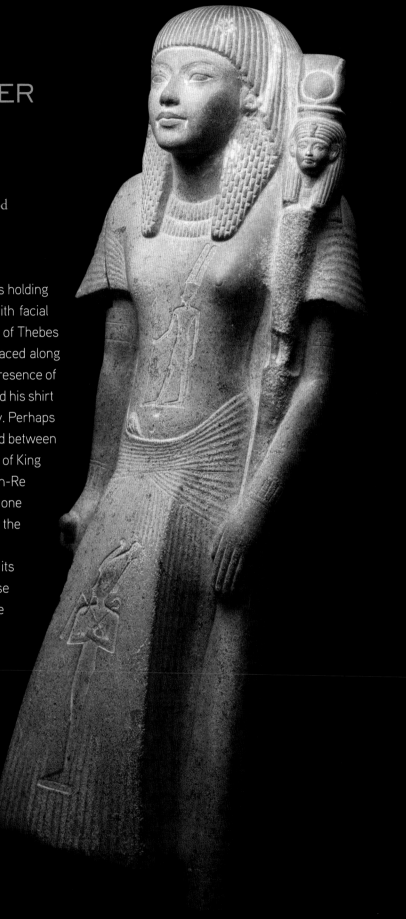

THIS STATUE REPRESENTS A NOBLEMAN of the late 18th dynasty who is holding the emblem of the goddess Mut. The statue dedicant was fashioned with facial features similar to those of Tutankhamun or Ay, in the time after the cults of Thebes were revived and refurbished. This man's statue was one that probably was placed along the central aisle of the Karnak temple, since the standard-bearers indicated the presence of the *kas* of the gods along the processional routes. With his long echeloned wig and his shirt with billowing sleeves, this man was dressed in the finery of the late 18th dynasty. Perhaps his statue stood along the central processional way for the 400 years that elapsed between its dedication at Karnak and its second life as the image of prince Sheshonq, son of King Osorkon I of the 22nd dynasty. Prince Sheshonq was the high priest of Amun-Re and chief of the army, and so his role within Thebes was certainly an important one that included not only leading the clergy of Karnak but also keeping the peace in the region, perhaps a harder job than in the time of Tutankhamun.

Sheshonq's reuse of the statue included having two gods carved on its front. On his abdomen is Amun-Re himself, while on the kilt is Osiris, whose presence in Karnak was expanding at this time. Note that these divine images are facing left, and we may suggest that, as the statue itself faced into the left, or north, side of the central aisle of the temple, in the manner of standard-bearers, these two gods faced out of the shrines and met all those who entered. Had the statue stood on the right side of the aisle, however, the gods would have been carved to face right for the same reason. — *B.B.*

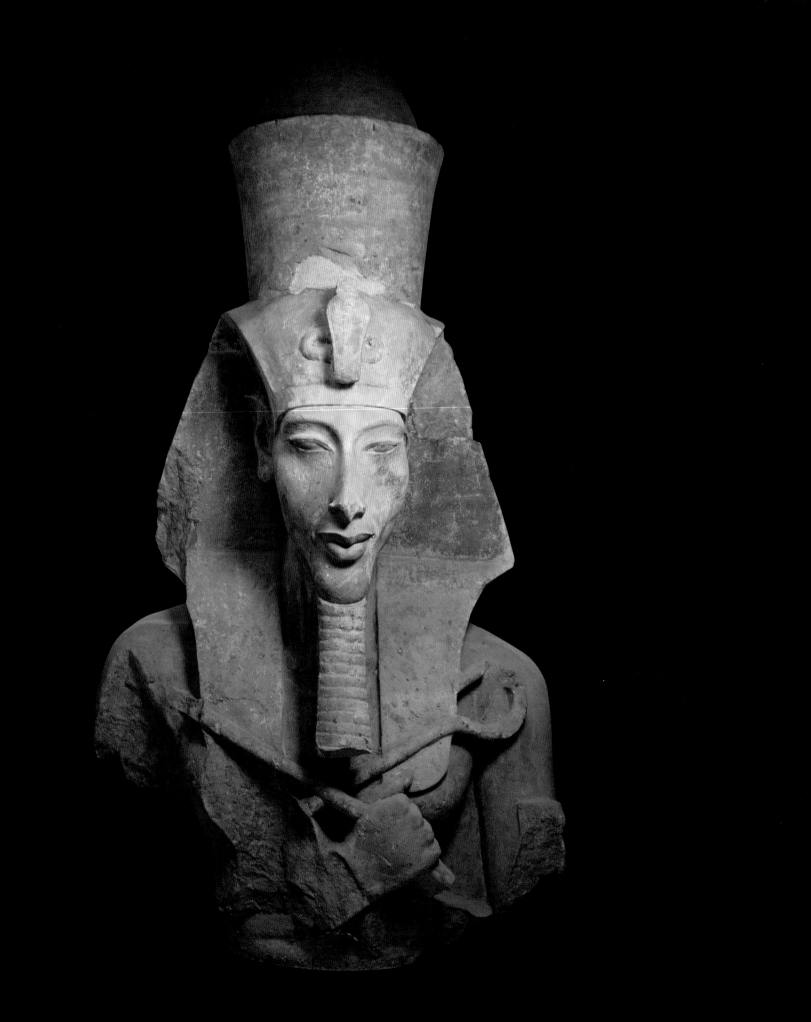

COLOSSAL STATUE
of AMENHOTEP IV/AKHENATEN

Sandstone

Height 205 cm

New Kingdom, Dynasty 18, reign of Akhenaten

Karnak East, Temple of Gempaaten

JE 98915

THE NUMEROUS COLOSSAL SANDSTONE IMAGES of Amenhotep IV enhanced the colonnade of the king's temple to the Aten at East Karnak. They were placed against large square pillars in a manner similar to the Osiride images of Hatshepsut at her Deir el Bahri temple. Amenhotep IV worshipped the god Aten in this temple, and for the first time depicted his god in the disembodied form of the sun disk with rays terminating in hands. Other gods were not shown in the temple, and Amenhotep IV's rather expressionistic portrait type served to fill the gap of human forms. He appeared in many different types of crowns on these statues, perhaps hoping to suggest the aspects of the solar deity. His double crown here, atop the nemes-headdress, alludes to the living king as representative of the sun god; the same crown atop the khat-headdress alludes rather to the rejuvenation of the king and the sun by means of the jubilee. The four feathers atop the nemes invoke the god Shu, the active aspect of the sun whose role Amenhotep IV sought to adopt.

In all of these, Amenhotep IV himself appears with an exaggeratedly long face, hollowed eyes, and long knobby chin. His body has enlarged breast areas, a paunchy belly, and swollen thighs. The surface of his sculpture is angular and creviced, at the face or the torso or below. As the king's god, the sun disk, rose and brought his changing light to the temple of Gempaaten, these statues changed constantly. In the early morning, the king's face softened from the rosy sunlight; in midmorning, some patches were bright while others were nearly dark. At midday, the sun god provided full and direct light across the statues, and everything was visible into the deepest little areas hidden behind the king's hands. But later, as the afternoon wore on, the lowering, slanted sun created shadows all over. Finally the face of the king was lost in shade. For Amenhotep IV, this god revealed himself in daylight, and so the king's statues might have been thought to do the same. — *B.B.*

LARGE STATUE *of* INTY-SHEDU

Painted limestone
Height 75 cm
Old Kingdom, Dynasty 4
Giza, Upper Cemetery of the Pyramid Builders
JE 98945

THIS STATUE SHOWS INTY-SHEDU seated on a backless chair, wearing a wig and short kilt. In his right hand he holds a piece of linen; his left hand rests on his lap. On the right side of the chair is a hieroglyphic inscription with Inty-shedu's name and the unusual title of "overseer of the boat of Neith," which seems to indicate that he was a carpenter and shipwright attached to the temple of this goddess. The inscriptions also bear the title "king's acquaintance," a testament to the prestige that Inty-shedu enjoyed in life.

This statue was found, along with three smaller companions, by Zahi Hawass in Inty-shedu's tomb in the upper cemetery of the Pyramid Builders at Giza. The decayed remains of a fifth statue, made of wood, lay near them on the ground. The five statues had formed a group with the largest at the center and two smaller staues on either side. Two of these smaller statues were seated, and it seems reasonable to assume that the decayed wooden piece, like the fourth limestone example, represented the deceased standing.

The group was placed in the tomb's serdab, a small, sealed chamber used to house statues thought to contain the ka, or life force of the deceased. From a small slit in the wall of the serdab, the statues were believed to be able to peer out, observing visitors to the tomb and receiving offerings. A typical serdab might contain only one statue, but some—including Inty-shedu's—contained a group of statues of the tomb owner, perhaps representing him at various stages of his life.

The powerful build and facial features of this statue suggest a mature man, and the inclusion of the title "king's acquaintance" indicates that this statue depicts Inty-shedu at the height of his career. — *Z.H.*

MID-SIZED STATUE *of* INTY-SHEDU

Painted limestone
Height 40 cm
Old Kingdom, Dynasty 4
Giza, Upper Cemetery of the Pyramid Builders
JE 98946

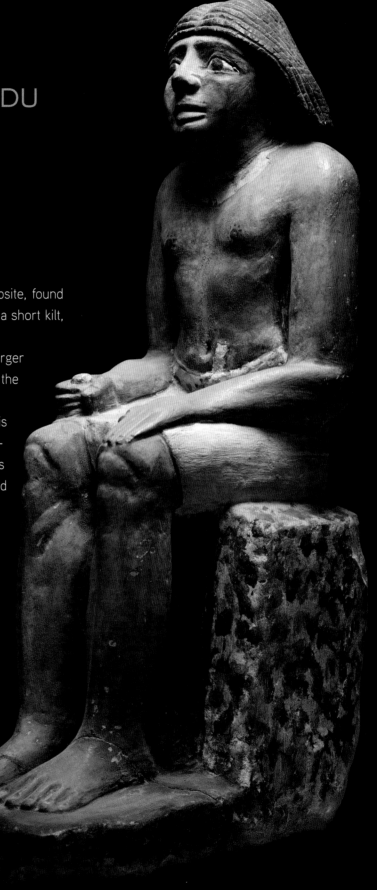

THIS SEATED STATUE is similar in many details to the larger one, opposite, found with it in Inty-shedu's serdab: It also shows the tomb owner dressed in a short kilt, wearing a wig and a broad collar, and sporting a thin mustache.

In style, however, this statue gives a less forceful impression than does the larger one that it accompanied. The shoulders are not as broad, and the muscles of the torso are less defined than in the other piece.

In this statue, Inty-shedu sits on a backless chair, on the side of which is inscribed the title "overseer of the boat of Neith." Here is another point of comparison with the larger statue, for on this mid-size piece the title of "king's acquaintance" is absent, perhaps indicating that this statue was intended to represent Inty-shedu before he had received the more exalted title. — *Z.H.*

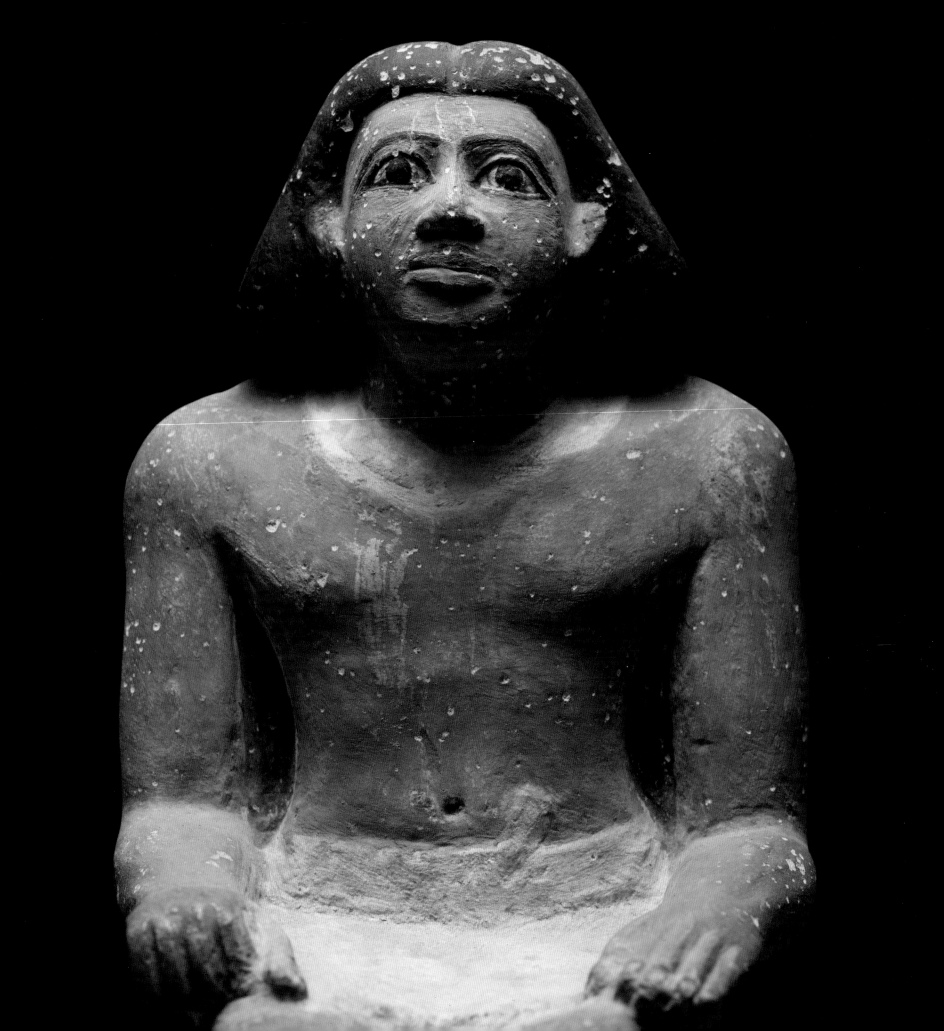

SMALL SEATED
STATUE *of* INTY-SHEDU

Painted limestone
Height 32 cm
Old Kingdom, Dynasty 4
Giza, Upper Cemetery of the Pyramid Builders
JE 98947

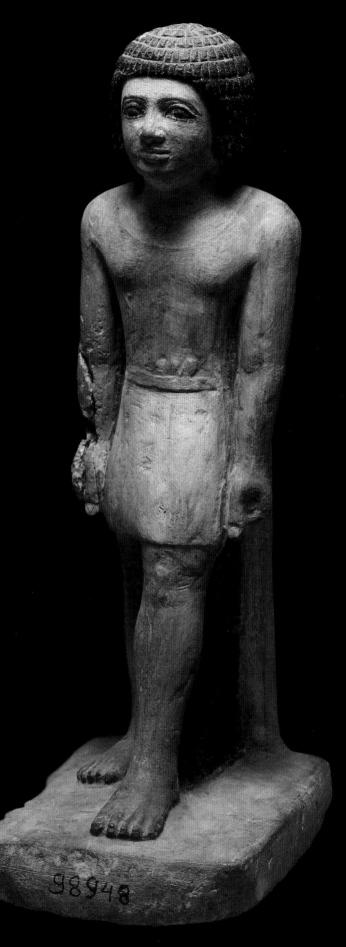

IKE THE TWO OTHER SEATED STATUES of Inty-shedu, this one, opposite, shows him wearing a short kilt and a broad collar. He wears a wig slightly different from those portrayed in any of the other accompanying statues, however, since it flares slightly at the bottom. Like the mid-size statue, this piece shows the tomb owner as a mature but still youthful man. — *Z.H.*

SMALL STANDING
STATUE *of* INTY-SHEDU

Painted limestone
Height 32 cm
Old Kingdom, Dynasty 4
Giza, Upper Cemetery of the Pyramid Builders
JE 98948

HE ONLY STANDING STATUE FOUND INTACT in Inty-shedu's *serdab* shows him in his youth, with lighter skin and more delicate features than those seen on the other pieces in the group. The title inscribed on the base of this statue refers to him simply as the overseer of Neith, not the overseer of the boat of Neith. He is shown wearing a short kilt and broad collar, but his wig is quite different from those of the seated statues; it is shorter and made up of ten rows of ringlets that radiate from the crown of the head. — *Z.H.*

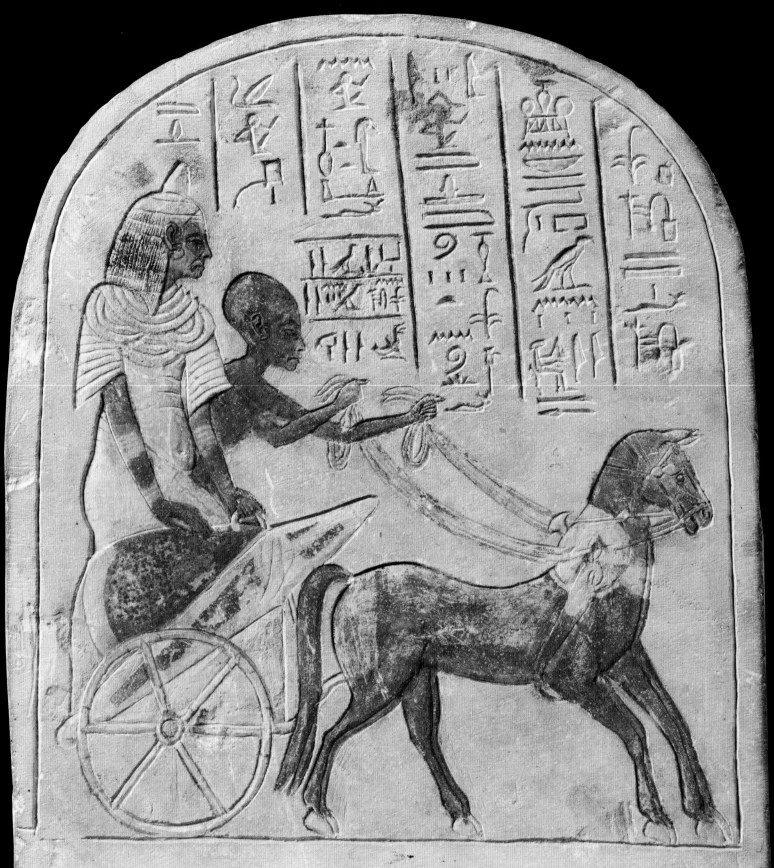

STELA *of* ANY *in a* CHARIOT

Limestone
Height 27 cm
New Kingdom, Dynasty 18, reign of Akhenaten
Tell el Amarna, Tomb of Any
JE 29748/CG 34177

FOUND ALONG WITH FIVE OTHER OFFERING STELAE, this piece comes from the Amarna south tomb number 23 of Any. Labeled here as the royal scribe, his truly beloved, scribe of the offering table of the lord of the two lands, and steward, Any's small stela celebrates his being decorated by Akhenaten with his favors—the large gold necklaces around his neck and a statue or coffin with funerary endowment. Any is shown returning from this award ceremony, driven by his charioteer, Tjay.

Any's tomb at Amarna was only partially decorated, and today only the entrance jambs and two scenes carry visible decoration. None of the scenes there include Any's reward by the ruler, and this stela may well celebrate a recent event that had consequently not been carved on the tomb walls. Yet the titles of Any in his tomb are the same as those on the stela, suggesting that not a great deal of time elapsed between the tomb's decoration and the making of the small stelae.

During the New Kingdom, chariots and horses were the equivalent of luxury racecars today and were entirely the province of royal and elite owners. At Amarna, however, there was an additional significance to the chariot scene. The king himself lived in a palace at the north end of town, and each day he drove southward along the royal road that bisected Amarna between east and west. At the great temple to the god Aten, Akhenaten dismounted from his chariot and, with his wife and daughters, entered the temple to make offerings to the sun-disk Aten. Thus the reference that Any makes on his stela is emulative of the king's own ritual activity and indicates that Any, too, would act on behalf of his king and the Aten in a similar daily cycle. — *B.B.*

STATUE *of* IMHOTEP

Bronze
Height 21 cm
Late Period
Saqqara, Serapeum
JE 375/ CG 38048

THE HISTORICAL IMHOTEP had held priestly and administrative functions during the reign of Djoser of the 3rd dynasty (circa 27th century B.C.), and in this capacity he is often considered the author and architect of the Step Pyramid. Beginning in the New Kingdom, and perhaps earlier, his legendary wisdom conferred on him the status of an archetypal wise man and healer who could intercede for the good of his worshippers. A cult grew up around Imhotep, treating him as a semidivine being who could cure disease in the same capacity as the Greek Asclepeius, with whom he is sometimes identified in the Late Period. Representations of Imhotep are common from the Late Period, especially in the form of bronzes (as shown here). These statues consistently show him as a seated or standing man with shaven head, in association with the priestly practice. The resultant bald head is also reminiscent of the depiction of the god Ptah. — *D.R.*

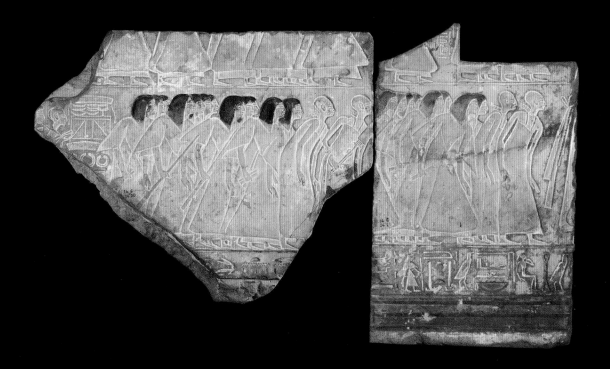

RELIEF SHOWING *the* ARRIVAL *of* SCRIBES *and* DIGNITARIES

Limestone
Height 102 cm
New Kingdom, Dynasty 19
Thebes, Assasif
TR 14.6.24.20

DERIVING FROM A TOMB IN THEBES, this relief depicts a procession of important members of the community, wearing their pertinent garb and carrying their insignia of office or status. The inscription beneath the scene contains the tomb owner's claim to have been "made great among the magistrates," and one might conclude that the dignitaries here are in attendance at his funeral. At the rear of the procession may be seen tables carried by a servant upon which are floral collars such as those distributed at funerary banquets. The figures at the front of the line of attendees represent the viziers, while the figure on the far right, clearly at a larger scale, could have been the focus of the event, but exactly what these images represent remains unclear. — *B.B.*

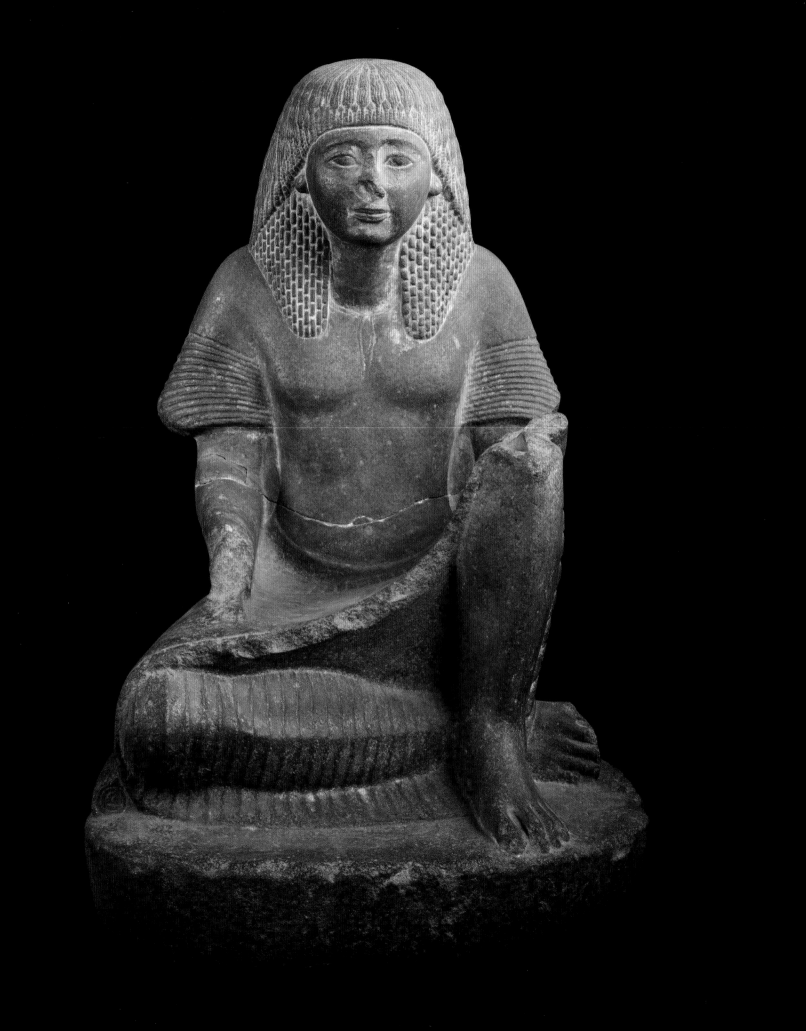

SEATED STATUE
of the SCRIBE HAPY

Quartzite

Height 71 cm

New Kingdom, Dynasty 19, reign of Ramesses II

Karnak Temple Cachette

JE 36914/CG 42184

THIS STATUE REPRESENTS HAPY, A STEWARD OF AMUN from the reign of Ramesses II. Although it is a scribal statue and the figure holds a pen in his right hand, his left leg is raised out of the traditional writing pose, perhaps to suggest the act of reading. Hapy wears an elaborate sleeved shawl that covers his kilt down to the ankles. The pleating of the transparent shawl is indicated by incised lines on Hapy's right leg in a highly imaginative bit of sculpting.

This statue represents the best of Ramesside artwork, and it suggests that Hapy was a man of some influence. The inscription dedication invokes not only Amun-Re and his consort Mut, here called the "eye of Re," but also the God's Wife of Amun Ahmose-Nefertari, the deified queen who is here referred to as a major goddess. — *B.B.*

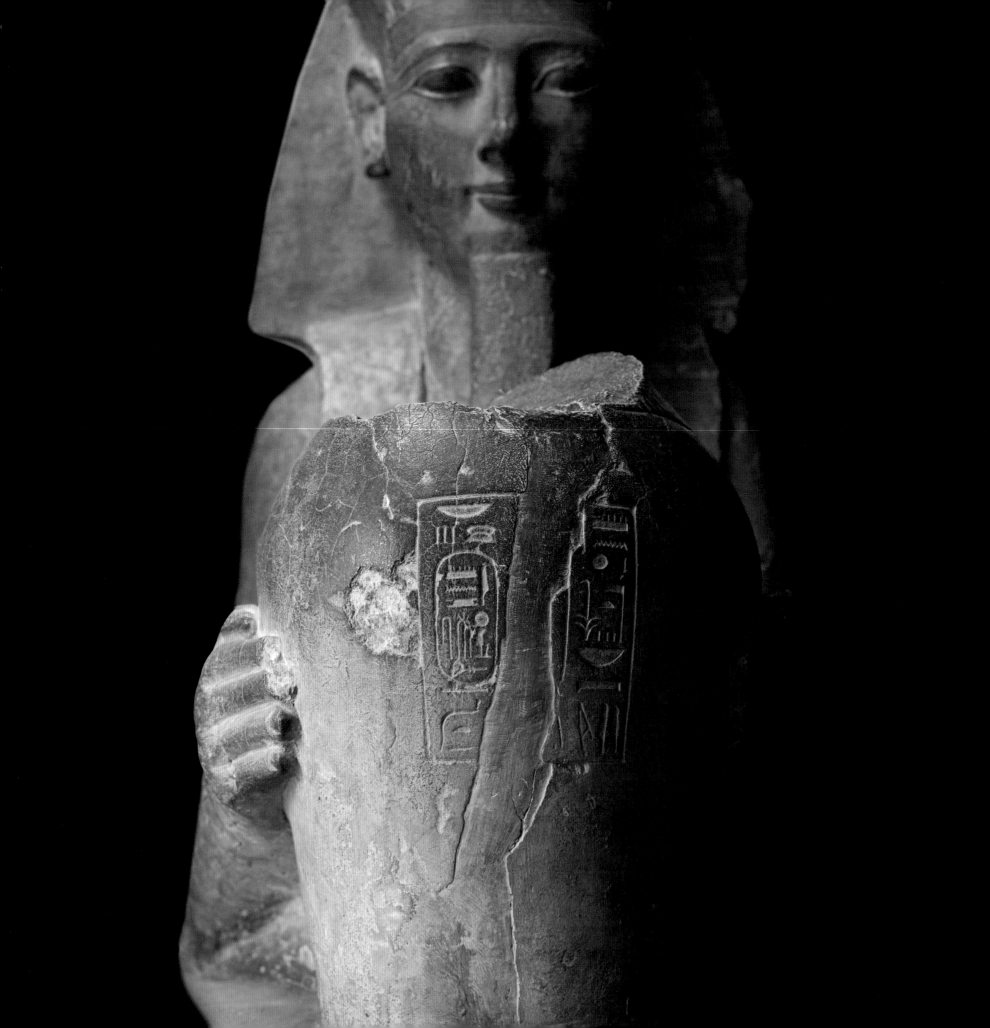

PHARAOH'S RELIGION

SPHINX OFFERING A VASE, *see page 163*

THE PHARAOH WAS THE INCARNATION of the divine on earth, the terrestrial representative of the gods. He was also, especially after death, counted as one of the gods himself. At the same time, he was the human high priest of every god, responsible for proper care of the gods worshipped in the many state temples built throughout the country. In the scenes that cover the walls of these temples, the pharaoh is shown in a reciprocal relationship to the gods: He carries out the proper offerings and rituals, and in return he is given the right to rule; together, king and gods maintain the proper order of the universe. ❧ Although in theory the king was the principal officiant for the temple cults, in reality, he could delegate many of these functions to representatives. These representatives were the high priests, important officials appointed to serve the state gods of Egypt. The high priest of the sun god at Heliopolis bore the title *wer maau*, or greatest of seers. There is evidence that the priests of this cult were astronomers, responsible for keeping the festival calendars according to the movement of the heavenly bodies. The high priest of Ptah in Memphis was called the chief of artisans. In Akhmim, the high priest of Thoth was called the great five of the House of Thoth. In the New Kingdom,

the high priest took on the role of the king in the temple, performing daily rituals on behalf of the monarch. Only the high priest could enter the inner sanctuaries where the images of the gods lived. He also supervised the vast administrations that developed to serve the gods and care for their earthly estates, which served as major centers for the redistribution of Egypt's wealth.

During certain periods of Egyptian history, the position of priest, and especially the priesthood of Amun in particular, involved significant political power. Some high priests challenged the authority of the pharaohs or even took the Egyptian throne for themselves.

CHIEF EGYPTIAN CULTS

The worship of Re, the sun god, was the principal cult for the Egyptians from early in their history. The pyramid was a symbol for this god. Associated with Atum, Re was the creator god at Iunu (the On of the Bible, known as Heliopolis to the Greeks). The daily solar cycle was thought to echo the cycle of life, with sunset parallelling death and sunrise parallelling resurrection. Thus Re, the sun god, is associated with cyclical, eternally repeating time.

Osiris was also known from at least the Old Kingdom; the first time that we see his name on a monument dates to the reign of Djedkare, in Dynasty 5. The myth of Osiris is one of the oldest in Egyptian history, however, dating back to the Predynastic Period. This legend has many fundamental truths embedded in it, such as the triumph of good over evil. It also conveys the Egyptian belief that death was not the end, but only a transition to a different state of being. Osiris represented fertility and the flood. If the flood was low, it meant that Osiris was dead; when the water level became higher, it meant that Osiris was coming back to life. Thus the god Osiris is linked with linear time, time with a beginning and, eventually, an end.

The myth of Horus and Seth was handed down through the Roman author Plutarch. The story begins in primordial time, when Geb was the god of the earth. When he tired of this role, he handed the terrestrial throne to his son, Osiris. Geb's second son, Seth, was jealous, and conspired to kill Osiris, then locked his body in a chest and threw it into the Nile. Isis brought Osiris as a pillar from the palace of the king of Byblos and revived him long enough to conceive a son, who took revenge on Seth when he reached his majority.

Osiris became the king of the netherworld. Egyptians believed that after his death, the king joined with Osiris in the depth of the night and was reborn as Re in the morning. For that reason, the deceased king is often shown in the mummiform shape of Osiris. From the reign of Unas on,

the kings inscribed Pyramid Texts in their burial suites, in the belief that this collection of spells helped the king reach the other world to meet Osiris. During the First Intermediate Period and the Middle Kingdom, these spells developed into Coffin Texts, used primarily by the elite. In the New Kingdom, the kings decorated their tombs with scenes and texts from a series of elaborate funerary books, such as the Imy-duat (What Is in the Netherworld) and the Book of Gates. Their tombs were constructed as passages, corridors, and chambers that led the king on his quest for eternity. The texts in the later royal tombs included the Book of Coming Forth by Day. Known commonly as the Book of the Dead, it was also used by the elite and the common people and usually written on papyri that were buried with them in their tombs.

Another extremely important god, first coming to the fore in the Middle Kingdom and increasing in power and influence in the New Kingdom, was Amun. A local god of Thebes, he was also one of the eight gods of Ashmunein. After the defeat of the Hyksos by the Theban princes, he became the main god of the empire and king of the Egyptian pantheon. He was syncretized with a number of other gods, such as Re, Min, and Khnum. As Amun-Re, he became one of the principal creator gods, along with Atum of Heliopolis and Ptah of Memphis. The monarchs of the New Kingdom identified themselves as sons of Amun and legitimized their claims to the throne through this god. Amun remained important through the Third Intermediate Period, and was the principal god of the Kushite 25th dynasty.

Long before Alexander the Great conquered Egypt in 332 B.C., Egypt had been in close contact with the people of the Aegean. The famous city of Naukratis was declared a Greek free-trade zone by Pharaoh Amasis in 560 B.C. Greek soldiers served as mercenaries in the armies of Psamtik I in the seventh century B.C. Greek mercenaries and traders spread stories back home about Egypt and gave Greek names to Egyptian deities and sites. The word "Egypt" itself is Greek in origin, apparently deriving from a corruption of the ancient name for Egypt's capital, the city we call Memphis. In Egyptian texts, Memphis was referred to as Hwt-ka-Ptah, which means "the temple of the ka (or life force) of the god Ptah." In Babylonian texts, this name appears as Hi-ka-ptah, and the Greeks seemed to have made it their own: "Aigyptos."

The Greeks assumed that Egyptian deities were the same as their own gods, but in different forms. Zeus was identified as Amun-Re and often depicted with a ram's head. In fact, Alexander the Great crossed Egypt's Western Desert to consult the oracle of Amun-Zeus in the Siwa Oasis. Apollo was identified with Horus; Thoth, the Egyptian god of wisdom, was identified with Hermes. Isis was identified with Aphrodite and remained an important goddess throughout the Greco-Roman period.

STELA *of* AMENHOTEP I *and* AHMOSE-NEFERTARI

Limestone
Height 52 cm
New Kingdom, Dynasty 18
Thebes, Sheikh Abd el Qurna
JE 27573/CG 34337 [34037]

THIS STELA IS ONE OF TWO NEARLY IDENTICAL PIECES dedicated on behalf of two Egyptian workers of the late 18th dynasty. It depicts two rulers, Ahmose and Amenhotep I, as well as Ahmose-Nefertari, a queen and god's wife of Amun. Dating the piece is complicated, though, and a date contemporary with the reigns of these two rulers, at the beginning of the 18th dynasty, is ruled out by the post-Amarna style of the figures and by the absence of mutilation to the name of Amun. Any monument visible in Thebes during the reign of Akhenaten was attacked to erase the name and image of the Theban deities, so a piece without such mutilation must belong to a period after that. The round faces, the snub noses of the kings, and the swollen bellies of the two offerers all suggest a date soon after the time of the Amarna revolution, in the mid-14th century B.C. Dating this piece to the reign of Tutankhamun is greatly favored, since the images of the kings resemble him.

The dedicants of this stela and its twin in the Brooklyn Museum are Huy—the servant who hears the call of Amun—and Sementawy—the pure priest and adjutant. Quite likely both these men were artisans, and they may have been part of the crew newly forming to build the tombs in the Valley of the Kings. Those artisans reinhabited Deir el Medina at the end of the 18th dynasty, but craftsmen had been there before the Amarna period as well. The population of Deir el Medina venerated King Amenhotep I; his mother, Ahmose-Nefertari; and the other early 18th-dynasty rulers. They invoked them as intermediary gods, believing that the normal travails of life were influenced by enemies in the land of the dead and that these deities could exert powers there on their behalf.

These two stelae may have been set up in a small personal shrine in Deir el Medina itself, or they may have been associated with an actual tomb chapel. — *B.B.*

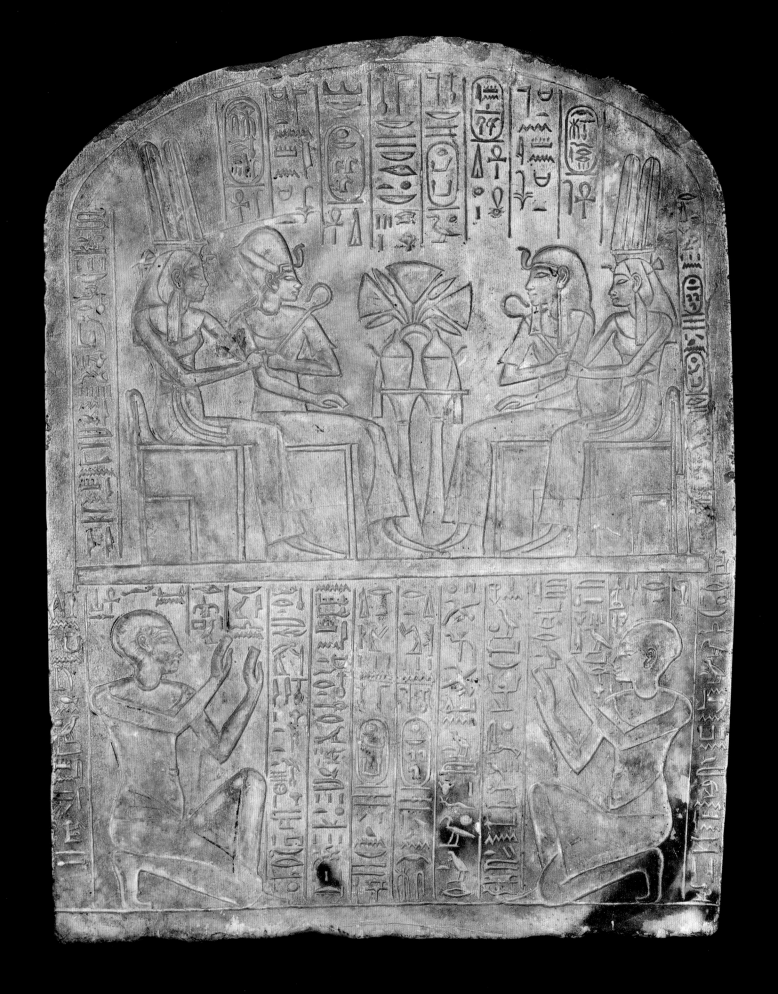

STATUE *of* KAI *and* HIS CHILDREN

Painted limestone
Height 56 cm
Old Kingdom, Dynasty 4
Giza, Western Cemetery, Tomb of Kai
JE 99128

THIS STATUE SHOWS THE PRIEST KAI with his son and daughter. Kai is seated in a high-backed chair and wears a short, pleated, white kilt and a *wesekh,* or broad collar. In his right hand, which is placed on his chest, he holds what may have been a piece of rolled linen. His left arm rests on his thigh. Kai's facial features have been carefully modeled and detailed. The eyes are inlaid in calcite, with pupils of rock crystal, which give them a lifelike appearance. They are outlined with copper, which over time has taken on a green patina. His body is also well sculpted, with the chest and shoulders strongly modeled and the collarbone well defined. The legs are heavy and muscular, with thick ankles.

Kai's daughter, named in the inscription above her head as Nefret-ankh, sits beside his left leg, which she embraces with her right hand. Her pose, with her legs tucked underneath and slightly to the side, is unusual and remarkably natural. Although her figure is quite small, its details have been carefully rendered. Her eyes are shown as if outlined with kohl and the rows of beads on her wesekh-collar are indicated in different colors.

Kai's son is identified in an inscription as the scribe Shepses-ka. He is shown wearing the sidelock of youth and holding his finger to his mouth in a gesture which signified childhood in Egyptian art. — *Z.H.*

SPHINX OFFERING *a* VASE

Limestone
Height 90 cm
New Kingdom, Dynasty 18,
reused during Dynasty 19, reign of Ramesses II
Provenance unknown

TR 2.11.24.2

THE FRONT OF THIS LIMESTONE SPHINX is preserved and represents a king of the first half of the 18th dynasty in an offering pose. During the 19th dynasty the name of Ramesses II was added to this piece, whose original provenance remains uncertain. Carved on a monumental scale, the statue represents the ruler with the body of a lion and the head and arms of a man, holding a vase dedicated to the god. On temple walls representations of such statues are shown as actual vessels containing ointments for anointing divine images. Thus the king is here offering cult necessities to the god in perpetuity. — *B.B.*

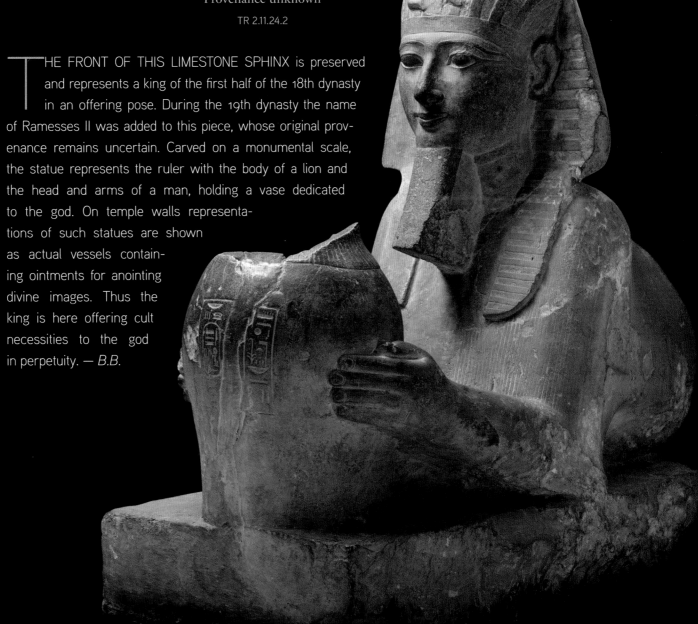

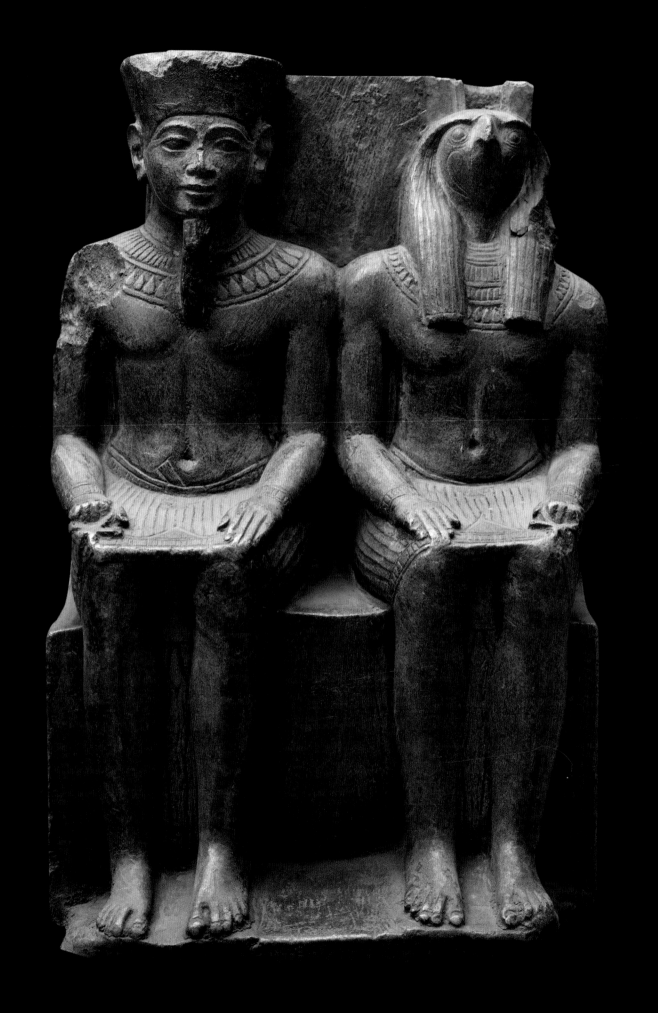

DYAD *of* AMUN *and* RE-HORAKHTY

Greywacke

Height 18.8 cm

New Kingdom, Dynasty 19, reign of Ramesses III

JE 67923

THIS SMALL DYAD REPRESENTS two of the major gods of Egypt in the New Kingdom, Amun-Re and Re-Horakhty. As a votive statuette that was dedicated by one or two scribes, this piece represents a form of personal religion that allowed the average Egyptian to connect with the great temple deities. The text on the rear is of interest:

> Behind Amun-Re:
> *A gift which the king gives to Amun-Re, lord of the sky, lord of the land, whom the gods praised as they are completed through him. May he cause that my body sit well in joy until I reach veneration at rest, for the ka of the scribe Tuyuwia. Made by the scribe Tuyutia.*

> Behind Re-Horakhty:
> *A gift which the king gives to Re-Horakhty* [changed from Seth] *the victorious, lord of virility, the mighty falcon in the forefront in the ship of millions* [the sun god's boat]. *May he give a good lifetime to the one who is his son, a good burial after old age in the great west of the city. For the ka of the scribe Tuyutia.*

This statuette's inscription was originally dedicated not to Re-Horakhty and Amun-Re but to Seth and Amun-Re. Of further interest, Amun is not referred to as the god of Karnak Temple, where he was called "lord of the thrones of the two lands," but rather is named "lord of the sky and the land." It may be that this statuette belonged to a functionary from the north residence at Pi-Ramesses, where Seth remained a major deity. The falcon deity's head may have been altered on the statuette, changing the ears and muzzle of the Seth animal to accommodate the beak of the sun god. Stylistically, this small votive shows features typical of the reign of Ramesses II, and the prayerlike inscription is also characteristic of the period. — *B.B.*

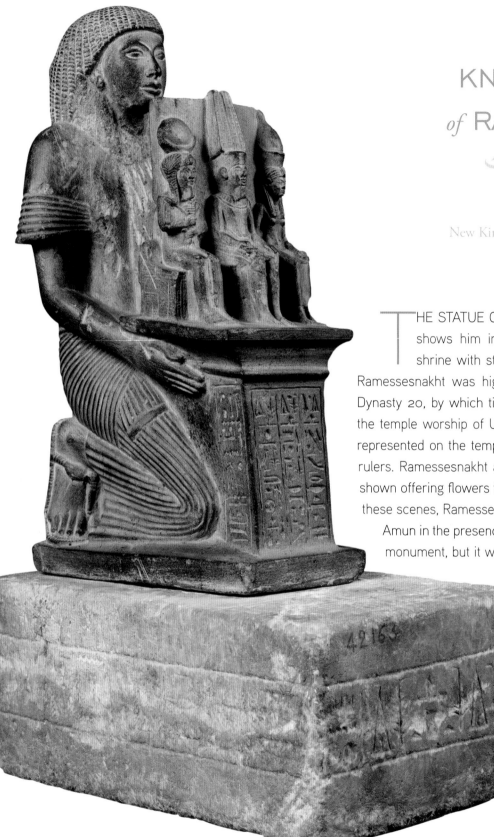

KNEELING STATUE
of RAMESSESNAKHT

Greywacke, calcite (base)

Height 41 cm

New Kingdom, Dynasty 20, reign of Ramesses VI

Karnak Temple Cachette

JE 37186/CG 42163

THE STATUE OF THE HIGH PRIEST of Amun-Re, Ramessesnakht, shows him in a pose of great piety, holding and presenting a shrine with statues of the Karnak gods, Amun, Mut, and Khonsu. Ramessesnakht was high priest during the reign of Ramesses VI, late in Dynasty 20, by which time the kings were less often directly involved with the temple worship of Upper Egypt. Consequently high priests began to be represented on the temple walls, sometimes nearly in the same manner as rulers. Ramessesnakht appears on the eighth pylon at Karnak, where he is shown offering flowers to Amun and Khonsu and greeting Amun and Mut. In these scenes, Ramessesnakht is promised "life, prosperity, and health" from Amun in the presence of the king. Thus the high priest's statue was a fine monument, but it was not the only indicator of his high status within the Theban clergy. — *B.B.*

STATUE *of* STANDING OSIRIS

Schist
Height 91 cm
Late Period
Karnak Temple Cachette
JE 37397/CG 48645

THE GOD WEARS THE *ATEF*-CROWN WITH A URAEUS, sports a false beard, and carries the crook and flail over his shoulders. All these are accoutrements shared by the royal and Osirian ideologies. Osiris was the hypostasis of royalty and the "king-in-death," a role that transformed him into the great ruler of the dead and the ultimate source of mortuary power and judgment. Combined with all these functions was his ineffable association with fertility in all its forms, and especially with the Nile. In the Late Period, the cult of Isis and Osiris developed an aspect of personal salvation, which promised protection from damnation to devotees. In the Greco-Roman Period, this cult transformed itself into one of the international mystery religions. — *B.B.*

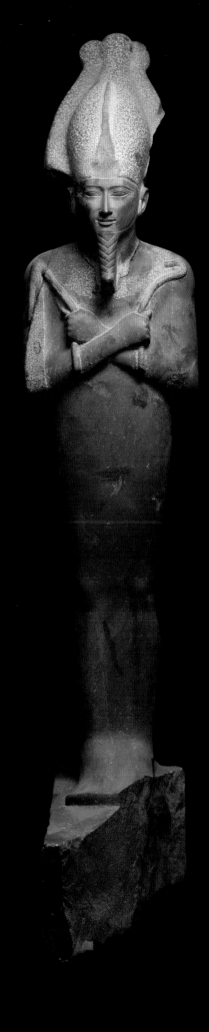

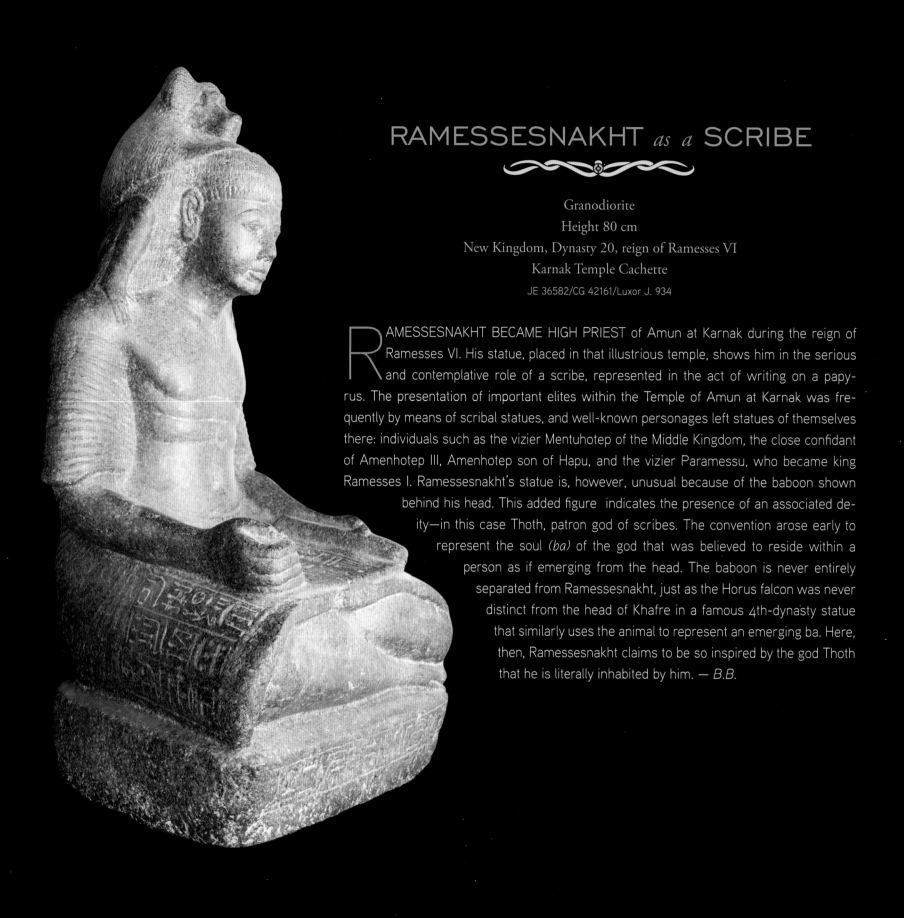

RAMESSESNAKHT *as a* SCRIBE

Granodiorite
Height 80 cm
New Kingdom, Dynasty 20, reign of Ramesses VI
Karnak Temple Cachette
JE 36582/CG 42161/Luxor J. 934

RAMESSESNAKHT BECAME HIGH PRIEST of Amun at Karnak during the reign of Ramesses VI. His statue, placed in that illustrious temple, shows him in the serious and contemplative role of a scribe, represented in the act of writing on a papyrus. The presentation of important elites within the Temple of Amun at Karnak was frequently by means of scribal statues, and well-known personages left statues of themselves there: individuals such as the vizier Mentuhotep of the Middle Kingdom, the close confidant of Amenhotep III, Amenhotep son of Hapu, and the vizier Paramessu, who became king Ramesses I. Ramessesnakht's statue is, however, unusual because of the baboon shown behind his head. This added figure indicates the presence of an associated deity—in this case Thoth, patron god of scribes. The convention arose early to represent the soul *(ba)* of the god that was believed to reside within a person as if emerging from the head. The baboon is never entirely separated from Ramessesnakht, just as the Horus falcon was never distinct from the head of Khafre in a famous 4th-dynasty statue that similarly uses the animal to represent an emerging ba. Here, then, Ramessesnakht claims to be so inspired by the god Thoth that he is literally inhabited by him. — *B.B.*

STATUE *of* PASER

Granodiorite
Height 110 cm
New Kingdom, Dynasty 19, reign of Ramesses II
Karnak Temple Cachette

JE 36935/CG 42164

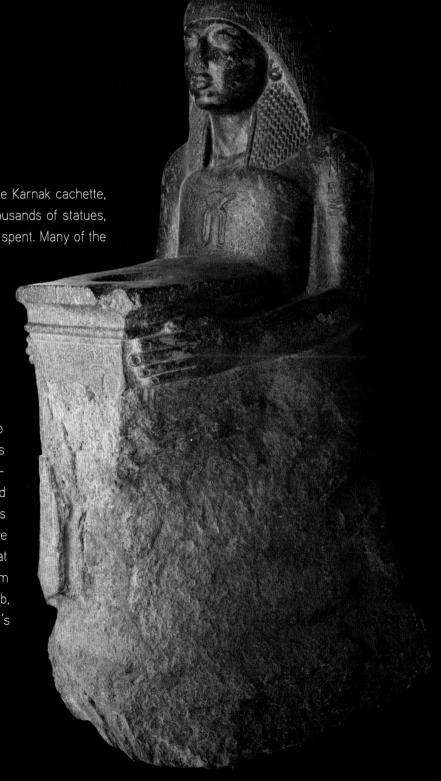

THIS REPRESENTATION OF THE VIZIER PASER was found in the Karnak cachette, a storage place under the floor of the temple where literally thousands of statues, whole and fragmentary, were placed after their time of use was spent. Many of the pieces in this book come from the Karnak cachette.

Paser's statue, a true masterwork of the 19th dynasty, dates from the reign of Ramesses II. It compares in style and workmanship with the "Upper Part of a Statue of Ramsses II" (page 102). The round face, rimmed mouth, and slightly bulging eyes are all features of Ramesses II, and in this statue—as in many other examples—the nobleman has been fashioned with the face of his liege, a practice by which he could identify himself with his patron, both in this world and in the next.

Paser built a large tomb west of Thebes, perhaps having done so already as vizier for Sety I. He was the last grand vizier to build his house of eternity there, since after Ramesses II built his city at Pi-Ramesses, the centers of power shifted northward and Saqqara—and perhaps the Nile Delta—became the expected locations for the burials of Egyptian elites. As vizier of the south, however, Paser was active in Thebes and left a number of monuments there, including several at the workmen's village of Deir el Medina. Correspondence between him and several scribes from that town refer to progress on the royal tomb, suggesting that Paser was therefore helping to oversee Ramesses II's tomb preparation. — *B.B.*

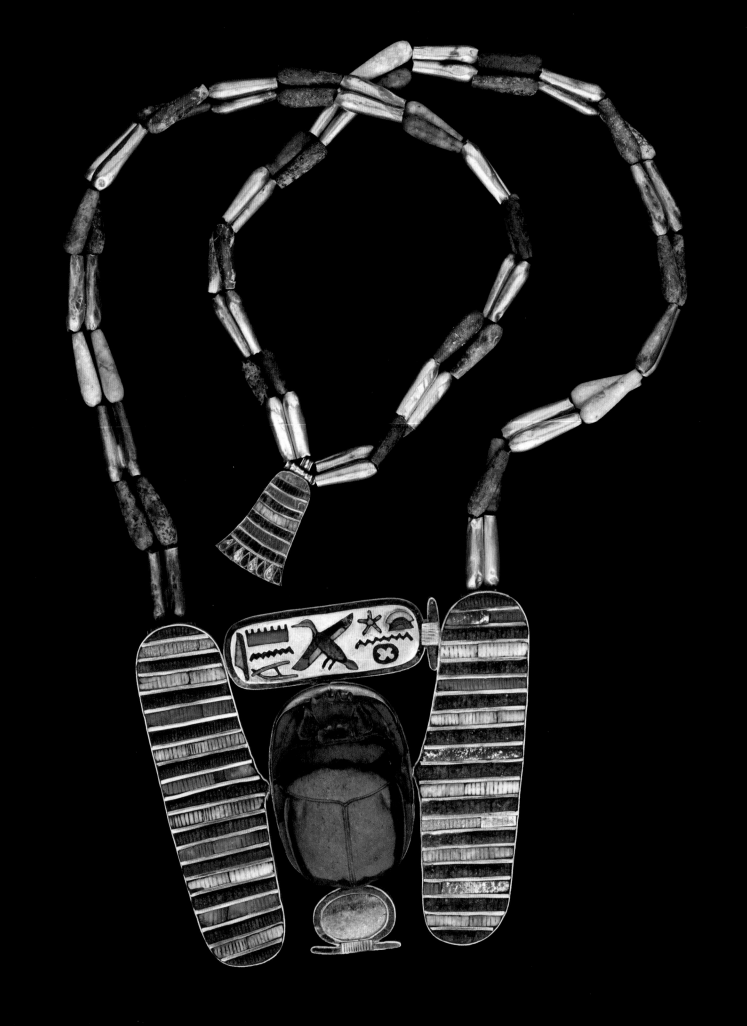

THE GOLD
of the PHARAOHS

NECKLACE WITH WINGED SCARAB PECTORAL, *see page 181*

ANCIENT EGYPT IS LEGENDARY for its wealth in gold. Prized by kings and commoners alike, gold was easy to work, and it did not tarnish. It formed the basis for beautiful jewelry and was used to cover boxes, coffins, and statuettes. For the Egyptians, this shimmering metal had miraculous power: Gold could protect the deceased in the next life. The bodies of the gods were made of gold; their bones were made of silver, their hair of lapis lazuli. Semiprecious stones had magical properties, too, but it was gold that captured the hearts of the ancient Egyptians—and it is gold that continues to fascinate us today. ❧ When we consider the quantities of gold found in the tomb of Tutankhamun—which survived until modern times only because it was hidden from tomb robbers by later work-men's huts—we can only imagine what was buried with other great kings, such as Thutmose III or Ramesses II. Ancient Egypt's wealthy had both the desire and the ability to use gold in large quantities—as is evident in the lavishly gilded burials of the Valley of the Golden Mummies—and even middle-class Egyptians could afford at least one piece of gold to take with them into the afterlife. The gold found in the tombs of private individuals can only hint at the abundance of gold that the pharaohs must have had at their command.

THE HISTORY OF GOLD IN EGYPT

Gold first appears in the Egyptian archaeological record during the Badarian period, between 4500 and 3800 B.C. The oldest known source of gold was located near Qift (today's Coptos), where about 1,300 workmen's huts dating to the Old Kingdom have been found near an old gold mine. In the Middle Kingdom, the Egyptians expanded their goldfields south into Nubia, and they continued to use gold from the deserts of Kush and Wawat during the New Kingdom.

In the reign of Amenhotep II, a load of gold from Kush required 150 men to carry it. During the reign of Amenhotep III, gold explorations went as far away as a place called Karka, which may have been south of the Fourth Cataract of the Nile. A series of trading posts and fortresses, begun in the Middle Kingdom and expanded in the New Kingdom, protected the southern goldfields and trading routes. King Sety I himself visited the gold mines in the middle of the Eastern Desert. A map from the reign of Ramesses IV shows the location of gold mines during this period; now in the Turin Museum, it is considered the oldest geological map in the world.

The Egyptians also collected gold as tribute from Nubia. New Kingdom tombs show Nubian chieftains bringing luxury goods to the Egyptian king. A scene from the tomb of Sobekhotep, for example, dating to the reign of Thutmose IV and now in the British Museum, shows Nubians bringing tribute to the pharaoh, with large rings of gold dangling from their arms.

THE GOLDSMITH

To extract gold from the quartz veins in which it was found, the Egyptians broke off large pieces of rock with heat, then brought them to the surface and further broke them up by pounding then grinding. When the resulting powder was washed, the gold separated from its rock matrix.

The earliest scenes of goldsmithing are found in the tomb of Nebemakhet, which dates to Dynasty 4. Goldsmiths also appear in the 5th-dynasty tomb of Ti and the 6th-dynasty tomb of Mereruka, both in Saqqara, and in the 12th-dynasty tomb of Ameni at Beni Hasan. The most famous New Kingdom images of goldworking are found in the tomb of Rekhmire, vizier under Thutmose III. One scene shows Rekhmire overseeing the production of metal objects for the temple of the god. A scribe is shown recording the circular ingots of gold and silver.

Goldsmiths were so highly valued, they could command luxury goods of their own. A golden seal now in the Berlin Museum once belonged to an overseer of goldsmiths during the reign of Menkaure. Titles connected with goldworking appear to have been hereditary. One king of Dynasty 12 honored

the son of one of his overseers of goldsmiths, and when the child reached adulthood, he took the same office as his father. During the New Kingdom, one supervisor of the royal goldsmiths calls himself the "overseer of the artisans of Upper and Lower Egypt" and mentions that he knew the "secrets of the houses of gold"—he knew how the statues of the gods, kept hidden from profane eyes, were made.

THE USES OF GOLD

Golden objects were made for many purposes, the most basic of which was to enhance the beauty of the wearer. Gold and jewels were worn by men as well as women: necklaces, rings, and bracelets on arms and legs. Although most pharaonic jewelry has been found in tombs, some examples have been discovered in settlement contexts. Much of the jewelry found in tombs was probably worn by its owners in life and then buried with them for their enjoyment and protection in the afterlife.

Golden jewelry indicated the wealth and status of the wearer. The wise man Ipuwer, who lived during the First Intermediate Period, lamented that gold, lapis lazuli, silver, and precious stones adorned the necks of the poor while noble ladies begged in the street. Foreign rulers loved to wear jewelry made in Egypt and to have Egyptian gold worked by their own local artists.

Gold was used by the king to reward the bravest soldiers. He would bestow golden collars and pendants in the shape of flies as rewards for valor. Gifts of gold were given to members of the royal family. In a famous scene from the tomb of Ay (page 60), Akhenaten, his wife Nefertiti, and three of their daughters present gold and other valuable gifts to the king's valued official.

The deceased were decorated with jewelry appropriate to their status. The poor sometimes buried their dead with beads colored yellow in imitation of gold. Gold was connected with the light of the sun, and just as the deceased had enjoyed sunlight during his lifetime, he could enjoy it after death by having gold buried with him. Amulets of gold and semiprecious stones, worn or wrapped into the bandages of a mummy, took many shapes, including hieroglyphic signs, gods, and animals. Both shape and material provided protection. The ankh-sign, which meant life, was a very popular amulet; the *wedjat*-eye of Horus was thought to grant health and happiness; the *djed*-pillar, sometimes thought of as the backbone of the god Osiris, symbolized stability.

Each piece of jewelry buried with a mummy had a particular function. In my excavations in the Bahariya Oasis, I found the tomb of the governor's wife, Naesa. Her mummy was adorned with 160 different pieces of amuletic jewelry, each one performing a specific function in ensuring her safe journey into the afterlife on her quest for immortality.

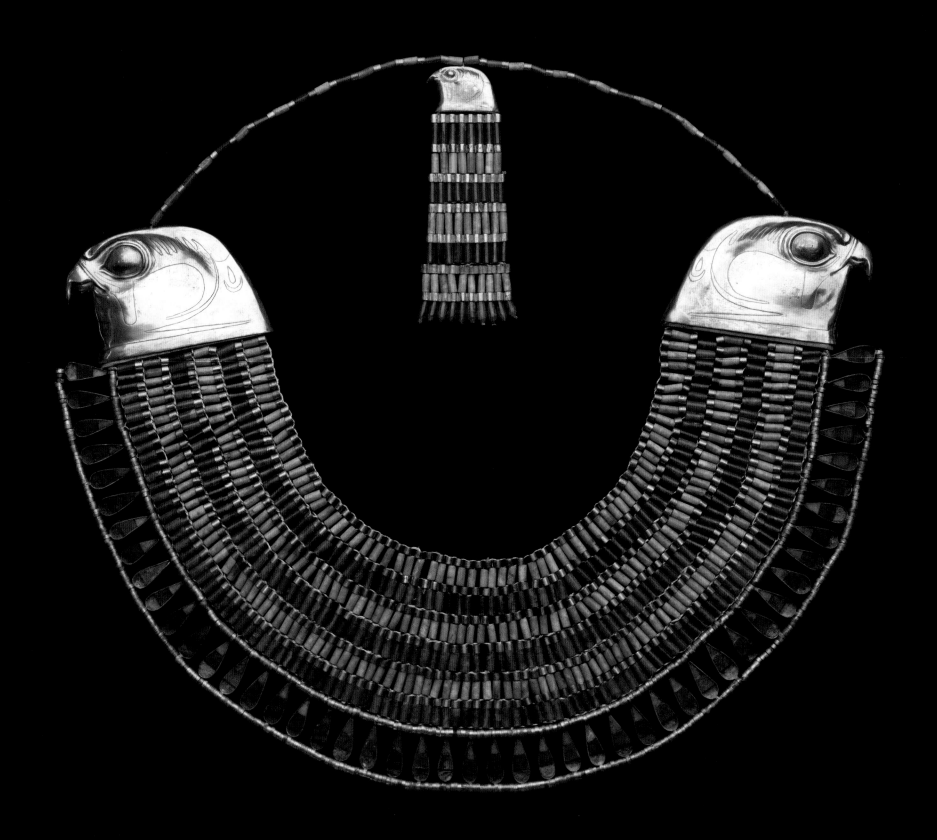

COLLAR *of* NEFERUPTAH

Gold, carnelian, feldspar
Length 36 cm
Middle Kingdom, Dynasty 12, reign of Amenemhat III
Hawara, Pyramid of Neferuptah
JE 90199

NEFERUPTAH WAS A DAUGHTER OF AMENEMHAT III, and it is possible that she survived the death of her father, since the place that her father had prepared for her burial within the royal pyramid remained empty after the funeral and burial of the king had taken place. Her interment probably occurred later, a short distance away, in a small mud-brick pyramid. Although water inflicted some damage in the pyramid, some of its contents, especially the jewelry, remained in good condition into modern times.

Neferuptah must have played a significant role in her father's reign, since he established a place for her entombment within his pyramid, and since she constructed a separate pyramid for her actual burial. Her mortuary equipment was significant as well, and she seems to have been the first female to have her name enclosed in a cartouche.

Found on the body of Neferuptah, this collar might have been worn in life and was included in the tomb for her use in the afterlife. It consists of six alternately colored rows of beads made of feldspar and carnelian. Tiny golden beads edge the horizontal bands, and drop-shaped beads with feldspar inlays form a final lower row, bordered by golden beads at the top and bottom. A single strand of tubular beads would have encircled the neck of the wearer. A counterweight that hung down behind the neck effectively balanced the weight of the collar and kept it in place. The hammered golden terminals, in the shape of falcons, are hollow, with details of the eye and beak finely executed. While they serve as decorative elements, they also functioned as protective amulets, since the falcon was associated with both Horus and the sun god.

Broad collars such as this one often appear along with other items of jewelry on the frieze of objects painted on the interior walls of elite coffins of the Middle Kingdom, and sometimes on the walls of burial chambers. The popularity of jewelry of this kind was widespread, and royal, nonroyal, and divine individuals wore such items. While wealthy patrons would have collars made of more valuable materials, private people might have possessed similar ones fabricated entirely of components of faience, a colored ceramic material. —*D.S.*

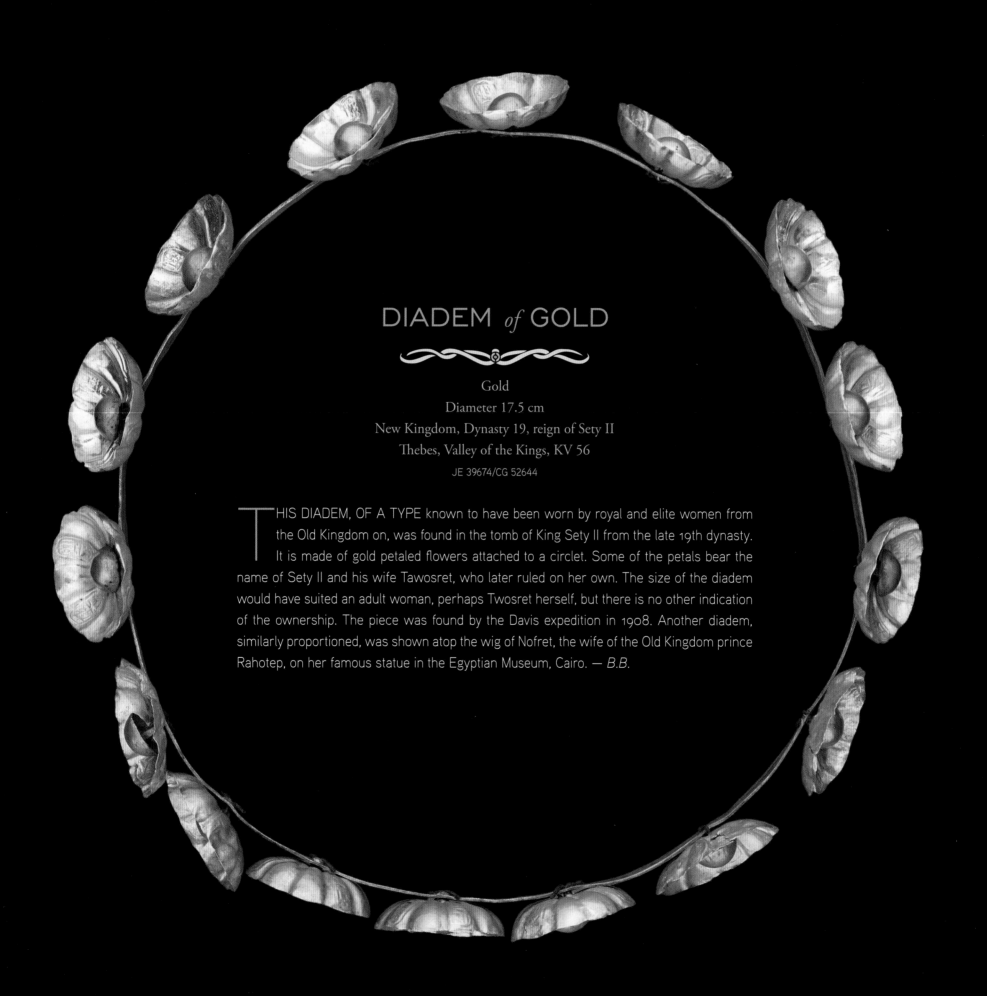

DIADEM *of* GOLD

Gold
Diameter 17.5 cm
New Kingdom, Dynasty 19, reign of Sety II
Thebes, Valley of the Kings, KV 56
JE 39674/CG 52644

THIS DIADEM, OF A TYPE known to have been worn by royal and elite women from the Old Kingdom on, was found in the tomb of King Sety II from the late 19th dynasty. It is made of gold petaled flowers attached to a circlet. Some of the petals bear the name of Sety II and his wife Tawosret, who later ruled on her own. The size of the diadem would have suited an adult woman, perhaps Twosret herself, but there is no other indication of the ownership. The piece was found by the Davis expedition in 1908. Another diadem, similarly proportioned, was shown atop the wig of Nofret, the wife of the Old Kingdom prince Rahotep, on her famous statue in the Egyptian Museum, Cairo. — *B.B.*

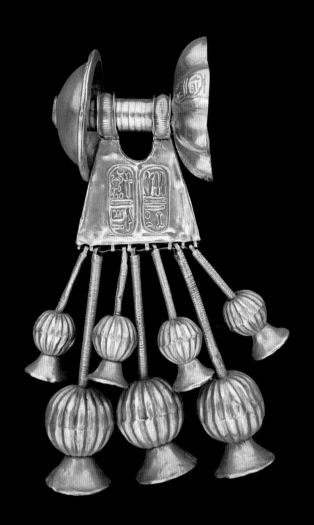

GOLD EARRINGS *with the* NAME *of* SETY II

Gold
Height 13.5 cm
New Kingdom, Dynasty 19, reign of Sety II
Thebes, Valley of the Kings, KV 56
JE 39675(a)/CG 52397

PIERCED EARS BECAME A FASHION STATEMENT in the New Kingdom. Tutankhamun had earrings like these, but in the Ramesside era wigs grew long and massive—a design against which this gold button with hanging cornflowers would balance nicely. Although pierced ears were common in this period, large earrings were often attached to the wigs, since otherwise they would hardly have been visible. Such was likely the case with these. — *B.B.*

NECKLACE *and* PECTORAL
of QUEEN MERERET

Gold, carnelian, lapis lazuli, and glazed material

Height 7.9 cm

Middle Kingdom, Dynasty 12, reign of Senwosret III

Dahshur, Tomb of Mereret

JE 30876/CG 52003

THIS JEWEL, DISCOVERED IN 1894 by the French archaeologist Jacques de Morgan near the pyramid of the king, belonged to the daughter of Senwosret III, Princess Mereret. The necklace consists of elongated beads of gold, lapis, and carnelian, separated by round golden spacers. Its ends attach to a rectangular gold plaque, bordered with architectonic details, such as the cavetto cornice forming the top of the piece. Both the interior tableau and the exterior border have inlays of glazed composition and semiprecious gems. Each of the inlaid sections has engraved details on the reverse.

Hovering over the main scene, the vulture goddess extends her wings. Hieroglyphs repeated on either side of her head express one of her epithets, mistress of heaven. Her talons grasp other hieroglyphs over each image of the king, forming an amuletic message meaning "life" and "endurance."

The central scene consists of two royal cartouches with the throne name of Amenemhat III, son of Senwosret III. They oppose each other and flank a column of vertical hieroglyphs with two royal epithets, the good god and lord of the two lands. A scene duplicated on each side depicts the pharaoh wielding a mace, ready to strike the foreign enemy cringing at his feet, whose hair he grasps. This image of the ruler functions as a hieroglyph itself. Read as the sign that means "smite" or "beat," and taken in conjunction with the signs in the center, the message recorded expresses a statement referring to the king's prowess: "Amenemhat the Good God and Lord of the Two Lands smites every foreign land." Behind the king stands the hieroglyph ankh, meaning "life," anthropomorphized with human arms that hold a fan over the monarch—a scene that implies that the king has eternal life.

Plaques were often favored by both men and women, and depictions of pectorals appear on both statuary and reliefs. Since this piece and other items of jewelry were part of Mereret's burial, it is likely that she may have worn it, despite its military image and message. The plaque was meant as a commemorative item, recognizing the power and accomplishments of Amenemhat III. — *D.S.*

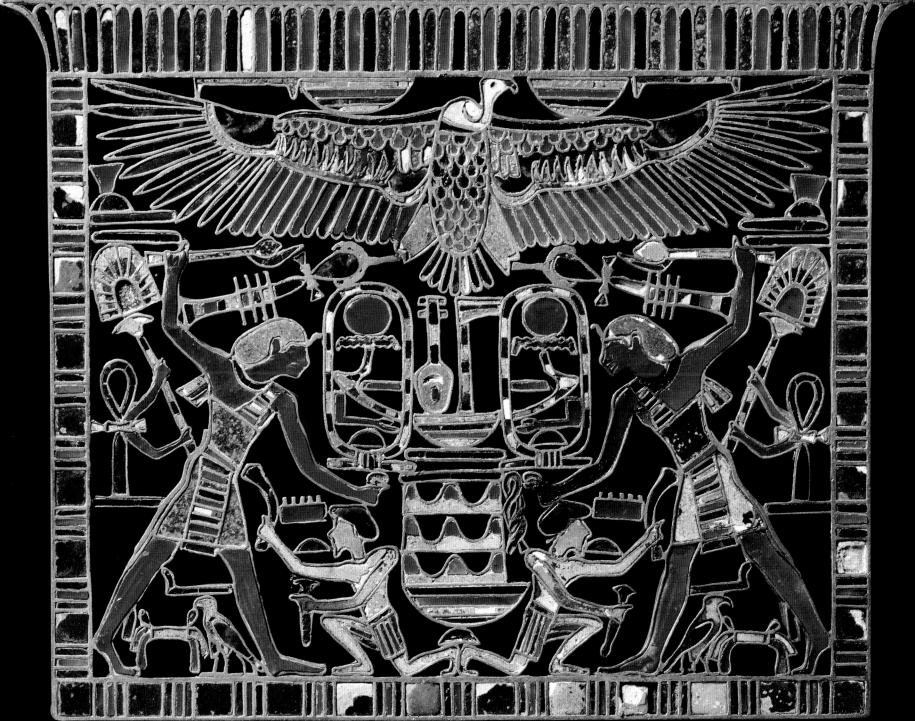

NECKLACE *with*

SNAKE HEAD AMULET

Gold and carnelian
Height of amulet 6 cm
Third Intermediate Period, Dynasty 21, reign of Psusennes I
Tanis, Tomb of Psusennes I

JE 85800

THIS AMULET REPRESENTS THE HEAD AND PART of the body of a snake. Most snake amulets are red like this one, and when found in tombs, they usually rest at the neck of the deceased's mummy. Psusennes I's carnelian snake amulet has inlaid eyes and is mounted with a gold cap suspended from a gold wire. An amulet like this one was placed on Psusennes I's mummy to protect it, especially the neck area.

The underside of this amulet is inscribed with two columns of hieroglyphs, which ask for protection for the pharaoh. — *D.R.*

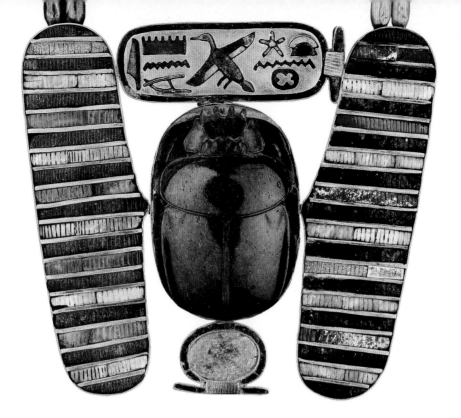

NECKLACE *with* WINGED SCARAB PECTORAL

Gold, jasper, and glass
Height 10.5 cm
Third Intermediate Period, Dynasty 21, reign of Psusennes I
Tanis, Tomb of Psusennes I
JE 85788/JE 85794/JE 85799

THIS PENDANT, HELD BY A NECKLACE of tubular beads of alternating electrum and blue stone (page 189), was made in the form of a scarab pushing a red ball with bar—a design that turns it into a *shen*-sign. The animal is flanked on both sides by lozenge-shaped wings and supported by an oblong cartouche that reads "Beloved of Amun, Psusennes," referring to Psusennes I of Dynasty 21. The amulet would lie on the chest to keep the heart from leaping forth at the final judgment and testifying against its owner.

The Late Period saw an enhanced belief in the magic spell as a tool in circumventing the requirement of moral rectitude to attain a blessed afterlife. The underside of this scarab is inscribed with a spell from the Book of Going Forth by Day: "O heart of my parents! O heart of mine when I was upon earth! Do not take the stand against me as a witness in the presence of Masters of the Offerings and say: 'He did it in very truth!' so that action will be taken against me. Do not create charges against me in the presence of the great god, the Lord of the West (Osiris)." — *D.R.*

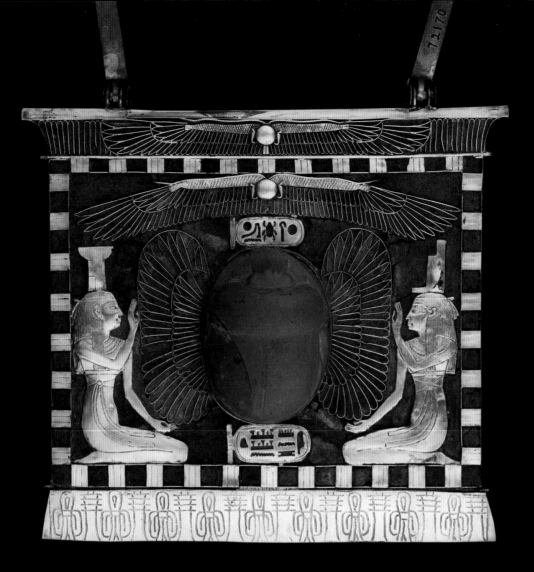

PECTORAL *with* WINGED SCARAB

Gold, semiprecious stones, and glass paste
Height 16 cm
Third Intermediate Period, Dynasty 22, reign of Sheshonq II
Tanis, Tomb of Psusennes I, burial of Sheshonq II
JE 72170

THIS PIECE OF JEWELRY BELONGED TO THE KING addressed as "Dominant is the Form of Re, He whom Re has Chosen; Sheshonq beloved of Amun." He appears to have reigned only briefly, and not independently, in about 875 B.C., at the end of the reign of Takelot II. The central scarab, with wings rising into the sky, conjures up associations with the sun god. At the sides, two goddesses, Nephthys to the left and Isis to the right, raise their arms in wonder and adoration. The back of the piece is inscribed with Spell 30, to protect the deceased during the entry into the afterlife. — *D.R.*

SPOUTED HES-VESSEL

Gold
Height 14.5 cm
New Kingdom, Dynasty 18, reign of Ahmose I
Tanis, Tomb of Psusennes I
JE 85895

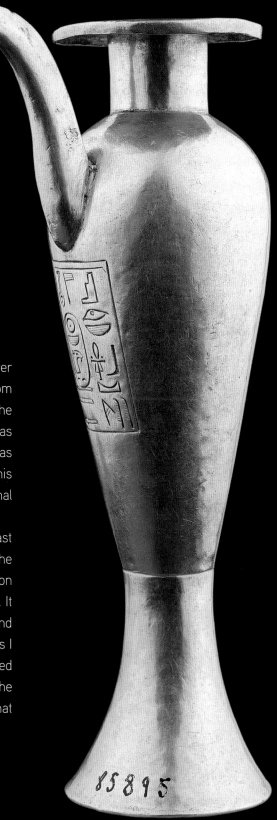

ALTHOUGH IT WAS FOUND IN THE TOMB of Psusennes I at Tanis, this gold ewer was originally made for the first king of the New Kingdom, Ahmose. Heirloom pieces were frequently placed in royal tombs, perhaps as a means of linking the newly deceased king with his predecessors already in the next world. A ewer such as Ahmose's would have been used as part of a funerary ritual in which pure water was poured during the Opening of the Mouth or some other aspect of the burial. Through this ewer, perhaps, the association with the famous former king could have given additional power to the magic of the liturgy.

The origin of the ewer itself is an interesting point. Ahmose was active in the northeast of Egypt during his wars against the Hyksos, and he built a number of monuments in the region thereafter, which is how the vessel could have arrived in that region. The dedication on the ewer is to Osiris, lord of Abydos, however, which may imply a funerary intention. It is the case that much of the Valley of the Kings was ransacked systematically at the end of the 20th dynasty, and many objects in Tanis—including the sarcophagus of Psusennes I himself—originated in kings' tombs of the New Kingdom. Ahmose, however, was not buried in the Valley of the Kings, but in a yet unknown location, probably near Dra Abu el Naga. The tombs there were violated, too, and reburied during the 21st dynasty, so it is possible that Ahmose's ewer came to Tanis through somewhat nefarious means. — B.B.

RING *with* SCARAB INSET

Gold and lapis lazuli
Diameter 2.5 cm
Third Intermediate Period, Dynasty 22, reign of Sheshonq II
Tanis, Tomb of Psusennes, burial of Sheshonq II
JE 72190

THIS GOLD RING HAS A SCARAB SIGNET of blue stone. Through trade or exchange, the form of the scarab signet spread rapidly throughout Egypt's sphere of influence in western Asia. Scarabs were sometimes inscribed with names or charms, with the shape of animals, humans, or geometric designs, and sometimes even with vignettes depicting historic events. They were made in materials including faience, lapis lazuli, amethyst, steatite, and precious metals. The scarab beetle, because of its amuletic powers and its shape, became the standard form for such rings. Known for rolling a ball of dung toward its den, the beetle captured the Egyptian imagination. The ball of dung was construed as the disc of the sun itself, and so the scarab beetle stood as a symbol of the rising sun and the constant renewal of life: an ideal candidate for use as an amulet. — *D.R.*

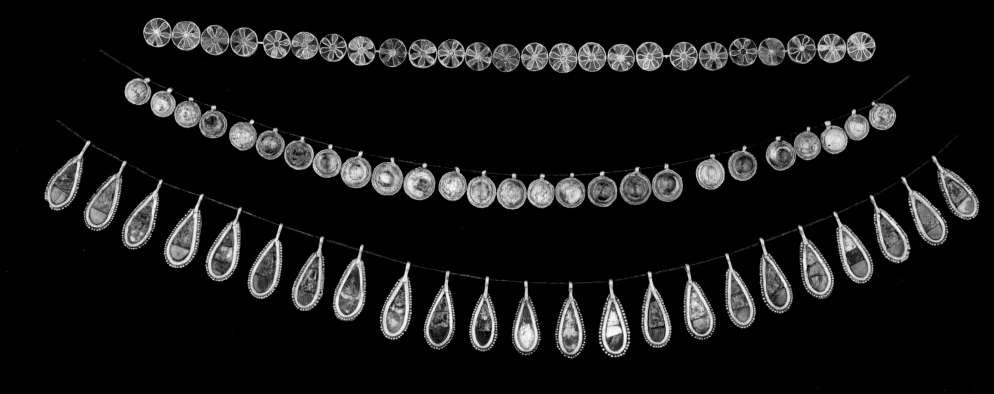

PIECES *and* PENDANTS *from* COLLAR *of* AHHOTEP

Gold, amethyst, carnelian, and turquoise
Width 25.5 cm
New Kingdom, Dynasty 18, reign of Ahmose I
Thebes, Dra Abu el Naga, burial of Ahhotep
JE 4725b/CG 52673

PARTS OF NECKLACES FROM THE BURIAL OF QUEEN AHHOTEP, these round amethysts set in granulated gold settings were found with the queen's items, as were teardrop pendants of carnelian and turquoise, or feldspar. Small rosettes similar to those carved on the breasts of many royal and divine female statues may have been made to adorn wigs or belts. Much of the material from Queen Ahhotep's burial has been lost, but what is preserved demonstrates both continuity and innovation in royal jewelry-making. — *B.B.*

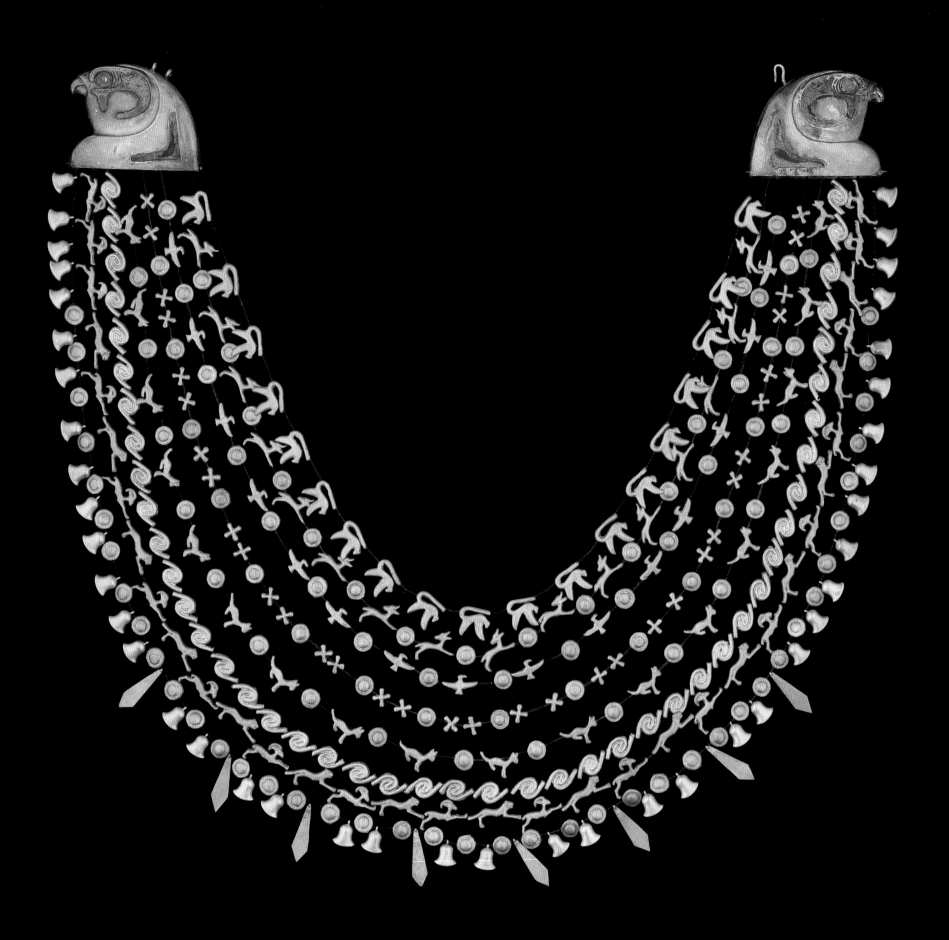

BROAD COLLAR *of* QUEEN AHHOTEP

Gold
Width 37.5 cm
New Kingdom, Dynasty 18, reign of Ahmose I
Thebes, Dra Abu el Naga, burial of Ahhotep
JE 4725a/CG 52672

THE BROAD COLLAR OF QUEEN AHHOTEP has been reconstructed out of many tiny gold elements found among her burial items. The falcon terminals assure us that there was indeed a broad-collar shape to begin with, an item of jewelry seen as early as the Old Kingdom. A counterweight attached to each of the falcon heads closed the collar and held it in place. At the bottom of the hollow falcon heads, small, perforated elements of gold were suspended on strings. The gold elements include dangling papyrus umbels; rampant felines chasing antelopes; running spirals—perhaps inspired by Aegean decoration; cats and disks; stars, perhaps, and disks; birds and disks; and felines pouncing on gazelles.

For Egyptians, the iconography of these elements may have been sexual in meaning. Cats were frequently associated with female aspects, both wild and domesticated. In the love poetry of the New Kingdom, male lovers were identified with antelopes as hunters' prey, sacrificing themselves to their lady loves. The papyrus umbels recall the ritual in which royal women shook the papyrus of the marshes as an allusion to the manual excitation of a male deity. Thus these small but animated gold pieces would have reflected the procreative and sexual power of the royal woman who wore them. — *B.B.*

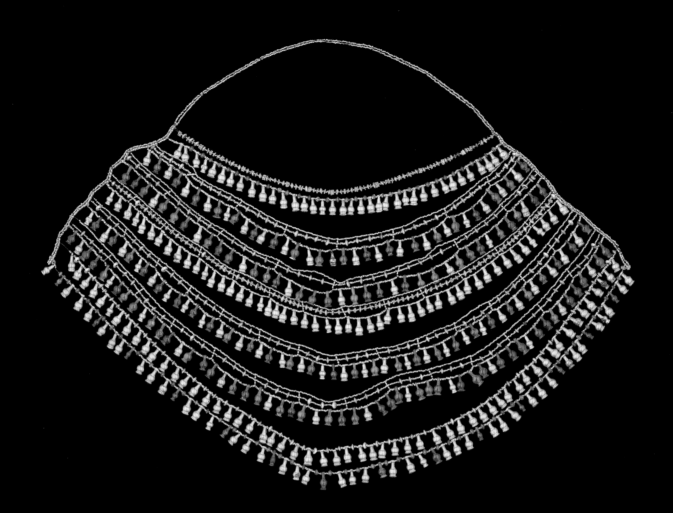

COLLAR

Gold and carnelian
Width 26 cm
New Kingdom, Dynasty 19
Bubastis
JE 38713/JE 39875/CG 53184

A LARGE COLLECTION OF LOOSE BEADS, including many shaped like cornflowers, was found in the area of Bubastis. They almost certainly derived from a necklace or necklaces. Although the original arrangement is unknown, they have been restrung to form a collar. Collars with such elements could have been worn by either women or men, so the owner of this one might have been one of the Ramesside kings or queens associated with the Bubastis treasure objects. — *B.B.*

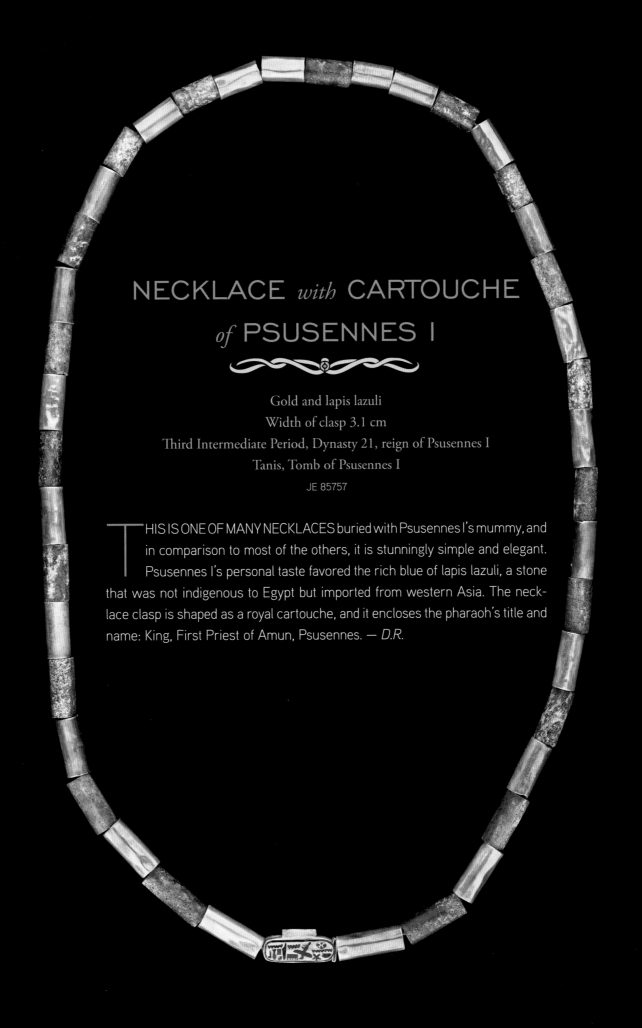

NECKLACE *with* CARTOUCHE
of PSUSENNES I

Gold and lapis lazuli
Width of clasp 3.1 cm
Third Intermediate Period, Dynasty 21, reign of Psusennes I
Tanis, Tomb of Psusennes I
JE 85757

THIS IS ONE OF MANY NECKLACES buried with Psusennes I's mummy, and in comparison to most of the others, it is stunningly simple and elegant. Psusennes I's personal taste favored the rich blue of lapis lazuli, a stone that was not indigenous to Egypt but imported from western Asia. The necklace clasp is shaped as a royal cartouche, and it encloses the pharaoh's title and name: King, First Priest of Amun, Psusennes. — *D.R.*

BRACELET *of* QUEEN AHHOTEP

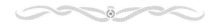

Gold, carnelian, turquoise, and lapis lazuli
Height 3.6 cm
New Kingdom, Dynasty 18, reign of Ahmose I
Thebes, Dra Abu el Naga, burial of Ahhotep
JE 4686/CG 52071/CG 19542

MARIETTE REPORTED FINDING THE BURIAL of Queen Ahhotep, wife of Seqenenre and mother of King Ahmose, in 1859 in Thebes. This bracelet, found within the queen's coffin, bears the name of her son on the clasp: "the son of Re, Ahmose, beloved of Re." The writing of the name of Ahmose is in a form that represents the first 18 years of his rule, so this bracelet must have been made during that period.

The bracelet is made of 30 rows of tiny beads shaped in a triangular pattern, 15 beads to each triangle. These numbers were very likely intentional, chosen to represent an association with the moon and the lunar calendar. The names Ahmose and Ahhotep both contain the name of the moon god Iah, and the 30 rows of beads may well refer to the number of days in the regular lunar month. The 15 beads in the triangles, clearly depicting half of a square, are likely intended to represent the rectified half of a full moon, or the 15th day of the lunar month. This half-month time, together with the beginning and the end of the month, was one of the regular temple festival days in ancient Egypt. These associations make Ahhotep's bracelet a means of honoring her namesake lunar god. — *B.B.*

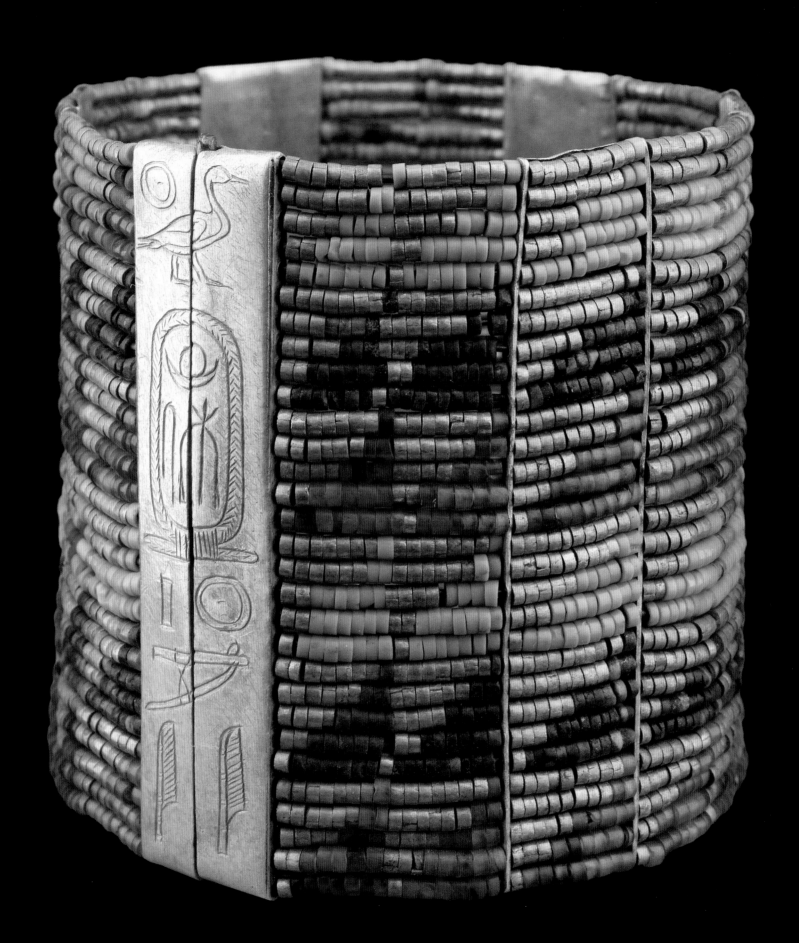

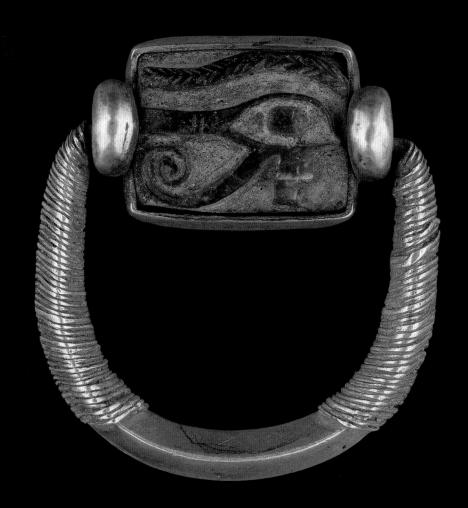

RING *with* WEDJAT BEZEL

Gold and lapis lazuli
Height 1.1 cm
Third Intermediate Period, Dynasty 21, reign of Psusennes I
Tanis, Tomb of Psusennes I
JE 85824b

THE *WEDJAT*-EYE, ONE OF THE MOST POTENT symbols in Egyptian iconography, was originally conceived as the eye of the falcon god Horus, wrenched out of its socket by the god Seth, the agent of disorder and sterility, and cast bleeding upon the ground. Horus presented his "sound eye" (wedjat) to his father as a symbol of filial devotion. The wedjat-eye became the metaphor for self-sacrifice, and every cult priest offered his sound eye, symbolically, to the god or deceased spirit. The wedjat was also viewed as a heavenly body, the sun or especially the moon, and it appeared in a wide variety of jewelry as an amulet of protection. — *D.R.*

THUMB RING *of* PSUSENNES I

Gold, lapis lazuli, carnelian, and glass paste
Diameter 2.2 cm
Third Intermediate Period, Dynasty 21, reign of Psusennes I
Tanis, Tomb of Psusennes I
JE 85822a

WHEN THE EXCAVATORS found Psusennes I's mummy in his burial chamber in the tomb at Tanis, they discovered a total of 36 rings on his hands. The rings were slipped over the gold finger stalls on his fingers. The king wore this ring on his thumb. Decorated like a bracelet and perfectly miniaturized, it is inlaid with lapis lazuli cartouches that give the various names of the pharaoh. — *D.R.*

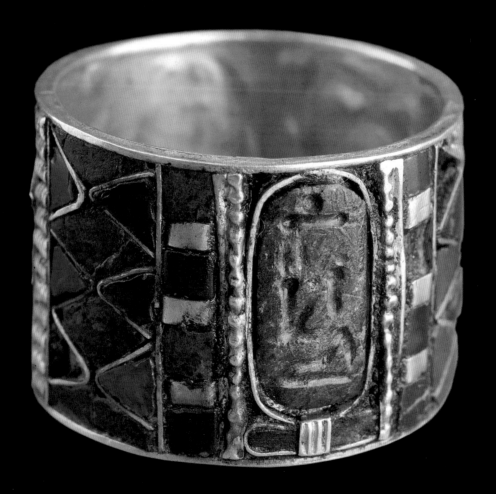

BRACELET *with* DEDICATION

Gold • Diameter 6.9 cm

Third Intermediate Period, Dynasty 21, reign of Psusennes

Tanis, Tomb of Psusennes

JE 85760

GOLD DEPOSITS ARE COMMON IN THE EASTERN DESERT south of the Wadi Hammamat. Northern Sudan's Wadi Allaki and the Wadi Gabgaba came to be known as Nubia, "gold country." During the 18th dynasty, gold also came as gifts, booty, and taxes, from Asia and the Near East. By the reign of Thutmose III, so much gold had entered the country that the ratio of gold to silver was depressed. Three generations later, it was said that in Egypt, gold was as plentiful as dust. Trace elements are found in Egyptian gold, mainly silver. Not until the sixth and fifth centuries B.C. did techniques make refined gold a real possibility. A high percentage of silver produced an alloy called electrum. In Amarna times, copper was sometimes added, producing a sort of reddish gold. Goldworking involved mainly the beating of sheet gold and the soldering of joints, although casting was also known. — *D.R.*

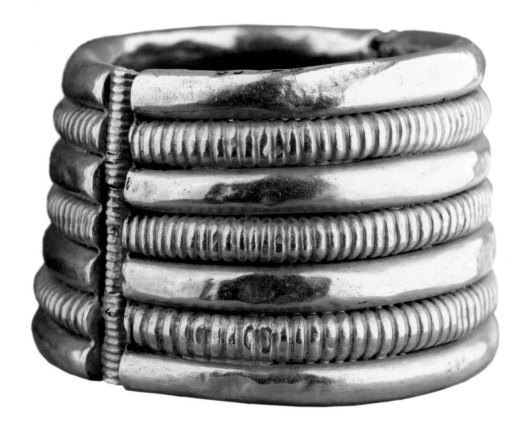

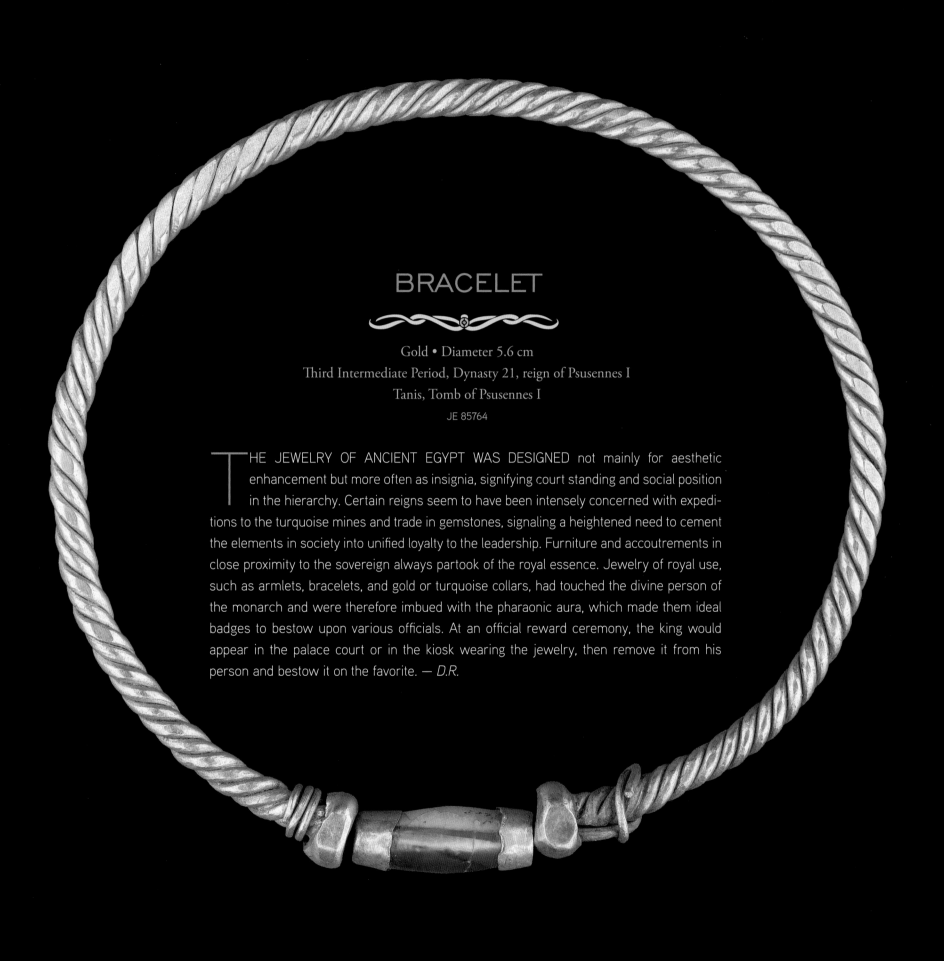

BRACELET

Gold • Diameter 5.6 cm

Third Intermediate Period, Dynasty 21, reign of Psusennes I

Tanis, Tomb of Psusennes I

JE 85764

THE JEWELRY OF ANCIENT EGYPT WAS DESIGNED not mainly for aesthetic enhancement but more often as insignia, signifying court standing and social position in the hierarchy. Certain reigns seem to have been intensely concerned with expeditions to the turquoise mines and trade in gemstones, signaling a heightened need to cement the elements in society into unified loyalty to the leadership. Furniture and accoutrements in close proximity to the sovereign always partook of the royal essence. Jewelry of royal use, such as armlets, bracelets, and gold or turquoise collars, had touched the divine person of the monarch and were therefore imbued with the pharaonic aura, which made them ideal badges to bestow upon various officials. At an official reward ceremony, the king would appear in the palace court or in the kiosk wearing the jewelry, then remove it from his person and bestow it on the favorite. — *D.R.*

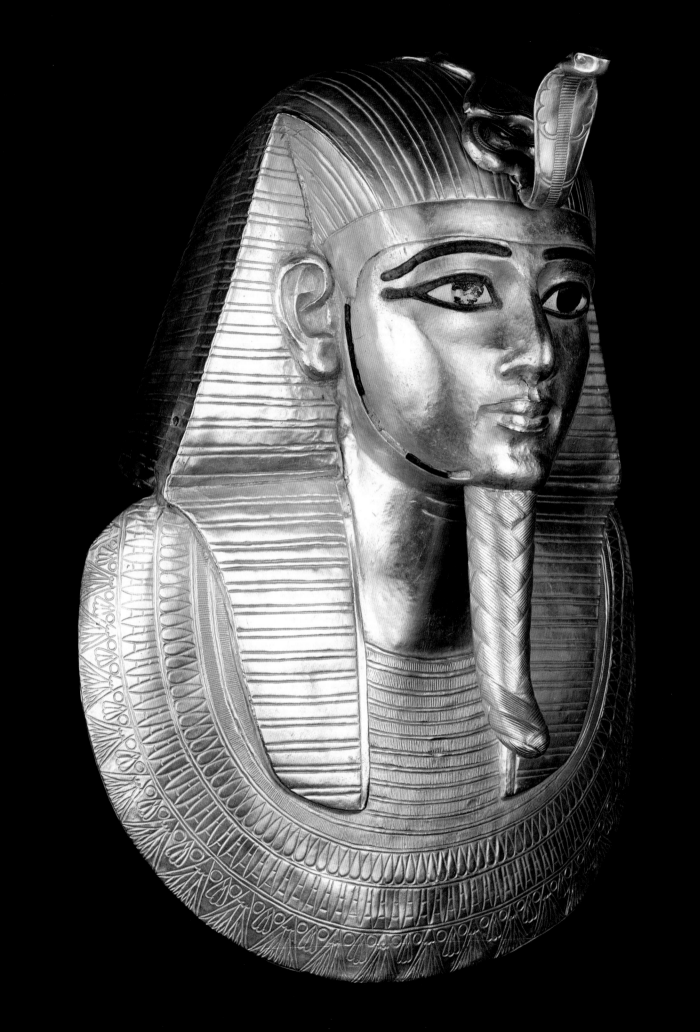

FUNERARY MASK
of PSUSENNES I

Gold inlaid with lapis lazuli and black and white glass
Height 48 cm
Third Intermediate Period, Dynasty 21, reign of Psusennes I
Tanis, Tomb of Psusennes I
JE 85913

THIS IS THE MOST BEAUTIFUL AND THE FINEST of four gold masks discovered in the royal treasure at Tanis. When found, it was exactly where it had been placed 3,000 years before: covering the face, head, and chest of King Psusennes I's mummy.

A symbol of the king's royal status, the uraeus cobra rises from the front of his headcloth, and a long, divine beard is attached to his chin. This is the face of a youthful ruler, with refined features reminiscent of this pharaoh's New Kingdom ancestors. Made of gold, the flesh of the gods, it becomes a powerful symbol of eternal life.

The splendid broad necklace covering the entire chest of the mask imitates a floral collar. Its ornamentation includes lotus blossoms in the lowermost row, an ancient symbol of rebirth. — *D.R.*

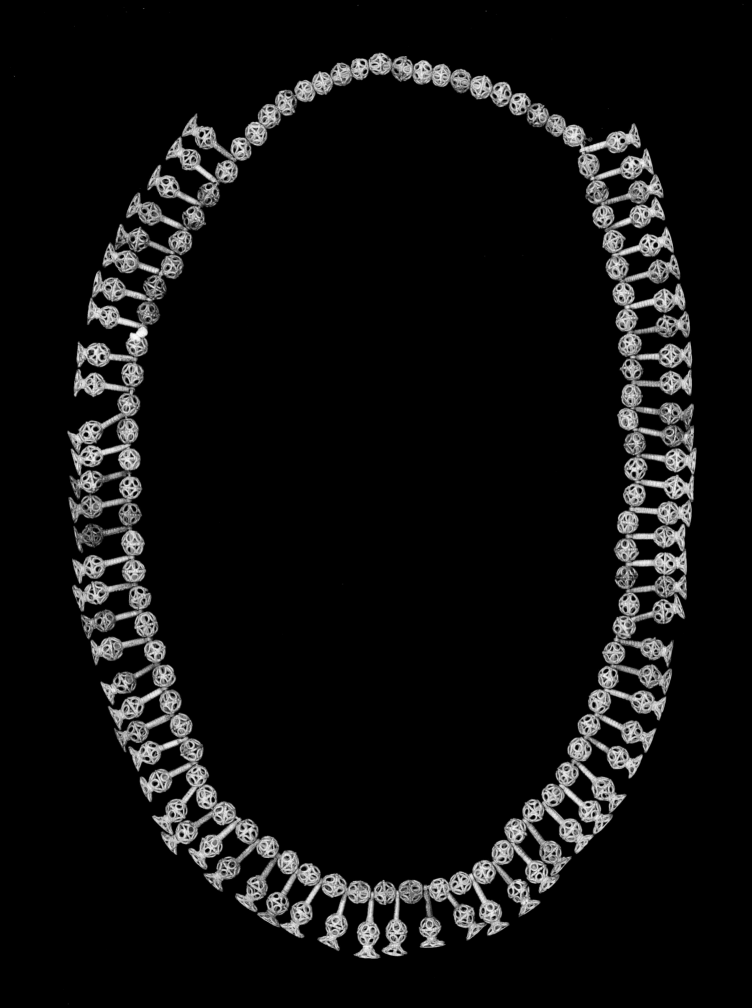

NECKLACE *and* CUP *of* TAWOSRET

Gold

Necklace: Length 61 cm • Cup: Height 9.5 cm

New Kingdom, Dynasty 19, reign of Sety II

Necklace: Thebes, Valley of the Kings, KV 56 • Cup: Bubastis

Necklace: JE 39679/CG 52679/CG 52680/CG 52681 • Cup: JE 39872/CG 53260

L IKE THE DIADEM AND EARRINGS FOUND IN THE TOMB OF SETY II (pages 176 and 177), this necklace was found in a chamber first excavated in the 18th dynasty and used in association with Sety's burial. Only the names of Sety II and Tawosret are found with the jewelry and other objects from this chamber, but there could have been another family member buried there. This necklace represents only some of the filigreed cornflowers and balls found in this chamber. The others are in the Metropolitan Museum of Art, New York, where they have been strung into a second necklace. The original larger necklace would most likely have contained all the elements.

The small chalice is worked in the shape of a lotus, a popular form in the later New Kingdom, seen more often made of faience than of precious metals. A number of gold and silver vessels naming Ramesside rulers were found near Bubastis (modern Zagazig), but their original provenance remains uncertain. This piece consists of two hammered parts: the cup itself and the stem with base. The two have been joined by soldering. Because the lotus petals are chased into the gold sheet from the outside, their outlines are raised on the interior of the cup. Thus as she drinks her wine from the chalice, the queen sees the petals of the lotus revealed. The name of Tawosret is incised (not chased, as is the decoration on the vessel) on the stem; feathers with a disk top the cartouche. The cartouche may have been added to the cup after Tawosret became ruler of Egypt and took the throne names Sat-re, Merytamun, and Tawosret Meret-mut. Unlike Hatshepsut and Sobeknefru, Tawosret never wore the crowns of kingship, and so her headdress was that of the queen of Egypt: a flat-topped circlet with tall plumes, sun disk, and horns. The cartouche nearly creates a graphic interpretation of the ruling queen's image. — *B.B.*

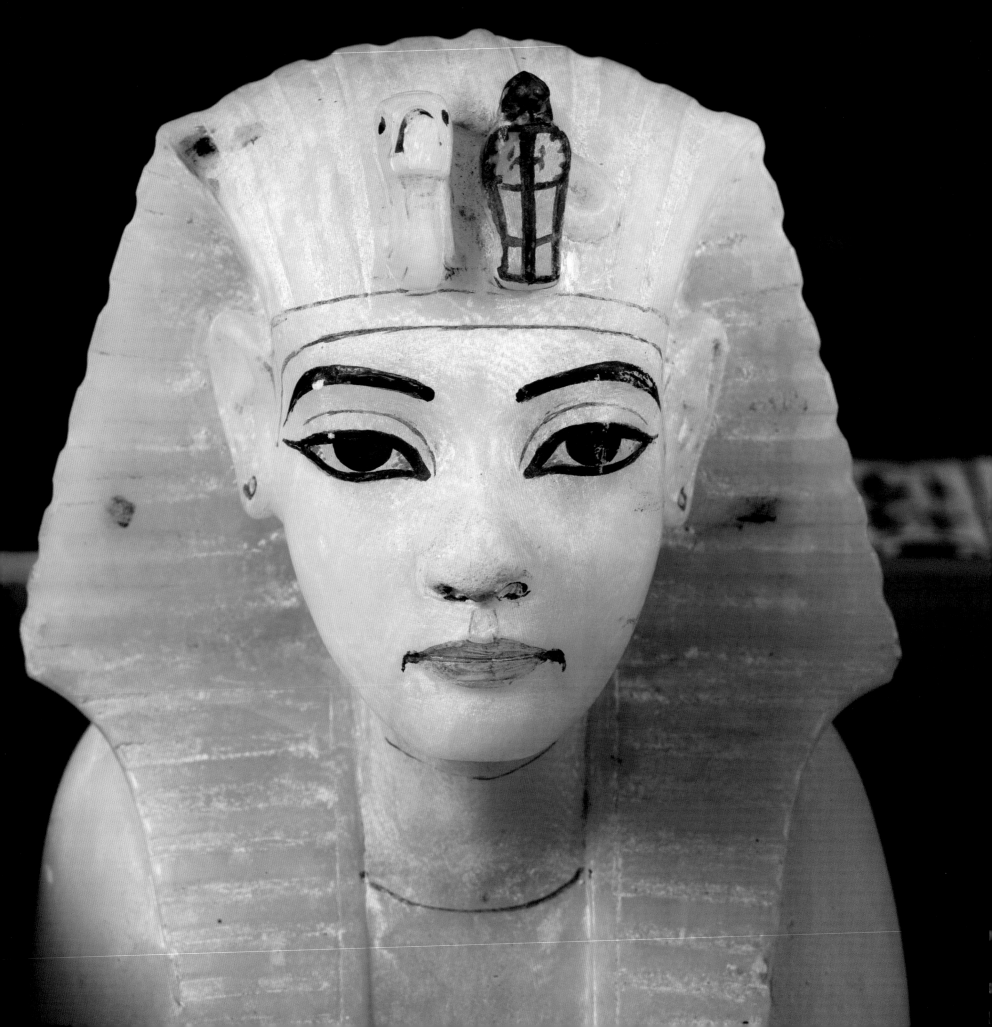

THE DISCOVERY *of a* PHARAOH: TUTANKHAMUN

CANOPIC STOPPER, *see page 234*

T HE ARCHITECTURE OF TUTANKHAMUN'S tomb, known as KV (for King's Valley) 62, is not like the other tombs of New Kingdom pharaohs. It is relatively small, consisting of four rooms. The first room that Carter and his team entered, the Antechamber, was filled with a jumble of things. Against the west wall were three large ritual beds with animal heads, piled high with furniture—boxes and vessels, chairs and stools, and other fabulous items. Four dismantled chariots were thrown in a heap, and two life-size figures of the king, painted black as symbols of fertility and gilded to shine like the sun, flanked a blocked doorway. Carter spent the first years clearing the Antechamber, and it was not until February of 1924 that the blocked doorway was dismantled, and Carter found himself face to face with a huge golden shrine. Less than a meter lay between the walls of the shrine and the Burial Chamber. This was the first of four nested shrines, all made of wood and then gilded, which surrounded a rectangular quartzite sarcophagus. The doors of the first shrine were open, but the second, covered with a great linen pall studded with golden rosettes, was still sealed. A number of artifacts were found in the

spaces between the walls: magical oars, bundles of staffs, fans, alabaster vessels, and, thrown into one corner, a bouquet of flowers. Inside the sarcophagus, set on a low funerary bed with a lion head, were three anthropoid coffins, the outer two of gilded wood and the innermost of solid gold. On October 28, 1925, they lifted the lid of the inner coffin and saw the beautiful golden mask of Tutankhamun. To remove the mask, unwrap the mummy, and recover the fabulous objects hidden there, Carter and his team were forced to dismember the body, using tools such as heated knives.

The tomb's only decorated room was the Burial Chamber. On the east wall, the mummy of Tutankhamun is shown on a lion bed, inside a shrine set onto a sledge that is being pulled to the tomb by 12 men, high officials of the king, wearing white mourning bands around their foreheads. Two of these, distinguished by their shaved heads, may be the viziers of the north and south. The north wall is divided into three vignettes. First Ay, Tutankhamun's successor, performs the Opening of the Mouth ceremony, in which the body would be reanimated, on the king's mummy. In the second scene, Tut is welcomed to the afterlife by Nut, great goddess of the sky. Finally, the king and his double, or ka, are embraced by Osiris, ruler of the netherworld. Rows of baboons dominate the west wall, which illustrates the first of the 12 hours of the night from a funerary book called the Imy-duat, What Is in the Netherworld. The south wall, which was mostly destroyed when Carter and his team took down the blocking between this room and the Antechamber, shows Tutankhamun guided by Anubis and being greeted by Hathor, goddess of the west (the land of the dead).

To the east of the Burial Chamber was a smaller room, nicknamed the Treasury. This too had been entered by the tomb robbers, who had squeezed around the shrines in the Burial Chamber to get in. The entrance was guarded by an over-life-size figure of the mortuary god Anubis in the form of a jackal, recumbent on top of a shrine-shaped box. Against the east wall of the room was a large shrine of gilded wood surrounded by exquisite statues of four tutelary goddesses: Isis, Nephthys, Neith, and Selket. This shrine protected the king's alabaster canopic chest, in which his mummified internal organs were stored. Filling the Treasury were rows of boxes and resin-covered shrines, many with model wooden boats stacked on top of them. Several boxes contained jewelry of gold inlaid with precious stones. In the resin-covered shrines were gilded wooden statues, some of the king and others of a bewildering variety of gods. Two more chariots were in this room, again dismantled and tossed in a corner. One of the most touching of the finds here were the remains of two female fetuses who had been carefully mummified and buried in their own small coffins.

A small opening low on the west wall of the Antechamber led to the fourth room, the Annex. More than 2,000 artifacts had been crammed into this room, including most of the king's *shabtis* (statues believed to do service for the deceased in the afterlife) and 36 beer or wine jars sealed with

mud seals. Sir Alan Gardiner and James Henry Breasted dated some of these seals to Year 9 of Tutankhamun's reign, most likely the year in which he died.

Carter's forensic team was composed of Douglas Derry of Cairo University and Saleh Bey Hamdi of the University of Alexandria. After unwrapping the mummy, they measured the king and judged his height to be about 1.67 meters. They estimated that he died between the ages of 18 and 22 but could not determine a cause of death. Carter placed the mummy in a tray full of sand and put it back inside the outermost coffin, which was left inside the sarcophagus in the tomb.

The first x-rays of Tutankhamun were taken in 1968, when Richard Harrison of the University of Liverpool studied the body. A second set of x-rays, this time only of the skull, was taken ten years later by James Harris of the University of Michigan. These led to increased speculation about the cause of the young king's death, with murder by a blow to the head leading the field.

The National Geographic Society, along with Siemens Inc., donated a portable CT-scan machine to the Supreme Council of Antiquities as part of their sponsorship of our mummy project, in which we plan to scan many of Egypt's mummies to study patterns of disease. When the Egyptian parliament agreed to send some of Tutankhamun's treasures abroad for the first time in almost 25 years, I decided this would be a good opportunity to use the new machine to examine his mummy. We took it to the Valley of the Kings, and on January 5, 2005, I looked upon Tutankhamun's face for the first time. The 1,700 images produced by the machine, rendered as three-dimensional images by the computer, were studied by a group of Egyptian radiologists, led by Dr. Mervat Shafik and Dr. Ashraf Selim, later joined by Dr. Frank Rühli, Dr. Frank Egarter, and Dr. Paul Gostner.

Our international team concluded that Tutankhamun died at the age of about 19. A mysterious shadow on the earlier x-rays, which had led to the theory of Tut's death by a head blow, was nowhere to be seen, although there is a hole made by the embalmers through which they extracted the brain. Perhaps the most interesting find was that there was an unhealed premortem fracture just above the left knee (a fracture noted already by Derry and Hamdi); this may have been the result of an accident that happened just before Tutankamun's death.

We also gave the results of the CT scan to three forensic reconstruction teams: one French, one American, and one Egyptian. The American team worked blind, without any information about the identity of their subject. The results were inconclusive. All three teams identified the mummy as North African in origin, and all agreed on the strange, elongated shape of the head. Otherwise, the three reconstructions were very different. The French team created a French-looking Tutankhamun. The American attempt looks nothing like ancient images of the boy-king. The Egyptian version looks more Egyptian, but still not much like Tut.

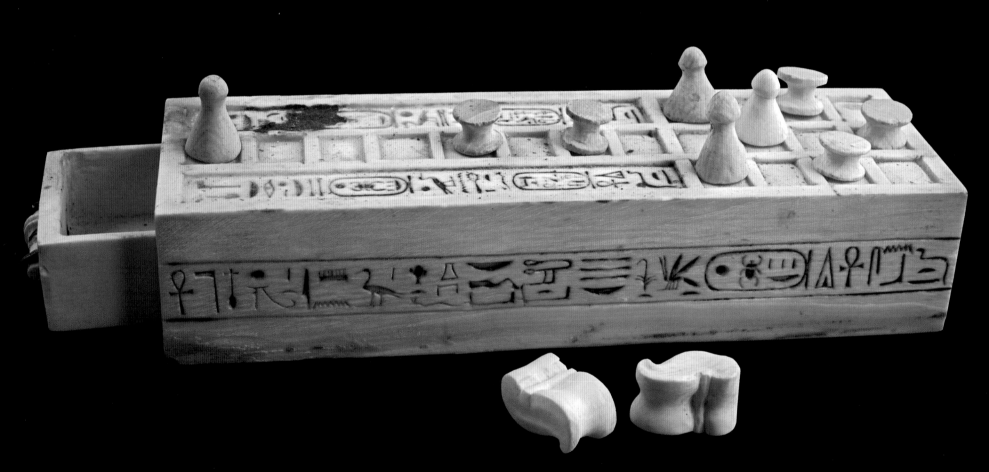

GAME BOX

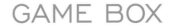

Ivory

Length 13.4 cm

Carter 585r

THIS RECTANGULAR BOX AND THE DRAWER THAT FITS into it were carved from a single piece of ivory. The box is set up for the game of *tjau* on one side and for the game of *senet* on the other. Tjau was played on a field of 20 squares in three rows, with a row of 12 squares between two rows of 4 squares each. These rows were separated by walls, called "tjau," from which the game takes its name.

The game of senet depended on a combination of luck and skill. Although different configurations are sometimes seen, the board was usually divided into 30 squares, in three rows of 10 squares each. Although we do not know the exact rules by which the ancient Egyptians played senet, it seems that they threw sticks to determine the distance a piece would move on a given turn. Players were able to use strategy in blocking and capturing one another's pieces.

The popularity of senet is evident from the frequency with which it appears in Egyptian art. People from servants and sailors to officials and kings were shown on the walls of tombs and temples enjoying the game. Depictions of senet appeared as early as the 3rd dynasty, in the tomb of the official Hesy-re. Over a millennium later, Ramesses III was shown on the walls of his mortuary temple at Medinet Habu playing the game with his daughters.

The word "senet" means "pass," and the ancient Egyptians saw a close relationship between the passage of a game piece across the board and the passage of the deceased through the obstacles that awaited him on the path to the underworld. Senet was thus not only a popular board game played by the living, but by the New Kingdom at the latest it had also become an important funerary symbol. During the New Kingdom, scenes showing the deceased playing the game appeared often on the walls of tombs. Chapter 17 of the Book of the Dead was illustrated with an image of the deceased facing an invisible opponent at senet, with victory at the game symbolizing victory over the forces that might prevent him from passing safely into the next world.

This game box, one of four complete examples that were found in Tutankhamun's tomb, is decorated with inscriptions containing the names and epithets of the young king. Howard Carter found it lying broken on the floor of the tomb, the playing pieces scattered. — *Z.H.*

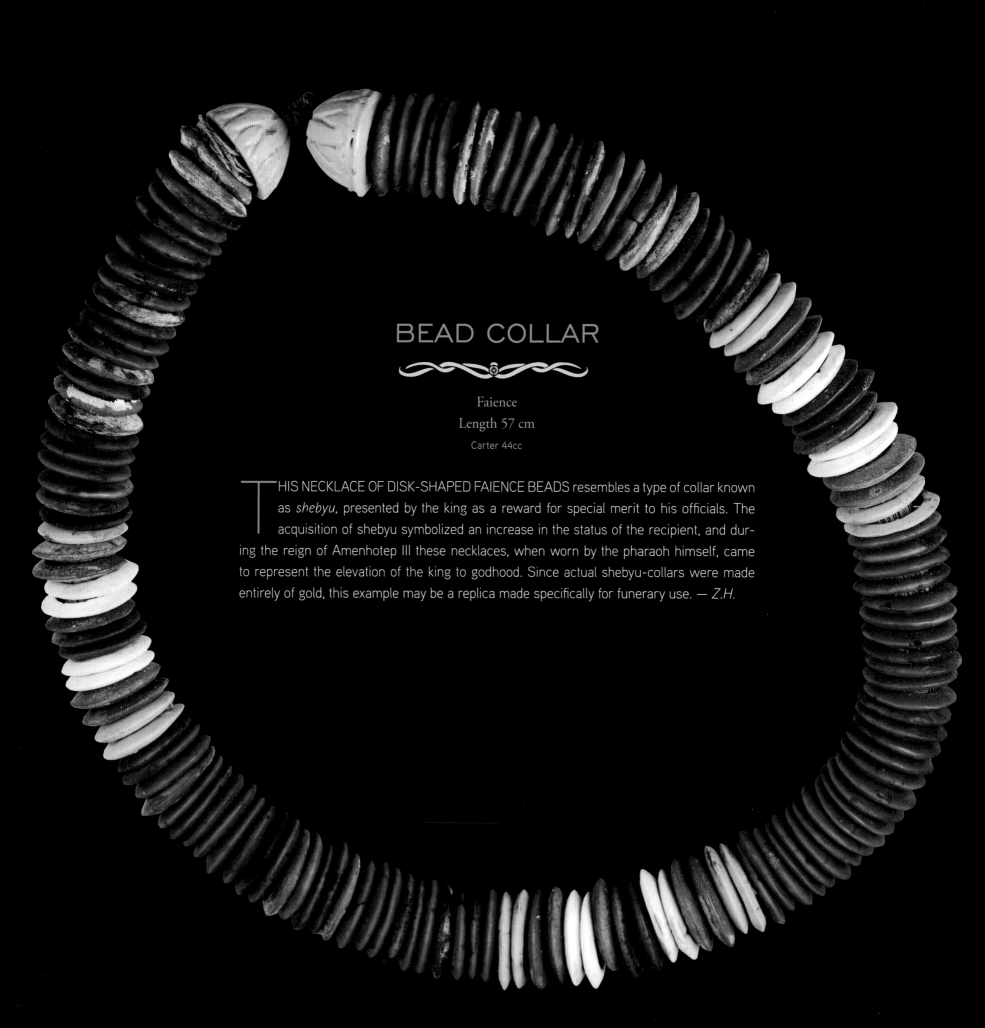

BEAD COLLAR

Faience
Length 57 cm

Carter 44cc

THIS NECKLACE OF DISK-SHAPED FAIENCE BEADS resembles a type of collar known as *shebyu*, presented by the king as a reward for special merit to his officials. The acquisition of shebyu symbolized an increase in the status of the recipient, and during the reign of Amenhotep III these necklaces, when worn by the pharaoh himself, came to represent the elevation of the king to godhood. Since actual shebyu-collars were made entirely of gold, this example may be a replica made specifically for funerary use. — *Z.H.*

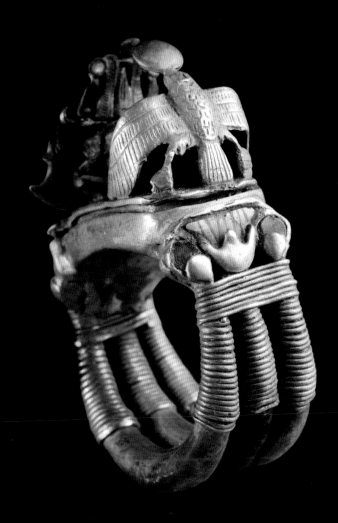

RING *with* SCARAB BEZEL

Gold, semiprecious stones, and colored glass

Diameter 2.6 cm

Carter 44i

DURING THE NEW KINGDOM RINGS CAME TO BE USED as seals, and large square or oval-shaped bezels inscribed with the owner's name and titles became more common. This ring, from Tutankhamun's tomb, has a shank composed of three bands, the central one set with lapis lazuli. All three are wrapped with gold wire below a motif of three flowers: an open papyrus flower set with green feldspar at the center and a bud of red carnelian on either side. A central lapis lazuli scarab wears a tiny *atef*-crown of thin sheet gold. At the scarab's head is the divine lunar bark; at its feet, the god Horus as a falcon crowned with a sun disk spreads its wings protectively. — *Z.H.*

NECKLACE *with a*
TRIPLE-SCARAB PECTORAL

Gold and lapis lazuli
Width of pectoral 9 cm
Carter 256000

THE EGYPTIANS WORE JEWELRY from the Predynastic Period on, in part because they believed that its magic could protect them from all manner of evil. The first jewelry was simple, but over time it became more elaborate, inscribed with hieroglyphs and set with semiprecious stones. A peak of jewelry-making was reached during the Middle Kingdom, and during this period we begin to see the first collars, bracelets, rings, and earrings.

This necklace was found within the wrappings of Tutankhamun's mummy. It was one of about 150 pieces that adorned the king's body. It lay around the king's neck, the pectoral resting on his chest.

Although the basic form of the necklace is simple, it contains many symbols. The main decorative element is a group of three lapis lazuli scarabs set in casings of gold. Each scarab supports a disk. The outer two, made of gold, represent the sun, while the central one, made of electrum, indicates the moon, as seen by the crescent beneath it. Below each scarab is a basket of green feldspar. Some believe that this combination of scarab, disk, and basket represents the throne name of Tutankhamun, Nebkhepherure, which was written as a sun disk atop a scarab, which itself rested on three strokes above the basket sign, indicating plurality. The triple scarabs would have served the same purpose as the three strokes. The bar beneath the scarab motif was decorated with 12 flowers made of blue glass and gold. From this bar were suspended four lotus flowers separated by three large and six small lotus buds. Of the smaller buds, only three remain. The pectoral and counterpoise, connected on each side by five strands of gold and glass beads, end in connectors in the shape of winged cobras. — Z.H.

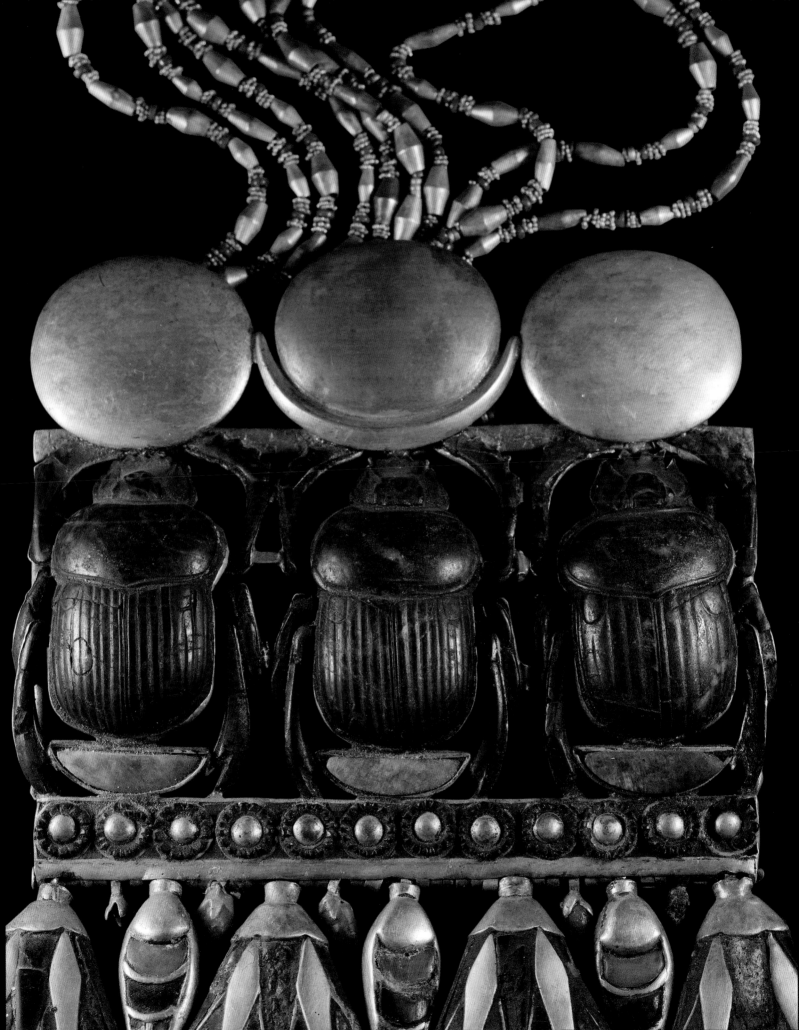

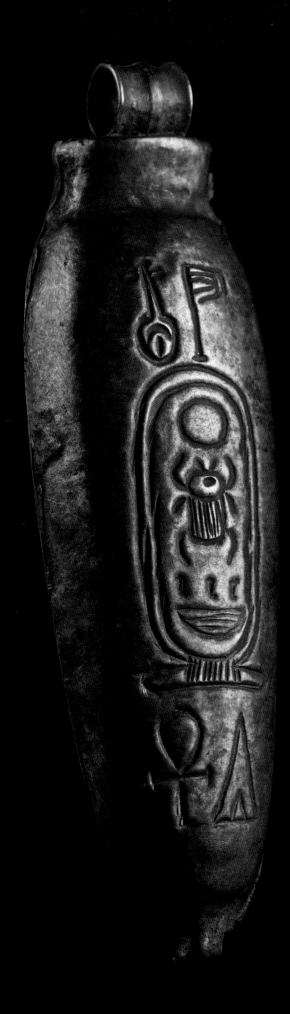

PENDANT *with* THE NAME *of* TUTANKHAMUN

Gold

Height 5.9 cm

Carter 620(69)

THIS HOLLOW GOLD PENDANT is another of the many amulets found in Tutankhamun's tomb. An inscription chased into its surface contains the throne name of Tutankhamun, Nebkheperure, enclosed within a cartouche. Above the cartouche are the hieroglyphs for *ntr-nfr*, meaning "the good god," and below it is written *di ankh*, which means "given life." A loop at the top allowed the pendant to be suspended from a necklace or collar. — *Z.H.*

BOX *in the* SHAPE *of a* CARTOUCHE

Wood

Length 12.2 cm

Carter 14b

CARTER FOUND FOUR CARTOUCHE-SHAPED BOXES in the tomb. The cartouche is one of the symbols that was connected with kingship in ancient Egypt. Its shape is derived from that of the *shen*-sign, which symbolized eternity. The cartouche represents a circle of rope with a knot at its base. The inscription of the king's names in cartouches was thought to ensure his dominion over the entire world and the eternal stability of his rule. Two of the king's names were written in cartouches. The first was the throne name, which designated the king as the ruler of Upper and Lower Egypt. The second was his birth name, by which he was known as the son of Re. The cartouche is actually one of the most important keys to the mysteries of the pharaohs, because it can tell us whether a monument was made for a king or a private individual.

A wooden hinge allows the lid of this box to swivel open from side to side. Boxes of this type were used to store cosmetics. The inscription on the box gives Tutankhamun's throne name, Nebkheperure. The tomb contained about 50 boxes, which contained various kinds of precious stuff. The boxes were of all different sizes; some were beautifully decorated while others were plainer, apparently for daily use. This box is one of three identical examples, and its manufacture is of the highest quality. — *Z.H.*

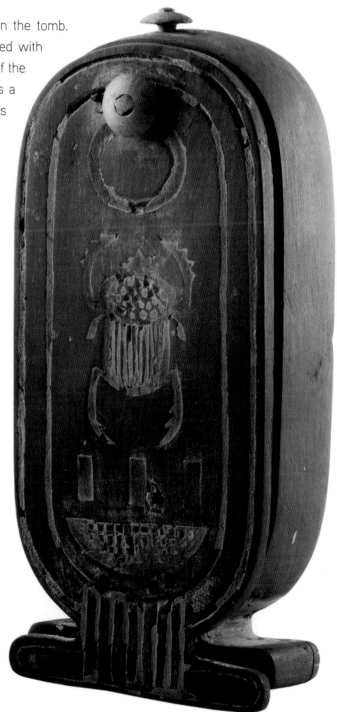

211

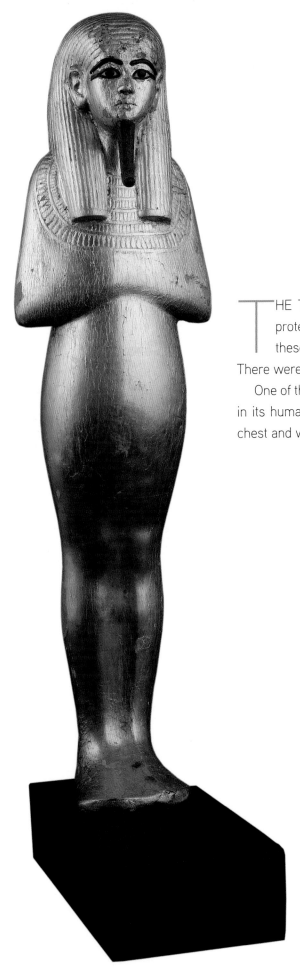

STATUE *of the* GOD SENED

Gilded wood

Height 58 cm

Carter 294a

THE TOMB OF TUTANKHAMUN contained many statues of gods, placed inside to protect the king in the afterlife and to help him in his quest for immortality. Among these gods were Isis and Nephthys, and also creator gods such as Atum and Ptah. There were also gods who gave renewed life, like the four sons of Horus.

One of the statues of gods found in the tomb, which we see here, was of the deity Sened in its human aspect and in the mummiform guise of Osiris, with arms folded across the chest and wearing a long wig. — *Z.H.*

STATUE *of the* GOD DUAMUTEF

Gilded wood
Height 58 cm
Carter 304b

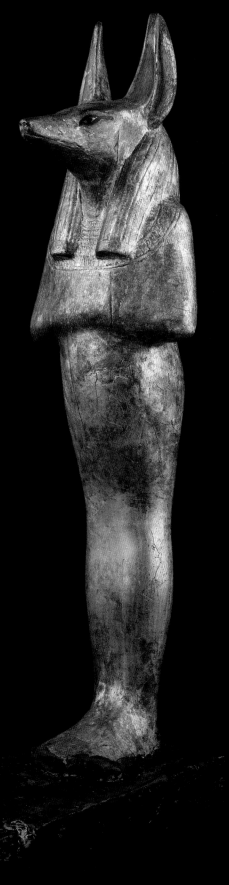

SEVERAL OF THE STATUES found in the Treasury represent deities known as the "four sons of Horus": Imsety, Hapy, Duamutef, and Qebehsenuef.

Imsety appeared with a human head, Hapy with the head of a baboon, Duamutef with the head of a jackal, and Qebehsenuef with the head of a falcon. Beginning in the New Kingdom, these heads appeared on the lids of canopic jars, which held the internal organs of the deceased. All four can also be shown on these lids as human-headed.

Each of the sons of Horus was charged with the protection of a particular organ. In mythology, they protected their father Horus during his struggle with his uncle, Seth. They are often shown atop the lotus flower, from which they were said in some accounts to have sprung. They appear not only on canopic jars but also on all sorts of objects associated with embalming and burial, including coffins and mummification beds. Mention of the sons of Horus goes back as far as the Pyramid Texts, the collection of royal funerary spells that dates from the Old Kingdom.

This statue, made of gilded wood with the eyes and eyebrows outlined in black paint, represents Duamutef with the head of a jackal, standing with his hands folded on his chest. Duamutef was responsible for guarding the stomach of the deceased. — *Z.H.*

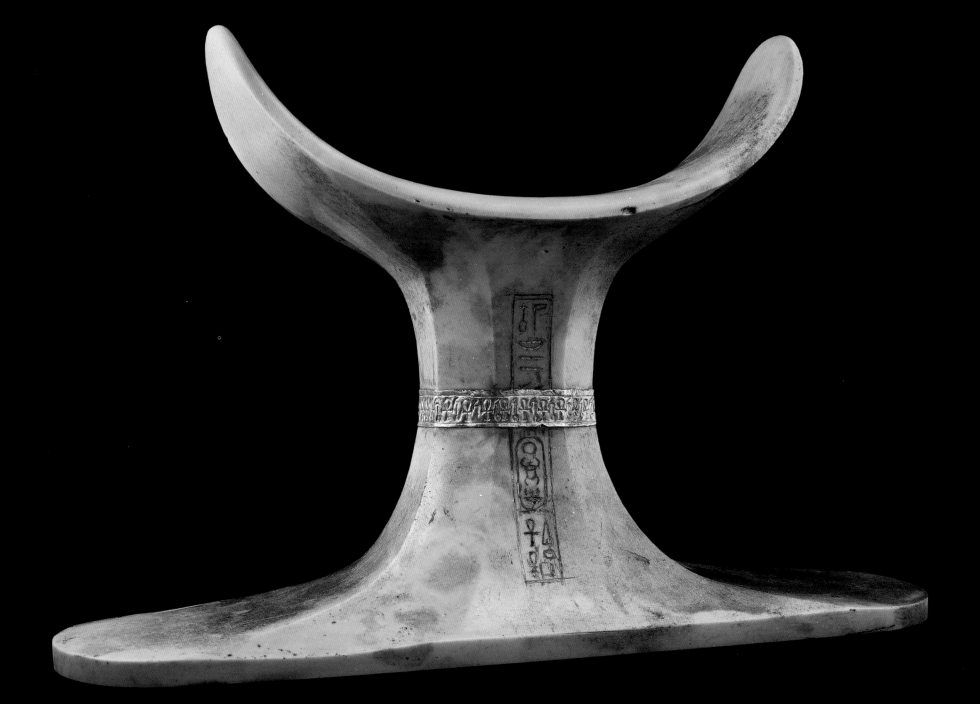

HEADREST

Faience
Height 18 cm
Carter 403a

HEADRESTS LIKE THIS ONE were designed to fill the space left by the shoulders and neck of a sleeping individual, supporting his head. A thick linen pad would have served to cushion the hard surface. Headrests intended for use by the living were usually made of wood, but examples produced specifically as burial furniture could also be crafted of less utilitarian materials, such as faience, calcite, limestone, or ivory.

Headrests were an essential part of the burial equipment with which the deceased were provided. A headrest was generally placed in the coffin under or beside the head of the mummy, and many tombs were provided with multiple headrests. They were not intended solely for the comfort of the deceased in the next life but were also thought to serve important magical functions. During the New Kingdom, the pillar that supported the crescent-shaped portion where the head actually rested was sometimes carved in the shape of a protective deity, to ward off forces that might harm the owner as he lay asleep. As we know from texts contained in the Book of the Dead, the base of the headrest could symbolize the horizon; the head of the deceased was considered to rise above it like the sun, reborn in the east each morning.

This example is made of two pieces of blue faience, held together by wooden dowels. The join between the two pieces is covered by a band of gold decorated with alternating *ankh*- and *was*-signs, which represented life and power respectively. The inscription on the center column gives the name and titles of the king.

This headrest is one of four that were found in a long-legged box in Tutankhamun's tomb. Carter felt that the box had not contained them originally, but that they had been placed inside after they had been scattered by the tomb robbers. — *Z.H.*

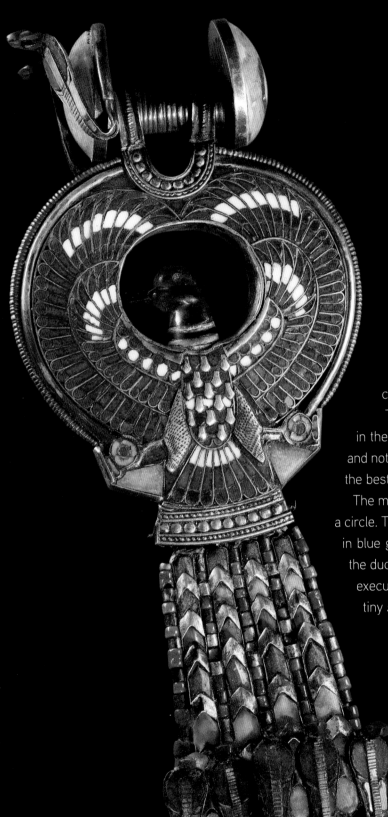

EARRINGS *in the* SHAPE *of* DUCKS

Gold, quartzite, colored faience, colored glass,
and semiprecious stones
Length 10.9 cm

Carter 269a(1)

EARRINGS WERE IMPORTANT ITEMS OF JEWELRY in ancient Egypt;
six pairs were included among the objects that Tutankhamun took with
him into the other world. We can see two holes for earrings in the ears
of the golden mask, a fashion that appeared for the first time during the New
Kingdom. Royal children, both boys and girls, had pierced ears, and earrings
came in many different shapes and styles.

These earrings were among five pairs found in the large cartouche-shaped box
in the Treasury. Scholars believe that they were made to be worn by the king in life
and not crafted for funerary purposes only. The pair to which this earring belonged was
the best of the five found in the box, because of its fine detailing.

The main element of the design is the bird in the center, with its wings spread to form
a circle. The feathered body appears to be that of a hawk, but the head of a duck modeled
in blue glass is mounted in the center. A fringe of uraei—upright cobras—hangs from
the duck's tail, and two cobras decorate the ear stud. All of these details are beautifully
executed in gold, colored glass, and semiprecious stones. In its feet, the bird holds
tiny *shen*-signs. — *Z.H.*

TORCH HOLDER *in the* SHAPE *of an* ANKH

Bronze and wood
Height 24 cm
Carter 41c

THIS TORCH HOLDER IS ONE OF A GROUP OF FOUR found together in the Antechamber. Each one consisted of a bronze ankh, the ancient Egyptian symbol for life, fitted into a wooden base. Each ankh was provided with two human arms, which reached out to support a small golden cup, in which stood a long wick made of linen. Unfortunately, it seems that the tomb robbers of antiquity managed to make off with the cup that belonged to this example.

Most of the everyday lamps used in Egyptian homes were pottery dishes, very simple in shape, which were filled with oil and lighted by a linen cord. Many such lamps have been excavated, and we know that they were often placed on tall stands in order to fill the homes with light. In ancient Egypt, the fires from which these lamps would have been lit were started by means of a thin, pointed wooden stick that would be spun vigorously in a sawdust-filled hollow in a piece of wood. The friction generated by the motion would ignite the sawdust.

The ankh-sign, the most famous of ancient Egyptian symbols, signified life in hieroglyphic writing. Magical objects were often fashioned in this shape. In funerary contexts, it was hoped that these objects would help the deceased to live again for eternity. — *Z.H.*

ANUBIS FETISH

Calcite and gilded wood
Height 167 cm
Carter 44a(2)

THIS OBJECT, A SYMBOL OR FETISH OF THE GOD ANUBIS, is one of two nearly identical examples that were found in the Burial Chamber. It represents a headless, stuffed animal skin hanging by its tail from a pole. The pole and the body of the animal are made of gilded wood, while the tail, which ends in an open papyrus flower, is made of bronze. The calcite base is inscribed: "the good god, Nebkheperure, son of Re, Tutankhamun, ruler of the south, given life forever, beloved of Anubis, the overseer of the place of embalming." The inscription on the second fetish is slightly different, giving different epithets for the god.

Anubis appears in Egyptian art either in the shape of a jackal-headed man or entirely in animal form. He was the god of embalming and the protector of cemeteries, and he was thought to guard the mummies of the deceased from evil spirits. He was also associated with the judgment of the dead in the underworld, shown presiding along with other deities over the "weighing of the heart," the trial that determined whether an individual would be permitted to enter paradise. — Z.H.

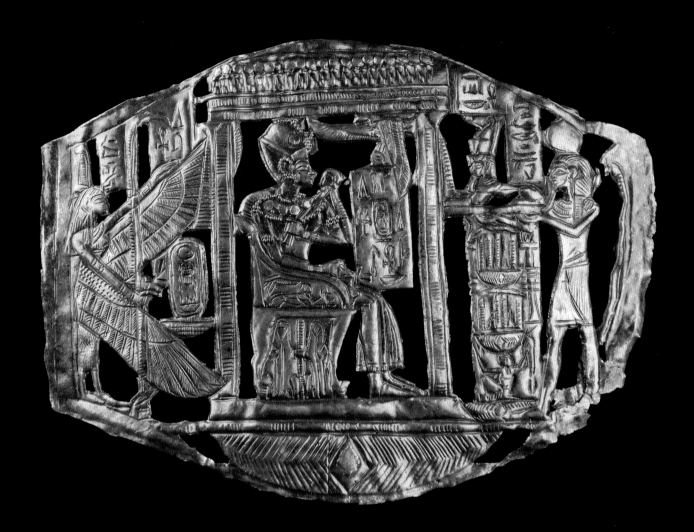

OPENWORK PLAQUE

Gold

Length 9 cm

Carter 44,a,2

MADE OF GOLD IN AN OPENWORK TECHNIQUE, this plaque could have been a belt buckle or a clothing ornament. Four such objects, depicting different scenes, were found in a box in the Antechamber. This one shows the king enthroned inside a chapel, wearing a pleated robe and the *khepresh*, or blue crown, and holding the royal flail. A vulture hovers in front of him, clutching a panel inscribed with the epithets and name of the king. Approaching the chapel is the god Atum, bearing a statue of a sphinx on a pedestal. Behind the chapel, Ma'at, the goddess of justice, spreads her wings around a cartouche containing Tut's throne name. She holds a palm branch, symbolizing eternity. — *Z.H.*

SCRIBE'S PALETTE

Slate and gilded wood
Length 28 cm

Carter 620(92)

MANY OBJECTS FOUND IN TUTANKHAMUN'S TOMB were related to activities that might have been part of the king's daily life. Along with musical instruments and games, the pharaoh was supplied for the afterlife with a number of tools for writing. This piece is a ritual model of the kind of palette that scribes would have used to mix the red and black pigments with which they wrote on papyrus. The center is decorated with a carved representation of an opening which would have held reed pens, while wells for cakes of pigment are represented in steatite and calcite, the latter of which was backed with red cement to give it the correct color.

Scribes were important in ancient Egypt. Literacy was rare, and those who could read and write were able to attain important positions as royal officials. The sons of kings were often educated as scribes. Writing was also connected with a number of Egyptian gods, including the ibis-headed Thoth, who was considered the scribe of the sun god, Re. — *Z.H.*

BED

Wood
Length 185 cm
Carter 80

THE TOMB OF TUTANKHAMUN CONTAINED SEVEN BEDS, three of which, made of gilded wood with sides in the shape of protective animal deities, were made specifically for use in the king's funerary rituals. The remaining four, however, were functional in design and might have been used during his lifetime. The beds were found in a jumble on the west side of the Antechamber. This example was actually impaled on a horn of the cow goddess that decorated one of the funerary beds. It is very simple, made of whitewashed wood with a mat of reeds woven across the frame. The legs are carved to resemble those of a lion, a common element of furniture design that invoked the protection of this powerful animal. — Z.H.

FUNERARY FIGURE (SHABTI)

Gilded wood

Height 51.6 cm

Carter 110

THIS IS ONE OF THE LARGEST AND FINEST of the funerary figurines found in Tutankhamun's tomb. Figurines of this type were placed in Egyptian tombs beginning in the Middle Kingdom to serve the deceased in the afterlife and to take his place if he should be asked to do any kind of work in the fields of paradise. In Chapter 6 of the Book of the Dead, we find a magical formula for these statuettes, which was intended "to make the lazy one raise his head and work for [the deceased]." These statuettes were usually small in size and could be made in many materials, with the greatest variety seen during the 18th dynasty. They are referred to as *ushebtis*, *shawabtis*, and shabtis—terms that are incorrectly used interchangeably and which should each be restricted to pieces that actually bear the Chapter 6 inscription with the term in a given spelling. These figurines were sometimes supplied with miniature tools, which might be sculpted or painted directly onto the surface or fashioned separately. The tomb of King Tut had 413 of these statuettes: 365 workmen, one for each day of the year; 36 overseers; and 12 directors.

Most of the funerary figurines found in the tomb of Tutankhamun were in the Treasury or, like this piece, in the Annex. This example is remarkable both for its large size and for the quality of its workmanship. It represents the king wearing the royal *nemes*-headdress with two goddesses, Nekhbet and Wadjet, adorning his brow. The vulture and uraeus are both of bronze. On the king's chest is a broad collar, and his left wrist is adorned with a bracelet; both are delicately indicated in gilt. The crook he once held in his right hand is missing, but the flail is intact. On the shabti's body, four lines of text contain the formula mentioned above, which was meant to bring the statuette to life to work for its owner in the next world. — *Z.H.*

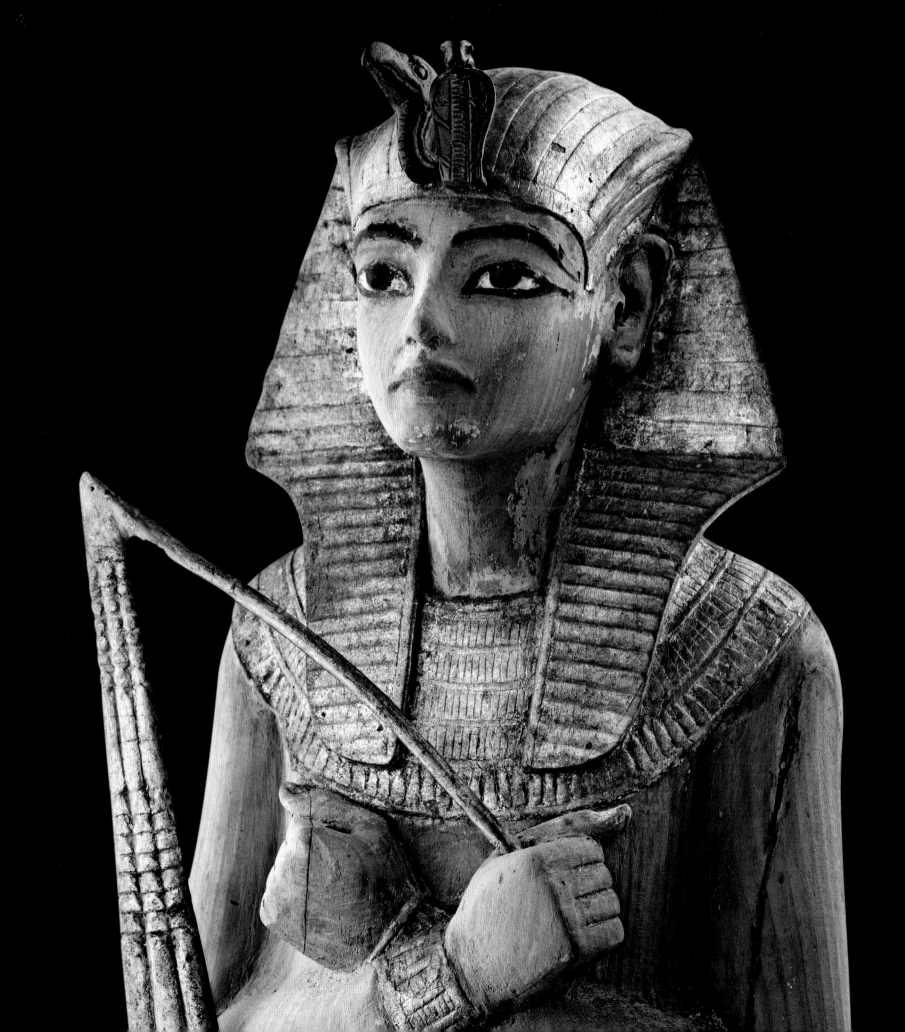

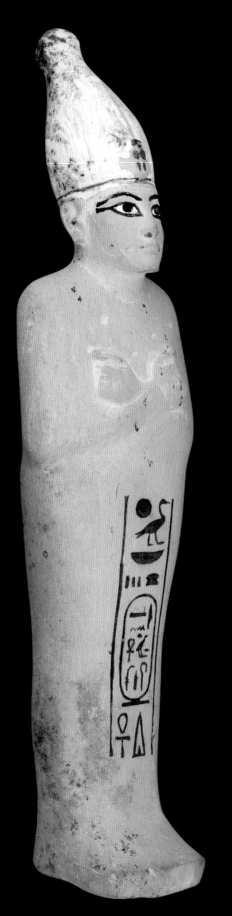

SHABTIS

T HIS GROUP OF SHABTIS REFLECTS the great diversity of materials and designs seen in funerary figurines of the 18th dynasty. While they are not shown to scale here, the diversity of design and materials is evident. Tutankhamun's tomb contained shabtis made of faience (Carter 326d, Carter 519b, Carter 496d, and Carter 519f), painted or gilded wood (Carter 325b, Carter 323f), and various types of stone. Carter 380f is of calcite (also called Egyptian alabaster), while Carter 605a is of a distinctive type of yellow limestone found in the eastern and western deserts. Carter 605g is one of a large group of quartzite figurines found in the tomb, and Carter 322h is made of granite, a relatively uncommon material for funerary figurines. — Z.H.

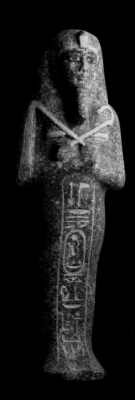

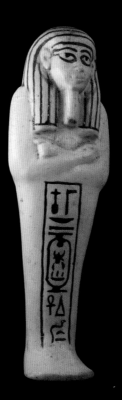

Limestone • Carter 605a Granite • Carter 322h Faience • Carter 519f Calcite • Carter 380f

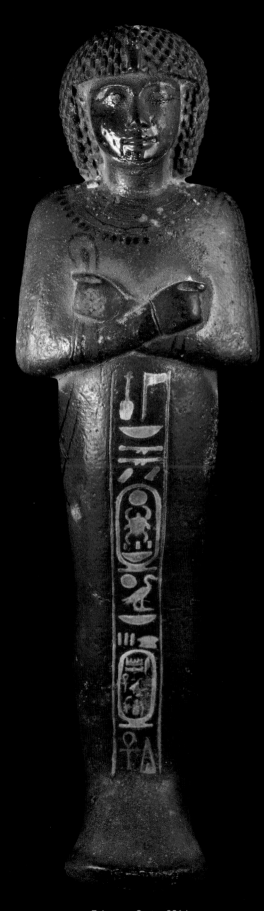

Painted wood • Carter 323f

Gilded wood • Carter 326b

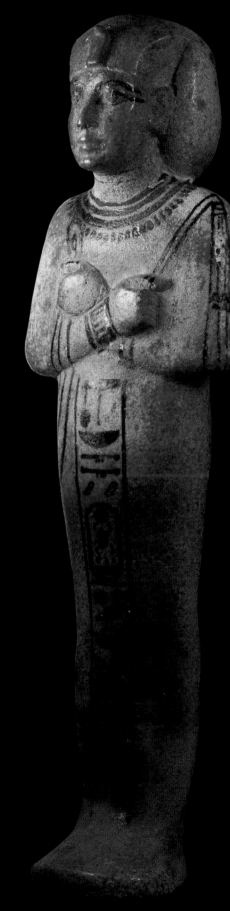

Faience • Carter 326d

Faience • Carter 496d

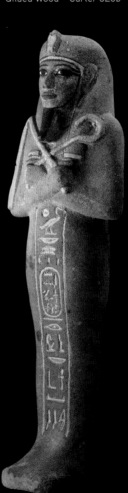

Quartzite • Carter 605g

Faience • Carter 519b

CHAIR

Wood, painted white
Height 75 cm
Carter 349

THIS CHAIR WAS AMONG THE FURNITURE placed in the tomb for the king's use in the afterlife. It stands on lion's legs, a feature commonly incorporated into furniture for the magical protection of those who used it. The lower part of the chair is decorated with the *sema-tawy* sign, which represented the unity of Upper and Lower Egypt, carved in delicate openwork. On the back of the chair, another openwork design shows Horus as a falcon with its wings outstretched. In his talons, he grips *shen*-signs, which represent eternity. Below each of the god's wings, the ankh, representing life, appears between two *was*-scepters, symbols of royal power. Above the wings, we see the cartouches of Tutankhamun. Horus protects them, and, by extension, the king himself, since names were thought to contain something of the magical essence of the person to whom they belonged. In addition, the falcon may represent Tutankhamun as Horus, because as we know, the king on earth was considered a manifestation of this god.

Chairs in ancient Egypt ranged from simple examples with no arms and backs of varying height to elaborate thrones, gilded and ornamented with glass and semiprecious stones. Some of them, including this example, were made specifically as funerary furniture, while others were used in daily life and then buried with the king for his enjoyment in the afterlife. Most of this funerary furniture was made of wood, although pieces made of limestone have been found at Amarna.

The tomb of Tutankhamun contained a remarkable number of chairs. Small chairs found in the tomb were probably made for Tutankhamun while he was still a child. It is important to note that in every case, the artisans who created them were able to produce the finest workmanship, whether they were using Egypt's difficult native woods or fine, imported Lebanese cedar. Only a royal palace would have been a fitting setting for these beautiful pieces of furniture. — *Z.H.*

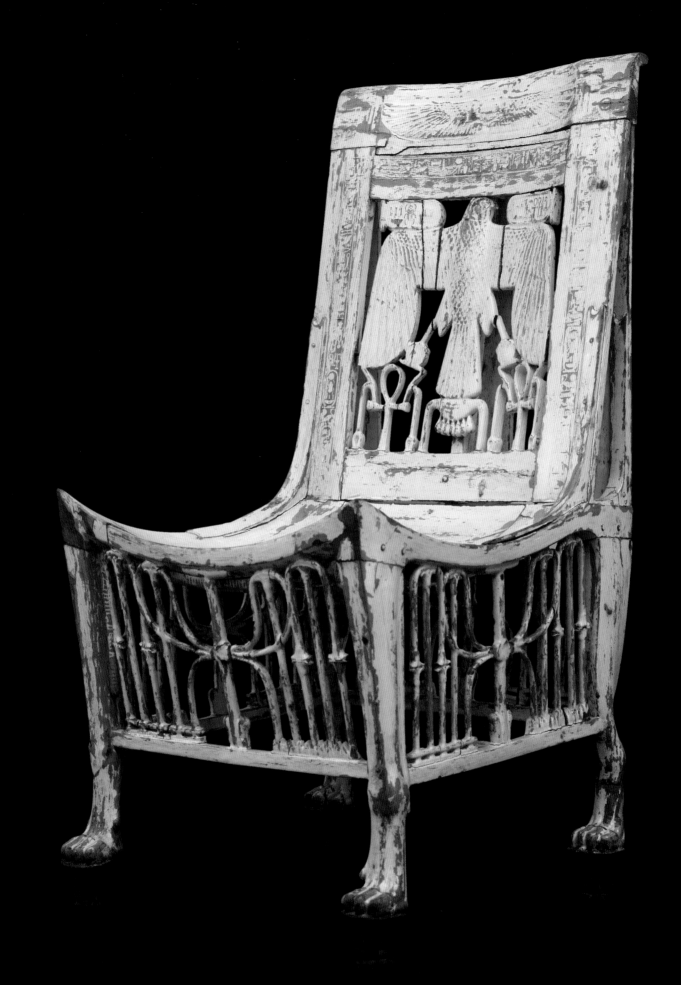

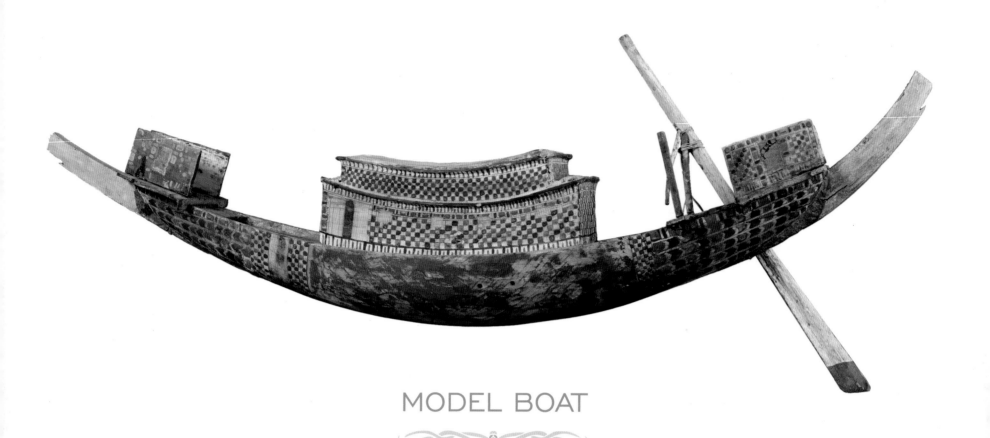

MODEL BOAT

Painted wood
Length 110 cm
Carter 273

A LARGE NUMBER OF MODEL BOATS were found in the tomb of Tutankhamun. About 18, including this one, were discovered in the Treasury, and others were found in the Annex. This example, probably of some sort of ceremonial barge, has a large cabin in the middle, smaller lookouts at each end, and a large steering oar on either side of the stern.

Boats were extremely important in the everyday lives of the ancient Egyptians, as they were one of the principal modes of transportation. There are many scenes and inscriptions from Egyptian tombs that show boats similar to this one sailing on the Nile. A number of these scenes depict pilgrimages to Abydos—the mythical burial place of the god Osiris and the actual cemetery of the first kings of Egypt—and to other sacred sites. As early as the Old Kingdom, the pilgrimage became an important rite for many Egyptians. Many Old and Middle Kingdom tombs show versions of this journey, with the deceased as a mummy traveling in one direction and as a blessed being who had passed to the next stage of the afterlife on the way back. — *Z.H.*

BOX *with a* GABLED LID

Wood
Height 55 cm
Carter 317

THIS IS ONE OF THE DOZENS OF BOXES of many shapes and sizes with which the young king was buried. Many were beautifully decorated, painted, and inlaid with glass and precious stones, while others, like this piece, were quite simple. This one is remarkable in that when Carter opened it, he found that it contained two miniature coffins, each of which contained the tiny mummy of a fetus. One had been born significantly prematurely, while the other may have been stillborn closer to full term. This poignant discovery probably reflects the loss by Tutankhamun and his young wife of their only offspring, who were buried, as was often the case with kings' children, in the tomb of their father. — *Z.H.*

FAN

Wood, gilded and inlaid with glass
Length 125 cm
Carter 245

THIS FAN, FOUND IN THE BURIAL CHAMBER, was inlaid with multicolored glass and includes two cartouches of Tutankhamun at its center, each topped with the sun disk and the hieroglyphic sign for "sky" and flanked by vulture-goddesses with *was*-scepters and *shen*-signs between their wings, symbolizing power, eternity, and protection. One wears the red crown of Lower Egypt, the other the white crown of Upper Egypt.

The fan was a symbol of kingship. Fans were carried behind the pharaoh during ceremonies to protect him from the sun, and certain officials held the title of "the fan-bearer of his majesty." Fans offered relief from heat, and the breeze they produced was connected with Shu, the god of air. The fan's movement represented breath, and thus life, rebirth, and resurrection in the other world. It was also connected with the *ba*, one part of the soul of the deceased, shown as a human-headed bird. — *Z.H.*

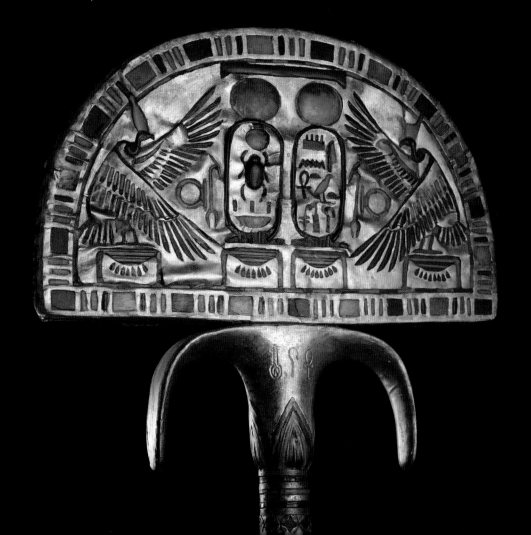

LEOPARD-HEAD DECORATION
from a RITUAL ROBE

Gilded wood, rock crystal, and colored glass
Height 13 cm
Carter 44q

THIS LEOPARD'S FACE DECORATED A ROBE of the type worn by the *sem*-priests, who performed an important funerary ritual called the Opening of the Mouth. The officiant, dressed in a leopard-skin robe, magically "opened" the eyes, nose, ears, and mouth of the mummy, so that in the next world its owner could breathe, use his senses, and answer questions posed by the deities who would judge him before Osiris. After this ritual, the deceased was ready for burial. Tutankhamun's successor, Ay, is shown in the young pharaoh's tomb in the leopard-skin robe of a sem-priest, performing the Opening of the Mouth on Tutankhamun's mummy. A similar leopard-head ornament was found in the tomb, together with the remains of a linen robe that had silver stars and claws of silver attached. — *Z.H.*

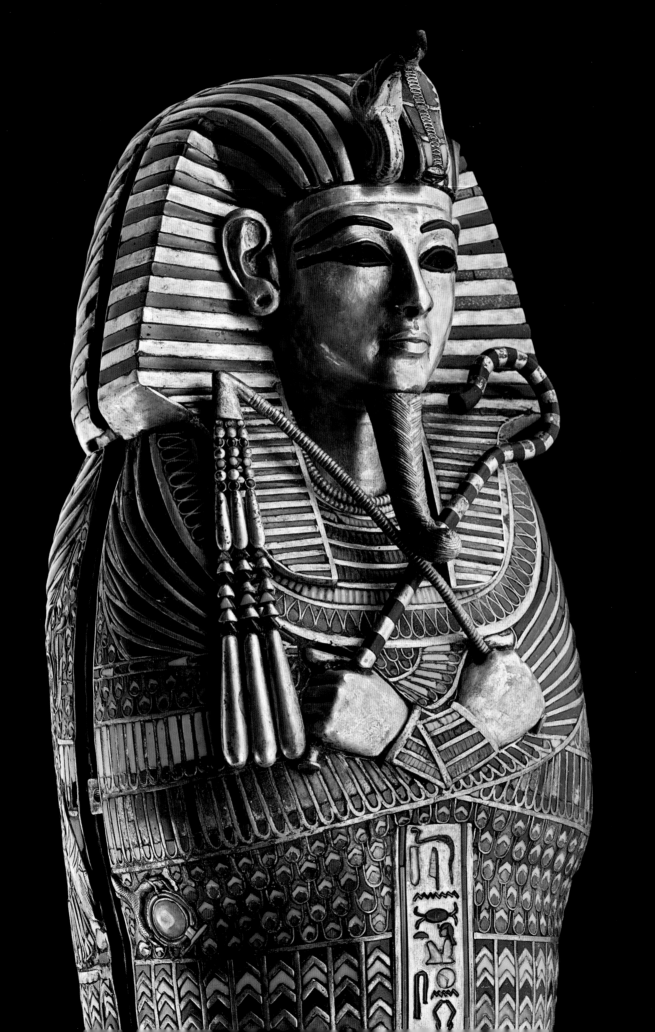

CANOPIC COFFINETTE

Gold, carnelian, and colored glass

Height 39 cm

Carter 266g

THIS MINIATURE COFFIN IS ONE OF THE FOUR that were contained within the hollows in Tutankhamun's canopic chest. They are made of gold inlaid with carnelian and colored glass. Each one is unique in its decoration and in its beautiful inscription, although in all of them, the king appears in Osiride form, his hands on his chest, holding the crook and flail insignia and wearing the royal *nemes*-headdress. On his forehead, we see the goddesses Wadjet and Nekhbet, symbols of Egypt's northern and southern regions, in the form of a cobra and a vulture. They were also thought to protect the king in the underworld. The king wears a divine beard, along with a beautifully inlaid collar and brace-lets. The features of the long, oval-shaped faces are remarkably similar to those of the golden mask, although the canopic coffinettes were not originally made for Tutankhamun.

The coffins are covered with the feathered decoration known as *rishi*. The chest and shoulders are protected by the goddesses Wadjet and Nekhbet, whose wings surround the king. In the center of each coffin, a hieroglyphic inscription refers to the deities believed to protect the organ it contained. Each organ was guarded by one of the four sons of Horus: Human-headed Imsety watched over the liver, baboon-headed Hapy the lungs, jackal-headed Duamutef the stomach, and falcon-headed Qebehsenuef the intestines. Each of these funerary genii, as they are called, was assisted by a tutelary goddess and associated with one of the four directions. Isis assisted Imsety in the east, Nephthys and Hapy were together in the north, Neith and Duamutef in the east, and Qebehsenuef and Selket in the south.

The earliest surviving canopic chest comes from the tomb of Queen Hetepheres at Giza. During the First Intermediate Period, canopic jars appeared topped with human-headed lids. It was only during the New Kingdom that the sons of Horus began to be represented with their distinctive heads. The last known set of these jars belonged to King Apries of the 26th, or Saite, dynasty. — *Z.H.*

FOUR CYLINDRICAL CAVITIES WERE CARVED into the calcite body of Tutankhamun's canopic chest to hold miniature coffins containing the king's organs. Each was sealed with a human-headed stopper, portraits in miniature of the king, beautifully carved in calcite, the eyes and nostrils detailed in black and the lips painted red.

There is some debate over the original owner of Tutankhamun's canopic equipment, which may have been intended for a predecessor, perhaps the ephemeral Smenkhkare. These stoppers, however, are clearly portraits of Tut himself. — Z.H.

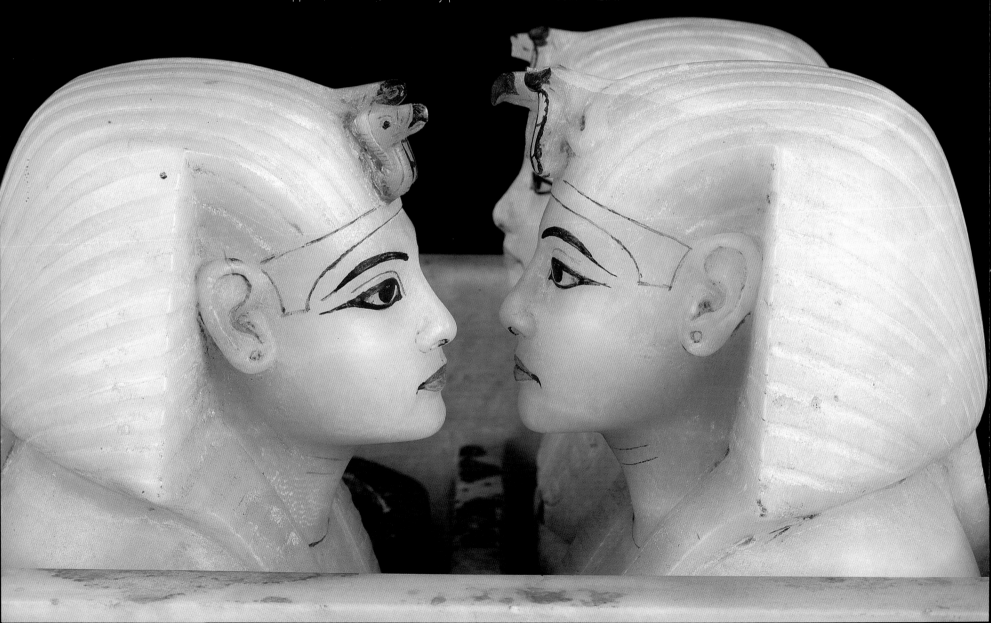

STATUETTE

Blue glass

Height 5.8 cm

Carter 54ff

THIS STATUETTE WAS FOUND IN THE ANTECHAMBER, inside a box that contained a jumble of objects of different types. The king is shown in a squatting position, wearing a short kilt and the *khepresh,* or blue crown, with the royal insignia of the vulture and uraeus on his brow.

The king holds a finger to his mouth, a gesture that signified childhood in Egyptian art. In royal images, this gesture connected the king with the god Horus the Child, whose Egyptian name Har-pa-khered was pronounced "Harpokrates" by the Greeks. Horus was the son of Osiris, the king of the underworld, and his sister-wife Isis. Horus spent his childhood in the marshes of the Nile Delta, and when he reached adulthood, he took revenge against his uncle Seth for the murder of Osiris. The victory of Horus over Seth in battle represented the triumph of good over evil. According to myth, Horus then became the ruler of Egypt, and Egypt's kings were considered the living embodiments of the god.

Howard Carter believed that this statuette was made not for Tutankhamun but for his father, Akhenaten. A ring at the back of the king's head allowed it to be suspended by a chain and worn as a pendant. — *Z.H.*

AMULETS

THE FORM AND MATERIAL OF AMULETS, it was believed, enabled them to confer power and protection on the wearer. The Book of the Dead contained detailed prescriptions regarding which amulets were to be included among the wrappings of a mummy, although Tutankhamun seems to have been prepared for burial without regard for these instructions. The three sheet-gold amulets shown here were part of a group that was suspended by gold wires around the mummy's neck, deep within the bandages. One depicts a vulture, the symbol of the goddess Nekhbet, who was considered the protectress of Upper Egypt. In this piece she is shown alone, but she was often accompanied in art by the cobra goddess of Lower Egypt, Wadjet. Nekhbet herself could also appear as a serpent, as seen in another sheet-gold amulet, where both of these goddesses are shown together in the same form. The third sheet-gold amulet combines the body of a serpent with a pair of outstretched wings and the head of a human woman. It is not known which goddess is represented by this image, but the amulet displays the gift of Egyptian artists for combining different features to create convincing imaginary composite creatures.
— Z.H.

AMULET OF ANUBIS
Gold and green feldspar
Height 5.5 cm
Carter 256xxx

AMULET OF HORUS
Gold and lapis lazuli
Height 4.6 cm
Carter 256yyy

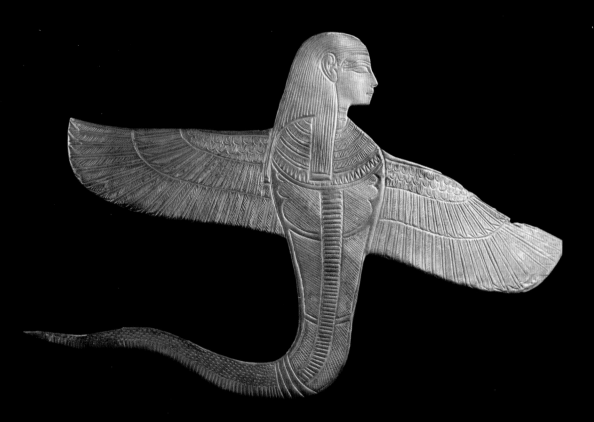

PAPYRUS AMULET

Gold and green feldspar

Height 6.3 cm

Carter 256ggg

HUMAN-HEADED URAEUS AMULET

Sheet gold

Height 9 cm

Carter 256,4,f

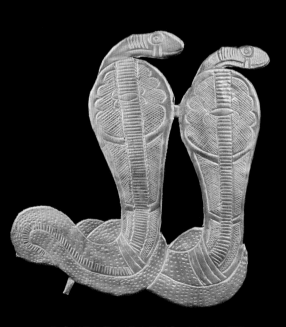

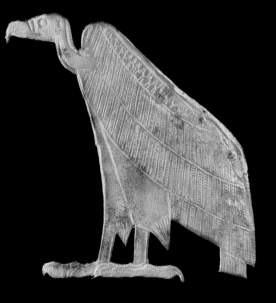

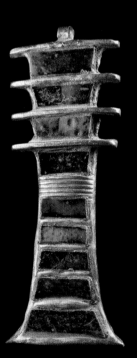

DOUBLE URAEUS AMULET

Sheet gold

Height 7 cm

Carter 256,4,g

VULTURE AMULET

Sheet gold

Height 6.6 cm

Carter 256,4,h

DJED-PILLAR AMULET

Gold and blue faience

Height 8.8 cm

Carter 256hhh

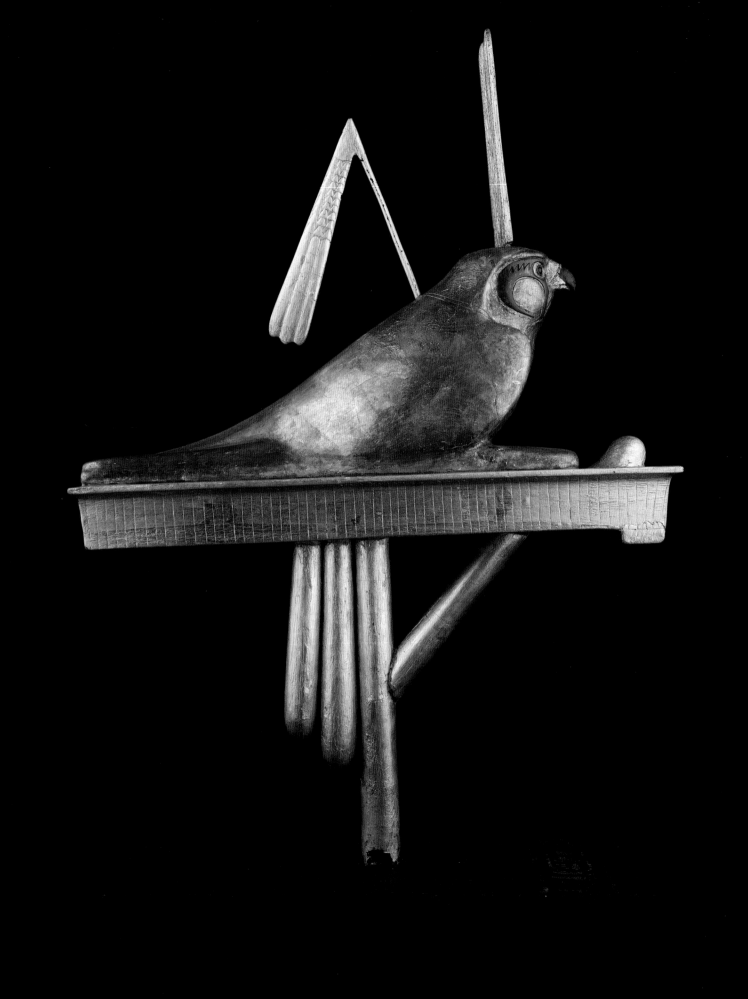

STATUE *of the* GOD SOPDU
on a STAND

Wood, gilded and painted with glass inlay

Height 65.5 cm

Carter 283b

THE EGYPTIAN GOD SOPDU FIRST APPEARED in the Old Kingdom and was known as the "lord of the foreign lands." His job was to control the important desert area which made up Egypt's eastern border. He was worshipped in the 20th nome of Lower Egypt and is shown here as a seated hawk, the same form in which his name was written in hieroglyphics. He was also shown in human form, wearing a crown made of plumes and a tasseled *shemset*-belt. Sopdu was connected with Horus in the Middle Kingdom. By the time of the New Kingdom, the two gods had merged into one, under the name of Hor-Sopdu.

On the base of the statue, an inscription in black paint reads, "Tutankhamun, beloved of Sopdu." The statue is made of gilded wood, with glass inlay around the eyes. The eyes themselves, along with the upper portion of the beak, are made of black glass. The statue stands on a gilded base decorated with a cavetto cornice. On the head of the hawk, we see a remarkable plumed headdress, and the bird carries the royal flail. The statue of the god symbolizes Sopdu's protection of the king and the country's border with the foreign lands to the east. — *Z.H.*

FINGER *and* TOE COVERS

Gold

Carter 256ll

THESE GOLDEN COVERS, OR STALLS, were found on the fingers and toes of Tutankhamun's mummy, and they served a function similar to that of the amulets that protected other parts of the king's body from various magical dangers. The precious material of which they were made also identified the king with the gods, whose flesh was thought to be of gold. — *Z.H.*

FUNERARY SANDALS

Gold

Length 29 cm

Carter 256ll

THESE SANDALS, which adorned the feet of the king's mummy, were not meant for daily wear but were made especially for the king's burial. Details chased into the gold imitate the papyrus of which many sandals worn in life were made. Sandals for everyday wear could also be made of leather, while others that were probably only for ceremonial use were made of wood and bark, brightly gilded and painted. — *Z.H.*

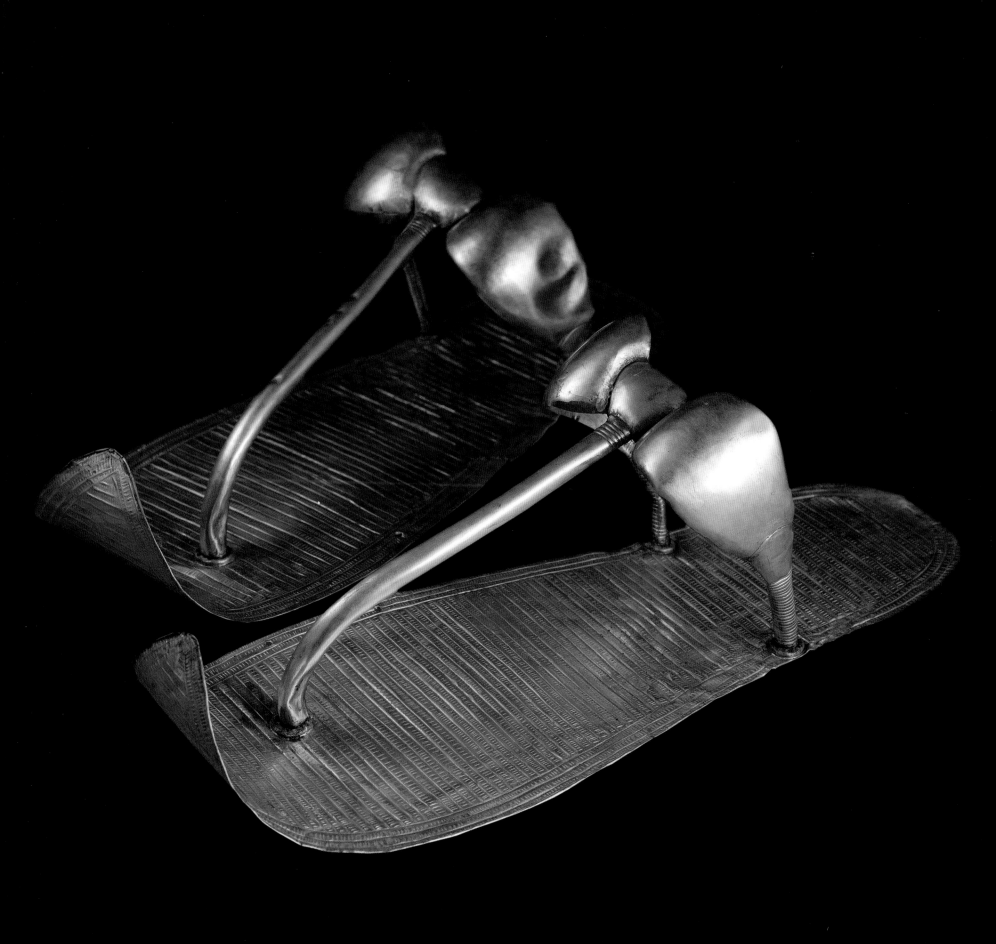

NEMSET-EWER *with* STAND

Calcite (Egyptian alabaster)
Height 28 cm
Carter 45

THIS EWER, OR PITCHER, with its short spout is another of the charming pieces found inside the tomb. The curves of the tapered lid were beautifully rounded by the stone-carver. The base is decorated on all four sides with openwork scenes. Bes, the lion-headed dwarf god who protected the home, squats at the center of each panel. On two of the four sides of the base, he is flanked by winged sphinxes. On the other two, a griffin on each side, supported by a *djed*-pillar, presents the god with an ankh, the symbol of life. — *Z.H.*

UNGUENT VESSEL

Calcite (Egyptian alabaster)
Height 26 cm
Carter 420

THE EGYPTIANS WERE MAKING VESSELS of calcite as early as the Predynastic Period. This example is one of many containers found in the Antechamber. It is remarkable for the openwork decoration that flanks the central portion, composed of papyrus flowers which bloom atop stalks emerging from lilies and framed by notched palm branches, which symbolized a wish for the king's long life. No two of the vessels from Tutankhamun's tomb are exactly alike; each one has its own unique beauty. — *Z.H.*

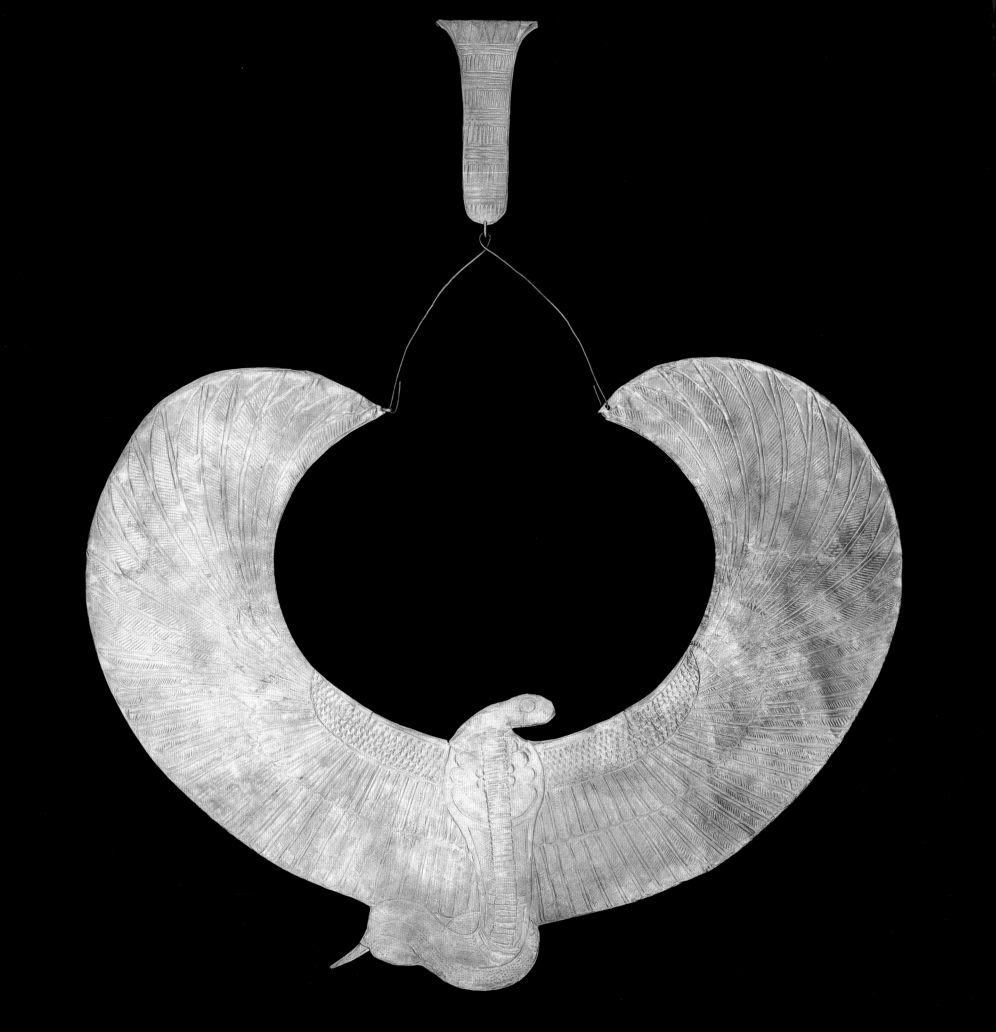

COBRA COLLAR

Gold

Width 33 cm

Carter 256g

THIS COLLAR WAS FOUND within the wrappings of the young king's mummy. It is made of a piece of thin sheet gold, with details chased into the surface. The artist succeeded admirably in depicting a cobra with outstretched wings, another example of the Egyptian genius for creating visually plausible composite creatures. The goddess depicted here is Wadjet, who was considered the protectress of Lower Egypt. The wing tips are pierced with tiny holes for the wire by which the collar was suspended around the mummy's neck. A counterpoise of sheet gold in the shape of an elongated lotus blossom is suspended from the wire in back. — *Z.H.*

DECORATED UNGUENT VESSEL

Calcite (Egyptian alabaster)

Height 65.7 cm

Carter 58

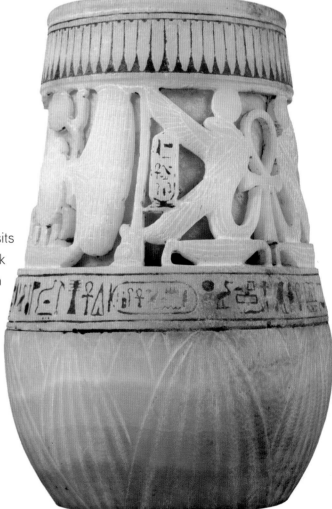

THIS UNIQUE VESSEL was made in three parts. A thin lining sits inside a thicker shell, which has been carved with an openwork design. The outer vessel was made in two segments: A rim on the bottom fits inside the base, which has been carved into a lily or lotus blossom. The band of openwork decoration is composed of three vignettes. In two of them, winged cobras perch atop *nub*-signs (symbolizing gold) and support the king's cartouches, their backs to the ankh-sign between them. In the third, a winged scarab supports the disk of the sun with its forelegs. Strokes below show it to be a rebus for the throne name of Tutankhamun, Nebkheperure. — *Z.H.*

COLOSSAL STATUE *of* TUTANKHAMUN
USURPED *by* HOREMHEB

Quartzite
Height 285 cm
New Kingdom, Dynasty 18, reigns of Tutankhamun and Horemheb
Thebes, Medinet Habu, Temple of Ay and Horemheb
JE 59869

THIS STATUE IS ONE OF A PAIR found at the remains of the funerary temple of Ay and Horemheb on the west bank of Thebes near Medinet Habu; its twin is at the University of Chicago. The belt is inscribed with the name of Horemheb, written over the earlier ones of Ay and Tutankhamun. The statuary style is post-Amarna: The thick lips, spreading snub nose, heavily outlined eyes, and thickened torso and belly are all characteristics of that era. Perhaps the most remarkable thing is the amount of paint still on the face. The king looks quite "made up," with a pink pigment on the skin, black and white making the eyes stand out, and strong red for the lips. The appearance is dramatic and reminds one of the coloring on the face of Queen Nefertari in her tomb in the Valley of the Queens.

King Tutankhamun was only about 19 when he died without an heir, and his young wife may have suspected that one of his high officials, Ay or Horemheb, had conspired to murder him. Many believe that Horemheb had the prince sent by the Hittite king to marry Ankhsenamun killed on his way to Egypt. Yet Ay became the next king, perhaps because, as a priest and possible father of Nefertiti, he was closest to the royal blood. Evidence also suggests that he married Ankhsenamun to secure his right to the throne. He is shown in Tutankhamun's tomb performing the Opening of the Mouth on the deceased king, and thus acting as the legal heir to the throne.

Ay, an old man, ruled for only a few years. After Ay, Horemheb, commander in chief of the army, took the throne. Some Egyptologists believe that he began demolishing monuments right away. Other scholars, such as Ray Johnson, think that the erasing of Tut's memory began late in Horemheb's reign, as part of his efforts to place Ramesses I on the throne. Certainly Horemheb usurped many of Tut's monuments, though I am not convinced that Horemheb had Tutankhamun's monuments demolished at all; there would have been no need to do away with the young king's memory in order for the succession to take place smoothly. Horemheb was a powerful military leader even before taking the throne, and his reign had been relatively long and stable. The young king's monuments may have been destroyed by other people, for reasons we do not know. — *Z.H.*

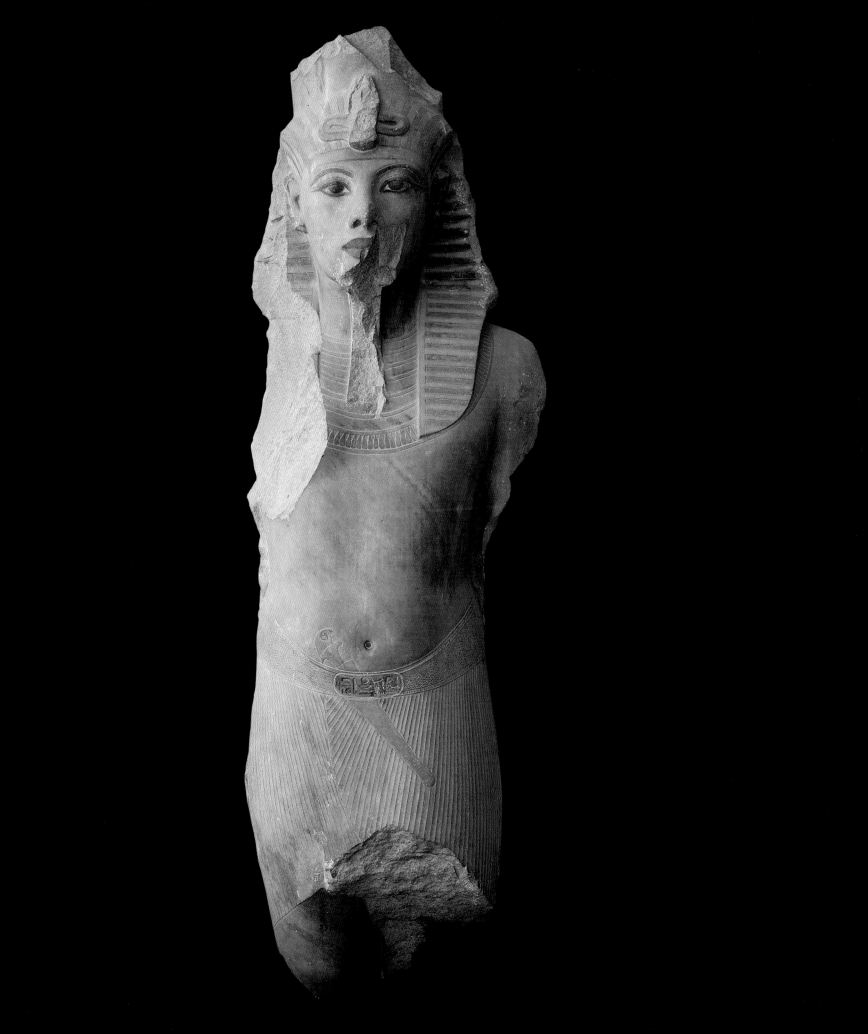

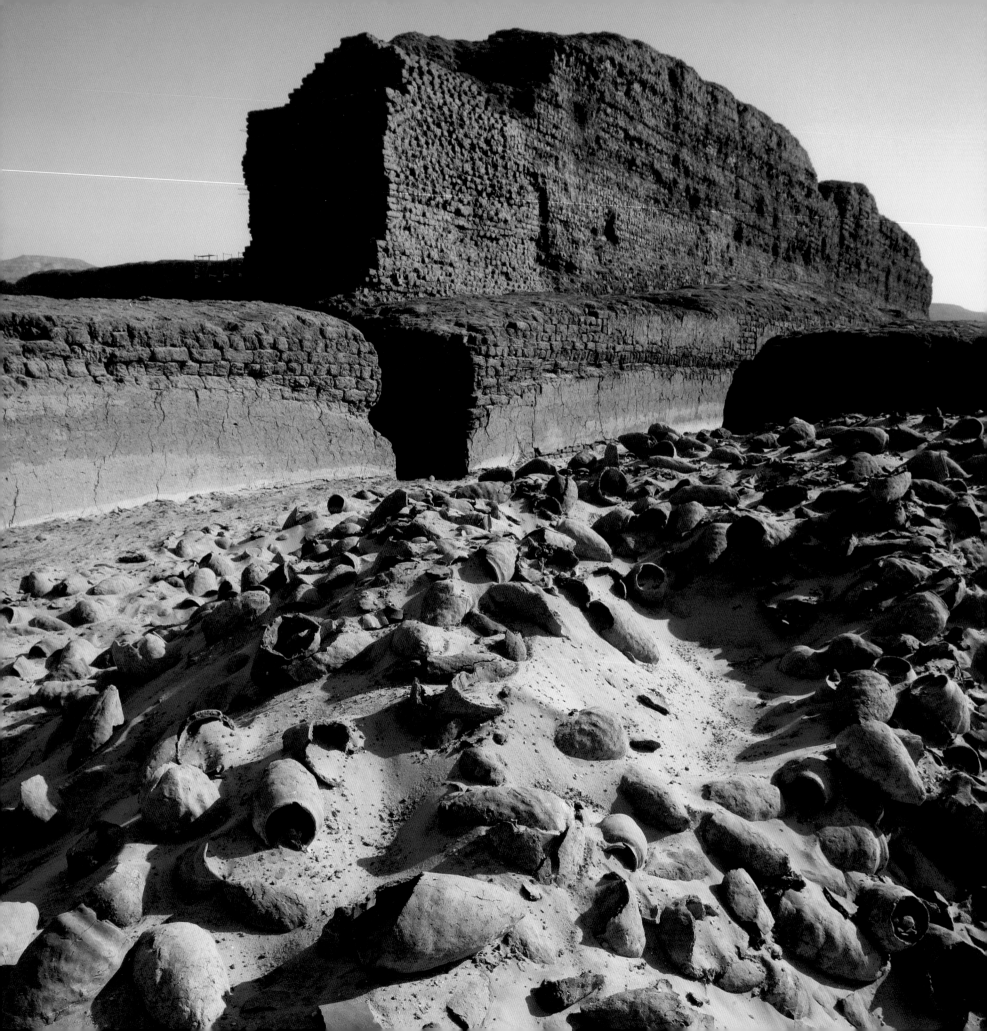

THE SECRETS *of the* PHARAOHS

Zahi Hawass

I ALWAYS SAY THAT UP TO NOW we have discovered about 30 percent of our Egyptian monuments, and 70 percent still lie buried in the sand. The discovery of the tomb of Tutankhamun was the most fascinating in the history of archaeology. The gold, the precious and personal objects, as well as the curse stories, made people feel as though they were living an adventure. We are all fascinated by the stories of this young boy.

As the artifacts in this exhibition demonstrate, there have been many other important discoveries in Egypt, both before and after Tutankhamun. One of my personal favorites is the royal mummy cache at Deir el Bahari, found by the Abdel Rassoul family. These local villagers knew the secrets of the West Bank of Luxor—the Valleys of the Kings, Queens, and Nobles.

One day in the early 1870s, Ahmed Abdel Rassoul was herding his goats near Deir el Bahari. He heard a faint bleating and saw that one goat had fallen down a deep shaft. Climbing down, he entered a tunnel carved back into the cliffs and saw an amazing sight—piles of coffins and boxes in a series of tunnels, ending in a roughly cut burial chamber. Over the next decade, he and his family secretly entered the tomb several times and removed objects to sell on the black market.

Some of these artifacts bore royal names, and the Antiquities Service, always on the lookout for illegal smuggling, caught wind of them. At first the family refused to give up the secret, then they began to fight among themselves. Eventually one of them led the authorities to the tomb. They entered immediately and found it full of coffins, mummies, and burial equipment of the great kings and queens of the New Kingdom, including Thutmose III and Ramesses II. Mummies of 21st-dynasty high priests of Amun and their families were also hidden with them in this cache. In less than a week, about 40 mummies in all were brought out of the tomb and taken by boat to Cairo.

I met one of the last members of the Abdel Rassoul family more than 30 years ago, when I was working on the West Bank. This man, around 70 when I met him but still tall and energetic, used to tell us stories about the secrets of the pharaohs. One day, he asked me to go with him to the tomb of Sety I. He took me into the burial chamber and pointed at a tunnel that led into the

SHUNET EL ZEBIB, Abydos, Dynasty 2. Excavations continue at the great royal necropolis and cult site of Abydos, where an American team is clearing and restoring the cult enclosure of King Khasekhemwy.

cliffs. He told me that this tunnel sloped down for about 100 meters, and that the real burial chamber of Sety I lay at its end. He told me that the Antiquities Service had given him permission to dig there. He was sure that the secret burial of Sety was there, and that I was the one who would find it.

Later, I began to think that this man could have been right, since we do have only a few artifacts from the tomb of Sety I (although we have his mummy, found at Deir el Bahari). Also, no one has been able to explain this tunnel, so when I became the head of the Supreme Council of Antiquities, I decided that it was time to explore it. I came prepared, with a thick rope, a measuring tape, and lights. I held a flashlight and wore a hard hat to protect myself from falling rubble. I descended almost 77 meters before falling stones stopped me. I turned back—but we have since begun work there again, determined to restore the tunnel and explore it to its end. We may soon discover its secret.

The decades after the discovery of the Deir el Bahari cache were exciting ones. In 1891, a cache of 153 mummies belonging to the families of the 21st- and 22nd-dynasty high priests of Amun was found in a shaft tomb near the temple of Hatshepsut at Deir el Bahari; many of these are now in the basement of the Cairo Museum. A second cache of royal mummies was found, this time in the tomb of Amenhotep II, in 1898. In addition to the mummies of important New Kingdom pharaohs stored in the tomb, several nameless bodies were found in a side chamber. One of these, the so-called Younger Lady, became a media star when she was identified— unconvincingly—as Queen Nefertiti. We have recently CT scanned these mummies and hope to learn more about their identities soon. Another great early discovery in the Valley of the Kings was the mostly intact tomb of Yuya and Tuya, great-grandparents of Tutankhamun, made in 1905.

It was not only in Luxor, to the south, that great discoveries were made. In 1925 American archaeologist George Reisner found the intact reburial of Queen Hetepheres, mother of Khufu, at the foot of the Great Pyramid at Giza. At the bottom of a deep shaft lay the funerary equipment of this powerful royal woman, including her alabaster sarcophagus and canopic chest, gilded wooden furniture, and objects of gold and silver. One mystery still remains: When her sarcophagus was opened, her body was not there. In

1939 at the delta site of Tanis, in the complex dedicated to the god Amun-Re, Pierre Montet discovered several intact royal tombs of the Third Intermediate Period, which contained extraordinary objects. Some of those are displayed in this book.

It is not only foreigners who have made discoveries in Egypt. I mention here the work of two Egyptians: The first is Kamal el-Mallakh, who in 1954 found two huge dismantled wooden boats buried beside the Great Pyramid of Khufu. These boats—one of which was excavated and reconstructed, the other of which still lies in its pit—were symbolic solar boats to be used by Khufu in the afterlife. The other is Zakaria Ghoneim, who in 1950 uncovered the unfinished pyramid of Sekhemkhet at Saqqara. Inside the burial chamber was a sarcophagus, which Ghoneim opened for the press—only to find, to his great disappointment, that it was empty.

ABYDOS

Very important excavations have been underway for several decades at the site of Abydos in northern Upper Egypt, where Gunter Dreyer from the German Archaeological Institute is reexcavating the tombs of the 1st- and 2nd-dynasty kings. Among his important discoveries are examples of the earliest hieroglyphic writing in Egypt, circa 3300 B.C., and proof that Aha, first ruler of Dynasty 1, should be identified as Menes, the legendary unifier of the Two Lands.

Also at Abydos, David O'Connor is working in the funerary enclosures of the early dynastic kings, carrying out important conservation work at the Shunet el Zebib, the enclosure of Khasekhemwy. His team has found three small enclosures belonging to Aha and has also uncovered 14 mysterious full-size wooden boats covered with mud brick, moored in the desert.

GIZA

At Giza, my discovery of the Necropolis of the Pyramid Builders and Mark Lehner's excavations of the workmen's installation east of these tombs has enriched our knowledge of the lives of the

workmen involved in the construction of the pyramids and elite tombs of the 4th and 5th dynasties. The tomb and settlement tell us that these men and women were free Egyptians, laboring voluntarily in the service of their divine kings. They were honored with tombs in the shadow of the pyramids; they were housed and fed well, as shown by evidence that 33 goats and 11 head of cattle were slaughtered each day, enough to feed a workforce of about 10,000. Their spines show signs of stress from moving heavy loads, but their skeletons also reveal that they received good medical care: One worker had successful surgery to remove a brain tumor, and another survived the amputation of a leg. The different titles in the cemetery, such as "overseer of the workmen who drag the stones" and "overseer of the side of the pyramid," offer a glimpse into the organization of this workforce. There were many permanent workers and also temporary laborers sent to Giza from the provinces. The pyramid was a great national project and everyone participated, either by providing labor or by sending food for the workforce.

The mysteries of the Great Pyramid continue to fascinate us. More than ten years ago, when I closed it to the public for the first time to treat the high humidity and salt deposits that were threatening the interior, I asked Rainer Stadelmann, at that time director of the German Archaeological Institute in Cairo, to help me find a scientific institution that could build a ventilation system for the pyramid. Engineer Rudolf Gantenbrink designed a robot to explore and clear the so-called air shafts, tunnels 20 centimeters in diameter that extend from the King's and Queen's Chambers, to prepare for installing a ventilation system. In the northern shaft of the Queen's Chamber, the robot was unable to navigate a bend it encountered after about 18 meters. In the southern shaft, the robot made it 60 meters before being blocked by a stone slab with two copper handles.

In 2002, the National Geographic Society sponsored the design of another robot, which was able to turn corners and drill holes into which a small camera could be inserted. In the southern shaft, we found a second slab 21 centimeters past the first one; in the northern shaft, we found another copper-handled door. I am now building a team to work on a robot that can help us discover what is behind these mysterious doors.

ABUSIR

The Czech mission under Miroslav Verner, excavating around the pyramids of Dynasty 5 at Abusir, has reexcavated a site and confirmed that it belonged to the little-known King Neferefre. The funerary temple associated with this pyramid contained an important papyrus archive, which provides information on the administration and economies of the temples and the duties of priests who performed the ceremonies there.

Clearing the area near the pyramid complex of Sahure, my team discovered some blocks that had once decorated his causeway. These bear important scenes, including one that shows workmen dragging the capstone that once topped the pyramid. Performances by the king's troops are depicted, offering a glimpse of the celebrations that attended the completion of the pyramid complex, which would help the king to achieve divinity and eternal life. Another fascinating scene shows a group of emaciated Bedouin, desert dwellers who were considered hostile to the inhabitants of the Nile Valley.

One of the most interesting recent discoveries from Abusir is the intact tomb of Iufaa. Uncovered by the Czech expedition under Ladislav Bareš, the tomb is part of a Late Period cemetery. The burial chamber lies at the bottom of a 28-meter-deep shaft. The original ceiling was a limestone vault. High humidity and earthquakes in the 1990s had weakened the stone, and work to save the tomb had to be carried out quickly to prevent the walls from collapsing into the chamber. It was amazing to see the workmen mixing concrete in the desert with water brought in on the backs of donkeys.

The intact burial chamber contained the complete funerary equipment of Iufaa, including his canopic jars and a set of 408 faience shabtis. Opening the enormous, 20-ton lid of the limestone sarcophagus was a great feat. We were delighted when we revealed a beautiful anthropoid inner sarcophagus made of greenish black schist. It proved to contain a fragile wooden coffin which, unfortunately, disintegrated at a touch. Iufaa's mummy lay within, covered by an intricate broad-collar and net of colored faience beads. We performed an x-ray on the mummy in Cairo, which revealed that Iufaa had been about 54 years old at his death. Then we returned the remains to Abusir.

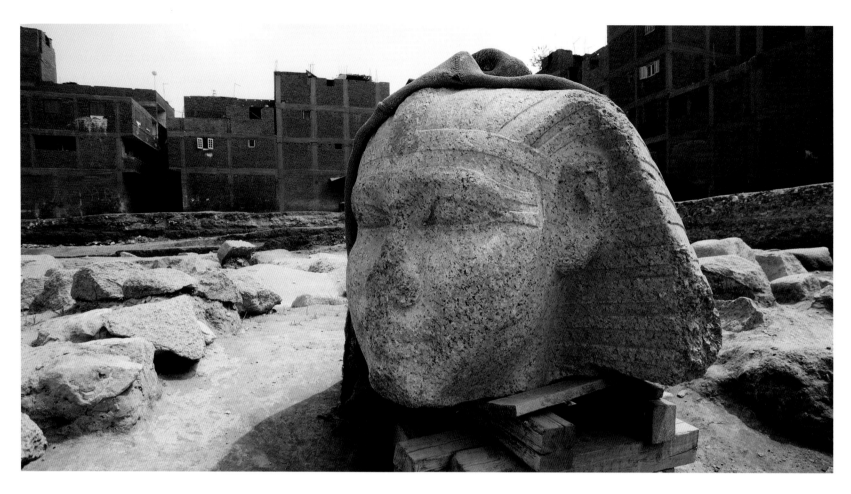

SAQQARA

A great deal remains to be done at the vast and important site of Saqqara. We are now restoring the pyramid of Djoser and shoring up the approximately 3.5 miles of underground tunnels and chambers that form its substructure. I am also excavating near the pyramid of Teti, the first king of Dynasty 6. We have now reexcavated the pyramid complexes of his queens: his principal wife, Khuit, and a secondary wife, Iput I, the mother of Pepy I.

Near the queens' pyramids, we found the beautifully decorated tomb of a son of King Teti named Tetiankhkem. In the burial chamber was found a sarcophagus and the damaged mummy of a man who died at about the age of 25, along with a beautiful calcite headrest and a tablet for the seven sacred oils. Nearby, we are reexcavating the substructure of the "headless pyramid," attributed alternatively to Menkauhor of Dynasty 5 or Merikare of Dynasty 9. Our new excavations have uncovered a substructure lined by huge granite blocks and the lid of a sarcophagus;

the architecture style suggests that the pyramid dates to Dynasty 5 and could have belonged to Menkauhor.

The work of the French team under Audran Labrousse around the pyramid of Pepy I at South Saqqara has shed additional light on the pyramids of Dynasty 6. They have found six new subsidiary pyramids of queens and princes, the wives and children of Pepy I. I do not think that any other pyramids of the Old Kingdom are accompanied by this many subsidiary pyramids. At the time of Pepy II, his mother, Ankhesenpepy II, built a pyramid near her first husband, Pepy I. The Pyramid Texts were found inscribed on the walls inside the burial chambers, showing the great prestige of this woman, wife of two pharaohs, mother of a third, and regent

COLOSSAL HEAD OF RAMESSES II, Heliopolis, New Kingdom, Dynasty 19. This royal head of red granite, along with other architectural and sculptural elements from various periods of pharaonic history, was discovered recently during the construction of a new shopping center in Heliopolis.

during the childhood of Pepy II. The size of the pyramid shows that she was given a burial equal to that of a king.

Saqqara is also rich in New Kingdom material. A University of Leiden expedition has revealed the locations of several "lost" tombs that had previously been excavated, as well as several heretofore unknown. These include the sepulchers of Ptahemwiya, a seal-bearer to Akhenaten; Horemheb; Maya, Tut's treasurer; and Meryneith, a high priest of the Aten. Another expedition, led by French archaeologist Alain Zievie, has excavated the tombs of Tutankhamun's wet nurse, Maia, the vizier Aper-El, and an ambassador under Ramesses II, Netjerwemes.

DAHSHUR

South of Saqqara lies Dahshur, where Dieter Arnold has been excavating. Among his recent discoveries is a cache of jewelry of Queen Weret II, chief queen of Senwosret II, found in her burial complex beneath her husband's pyramid. Included in this group were four bracelets, two anklets with claw pendants (to protect against scorpions), two amethyst scarabs bearing the name of Amenemhat II, and a girdle of gold cowrie shells.

Also at Dahshur, Sakuji Yoshimura, heading an expedition from Waseda University, has made some wonderful finds, including three unopened wooden coffins. One—an anthropoid coffin from the 18th dynasty belonging to a "chief craftsman at the Temple of Amun" named Wiay—was in a small pit; the others, found in burial chambers at the bottom of a shaft, were rectangular coffins from the Middle Kingdom belonging to a couple, apparently husband and wife, named Sobekhat and Senetites. Pottery vessels and other offerings were found at the entrance to each burial.

HELIOPOLIS

Ancient Heliopolis, known to the ancient Egyptians as Iunu, or On, was the "city of the sun," where the prophet Joseph is said to have married the daughter of the high priest of the sun cult. Ancient Greek philosophers came to study at the university here. The oldest obelisk in Egypt, dating to the reign of the 6th-dynasty king Teti, was found in Heliopolis, and an obelisk of the 12th-dynasty king Senwosret I still dominates a park there. Other important remains include a column there from the reign of Merenptah and temples of a number Ramesside kings.

Egyptian law now requires that the Supreme Council of Antiquities inspect any area before new building occurs, and this has led to a number of new discoveries in Heliopolis. In one area where inhabitants wanted to build a mosque, we found the remains of a tomb of Dynasty 26, filled with artifacts like canopic jars and shabtis. We found another sealed tomb of the same period under the site of a planned villa.

The most recent important discovery here is a great temple of Ramesses II, east of the obelisk of Senwosret I. The area around this temple is called the Souk el Khamis, "the Thursday market," and the remains came to light when the government decided to build a shopping mall in this area. It is interesting that the site is mentioned in the "Déscription de l'Égypte" published by Napoleon's expedition at the beginning of the 19th century. We found remains of a temple, along with sphinxes of King Merenptah; a headless seated statue of Ramesses II in a leopard-skin robe; another head, weighing three tons, of Ramesses II; and a huge, uninscribed royal head. the style of which dates it to Dynasty 26. We also found the names of Akhenaten and Nefertiti on *talatat* blocks, used for construction during the Amarna period—proving that there was a temple to the Aten at Heliopolis under the "heretic" king.

BAHARIYA

Perhaps the most interesting discovery that I have made over the course of my career as an Egyptologist is the Valley of the Golden Mummies at the Bahariya Oasis. The smallest of Egypt's five oases, Bahariya is located about 220 miles southwest of Cairo. There is evidence that it was inhabited during many different parts of the Pharaonic Period, but the two golden ages at the site were the Saite and Greco-Roman Periods, around 664-525 B.C. and from 332 B.C. into the fourth century A.D. respectively.

The Valley of the Golden Mummies dates to the Greco-Roman period. The site is large, about six square kilometers, and may contain as many as 10,000 mummies; since 1999, we have found more than 200. Most of them belonged to the wealthy merchant families who controlled trade in the sweet date wine produced in the oasis. They are buried in large sepulchers that house multiple generations and are elaborately wrapped in the bandaging style of the time. The wealthiest are extensively gilded, leading to the site's nickname. In our most recent season at the Valley of the Golden Mummies, we decided to look for tombs of the poor. Using radar, we located many pit tombs belonging to the lowest stratum of Greco-Roman society at Bahariya. We have suspended excavations but we are opening a museum there.

The necropolis of Sheikh Soby, where the 26th-dynasty governors of Bahariya were buried, lies under the modern town of Bawiti. Among the maze of tombs are those of the governor, Djedkhonsu-iuf-ankh; his father, Padi-Isis; and his mother, Naesa. Recently we discovered a new shaft, sealed in Roman times, containing the robbed sarcophagus of another son of Padi-Isis. Opening the shaft was a great adventure. One of my favorite sites, this one promises excitement in the future. Recent excavations have revealed an embankment built during Dynasty 25 to protect the temple from the annual flood. A Roman bath was found nearby and, to the south, ramps dating to Dynasty 24.

DEIR EL BERSHEH

Interesting remains from the First Intermedate Period were found at Deir el Bersheh by a mission from the Catholic University of Leuven under Harco Willems and Marleen De Mayer. In 2005-06 this team found a tomb belonging to a man named Uky; in 2007 they excavated two shafts in the tomb's rear chamber and found that one contained the intact burial of an official named Henu. In addition to a wooden coffin containing a linen-wrapped mummy, the team excavated a pair of wooden funerary sandals and models of grinding grain, making beer, and manufacturing bricks. There was also a model boat and a statue of the deceased.

LUXOR

Luxor is the city that witnessed the glory of Egypt during its golden age—the New Kingdom. Here begins the story of Queen Nefertiti, starting with three unidentified mummies—named the Elder Lady, the Young Boy, and the Younger Lady—found in the site labeled KV 35 in the Valley of the Kings. A team from York University x-rayed the Younger Lady and concluded that the mummy was Nefertiti's—an idea suggested before but not generally accepted by Egyptologists.

When we examined the mummy with a CT machine, results did not support this identification. The CT scan showed that the bent arm (not in any case proof of queenly status, as private women are also shown in this pose) did not belong to the mummy. As for the trauma to the mummy's face, our radiologists determined that it had not been inflicted on the finished mummy but had taken place prior to embalming, perhaps even prior to death. The mummy's double-pierced left ear is hardly unique; nonroyal female mummies of the period have such piercings. The Nubian wig was not unique to Nefertiti either; many people during this era wore such a wig. In short, there is no reason at all to think that the Younger Lady from KV 35 is the mummy of Nefertiti. Further study is required before we can suggest who she might have been—much less which, if any, of the unidentified female mummies known to us is that of Akhenaten's famous queen.

KV 63

The New Kingdom tomb called KV 63, the first to be found in the Valley of the Kings since that of Tutankhamun, was discovered by accident during the clearing of the area in front of the tomb of Amenmesse. It consists of a shaft that goes down about four and a half meters, with a roughly cut chamber opening off to one side.

GILDED MUMMY, Valley of the Golden Mummies, Roman Period. More than 250 mummies covered in cartonnage, many elaborately gilded, have been found in this valley of the Bahariya Oasis. With its idealized portrait mask, this upper-class woman's mummy emanates an ethereal expression.

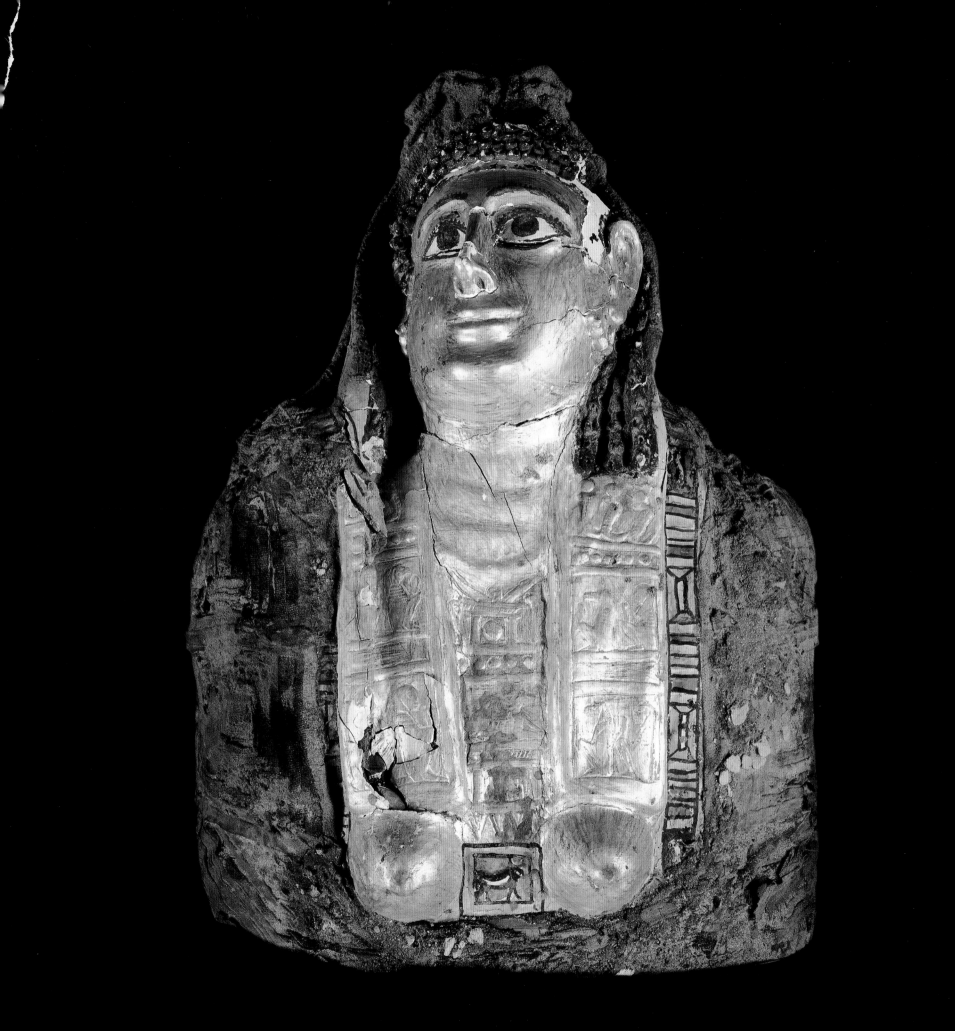

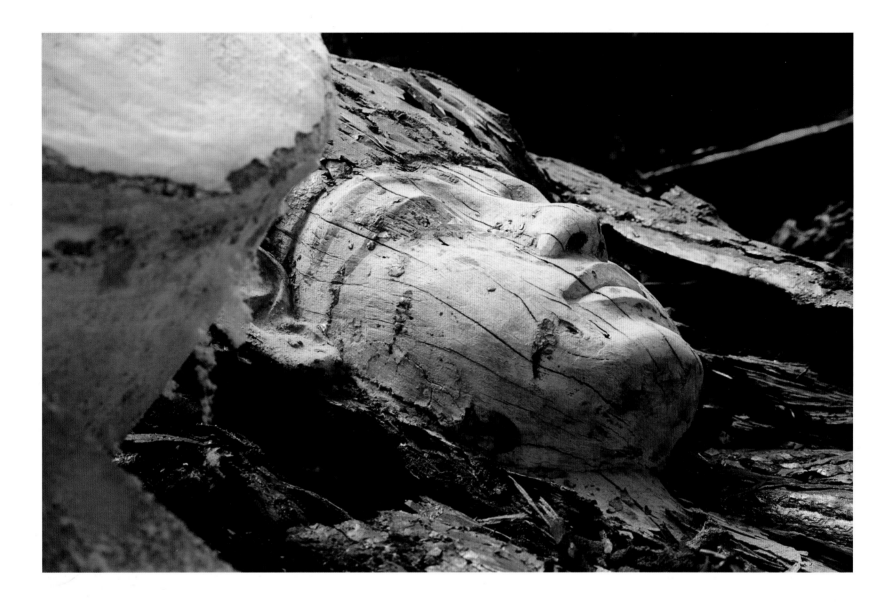

The chamber contained seven wooden coffins and numerous sealed jars lying on a layer of rubble. The coffins contained not mummies but natron, potsherds, and other materials used in embalming. The jars, still being opened, also contained miscellaneous materials, many connected with mummification. Seal impressions were found, including examples of the necropolis seal. Similar seals are known from Tutankhamun's tomb and from KV 55, the Amarna cache to which the burials of some members of Akhenaten's family may have been relocated after the abandonment of his capital at Amarna. The artifacts date KV 63 to late in Dynasty 18. The tomb may have been made for Kiya, the queen thought by some to have been Tutankhamun's mother, who may have died

giving birth to her son. Whatever its original purpose, KV 63 was ultimately used as an embalming cache.

THE MUMMY OF HATSHEPSUT

My search for the mummy of Queen Hatshepsut began with an adventure in her tomb, KV 20. I had to negotiate more than

PAINTED WOODEN COFFIN, Valley of the Kings, Dynasty 18. This anthropoid wooden coffin, the most expressive of those found in KV 63, has a face carved in the style favored around the time of Tutankhamun.

200 meters of slippery descending passages filled with the smell of bats before I reached the burial chamber. Few archaeologists have tried to explore this tomb since Howard Carter excavated it in 1903. It once contained the queen's sarcophagus, now in the Cairo Museum, and a sarcophagus recarved for her father, Thutmose I, which is now in the Museum of Fine Arts, Boston.

Next I began a scientific examination of four unidentified female mummies, hoping that one might be that of the great queen. One of them was found in the Deir el Bahari cache in 1881, and another in KV 35. The other two were from a small tomb, KV 60, discovered by Carter in 1903, which included a coffin inscribed with part of the name of Hatshepsut's wet nurse, Sitre-In, and the mummy of an obese woman.

I searched for the mummy from the wet nurse's coffin in the Cairo Museum and found it in storage there. I also moved the coffinless mummy from KV 60 to the museum. I then had CT scans performed on all of these mummies, as well as on the mummies of Thutmose II, Hatshepsut's husband; Thutmose III, her stepson; and on a mummy once identified as her father, Thutmose I, although most scholars believed this is not the king.

We also scanned a small wooden box containing what was thought to be a liver and marked with the queen's cartouches that was found with the cache of mummies discovered in the Deir el Bahari tomb. This was the biggest surprise: In addition to what looked like some intestines and what could be the liver, the scan revealed a tooth. Missing from the jaw of the mummy of the obese woman from KV 60 was this exact tooth: It was a perfect fit! We brought in a dentist, who confirmed that the tooth matched the space in the jaw, meaning that this is most likely the mummy of Hatshepsut. We also had a DNA lab built in the basement of the Cairo Museum, and performed tests on this mummy and the mummy of Ahmose-Nefertari, probably her great-grandmother, as well as on some of her male relatives. Preliminary results of these tests are promising, but we will have to wait for the final word.

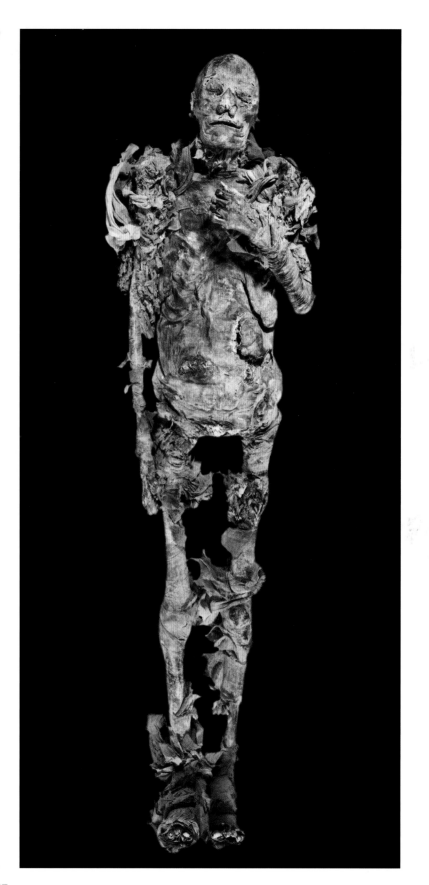

HATSHEPSUT'S MUMMY, KV 60, Dynasty 18, circa 1502-1482 B.C. The mummy of an obese woman who appears to have died between the ages of 45 and 60, this eternal figure has recently been identified as the earthly remains of the great female pharaoh Hatshepsut.

NOTES *on the* EXHIBITION

OBJECTS FROM THE TOMB of Tutankhamun left Egypt for the first time to travel abroad in 1961, but it was the exhibition launched in the late 1970s, "Treasures of Tutankhamun," containing the 50 greatest masterpieces from the burial, that really captured the imagination of the world. This exhibition went first to the United States and then to Europe. While conservators were installing the artifacts in the German venue, the scorpion on the head of Selket, one of the gilded wooden goddesses that guarded Tutankhamun's canopic shrine, fell off and broke. It was able to be repaired, at a cost of 50,000 marks (around $100,000), but the Egyptian government did not want anything like this to happen again. The Egyptian press wrote a great deal about the dangers of allowing our precious artifacts to travel, and Parliament reacted by requesting that these priceless objects never again be allowed to travel outside Egypt.

In 2002, Andy Numhauser—a friend of Omar Sharif's and thus, I knew, respectful of our homeland and its heritage—called me to say that the company of which he is vice president, Arts and Exhibitions International, wanted to arrange for a Tutankhamun exhibition in the United States. I said that it would be impossible because of the Egyptian Parliament's request. But at the same time, Peter Blome, director of the Antikenmuseum in Basel, Switzerland, came to see me, also to ask for a Tut exhibit. My original answer was no, but Dr. Blome was quite insistent. Finally, primarily because of Egypt's excellent relationship with Switzerland, the Egyptian government agreed to consider the request.

The decision still had to be approved, however. Mr. Farouk Hosni, Egypt's Minister of Culture, and I attended a parliamentary meeting, and he gave an important address, saying, "We need to restore the Egyptian monuments, and sending King Tut abroad will bring in money for the conservation and restoration of the objects at the Egyptian Museum. Tutankhamun should travel to save his ancestors, and himself." Parliament agreed.

We thought that this time it would be better if Tutankhamun did not go alone but went instead with objects introducing him and his extended royal family. The curators at the Cairo museum chose well over 100 objects, almost 50 of them from the tomb of Tutankhamun. The exhibition went first to Basel and then to Bonn, Germany. Andy Numhauser never lost hope that Egypt would allow Tutankhamun's treasures to visit the United States as well. He kept calling me, although I could not give him a definite answer. Finally, I asked him to meet me in Basel when the exhibition opened there. He arrived accompanied by his colleague John Norman, the president of Arts and Exhibitions (now part of AEG), and I was able to give them the great news that Egypt would allow the exhibition to continue to the United States and England before finally coming home. In appreciation of their contributions to many projects in Egypt, I would like to draw attention to the contributions of AEG's owner, Philip Anschutz; its president, Tim Leiweke; and Mr. Leiweke's assistant, Tom Miserendino. I value their friendship very highly.

This first exhibition has been enormously successful and has brought a great deal of money to Egypt, which is being used to fund conservation efforts as well as the new museum being built at Giza, to which Tutankhamun's treasures will move in 2012. This financial arrangement is due in great part to the work of Mr. Numhauser and Mr. Norman, who agreed with my goal to bring exhibition proceeds to Egypt. The National Geographic Society joined the project as the sponsoring scientific institution, and now these three groups—AEI, AEG, and NGS—are working well together and even contributing funds for a project very close to my heart, the Suzanne Mubarak Children's Museum in Cairo.

Based on the success of the first exhibition, we decided to send a second exhibition to the United States. This time, we decided, Tut would travel with the great pharaohs of Egypt, including ancestors and kings who came after him. The golden king is becoming the ambassador for pharaonic Egypt. Fifty new artifacts from the tomb of Tutankhamun, along with almost one hundred objects from all periods of Egyptian history, were selected to represent the kings and queens, members of the elite, and gods. We chose to include some of the statues from my excavations at Giza at the tombs of the pyramid builders and in the great necropolis west of the pyramid of Khufu, leaving Egypt for the first time ever.

TIME LINE OF ANCIENT EGYPT

EARLY DYNASTIC

CIRCA 3100 - 2687 B.C.
DYNASTY 0 - 2

3100 B.C.

2687 B.C.

SELECTED BIBLIOGRAPHY

Arnold, D., *The Royal Women of Amarna: Images of Beauty from Ancient Egypt*. 1996.
Bárta, M., Krejčí, J., eds., *Abusir and Saqqara in the Year 2000*. 2000.
Bongioanni, A., et al., eds., *The Illustrated Guide to the Egyptian Museum in Cairo*. 2001.
Breasted, H., *A History of Egypt from the Earliest Times to the Persian Conquest* (2nd ed.). 1970.
Carter, H., and Mace, A., *The Tomb of Tut-Ankh-Amen* (3 volumes). 1923-33.
Cottrell, L., *The Secrets of Tutankhamun*. 1965.
Desroches-Noblecourt, C., *Tutankhmun: Life and Death of a Pharaoh*. 1963.
Edwards, I. E. S., *The Pyramids of Egypt* (rev. ed). 1985.
———, *Tutankhamun: His Tomb and Its Treasures*. 1976.
———, *Tutankhamun's Jewelry*. 1976.
Freed, R., Markowitz, Y., and D'Auria, S., *Pharaohs of the Sun: Akhenaten, Nefertiti, Tutankhamen*. 1999.
Hawass, Z., *Tutankhamun and the Golden Age of the Pharaohs*. 2005.
———, *Hidden Treasures of Ancient Egypt*. 2004.
———, *Secrets from the Sand: My Search for Egypt's Past*. 2003.
———, ed., *The Treasures of the Pyramids*. 2003.
———, *The Hidden Treasures of the Egyptian Museum*. 2003.
———, *Silent Images: Women in Pharaonic Egypt*. 2000.
———, *Valley of the Golden Mummies*. 2000.
———, *The Secrets of the Sphinx: Restoration Past and Present*. 1998.
———, *The Pyramids of Ancient Egypt*. 1990.
Kemp, B., *Ancient Egypt: Anatomy of a Civilization*. 1989.
Lepre, J. P., *The Egyptian Pyramids*. 1990.
Málek, J., *In The Shadow of The Pyramids: Egypt During the Old Kingdom*. 1986.
Metropolitan Museum of Art, *Egyptian Art in the Age Of the Pyramids*. 1999.
Petrie, W. M. F., *The Pyramids and Temples of Gizeh*. 1883; new edition, ed. Hawass, 1990.
Redford, D. B., ed., *The Ancient Gods Speak: A Guide to Egyptian Religion*. 2002.
———, *The Oxford Encyclopedia of Ancient Egypt* (3 vols.). 2001.
Reeves, C. N., *The Complete Valley of the Kings: Tombs and Treasures of Egypt's Greatest Pharaohs*. 1996.
———, *The Complete Tutankhamun: The King, the Tomb, the Royal Treasure*. 1990.
Roehrig, C., et al., eds., *Hatshepsut: From Queen to Pharaoh*. 2005.
Smith, W. S., *The Art and Architecture of Ancient Egypt* (rev. ed. with additions by W. K. Simpson). 1998.
Trigger, B. G., et al., *Ancient Egypt: A Social History*. 1983.
Verner, M., *Forgotten Pharaohs, Lost Pyramids: Abusir*. 1994.
Wengrow, D., *The Archaeology of Early Egypt: Social Transformations in Northeast Africa, 10,000 to 2650 B.C.* 2006.
Wilkinson, T., *Early Dynastic Egypt*. 1999.
Winstone, H. V. F., *Howard Carter and the Discovery of the Tomb of Tutankhamun* (rev. ed.). 2006.
Ziegler, C., ed., *The Pharaohs*. 2002.

3RD INTERMEDIATE PERIOD

LATE PERIOD

CIRCA 1081 – 711 B.C.
DYNASTY 21 - 23

711 B.C.

CIRCA 724 – 333 B.C.
DYNASTY 24 - 31

333 B.C.

NEW KINGDOM

CIRCA 1569 – 1081 B.C.
DYNASTY 18 - 20

3RD INTERMEDIATE PERIOD

CIRCA 1081 – 711 B.C.
DYNASTY 21 - 23

1081 B.C.

INDEX

MIDDLE KINGDOM

CIRCA 2061 – 1665 B.C.
DYNASTY 11 - 14

2ND INTERMEDIATE PERIOD

CIRCA 1664 – 1569 B.C.
DYNASTY 15 - 17

1665 B.C.

1569 B.C.

This exhibition has been inspired in many ways by children and young people. In Egypt today, our children know their history very well. I receive hundreds of letters asking me about King Tut or how to become an archaeologist. Those letters are really what gave me the idea of sending this exhibition to the United States, to share the wonders of ancient Egypt with a new generation. They are also part of the reason why I agreed to license my signature Indiana Jones hat and use the proceeds to support the Suzanne Mubarak Children's Museum in Cairo. Mrs. Mubarak has dedicated her life to children, women, and progress toward world peace. She encouraged me to send this exhibition abroad knowing that it could help fund the construction of new museums like the Children's Museum in Egypt, as well as the redevelopment of such landmark institutions as the Egyptian Museum in Cairo.

I want to emphasize again that the money raised by this exhibition will go in large part for the conservation and restoration of the Egyptian monuments, which belong to the world. Some of the money will go to the Grand Museum of Egypt. This is being built to the highest international standards, and it will house not only Tut but many of the objects that currently overcrowd the galleries of the Egyptian Museum in Tahrir Square, along with treasures now hidden in storage around the country. We are also building a new national museum in Fustad (Old Cairo), the National Museum of Egyptian Civilization; part of the current collection of the Egyptian Museum will also move there. The Egyptian Museum in Tahrir Square, which will be dedicated to the history of Egyptian art and archaeology, will be renovated and provided with a new scenario and updated displays. Other funds raised by these exhibitions will be distributed around the country to help with site management and conservation of major monuments.

Many people thought that when the CT scan proved that Tutankhamun was not in fact murdered by a blow to the head, the mystery of the boy king had come to an end. As I have told the press, however, the story is still unfolding. When KV 63 was discovered, it drew the world's attention not only because it was the first tomb to be found in the Valley of the Kings since Tutankhamun's, but also because of its connection with the young pharaoh. I have suggested that although it was later used as a cache for embalming materials, it might originally have been the tomb of Kiya, Tutankhamun's mother, in part because it lies so close to his tomb. Many questions remain about the king's family, and I think that one of my next projects may be to search for answers to them.

My latest adventures in the Valley of the Kings resulted in the discovery of the mummy of Queen Hatshepsut, one of history's most powerful women, who ruled Egypt for more than 20 years during its golden age. A single tooth inside a wooden box proved to be the key to the identity of her mummy. The CT scan machine and the new DNA lab at the Egyptian Museum in Cairo are helping us to rewrite the history of the New Kingdom through a better understanding of the physical remains of its great monarchs.

The Valley of the Kings will continue to reveal secrets well into the future. The location of the tomb of Amenhotep I is unknown, and it may lie somewhere in the valley. The burial of Nefertiti also remains to be found, and we do not know where Ankhsenamun, Tutankhamun's wife, was interred. I believe that there is much archaeological work yet to be done in the Valley of the Kings. Egypt's sands may always hide secrets.

— ZAHI HAWASS
Secretary General of Egypt's Supreme Council of Antiquities

I N 1976 a collection of 55 treasures from the tomb of the Pharaoh Tutankhamun left the Egyptian Museum en route to the United States. These artifacts comprised an exhibition that the government of Egypt had agreed would travel throughout our country as a cultural initiative. It took the country by storm and introduced millions of Americans to these wonders of the ancient world. Still today it remains the most visited exhibition tour in the world. Now Egypt presents another opportunity for us to have the privilege of viewing such treasures. On behalf of Andres Numhauser, the National Geographic Society, AEG Exhibitions, and myself, I would like to express our appreciation and gratitude to the Arab Republic of Egypt for this generous and important loan of antiquities.

Exhibitions are realized through the collaboration of many dedicated, talented, and resolute individuals. This one was no exception. "Tutankhamun and the Great Pharaohs" benefited from the support and vision of many such people, including Terry Garcia, Phil Anschutz, Tim Leiweke, John Meglen, Tom Miserendino, Mark Lach, Michael Sampliner, Shawn Trell, Randy Phillips, David Silverman, and Omar Sharif. I extend a very special acknowledgment to Dr. Zahi Hawass, Secretary General of the Supreme Council of Antiquities in Cairo. All of my colleagues and I are honored to be associated with this magnificent exhibition.

This is especially gratifying work, for it allows all of us to participate in an ancient Egyptian wish: "Causing his name to live." Funerary texts often included a phrase like this to ensure that the memory of the deceased and the spirit of the individual would continue to live in perpetuity in the afterlife. By tradition, the children and ancestors would fulfill this role, but Tutankhamun had no direct heirs to succeed him. In a way, each of us who sees the exhibition partakes in its marvels and repeats his name, helping to ensure that Tutankhamun will indeed achieve immortality.

— JOHN NORMAN
President of Arts and Exhibitions International

OLD KINGDOM

CIRCA 2687 — 2165 B.C.
DYNASTY 3 - 8

1ST INTERMEDIATE PERIOD

CIRCA 2165 — 2061 B.C.
DYNASTY 9 - 11

MIDDLE KINGDOM

CIRCA 2061 — 1665 B.C.
DYNASTY 11 - 14

2165 B.C. 2061 B.C.

ABOUT *the* CONTRIBUTORS

ZAHI HAWASS is an Egyptian archaeologist known worldwide for his contributions to the understanding and preservation of Egypt's heritage. Among his most important discoveries are the Tombs of the Pyramid Builders at Giza and the Valley of the Golden Mummies in the Bahariya Oasis. Recently he conducted a CT scan study of Tutankhamun's mummy and led the team that identified the lost mummy of Queen Hatshepsut. A popular lecturer, Dr. Hawass has won many awards for his work with the public. In 2006, he was chosen by *Time* magazine as one of the world's 100 Most Influential People.

SANDRO VANNINI, an Italian photographer, specializes in geographic and ethnographic reportage, architecture, archaeology, and portraits. His work has been published in numerous European and American travel magazines, including *Viaggi nel Mondo, Arte, In Viaggio,* and *National Geographic Traveler.*

BETSY M. BRYAN, a chaired professor of Egyptian art and archaeology and Near Eastern studies at Johns Hopkins University, is the leader of an excavation at Karnak in Luxor, Egypt.

DAVID O'CONNOR, an Australian Egyptologist, holds a chaired professorship in ancient Egyptian art at the Institute of Fine Arts, New York University.

DONALD REDFORD, a professor of classics and ancient Mediterranean studies at the University of Pennsylvania, directs excavations at Mendes in Lower Egypt and at Tel Kedwa in the northern Sinai.

DAVID P. SILVERMAN, the curator of the Penn Museum's Egyptian Section, is a chaired professor of Egyptology at the University of Pennsylvania.

ACKNOWLEDGMENTS

I would like to thank the many people who helped me in finishing this book. I would like first to thank my dear friend Dr. Janice Kamrin for editing my English. I would also like to thank the many people in my office who helped by reading the text and offering suggestions, such as Dr. Tarek El-Awady, Mohammed Megahed, Wesam Mehrez, Heba Abdel Monem, Sherif Shabann, and Maggie Bryson. My sincere thanks to John Norman and Andy Numhauser, who worked hard to make the exhibition successful; also to my dear friends Tim Leiweke and Tom Miserendino. At the National Geographic Society, I would like to thank Kevin Mulroy, Susan Tyler Hitchcock, Melissa Farris, Dana Chivvis, and also Terry Garcia for his support.

— ZAHI HAWASS